Talk of Drama

Talk of Drama

Views of the television dramatist now and then

Sean Day-Lewis

UNIVERSITY
UP *of*
LUTON PRESS

British Library Cataloguing in Publication Data
A catalogue record for this book is available from the British Library

ISBN: 1 86020 512 7

For Jake, Sam, Jesse, Calum and Cavan
Just too late for 'the golden age'.

Published by
ULP/John Libbey Media
University of Luton
75 Castle Street
Luton
Bedfordshire LU1 3AJ
United Kingdom

Tel: +44 (0)1582 743297
Fax: +44 (0)1582 743298
e-mail: ulp@luton.ac.uk

Typeset in Galliard and Brody
Printed in Great Britain by Whitstable Litho Ltd, Whitstable, Kent, UK

Contents

Introduction

This is a book of bias. First in favour of original small screen drama that is not adapted novel, imitation theatre or would be cinema but television. More importantly in favour of the prime movers in that form, the television dramatists. Through the spoken thoughts of such writers I aim to give students of the medium in general, and would be writers in particular, a readable and comprehensive account of what it takes to be a television dramatist of the 1990s. I have not selected or edited to labour a particular view of now and then. It is self-evident that there is much less space than there was for scriptwriting originality. The elimination of commissioning producers, able to cultivate writing talent, does not signal a better future. Centralisation of power throughout British terrestrial television means all decisions are made by channel controllers lacking any drama background. They look for known market appeal, 'drama demographics' as pointed by 'focus' groups, not writers' visions.

I have spent the past 30 years writing for the public prints about television programmes. If there has been one seam that has made this marathon seem worthwhile it is the hundreds of single, series and serial dramas through which I have been entertained, informed and educated over three decades. I owe the writers of these the thanks offering that is this book. Fellow television reviewer Nancy Banks-Smith famously wrote of Dennis Potter, when celebrating his loyalty to television, that 'I will always love him for making me feel it mattered'. My purpose is to extend that thought to cover all the dramatists interviewed for or celebrated by this book and, in a different way, to those justly or unjustly left out. Over three decades I have seen a little as great, a lot as good, a lot more as mediocre and just a few pieces that lodged in my mind as memorably bad. I have not seen five minutes of drama anywhere exposing a writer who had not tried or who did not care.

In these pages I attempt to beat a drum for a tradition that needs and deserves cherishing but looks to be slipping away through lack of care, or even interest, from those at the commanding heights of television. This is emphatically not a call to turn the clock back. The heyday or 'golden age' of the BBC's Wednesday Play and Play for Today has gone and, as channels multiply and choice diminishes, there is no hope of bringing it back. But quality drama is still written and made. It is not too late to rescue, revive and broaden the tradition, at least on the BBC and Channel 4 networks, where properly directed leadership could resist complete surrender to market place values.

The bulk of the book consists of material obtained through 40 taped interviews, mostly with writers but also with a handful of executives, producers and directors. Nobody who I approached turned me down and I am grateful for the time, patience and, in several cases, hospitality they gave me. I let all speak for themselves. After a chapter one call to arms I have limited my own prejudices to my questions. Television drama depends on a collaborative process and writers through the decades have inevitably bumped into, and been frustrated by, structural, institutional constraints. There is talk in these pages of the 'television novel' but, even for writers who become their own directors and producers, it cannot ever be simply a medium of individual expression like the novel itself. Writers are as capable of self-delusion as anybody else. They may well not realise quite how much they are formed by the medium and its institutions. I have nevertheless been heartened to learn how dramatists of today, soap providers as well as the fortunate few able to originate genuinely new work, still somehow find ways of using television to give us rewarding impressions of their mind prints.

One writer who could not speak for himself in this book, eloquently as he did so during his lifetime, is the late Dennis Potter. He is nevertheless the Chapter Two starting point because he achieved the ultimate in writer power. It is safe to say that the changing structures and attitudes in broadcasting will ensure that no television dramatist can ever again achieve such power. If Potter had waited until 1996-97 to die his last serials, *Karaoke* and *Cold Lazarus*, would almost certainly never have reached the screen. Some fellow writers speaking for this book, while admiring his earlier work, think it would have been better for him if those scripts had been spiked. One asserts that having achieved such power Potter seriously misused it. I remain convinced that *Karaoke* has been under-rated, an essential and distinctive last chapter for Potter's screen autobiography. Quite apart from anything else the dying protagonist Daniel Feeld spoke for all true television dramatists in his fear of directors with cinematic ambitions and in his frustration at writers perceptions being inhibited by prescriptions. Listen to him: 'It's my work, my sweat, he's (director Nick Balmer) fucking up! I'm not going to be knocked down by his bloody Rolls-Royce... The music's written and performed by someone else, and there's this piddling little space for you to sing yourself, but only to *their* lyrics, *their* timing'.

Despite Potter at the top I make no underlying qualitative distinction between areas of drama or the heights of brow from which it emerges or to which it is directed. The 'up market' and the 'popular' are treated with similar respect. Television dramatists come from all classes and places, they range from Oxbridge graduates to writers who escaped formal education in their middle teens and could never pass an exam to save their lives. Most writers lean a little to the political left but no two writers lean in the same way. A high proportion of television dramatists are blessed with some Irish genes but they only add to the variety. From such diversity comes their strength, a diversity much less evident among their director, producer and executive collaborators.

I have imposed just one rule of house style, where necessary changing sentences of reported speech. It has been done to avoid the customary solecism of using 'film' to mean 'cinema'. Film is material for television and cinema. It is time, I suggest, that our national institutions like the British Film Insti-

tute (BFI) and the British Academy of Film and Television Arts (BAFTA) recognised this, dropped 'film' from their titles and became what they are – the British Cinema and Television Institute and the British Academy for Television and Cinema Arts.

The writers who speak were selected in mid 1996 largely on the basis of their work seen earlier that year or scheduled for later 1996 and 1997 transmission. The book thus becomes a snapshot of television drama in those years as well as a selective history of all British television drama. It is a happy coincidence that so many of my selections were winners at the 1997 BAFTA award ceremony for the best television of 1996. Jimmy McGovern's *Hillsborough* was judged best single drama, *EastEnders* was voted best series and Peter Flannery's *Our Friends in the North* took the best serial award. For good measure Gina McKee in *Our Friends in the North* was best actress and Nigel Hawthorne in Paula Milne's *The Fragile Heart* was best actor.

My grateful thanks to all who have helped with this book. They include Manuel Alvarado, Peter Ansorge, Simon Ashdown, Ronan Bennett, Alan Bleasdale, Steve Bochco, Ruth Caleb, Jimmy Cellan Jones, Deborah Cook, Anna Day-Lewis, Finian Day-Lewis, Nick Elliot, Peter Flannery, Lucy Gannon, W Stephen Gilbert, Simon Gray, Elizabeth Guider, Jane Harris, William Ivory, Tony Jordan, Troy Kennedy Martin, Ian Kennedy Martin, Verity Lambert, Lynda La Plante, Phillipa Lowthorpe, Joanne Maguire, Joan McConnell, Jimmy McGovern, Paula Milne, Robert Muller, Gub Neal, Ol Parker, Alan Plater, Kieran Prendeville, Philip Purser, Michael Robson, Boz Routledge, Renny Rye, Howard Schuman, Antony Thomas, Ken Thomson, Kenith Trodd and Michael Wearing.

Sean Day-Lewis
Colyton, Devon
December 1997

1 The best bloody cow in the world...?

The diminishing yield

*All these moguls are buying up the milk floats and the BBC has got
the cow, the best bloody cow in the world. Once you have got all these
milk floats, taking information and programmes of various kinds
all over the world, the beast that can rule the world is the cow.*

The metaphor of the cow and the floats was given to me by Alan Plater,
master craftsman of television (and stage) drama and eloquent
spokesman for all writers, as he talked to me for this book about the
shifting ground on which he worked. He allows that 'they are still pretty good
at making milk in the BBC' and that is right. The question mark of the chap-
ter title is mine. The problem is that in vainly trying to compete as a major
player in the global delivery contest inadequate resouces are being set aside
for cattle husbandry and land enhancement. To recover its former position of
strength, confidence and leadership the BBC needs to return to concentration
on what it still does best. It should, as Plater pleads, 'put all its resources into
programme making, into production'.

Former BBC Director General Alasdair Milne once told me that the best
drama was the 'glory of the output'. Its providers were, in other words, the
Jerseys of the mixed herd. His successors have been too busy in the counting
house, or drawing up farm reorganisation plans, to notice the value of price-
less assets. To extend the Plater metaphor just a little further the flow of
increasingly impenetrable blueprints emerging from farmer John Birt's office
have done drama production a lot of harm and no discernible good. They
have all but eliminated the ability of the dairymen to exercise initiative and
enterprise. They have unwittingly encouraged a narrowing of the drama out-
put towards just two products – genre television and ersatz cinema. Most
damagingly they have failed to act on the awkward but unavoidable fact of
nature that to produce cream you have to maintain a high volume milk yield.

The two BBC channels obviously do not have a monopoly in generating television drama. In its confident past the BBC often, though not always, led the way. A crucial factor of recent years has been that as the prevailing Thatcherite destructiveness of the 1980s chipped away at the concept of public service broadcasting, and public service everything else, the BBC lost its confidence. The ITV network was driven into the market place and its consequent dictum, broken occasionally by the odd 'one off' pilot or docudrama, that no fiction failing to attract ten million or more viewers could have a place on the channel. Meanwhile Channel 4 has chosen to concentrate the greater part of its drama budget on would be cinema. Instead of endeavouring to make its own drama complementary to, or broader than, the ITV genre and C4 cinema strands the BBC felt bound to follow and imitate the trends. The view that, by Thatcherite definition, any public service organisation must be badly run and commerce must know best, has punctured internal BBC self-esteem. The BBC promotion ladder was kicked aside and ITV men, from John Birt downwards, were invited in to putsch and rule.

It would be tedious to labour the 'golden age' tag too much. In his memorable James MacTaggart memorial lecture at the 1993 Edinburgh Television Festival the pungent Dennis Potter recalled the times 30 years before when drama producer MacTaggart and his acolytes sat around talking of 'the evident iniquities of the BBC management, the tapeworm-length persistence of BBC cowardice, and the insufferable perversities of the BBC threat to the very existence of the single play. You can imagine how much greater our indignation would have been had we known at the time that we were sitting slap in the middle of what later observers were to call the 'golden age' of television drama'. When MacTaggart acolyte and producer Tony Garnett harangued the broadcasting establishment about its culture of censorship, in a November 1997 lecture to the London Drama Forum, the mandarins could comfort themselves that they and their predecessors had heard it all before.

For all that the 'golden age' memory is not to be dismissed as a nostalgic fantasy or a journalistic pigeon hole. It was a demonstrable reality. Sceptics argue that as so much rubbish was produced in those 30 years it is absurd to call the era 'golden'. It was precisely because there was so much failure, so much good, bad and indifferent drama, that the times were 'golden'. The high peaks needed the mountains of the mediocre to support their pre-eminence. It must have been much the same with the stage drama of the first Elizabethan age. Television drama grew out of theatre, a process which began before the Second World War and was re-started in the post-war years. In the 1990s ambitious practitioners, perhaps the majority, appear intent on a surrender to cinema. Between photographed theatre and small screen cinema there emerged a distinct art or craft form that was and is television drama.

As early as 1937 Grace Wyndham Goldie, later to become a formidable television current affairs producer, put her finger precisely on the differences of the media. Television 'has a vividness which we cannot get from sightless (radio) broadcasting and a combination of reality and intimacy which we cannot get from the (cinema) films', she wrote in her first television review for the BBC weekly *The Listener*.[1] Definitions are always difficult because they at

1 *The Listener*, page 1196, 16.6.37

once bring to mind examples of work that does not fit them. But certainly the difference between television and cinema is not defined by whether drama is made on film or tape, by whether it is a studio show or shot on location, by whether it is a single or a series. It is to do with the larger pictorial scale and dramatic directness required for cinema. Against the close-up human intimacy and the value put on words for television. That does not make television better or worse than cinema, just different. As a very broad but useful generalisation cinema drama is director led and is pictures supported by words and television drama is writer led and is words supported by pictures.

There can be no precision about when the British 'golden age' of television drama began and ended. It is generally thought of as starting with the 1958 arrival at ABC of Canadian producer Sydney Newman and his creation of ITV's Armchair Theatre. Some who were around at the time reckon it finished around 1970. For me it lasted at least another decade. I saw the 1970s, with its string of banned single dramas fought over by determined BBC producers and alarmed BBC managers, as the strongest decade of all. It may be hard to credit now but between the gradual decline of London's Royal Court Theatre, after its 1956 and *Look Back in Anger* heyday, and the Channel 4 led revival of British cinema from *circa* 1982, television drama ruled. The strongest ideas, providing the most enriching and exciting new drama of the day, were deployed on the small screen.

That is not to say that the 'golden age' depended exclusively on what was then called 'the single play'. Interviewed at the National Film Theatre in late 1996 the American writer-producer Steve Bochco, the creator of *Hill Street Blues* and *LA Law*, commended Dennis Potter's *The Singing Detective* (1986) as 'the most extraordinary six hours of television I've ever seen'. I agree. Not all that far behind, certainly in my personal 'top twenty' of television drama events, I place John Hopkins's almost perfectly televisual four-part *Talking to a Stranger* (1966). In the 20 years between these two serials the 'single play' enjoyed more prestige, certainly at the BBC, but the 'television novel' form also gradually established itself. Being beyond the range of cinema it could be said that series and serials were quintessentially television in a way that singles never could be.

Interviewed for this book Troy Kennedy Martin remembers 'the *Wednesday Play* people' as 'a bit elitist'. 'A lot of it wasn't very good, there were a lot of declamatory speeches and I thought they were just turning the audience off...', he adds. Ian, his younger brother and fellow dramatist, agrees. 'I was suspicious of that whole *Wednesday Play* thing... I belong to the left but always suspected it was too easy to write these statements of the socially committed left wing thing'.

There is no doubt that some of the politically committed drama of that time did leave a strong impression in the memory but study the lists of all that was produced and you are reminded, or you learn, that such singles formed only a small proportion – even of the 'elitist' *Wednesday Play* strand. I put 'elitist' in single quotes because I find it a questionable usage. People who run television strands and command its contents may be seen, or see themselves, as an elite. But television made universally available cannot, by definition, be 'elitist'. That extraordinarily brave venture the BBC Television Shakespeare (1978–85), characterised by reviewer Clive James as 'the bardathon', could

have been better executed but it offered the 37 plays by the greatest of drama-tists to all. In other words it borrowed the plays back from the theatre-going elite and made them available to every dwelling in the land. At that time BBC people confidently distinguished between enduring art and ephemeral culture and knew they must find screen space for the former as well as the latter.

For writers as well as viewers the importance of the 'single play' was not that it was in some way superior to series and serials, much less a vehicle for leftish agitprop or expressions of elitism, it is that it encouraged variety and volume. As the 'single play' turned into the more expensive 'single film', and more resources were transferred to series and serials, opportunities for writers diminished. In time the greater demand was for writers to keep their percep-tions in check and work to prescribed formulae.

In the Steve Bochco talk already mentioned, actually a *Guardian* Interview conducted by then Channel 4 programme director John Willis, he spoke of his apprenticeship as a writer on long running and therefore popular Ameri-can series. 'In the literal sense of the word we were hack writers, we wrote to order', he said. Since then he has come to employ his own teams of hacks. 'Because you have so little time to write one of these scripts... the only way you can really get through... is to craft an hour's structure and then pass out pieces of it to each of the writers', he recalled from his *Hill Street Blues* period. 'Though in the end pretty much everything went through my typewriter'.

This concept of writing teams, people sharing an office and churning out scripts as if working to a factory conveyor belt, has become common practice in US drama production. It could well develop in Britain if television drama is allowed to consist only of concept tested, long running series able to hold high ratings. Such factory writing is at the opposite extreme from the condi-tions which greeted British television dramatists of the 1950s and 1960s.

In the theatre the writer of a new play rules. The director and actors work in service of the script. This was the position carried over to television in the era of live drama. In the final chapter of this book writer Jean McConnell recalls submitting her debut script in 1951. 'I didn't know anybody at the BBC... but they were businesslike and they were polite', she says. When the script was played on air her relationship was with a director who wanted only to realise her intentions. Script or story editors were still in the future, producers did not interfere. As the requirement for new scripts increased through the decade supply could hardly keep up with demand. Producers were obliged to look round for new writers and beg for screenplays.

Thanks in large measure to the 'single play' the 'golden age' opportunities for television dramatists were immense, almost unimaginable in the 1990s. Alan Plater estimates that when he made his television drama debut in 1961 there were around 300 slots for 'one offs' each year. By the early 1990s this had shrunk to 50, many of them earmarked for old movies made with BBC or Channel 4 money, some having achieved theatrical release and some having been held back for a release that never happened. About this time Plater led a Writers Guild delegation to meet then BBC drama head Charles Denton and talk of difficulties, particularly over the proportion of projects lost in devel-opment. The highly frustrated Denton was honest about the figures which Plater took as meaning that 75 per cent of the work done for the BBC2 *Screen*

Two single strand was wasted while 66.66 per cent of that written for BBC1's *Screen One* was similarly flushed away unused.

Former Channel 4 drama boss Peter Ansorge has recorded[2] that when he joined the BBC as a script editor in 1976 there were over 50 producers in London and the regions empowered to commission new drama. By 1997 this had been reduced to three: the two channel controllers and director of programmes Alan Yentob. 'With its two television networks and five national radio channels, the BBC has been the greatest patron of new writers that this country and possibly the world has ever known', Ansorge writes. The shame of this is that emphasis must now be realistically placed on the words 'has been'.

Where and why did the decline originate? When did television dramatists, once courted for their skills, start being given a hard time? Is it solely a long term consequence of the move from singles to series and serials? In chapter four of this book Jimmy McGovern argues that writers should take their own share of the blame and whinge less. If there has been a decline it is at least in part because writers have not come up with the goods. Producers of today are no different from those of yesterday, they 'would KILL for a good, young, passionate, honest writer'. There is a measure of truth in this and, as Ol Parker tells in chapter nine, it certainly does help to be young.

But the McGovern view does not budge the truth that there are now fewer opportunities for writers. Obviously the move from singles to serials, given such a boost by Dennis Potter's *Pennies From Heaven* (1978), left space and fewer resources. Its producer Kenith Trodd speaks for its writer. 'Dennis himself would have said that if one thing led to writers having a bad time it wasn't serials but it was something else that I and other producers were enthusiastic about at that time, the move to film away from studio', Trodd told me. 'The fact is that *Pennies From Heaven* and Dennis's clear mind were on the cusp of all that. His *Brimstone and Treacle* (1976) was the last studio made Potter. The two others I made with him that year, *Double Dare* and *Where Adam Stood*, were filmed. Our *Pennies From Heaven* was the last Potter serial that had to go the route of mixed studio and film'.

In fact the film versus tape argument began more than a decade earlier with the institution of the BBC's *The Wednesday Play*. It is often mentioned that the two screenplays that made Potter's name, *Stand Up, Nigel Barton* and *Vote, Vote, Vote for Nigel Barton* were shown on the second and third Wednesdays of December 1965. It is less remembered that *The Wednesday Play* of 22 December was James O'Connor's *The Coming Out Party*, directed by Kenneth Loach. It was the third Loach-directed screenplay by former prisoner O'Connor, reprieved after a murder conviction, shown that year. With Nell Dunn's *Up the Junction* they marked the start of Loach's one man rebellion against taped drama. Wherever he could escape from the studio and Equity rules he went out into the streets armed with lightish, monochrome 16 mm equipment to establish his own realist, documentary style. Although Dunn certainly wrote the book from which her drama was adapted, and took a nominal credit as screenplay writer, *Up The Junction* in fact marked the first instance of television director as auteur.

2 Peter Ansorge *From Liverpool to Los Angeles* Faber, 1997, page 16

'Ken (Loach) came in one day and gave each of us in the department a copy of the book', Kenith Trodd remembers. 'My fellow story editor Tony Garnett took it home and came in next day saying "It's all crap". Which it was. So we cobbled together a script from the book and showed it to the producer James MacTaggart. He was avuncular, a bit older, busy but supportive, kind of sceptical. The debate went on for a few days, Jim wouldn't give his approval, staff director Ken refused to take on anything else, everything came to a standstill. Then Ken said "I'm going to my office to do a bit of casting" and the production became unstoppable. Nell Dunn wrote it in a way, she did and she didn't, nominally or in theory she adapted the screenplay. But the reality is that Ken Loach became a kind of auteur'.

From 1966, when Tony Garnett achieved producer status, Loach had no more scepticism to slow his progress. That year they joined together to make Jeremy Sandford's *Cathy Come Home*, probably the most directly influential teleplay ever. From then Loach's severe documentary style, filmed naturalism, became at least as recognisable as the writing of any of the dramatists it served. Between 1964 and 1977, Kenith Trodd calculated in an index of such material, the BBC made 301 filmed tele-plays. And, in the words of Troy Kennedy Martin, 'somehow kept it secret'.

This is not to say that Loach and Garnett film settled arguments about the best ways of making television drama. They merely heightened them. Sydney Newman had left ABC to become the BBC head of drama in 1963. The Wednesday Play was his invention. He and his first appointed producer for the strand, James MacTaggart, still preferred their gritty realism to stem from a semi-theatrical use of an enclosed studio space. A third way, propounded through written theory and small screen practice by Troy Kennedy Martin, set itself against any kind of naturalism with impressionist collage and montage. For the most part writers could still flourish and make their visions tell. In 1971 Alfred Shaughnessy famously called on his *Upstairs Downstairs* collaborators to 'Remember, television is electronic theatre, not second-rate (cinema) film'. But by then all small screen drama styles were tuned to television itself, not theatre or cinema.

The use of film was always bound to turn the collaboration of writers and directors into more of a power struggle. 'You get an ambitious television director and he will favour the shot more than the content of the show, particularly if he has spent a long time setting it up, having got up at six o'clock in the morning. He won't want to reduce it even if its really superfluous', as Troy Kennedy Martin put it to me. 'It's very difficult in the editing room, you get it all the time, with directors looking at the shot more than what's going on'.

It was not until the late 1970s that the first cut backs of drama in general and single plays in particular, caused by the escalating cost of filmed production, started a serious erosion of space for the writer's individual voice. There is no agreement, even among the responsible executives of the day, about when precisely this disaster started or why it was not more effectively checked. But it did start and it coincided with the first signals of a more cinema orientated future that would further empower directors. Peter Ansorge, then *in situ* as a script editor at BBC Pebble Mill in Birmingham, is persuasive in pointing to 1977–78 as an indirectly crucial watershed time in the relationship of televi-

sion and cinema.[3] It saw the culmination of Philip Martin's *Gangsters*, a formula developed from a notable 1975 Philip Saville directed *Play for Today* and exhibiting rough, tough, pacey, stylized action which set the tone for the thriller genre over the next 20 years. Martin, with producer Barry Hanson, explored likely Birmingham locations and decided that the grainy realism of Loach and Garnett had had its day. Next day, according to Ansorge, English Regions drama boss David Rose came up with the idea that if the camera angles were right Birmingham's Seventies skyline could suggest Chicago. The result was a style that 'owed more to Hollywood genres than the realism of Ken Loach'.

Still more important for Ansorge was the transmission as a January, 1978, *Play for Today* of David Hare's *Licking Hitler*. A drama of World War Two counter intelligence, set in an English country house, it deservedly won the BAFTA award for the best 'single play' of the year. Hare wrote the script and, 12 years before Dennis Potter followed the same route with *Blackeyes*, he was his own director. With encouragement from David Rose he used celluloid instead of tape for his cinematically lit interiors as well as his rare exteriors. The drama went out as 'a film by David Hare', his writing credit brushed aside, and thus the BBC allowed its first admission that a director could adopt a cinema position as auteur.

If it is agreed that most of the best television drama depends on writers as prime movers this concession was clearly a mistake. Another mistake was the triumphalist rallying cry made by ITV mandarin Gus McDonald, at the 1977 Edinburgh Television Festival, that 'the British film industry is not dead – it's alive and well and its's called television'. But these were minor misjudgements compared with the more influential one made soon afterwards by Channel 4 founding chief executive Jeremy Isaacs. 'Television is heavily dependent on cinema, even, you could say, parasitical upon it', he wrote in his *Storm Over 4*[4] 'personal account' of how he set up and ran the 1982 opened channel. 'As television in the UK has prospered, the British (cinema) film industry has declined. "You take so much out," was the charge, "you put nothing back...",', Isaacs recorded. 'Surely a new television channel should find a *modus vivendi*, attempt a new partnership with cinema, put back into filmmaking something of what it was bound to take out... In my letter of application for the job of chief executive, I said I would make it a priority to put money into "films of feature length for television here and for the cinema abroad"'.

To run Channel 4 'fiction' Isaacs first approached star director and former BBC head of plays Christopher Morahan. Already at work on Granada's epic dramatisation of *The Jewel in the Crown* the wise Morahan turned the job down and suggested David Rose. With his belief in film Rose was clearly just the man. When he joined Channel 4 he probably saw Film on Four as the best possible way of prolonging the life of the television single drama but with the theatrical success of some of his movies, at home and abroad, he became caught up in the aesthetics, the risks and rewards, and the high profile of cinema features.

3 Peter Ansorge *From Liverpool to Los Angeles* page 62
4 Jeremy Isaacs *Storm Over 4* Weidenfeld, 1989, page 145

Isaacs has done many good things on and for television, not least his blueprint for Channel 4 itself, but at this point in the early 1980s he mistakenly considered the rescue of cinema more important than thoughts about how an innovative channel might bring much needed new life to television drama. Perhaps in the wider cultural panorama it was more important. In fairness it has also to be recognised that, over the years, the channel has commissioned some memorable drama serials as well as its *Brookside* soap. But how much more might have been achieved through innovative widening of small screen fiction?

It is not as if either Film on Four, or its less successful imitator BBC Films, receives any thanks for services to cinema. On the contrary many cinema buffs, a tribe renowned for its cultural snobbery, are inclined to reject a movie on the grounds that it is tainted with television money.

In 1997 high profile cinema director Alan Parker was appointed the new chairman of the British Film Institute, to take over in January 1998. He was at once in media demand and sounding off about the non-televisual qualities he looked for in cinema. The BFI remit covers care for television as well as cinema and there are staffers who, in the teeth of often discouraging leadership, do well by the junior medium. Before his cinema aggrandizement Parker's direction of Jack Rosenthal's BAFTA-winning *The Evacuees* (1975), among the most memorable television singles of its decade, was wonderful. Two decades later his sense of balance appeared to have tilted to match that of the BFI journal, *Sight and Sound*, which each month gives television two pages of often inaccurate and usually gossipy comment and devotes the rest of its space to cinema. 'What we have at the moment is a cinema firmly rooted in, and totally at the service of, the television industry. In many ways it has absolutely nothing to do with cinema, and, for the most part nothing to do with the legacy of David Lean or Carol Reed or, dare I say, the cinema that I represent', Parker began an article in the Media Guardian.[5] He genuflected to the pioneering filmed television of Ken Loach and went on to admire such 1997 television generated box office hits as *The Full Monty* and *Bean*. But, he argued, Channel 4, the BBC and ITV companies like Granada and Carlton, were using theatrical release not out of regard for cinema but to boost their own filmed drama ratings. He accused television of making films 'without care for many areas of the art of cinema'. And he trumpeted that 'the cinema is still the ultimate experience... the locomotive that pulls everything else along with it.... It is technically superior and artistically more ambitious and creatively fulfilling. It always was, and remains, the apotheosis of the dreams of everyone who deals in the art or industry of the moving image'.

It is natural that a cinema director should think like this. He makes pictures and sees their visual flair as the expression of his creativity. He took the BFI job on the back of his *Evita* (1996), a large-scale, sumptuous epic, an enveloping (if not engaging) experience for those fortunate enough to see it in a large, big-screened, state-of-the-art cinema. It was, as it should have been for that money, a feast for the eye. If music and book were ultimately found to be as fleetingly enjoyable as candy floss what else could be expected from an Andrew Lloyd Webber and Tim Rice musical? Only when and if the movie

5 Alan Parker 'Don't Get Me Wrong' *Media Guardian*, 27.10.97

is unsuitably placed on television screens will its words and thought processes be found clearly wanting. If Parker set out to make a film illustrating the difference between cinema and television he could not have done better.

While disputing the estimate of values, which Parker places on the two media, writers of television drama may well want to applaud his attempt to revive clear distinctions between big and small screen films. He estimates that of 128 British would be cinema films made during 1996, most of them with television backing, only a little over 50 per cent achieved theatrical release. There is no doubt that when, for instance, Danny Boyle's *Trainspotting* (1995) finally took its Film on Four television slot in late November, 1997, its audience was boosted by the publicity it received through cinema circulation: regardless of the letter box frame rendering faces distant and infuriating commercial breaks. Cinema can confer a lot of prestige, as much media coverage as any director or producer might want, much more informed critical respect than television drama achieves.

But for every *Trainspotting* there are 20 films which pass through the cinema virtually unnoticed or never make it there at all. In Parker's terms most of them are simply not cinema. The trouble is many are not television either, they are something in between. As things stood in 1997 BBC and Channel 4 executives found it easier to raise money for cinema than for television production and that was a real problem. At the BBC morale was so reduced that it seemed every drama person would rather be making cinema than television. That was another real problem. But these were, to an extent, self inflicted wounds. If 100 of the 1996 films had been written and produced with television in mind they could have been scheduled and promoted at regular times as television events, instead of being served up as failed old cinema movies. Writers would again know what they were doing and, by these means, the national habit of watching television singles might be revived and writing opportunities multiplied.

In Chapter Four Jimmy McGovern angrily tells the story of his *Priest*. It was commissioned as a television serial, reluctantly rewritten by McGovern as a television single and eventually made, against the grain of its close-up intensity, as a 35mm cinema movie. McGovern had been living with the scripts for a decade. The film went out as a work by its come lately director, Antonia Bird. When you blow up a television film you do not make it stronger you make a weak cinema movie, as McGovern so neatly puts his case. It is absurd and self defeating that the BBC takes such a route.

Strangely, or not so strangely, the few recognised successes of BBC Films have been, in Kenith Trodd's word, 'serendipitous'. Which means in this case that they have kept cinematic strivings in check. They have, in other words, been less of a hybrid, less of a neither one thing nor another film. I shall give the last sensible word on this subject to fellow producer Verity Lambert, in recent years a freelance who has had some success in cinema and a lot more in television. Sarah Edge, interviewing Lambert in 1994 for the University of Ulster and a Big Picture, Small Screen[6] research monograph, asked if television was more restrictive than (cinema) film?

6 John Hill and Martin McLoone (eds) *Big Picture, Small Screen* University of Luton Press, 1996, page 236

'No, I don't think it is very restrictive, I think certain material is better on television', she replied. '*Bill Brand* (1976) was a political series that Trevor Griffiths wrote. We did 12 hours of it. I don't think we could have made a (cinema) film as good as that series – the series needed the breadth to put forward what Trevor wanted to say and to give a proper perspective about what was going on...

I do think that certain films need the big screen. If you are doing an epic film it is obviously going to look better on a big screen than on a little square box in the corner of your living room. However, if you take films that are about people, about relationships, I think there is a cross-over. If you get commissioned to make something for television, for example *The Snapper* or *My Beautiful Launderette*, there is no point in looking at it and saying it could be cinema. I think you have to look at it and say "I am making this for television and I will tell the story in the best possible way for this particular story". I have seen cinema films that seem to work perfectly well on television. I don't think there is such a demarcation, as long as you don't try and do both things at once'.

In 1976 Christopher Morahan was succeeded as BBC head of plays by another director of rare skills and much accomplishment, James Cellan Jones. At that point there was every reason for confidence. In his first year the department produced 85 single dramas of various lengths and, with so many talented writers, directors and producers on board, the tradition built up over the previous 20 years was clearly in good hands. Hands which included those of David Rose, producing high quality English regional drama from Birmingham. With disinterested support from avuncular head of drama Shaun Sutton the resolute Cellan Jones held together a liberal regime which could survive bourgeois complainings from BBC1 controller Bill Cotton and real or rhetorical dissent from the avowed lefties within the department. It was also the time when Dennis Potter and his producer Kenith Trodd were able to demand and secure six 'single play' slots for his *Pennies From Heaven* (1978).

Was this the first fatal blow against the single play? Cellan Jones does not remember it like that. 'I do remember that we fudged a lot and we may have lost some dates but I don't think any play was not done that might have been done', he told me. 'The single play cut back did start in my time certainly, year by year, less money and fewer dates. We fought and shouted and lost. At first series and serials went down at the same rate so it wasn't visible that we were losing the single play. We thought it was true that there had to be economies. We got worried and then consoled ourselves because we had some successes'.

One of the most valuable strands at this time was the 30 Minute Theatre slot for apprentice writers. This was a training ground which Cellan Jones for one remembers as infinitely more helpful to budding writers than the soaps of the 1990s. 'What is so tragic is that people are so proud of having series like The Bill for new writers to cut their teeth. The reality is that they are not cutting anything. What they are doing is taking existing characters – perhaps they can shed new light on them but they can't create new characters and they can't really create stories because there are too many people telling them the stories that need to be written. That is not the way to learn to write. It is not even a way to learn to adapt. I am sure the soaps have produced a writer or two but that was not through the soaps but in spite of them. They emerge into free-

dom from soaps where they have been longing to make their own statements and have, literally, been prevented from doing so'.

The Cellan Jones way was a series of half-hour original plays, 'made on a very low budget and giving new writers a right to fail'. The result was that 'many of them did fail... only about a third of the plays had any merit'. 'Was that enough?', I asked him. 'I think a third was a very good return on the resources allocated. I thought it was important that they should be done cheaply, because a small budget does beget invention. And it is so important that people have the right to fail'.

Twenty years later it is absolutely plain that what is needed for the health and breadth of television drama are similar BBC2 and Channel 4 slots developing the 30 Minute Theatre model and avoiding generic titles with the words 'theatre' or 'cinema' in them. But Cellan Jones is the first to point to his model as a crucial factor in making BBC mandarins 'less enthusiastic about the single play'. He went on: 'People said "What's so good about the bloody single play when you get all this rubbish". I said "You can have jewels in the rubbish because that's the only way you find jewels... we are going to do more and spend less money on each of them, therebye justifying an increased output". People didn't sort of reckon that and now, it seems, nobody can put anything on unless it's got a budget of millions'.

When James Cellan Jones left to resume his directing career, and discover that ageism is as oppressive against directors as it is with writers, the BBC either failed to find or did not want to find another strong executive able to hold the line for either apprentice or fully fledged 'one offs'. Money and resources were diverted to series and serials. Peter Child arrived from the science department, clawed some money back and then spent it on factually based drama that left little or no scope for imagination and vision among writers. Producer talent hung on in hope of better times but was gradually defeated by the baleful effects of Thatcherism as ordered by the duo of 'croak-voiced Daleks', as Dennis Potter characterised chairman Marmaduke Hussey and director-general John Birt in his 1993 Edinburgh lecture, and their accountants, managers and strategists.

In the same lecture Potter referred to drama or fiction as 'one of the last remaining acres of possible truth-telling left to us in our over-manipulated and news-stuffed world'. Whether Hussey and Birt were arms of a Thatcherite establishment, or collaborators trimming in the hope of being tolerated by that threatening establishment, their then failure to care for the BBC drama tradition could be seen as natural. The Birtist adoption of an impenetrable language, based on a mid-Atlantic 'management culture', made it virtually impossible to pin down what the director-general and his support troops had in mind. 'Mission statements' were spouted, 'performance indicators' were computerised, '250 promises' were listed, desiccated documents of the *Extending Choice* kind were published, and as Alan Plater put it, 'nobody understood what anybody else was saying'.

When *Extending Choice* turned into extended destruction it was still not clear whether this was due to conspiracy or cock up. Retired (or discarded) television dramatist David Edgar is sure that the planners knew what they were doing. They had faced up to a 'precipitous decline in real licence-fee income'

with a 'comprehensive reordering of the BBC structure', he told the 1997 Birmingham Theatre Conference. This provided the excuse to shift power from 'the setter-uppers' (BBC Production) to 'the putter-outers' (BBC Broadcast).[7] Producers had lost touch with viewers, said BBC Broadcast chief Will Wyatt, his arm would put this right. It was all designed, Edgar believed, 'to tame the creative pretensions of supposedly elitist producers'. In future programme makers must 'stock shelves with the marketable items it is the broadcasters' job to recognise and pick'. As it has turned out this looks to be a true picture. Through 1997 the latest Birtist reorganisation brought about the most copious haemorrhage of 'elitist' (experienced) drama 'barons' (initiative takers) yet. In March, 1996, Charles Denton 'stepped down' as head of the drama group. A year later later the BBC had been unable to recruit a suitable replacement, either a cultural icon or even a respected producer, to replace him and work under the frustrating conditions that drove him away.

Michael Wearing, the head of serials still somehow holding on in late 1997, is one who gives the Birtists some benefit of the doubt. He sees, as everybody must, that change has brought an 'extreme centralisation of power'. He also believes that 'there is some dimension in which John Birt and Alan Yentob actually do share this uneasy sense of the real history and function of the BBC'. He justly points out that despite 'the complete turmoil of managerialism this place can still put on some things that are rated... Out of the battle between the old principles, and whatever managerial fashion happens to be in practice, good things still happen on screen'.

This is true but Yentob and Wyatt and fellow executives must know as well as anybody that if televison drama is ever to escape from its present trap of genre series and ersatz cinema to fresh uplands it will not be achieved through public consultation. The odd creative producer aside it can only be done by the encouragement of new writing. Viewers have other things to do. They expect the professionals to come up with new ideas which, with time and the nursing the BBC used to be so good at, they the punters may come to like. If asked for their view on the best way forward they will naturally mention things they like in existing shows. Public consultation can only create more constructs of the *Dangerfield* tendency, concepts which combine police and medical work with a cast led by either John Thaw or David Jason or, better still, both. In other words new wine in old bottles mixed with some classic serial old wine in new bottles. Drama concept testing has arrived from US practice a little ahead of factory writing. Both ideas are sure ways to keep the medium not good and not bad, just medium. ITV drama has now succumbed to market values and is almost bound to adopt American methods. The new order at Channel 4, of chief executive Michael Jackson and drama chief Gub Neal, declares itself keen to continue commissioning would be cinema while restricting its television drama to long running, if slightly off 'genre', series and maybe a few series pilots masquerading as single tele-plays. Some writer friendly new moves from the BBC have never been more urgently needed.

This is being written in the last week of November, 1997, quite a telling month in the history of television drama as it has unfolded. Last night John Birt was fleetingly seen on camera after a relay of Elgar's oratorio *The Dream*

7 David Edgar 'You Thought That Market Values Ruined the BBC' *The Guardian*, 16.4.97

of Gerontius, played at St Paul's Cathedral as part of the BBC's 75th anniversary celebrations. The Director-General looked as inscrutable as usual, there was no way of telling if he had been touched by the very moving peformance. My mind went back, as it usually does when hearing this music, to *Penda's Fen* (1974). That being the great David Rudkin written *Play for Today* of mysterious elemental forces built round the hero's addiction to *The Dream of Gerontius*. If only Birt had those kind of memories there could be some expectation that the BBC's television drama tradition might become as cherished as that which, happily, still protects the BBC Symphony Orchestra from 'down-sizing'.

Television drama, like music, has the capacity to help us recover the sensation of life and make us feel things. John Birt's news and current affairs, the use of television that does appear to interest him, is mere habitualism. However manipulated and manipulating it can only be itself.

This November has seen the death, aged 80, of Sydney Newman. 'For ten brief but glorious years' he was 'the most important impresario in Britain', wrote W Stephen Gilbert in his *Guardian* obituary. His invention of *Armchair Theatre* as a slot for original plays about mid-century Britain 'changed the face of British television'. With Harold Pinter's *A Night Out* (1960) he won an ITV audience, unthinkable today, of 21 million. The month has also seen the launch of News 24, the BBC's attempt to compete with CNN and Sky News as a 24-hours-a-day global news supplier. Concept testing is a useful way of eliminating fresh television drama that might otherwise be produced. Nobody has asked television licence payers whether they want the News 24 service they are obliged to fund. The chance of 21 million British viewers switching to any of its segments is nil. Sky experience has shown that television news junkies are a small minority, maybe a quarter of homes able to receive satellite or cable channels. The largest audiences for News 24 are likely to be composed of insomniacs still awake when it is switched on to BBC1 terrestrial in the early hours.

It seems that News 24 is supposed to be part of the 'digital dividend', the improved delivery system planned to replace analogue reception in the uncertain future. Estimates in 1997 suggested that nine per cent of BBC licence fee funds, now £1.9 billion a year, would be poured into 'digitalisation' over the next five years. That is money paid by viewers for programmes. So we return to the cow and the milk floats that started this chapter. 'Blame government', runs the official BBC line, 'it is going to turn off analogue television... the digital investment has to be made now'. Whatever the truth of the politics these are vastly expensive changes, of dubious benefit, being made without consulting those expected to pay.

So far as on screen drama is concerned the most significant date of the month was Sunday 16 November. With some on air trailing BBC2 transmitted Philippa Lowthorpe's *Eight Hours From Paris* between 10.00 until 11.15 pm. An enchanting and funny experiment, about which Lowthorpe speaks in chapter nine, it deserved to push aside the routine American fiction and home made current affairs shown earlier in the evening. But if Lowthorpe was ill scheduled the placing of Trevor Griffiths' *Food For Ravens*, a 100th birthday portrait of NHS creator Nye Bevan, was positively insulting. Here was a new £800,000 BBC Wales biopic, written and directed by one of the most

passionately committed of all television dramatists, entirely unpublicised before transmission and then hidden in an 11.15 pm to 12.40 am BBC2 slot on a Sunday night and Monday morning. With Brian Cox as Bevan and Sinead Cusack as his wife Jennie Lee, both extraordinarily close to the real thing, this could have been a television event to show the pessimists that all is not lost for television drama. Instead it passed unnoticed and left the impression that the all powerful schedulers of BBC Broadcast really do see themselves as market homogenizers who regard the cream of strong drama, 'the glory of the output', as an embarrassment. That is not good news for television consumers and in the end not even for those who would make money from the milk floats.

2 Switch on, tune in and grow

Dennis Potter

What I'd like to see, since it is my last work, and since I have spent my life in television, and since that life has not been insignificant in television, I would like Karaoke *to be shown first by the BBC and repeated the same week on Channel 4, and then the second part,* Cold Lazarus, *be shown first by Channel 4 and repeated by BBC.*

It had been an astonishing and unique television interview as telling in memory as it was when transmitted by Channel 4 on 5 April 1994. He was widely recognised as the most considerable of English, or British, television dramatists. He had given more of himself to the medium over the previous 30 years than any other writer. His last broadcast may have been a farewell public mind game or a vintage piece of hide-and-seek' as much as 'a splendid affirmation of the sovereignty of the human spirit', to borrow from critic W Stephen Gilbert. Either way it is unarguable that, facing imminent death from cancer, Dennis Potter remained a broadcasting natural. He talked as vividly as ever before thanking interviewer Melvyn Bragg for making it 'easy … and grateful for the chance to say my last words'.

Phrases from his description of how terminal illness had helped him to value the present linger in the mind along with the best of his screenplays. 'Well, I knew for sure on St Valentine's Day, like a little gift, a little kiss from somebody or something', he remembered of the day he was told that pancreatic cancer had spread to the liver. It had brought him to see the blossom outside the window of his Ross workroom as 'the whitest, frothiest, blossomest blossom there ever could be'. He found that 'the nowness of everything is absolutely wondrous'.

He shifted on his 'respectful agnostic' fence only to the extent of saying he could never subscribe to a religion created by fear of death. 'Religion to me has always been the wound, not the bandage … it should acknowledge the pain and the misery and the grief of the world'. He could not see God in any of the roles written for him by the men who created what have become orthodox religions. 'I see God in us or with us, if I see at all, as some shreds and particles and rumours, some knowledge that we have, some feeling why we

15

sing and dance and act, why we paint, why we love, why we make art', he said.

Melvyn Bragg had been warned by Potter's devoted friend and agent, Judy Daish, his companion through his last journeys between Herefordshire and London, that there could be no certainty about how long the writer could sustain the interview. He wanted to do it in what was recognisably a television studio and in the morning time when he was strongest but he might only last 20 minutes and he might be taken so ill that the whole project had to be abandoned. In the event, fortified by champagne, coffee, liquid morphine and defiantly smoked cigarettes, he talked for 80 minutes (cut by 10 minutes of repetitions for transmission) before surrendering to exhaustion and admitting 'That'll have to do – I'm done'.

He had time to look back again through his life: his childhood as the son of a Forest of Dean miner, his arrival at Oxford as one of the first brainy working class undergraduates able to use the new rights of passage created by the 1944 Education Act, his young man's book savaging the class system and metropolitan culture and seeing England as *The Glittering Coffin*, the crippling psoriatic arthropathy he recognised as 'the strange, shadowy ally on which I built my career' as a television dramatist and which gave him the will to 'reinvent myself, quite consciously, as an act'. Potter also showed that physical fraility had done nothing to diminish his general anger at the dismantling of creations assembled by the 1945 Labour Government and particular fury at the Thatcherite ideology which meant that the BBC, like other television structures, had become more concerned about the means of communication and its ownership than the programmes broadcast. His particular enemy was less Margaret Thatcher herself, elbowed out of power by her own party in 1990, but the media tycoon Rupert Murdoch.

The dying man recalled a favourite writers' fantasy plot in which a character was told he had only three months to live and could choose somebody to kill before he went. 'My cancer, the main one, the pancreas one, I call it Rupert, so I can get close to it, because the man Murdoch is the one who if I had the time – in fact I've got too much writing to do and I haven't got the energy – but I would shoot the bugger if I could', he said. Murdoch, he estimated, had done more than anybody to pollute the British press, and through it British political life, contributing significantly to 'the cynicism, and misperception of our own realities, that is destroying so much of our political discourse'.

It was good pungent rhetoric of the kind Potter had made his own over the years, 'a cry as much from the bile duct as the heart' as he had described his famous James MacTaggart Memorial Lecture at the Edinburgh Television Festival seven months earlier. Not so much a lecture more a personal statement he had called it before going on to attack the Thatcherite 'management culture' and its incomprehensible jargon forced on the BBC by Chairman Marmaduke Hussey and his Director-General John Birt. The communications of the duo to their minions 'were so laden with costive, blurb and bubble-driven didacticism that they were more than half perceived as emanating in a squeak of static from someone or, rather, something alien and hostile: and you cannot make a pair of croak-voiced Daleks appear benevolent even if you dress one of them in an Armani suit and call the other Marmaduke'.

Such remarks were a delight to those of us who mostly or entirely agreed with

them. Unfortunately the very strength of Potter's language, originating from his regular childhood attendance at the local Salem Chapel, enabled those in command of the broadcasting organisations, the Occupying Powers as he called them, to dismiss his thoughts as 'all very amusing if you like that kind of thing but Dennis is always so OTT (over the top) there is no need to take him seriously' – a dismissal echoed many times over by management allies writing in the press. On the other hand Potter was taken seriously, in hindsight it may be thought too seriously, by enough of those surviving television insiders who struggled against the grain of the times to preserve something of the public service ideal. People who fought the remorseless drip, drip, drip of infectious press contempt dismissing their best efforts as invariably ephemeral and usually trivial. In such a climate programme makers and enablers (and even some of us critics) were naturally flattered that a man of such rare gifts had, as Bragg put it, 'poured his talent with apparent recklessness into television'. When, at the end of his farewell interview, Potter made the request quoted as a superscription to this chapter there was no escape for those to whom it was directed. 'Lets face it, we would have been told to make *Karaoke* even if it had been complete crap', one of its executive producers is supposed to have whispered to a fellow worker.

Some of his fellow writers interviewed for this book were far from impressed at the way Potter had used his last interview, his exceptional powers of manipulation further strengthened by illness, to ensure production of his last two serials. Simon Gray, once as sure as Potter that anything he wrote for television would be produced, spoke for them. 'I think the most repulsive, controlling image of the state of television today was the sight of Dennis begging on television for his last plays to be produced', he told me. 'It was an eloquent interview in so many respects but the beg became a command. It was repulsive because there should never have been any question, he should never have had to think his plays might not be done. And I also think it was repulsive of him to say those things, I think when you are dying you would want to talk to your loved ones, not to the public'.

We can be pretty sure that at this point in the interview the public was far from Potter's mind. He was addressing the only two of his fans who still had power to meet his demands: Michael Grade, Chief Executive of Channel 4, and Alan Yentob, Controller of BBC1. 'There are two television men in whom I place a great deal of hope and in a way I'd like to see their roles reversed', he sweet talked. 'I haven't got space for meetings and things and this programme is like my day for this. If I could get those two together … Alan Yentob, in my opinion, should run Channel 4, and there is no question in my mind Michael Grade should be the Director-General of the BBC'. Three years later Grade, visibly tired of the high profile pressures of television administration, retired to a more obscure corner of the 'leisure industry'. While Alan Yentob who had acquired the nick-name of 'Forever Amber' through his alleged indecisiveness, except in the face of established star performers, was overtaken by BBC rival Michael Jackson as the new boss of Channel 4. So Dennis Potter was no king-maker. But he did ensure that, after his death and assuming he was given time to finish writing them, *Karaoke* and *Cold Lazarus*, would be produced and shown back to back as an unprecedented collaboration between the BBC and Channel 4.

His shining enthusiasm was as much a challenge, if not an inspiration, as ever. 'Let me remind myself how to paint clouds with sunshine', he said. 'I first saw television when I was in my late teens. It made my heart pound. Here was a medium of great power, of potentially wondrous delights, that could slice through all the tedious hierarchies of the printed word and help to emancipate us from many of the stifling tyrannies of class and status and gutter-press ignorance. We are privileged if we can work in this, the most entrancing of all the many palaces of varieties. Switch on, tune in and grow'.

Before moving on to the production, transmission and reception of Dennis Potter's final serials I offer a short account of his working life, the unique career so abundantly distinguished by the dramatic works he wrote for British television between 1965 and 1994. A body of work, backed by an increasingly manipulative personality, which gave Potter his reputation and ensured his unchallenged right to see all that he wrote translated, in strict accordance with his perceptions, to the screen. Some of us might, for instance, have preferred to see his *Cold Lazarus* attempt to write himself into the science fiction genre pulled and pushed into a satire on the BBC and its *fin de siècle* deterioration. His achievement over the previous 30 years ensured that he could prevent this from beyond the grave.

Born in Berry Hill in 1935 Potter considered that its proximity to Wales kept the Forest of Dean of his formative years 'enclosed, tight, backward' – factors which ensured that his memories of that time recurred through his scripts to the end. The family moved to Hammersmith, in West London, when he was 14 and success at St Clement Dane's Grammar School led to a place at New College, Oxford, but as would be expected the urban images in his work never had the same haunting resonance as those which referred back to his childhood.

After university he began a period of journalism, both television and print, mixed with an attempt to trim his very individual view of the world into something near the current orthodoxy of Labour politics. Recruited under the BBC's general trainee scheme in 1959 he worked first for *Panaroma* and *Tonight* and for the former managed to engineer a report on 'Closing of Pits in the Forest of Dean'. But the passion of his future drama was only foreshadowed when he became an apprentice to the innovative documentary maker Denis Mitchell. Under Mitchell's supervision Potter constructed his personal commentary on his native territory for *Between Two Rivers* (1960). The tone was that of the 'angry young man' made fashionable four years before through John Osborne's stage play *Look Back In Anger*. His disapproval of the anonymous supermarket culture, which he saw as submerging a distinctive area, was not in itself very original. 'Most young men of sensibility could produce a similar reaction, and in his vehemence Mr Potter came close to over-stating his case', wrote *News Chronicle* critic Philip Purser next day. It was that same vehemence cherished and honed, and arguably as counter productive as ever, which distinguished his last public statements of 1993 and 1994. And 'from that basic Forest of Dean film stemmed almost everything he ever did', claimed its producer Tony de Lotbiniere.

BBC executives were predictably displeased with the film and Potter, by now kicking against the appearance of neutrality expected of BBC men, left to write Labour supporting leaders for the *Daily Herald*. During this newspaper

period he partnered journalist colleague David Nathan in contributing to the BBC's satirical Saturday night *That Was The Week That Was* and experienced the first symptoms of the psoriatic arthropathy that would ruin his life and cement him as a dramatist. His destiny was further signalled when the *Herald*, acting on his health problems, moved him to television reviewing: then widely considered a slot for the disabled. In 1964 a remission in his illness enabled him to stand for Labour in the safe Tory seat of Hertfordshire East. The General Election in that year brought Labour back to power but it was no 1997 landslide and Potter gained only the certain knowledge that the glad handing pretence required for political success was not within his range. More importantly the experience of standing for Parliament led to the pair of plays that ensured his future as a television dramatist.

The first credit for moving Potter on to the television drama road goes to his Oxford friend Roger Smith, who in 1964 became story editor for James Mac-Taggart's series of single dramas that transmuted from *First Night* (1963-64) into *The Wednesday Play*. It will be hard for a writer of the 1990s to even imagine such a world but three decades before Smith could go to the untried Potter and say to him: 'Why on earth don't you write a play? This is a great opportunity. I don't know how long I'll be here but at the moment they're saying "Go and find playwrights" and I'm finding people who aren't playwrights. Haven't you got any ideas?'.[1] Potter, a journalist who had toyed with his first novel, clearly fitted into the not-a-playwright category. Except that he had done some work with David Nathan on the screenplay that became *The Confidence Course*, his debut television drama transmitted in *The Wednesday Play* slot on 24 February 1965. This was a moral fable and social comedy, adapting his slight journalistic investigation of the Dale Carnegie organisation, built round a fictional evangelistic scam persuading the public to pay for supposed new understanding of their insecurities. An illustration of public manipulation the piece might now be seen as a first oblique attack on media barons, Rupert Murdoch and his ilk. That is it could be seen if the £4,000 telerecording had not been wiped out of existence, like so many valuable productions, soon after transmission. Director Gilchrist Calder was attracted by the quality of the writing but grumbled he had had to turn a natural radio script into television. Ultimately too glib in its preachiness the drama caused little excitement at the time though Adrian Mitchell, who had taken over Potter's television review column in *The Sun*, did describe it as 'a powerful parable'.

The second Potter screenplay aired, opening the new Wednesday Play season on 13 October 1965, was *Alice*. This being an account of the relationship between the Oxford don Charles Lutwidge Dodgson (Lewis Carroll) and the child Alice Liddell who was probably the love of his life. The sexual torment from which Reverend Dodgson is thought to have suffered, as he pursued the skittish Alice with camera in hand, was left between the lines. And the tension of unspoken obsession was lost through the casting of an actress (Deborah Watling) clearly too old and knowing for a ten-year-old of her time. Again no lasting impression was left, as compared with other Alice dramas produced in

1 W Stephen Gilbert *Fight & Kick & Bite: The Life and Works of Dennis Potter* , Hodder and Stoughton, 1995, page 109

this period, though at least this first Potter exercise in the biopic genre can still be seen at the British Film Institute's National Film Archive.

So to *Stand Up, Nigel Barton* and *Vote, Vote, Vote for Nigel Barton*, introduced in *The Wednesday Play* slot on 8 and 15 December 1965, the related works that made Potter's name and told so many of us that here was a talent to be watched for as long as he was willing to devote himself to the medium. In June 1964, he let it be known through an archly coded television review that he was already writing a play using speeches by Nye Bevan and Sir Oswald Mosley.[2] This tells that months before the election campaign, otherwise providing the material for the two plays, Potter had already started work on *Vote, Vote, Vote for Nigel Barton* and had probably begun to accept that his future was as a writer not a politician.

The first written of the Barton plays followed a 1965 by-election caused by the death of the sitting Conservative MP, killed in a fox-hunting accident, in the somewhat Trollopean seat of West Barset. Nigel Barton, so memorably played by Keith Barron, was the Labour candidate who had been defeated in the General Election six months before. Like Potter in Hertfordshire East the floundering Barton was the son of a coal miner, an Oxford graduate and a journalist. There could be no mistaking the autobiographical content, the story of a candidate whose background was well fitted for his political position yet found it easier to puncture or mock party belief and believers than to canvass the party line. Only when provoked by his Tory opponent at the annual dinner held by the local council did he let loose a splendid volley of Potterish political rhetoric.

Even before director Gareth Davies had put his skill to work on the script it was clear that it was a success, both funny and serious, a brisk narrative style, a vital commentary on contemporary politics, pioneering with its use of address to camera in adapting the style of 1960s party political broadcasts. It was its reality which sparked one of those regular BBC executive panic attacks, marking the 'golden age' of television drama, usually giving valuable extra publicity to the disapproved production. A light remark by MacTaggart to head of plays Michael Bakewell, to the effect that the play 'had a go' at politicians, caused a series of 'references up' until director of television Kenneth Adam ordered a postponement of transmission.

Kenith Trodd, then a script assistant to Roger Smith, remembers Potter accepting an hour of management 'schmoose and whiskey' and then asking for somewhere quiet to phone home. 'He rang every national newspaper and made sure that his side of the row was bitterly, brilliantly on front pages well ahead of the Press Office's limping bromides. In these fracas with institutional or media darkness, Dennis had unique and lucky advantages. First, he was nearly always in the right and crucially he had polemical and journalistic talents which matched his writing powers'. Even in 1965 he needed both sets of skills. 'As a retiring writer figure, articulate only within his work, he might well not have survived – given the affront and edge and challenge that every new pieces presented'.

Even so Potter himself was eventually persuaded to rewrite about one fifth of the original *Vote, Vote, Vote for Nigel Barton* screenplay and complete its

2 *The Life and Works of Dennis Potter*, page 106

prequel *Stand Up, Nigel Barton*: the latter being a chronicle of the hero's progress from miner's cottage to dreaming spires and more surely introducing the Potter 'voice'. So much so that there is a classroom scene in which the children are played by adults, the device that would distinguish the writer's small masterpiece *Blue Remembered Hills* some 14 years later. Interviewed about the two plays,[3] a decade later, Potter was at pains to point out that he used only the external circumstances of his own life. The important thing was 'the interiorising process, the concern with people's fantasies and feelings and the shape of their lives'. The exterior Barton, it was admitted, could be a variation on Potter himself but, he claimed, the hopes and fears and fantasies of the hero, were fictionalised.

So it fortuitously came about that first *Stand Up, Nigel Barton* and then *Vote, Vote, Vote For Nigel Barton* were transmitted on successive December Wednesdays ensuring that by the end of 1965, the year which may be said to mark the start of the brief high tide of the single play, Dennis Potter was already famous. The newspaper reviewers helped by being generally aroused and only Nancy Banks-Smith in the *Sun* managed a warning note to stand the test of time, a worry that Potter's female characters were inclined to be 'weird'.

Over the productive 15 years from 1965 Potter would complete 29 single screenplays, of which all but *Cinderella* (1965) were produced. He mostly stuck with the BBC but wrote five pieces for ITV even before the angry 1980 defection to London Weekend, in company with producer-partner Kenith Trodd, to make the hugely expensive *Blade On The Feather*, *Rain On The Roof* and *Cream In My Coffee*. This period also saw his less than erotic six-part *Casanova* (1971), his four-part adaptation of Angus Wilson's *Late Call* (1975) and his resonant four-part version of Thomas Hardy's *The Mayor Of Casterbridge* (1978) all made at the BBC.

Born a century earlier Potter might have been a Wesleyan preacher. Through all his work there is a childlike seam, a mythical view of an uncorrupted world carrying the seeds of its own corruption. Yet it was his religious individualism which got him into most trouble with the censorious in those years. His *A Beast With Two Backs* (1968), a parable of faith gone astray in the Forest of Dean, passed with little notice. But his *Son of Man* (1969), dominated by an angry and persuasive Jesus, sounding more like a trade union baron than a mysterious Messiah, was found to be blasphemous by the self appointed television stable cleaners who began to proliferate under the baleful influence of accomplished self-publicist Mrs Mary Whitehouse.

Then came *Brimstone and Treacle* (1976) and the ban that helped to focus so much attention, and critical appreciation, on its screenplay. Brought into play again was the 'visitation' motif, the anti-naturalistic device of a stranger on the doorstep, maybe sick or illiterate or devilish, yet carrying a divine message. A figure to underline the Potter belief that good and evil are not separate entities but necessary to each other. Here the supernatural figure is a devil who rapes a young woman to awaken her from a road accident induced coma.

Its producer, Kenith Trodd, still believes the work to be 'the simplest and most luminous of morality tales and the wittiest play of ideas ever written

3 *British Television Drama Season*, NFT programme by Paul Madden, October, 1976

anywhere for television'. Alasdair Milne, the director of BBC TVprogrammes who banned the £70,000 production when it was ready for transmission and billed in the *Radio Times*, apparently still believes the drama went 'too far'. At the time he found it 'outrageous', 'diabolical' and 'nauseating' – as strong a back-handed tribute to the power of his writing as Potter ever received.

The very black comedy was delivered and accepted in 1974 and was scheduled to be shown two years later as part of a disconnected trilogy. Also including another tangle with the preoccupations and fantasies of writers and actors in *Double Dare*. And the father and son story of Philip and Edmund Gosse, illustrating tension between the fundamentalist religious belief of the Plymouth Bretheren and the newly arrived Darwinism, that was *Where Adam Stood*. Two excellent screenplays not deserving to be overshadowed.

Inevitably it was *Brimstone and Treacle* and its final rape scene which received most public attention. Potter joined the debate as only he knew how, never allowing mere consistency to blunt a strong assertion. 'The scene satirises the trendy assumption that sex liberates and cures everything', Potter explained to the *Guardian*'s Peter Fiddick. Rather contradicting the Kierkegaard superscription planted on the printed text: 'There resides infinitely more good in the demonic man than in the trivial man'. Potter's strongest words were kept for his indignant 'A Note to Mr Milne' in the *New Statesman*. He attacked Milne's 'brief and insolent' letter of explanation and described the BBC executive as 'a puritanical Scot in a corner'. And much more.

In fairness it might be argued that, although his decision was an uncharacteristic mistake, Milne's sensitivity to a genuinely shocking drama does him credit. The future BBC Director-General said to me during this period that drama, and particularly the single play, was 'the glory of the output'. Would that later generations of BBC executives had been so enlightened.

Milne was sacked for his liberality when the Thatcherites, led by obtuse chairman Marmaduke Hussey, took power at the BBC in 1986. The Potter screenplay fared rather better. It was quickly published, first in the *New Review* and then in paperback, and the tape was widely played at clandestine showings for appreciative newspaper reviewers. It was also shown at the 1977 Edinburgh Television Festival, a platform where industry delegates were as quick as ever to find and condemn censorship. Stage versions were produced in Sheffield and London before the original tele-play was transmitted through BBC1, to minimal public or press response, on 25 August 1987.

The universally praised *Blue Remembered Hills* (1979), memories of rural childhood in the early 1940s, and other single tele-plays was still in the future. Yet the biggest turn in Potter's career as a television dramatist, and one which would make its own contribution to the gradual demise of the 'single play', occured with his *Pennies From Heaven* (1978). This masterwork had the subtitle of 'Six Plays With Music' and it occupied six *Play for Today* slots but it also gave notice that the most cherished of television dramatists had started to demand the length of the serial form. A form that is unique to television, in terms of screen entertainment, but is greedy of resources, air time and money.

James Cellan Jones was BBC head of plays at this time. As he remembers it Potter's producer-partner Kenith Trodd came to him and said 'Dennis will never write for the BBC again after the way he was treated with *Brimstone*

and Treacle'. At which Cellan Jones decided he must at least try to restore the relationship. 'So I wrote to Potter and said "Look I wasn't here at the time, can we start again with a clean sheet". He agreed and came to see me. I asked if he had anything up his sleeve. He said "Yes, I've got this idea for a play about a ghost writer, about a man whose job it is to write autobiographies of people. As he does so illusion and reality become inextricably mixed and perhaps he's writing their lives, instead of books about their lives, because some of the things that he invents come to pass."' In other words a first hint of the idea that was to become Potter's last BBC serial, *Karaoke*.

Cellan Jones continues: 'I said to Potter "It's a wonderful idea" and he warned "It's six seperate plays" and I added "Well it's a sort of series really". We commissioned it, I had to fight the contracts department for six half fees up front, I argued "We've got him back, we've got him keen, don't fuck around". I heard nothing and Ken kept coming up and asking about the Performing Right Society and all that sort of thing. Then when the scripts came it was *Pennies From Heaven*. It wasn't Ghost Writer but it was wonderful'.

This was the first of Potter's three serials using the now celebrated non-naturalistic device of period popular songs as 'chariots of ideas'. Set in the year of his birth, 1935, it is built round the misadventures of Arthur Parker (Bob Hoskins) an unsuccessful travelling song-sheet salesman with a repressed wife unable to meet his sexual demands. His hopes of a better future are expressed through the banal optimism of the Thirties songs he peddles. A character at least as interesting as Arthur is Eileen (Cheryl Campbell), the Forest of Dean infant-school teacher who is seduced by him but who will not buy his fantasy life. She eventually moves on from rural innocence to willing acceptance of the London flesh-pot scene. Potter later told Trodd that if there was one of his characters who mirrored his own progress through life it was Eileen. With this role he demonstrated that he could write rich female roles even if it might also be observed that Eileen was in some ways 'weirdly' male.

How does Trodd remember the genesis of this serial? Partly as a time when he found himself in the firing line of one of the BBC's attempted 'leftie' purges. James Cellan Jones remembers that Director-General Ian Trethowan told him 'I don't want you to renew Ken's contract'. In high places Trodd was considered 'a Communist, a Trotskyite, all that kind of thing'. 'I didn't like Ken at the time, we had a funny relationship and had fallen out over a Jonathan Raban play I did with him at Granada, and I'd quite like to have got rid of him', says Cellan Jones. 'But of course he made it impossible to sack him. So I said 'I'm sorry Ian' and he said 'OK'. Nobody argued about it. Ken and I would quarrel about a lot of things all the time and he'd have terrible rages and shout and storm out of the office. It was very important to him to be able to shout at Nanny'.

Trodd shouting hardly met Potter's advice to 'play it low profile rather than high profile and I think you'll come through', but it may have served the writer's cause just as well. 'Although the BBC never apologised for confusing me with somebody else on the Left, who actually was a Trotskyite, they did sort of come to me and say "We'd like you and Potter to come up with something else"', recalls Trodd. 'And I am sure they assumed I would just go to Dennis and he would offer another 75-minute play and we'd dutifully do it and we would be back in the frame. But Dennis was never somebody who

thought forgiveness should be cheap and said he wanted to write a six-part original piece, a television novel'.

The accounts of Cellan Jones and Trodd do not precisely match, particularly on the question of whether five other potential *Play for Today* writers were denied slots to make room for *Pennies From Heaven*, but it is common ground that the plays department of the time had the daring and power to make such decisions without interference from above. Trodd does at least offer a back-handed tribute to Cellan Jones's liberal regime: 'Here was a writer who had his work banned, in disgrace, who then humiliated the BBC through what he said and wrote in the Press, in tandem with a producer suspected of being a professional Trotskyist, and within weeks they were saying "Come back" and with a bigger throw'.

Potter himself did not apparently see his serial as a body blow against the single play. 'Dennis himself would have said that if one thing led to writers having a bad time it was the expensive move to film away from the studio', suggests Trodd. 'Dennis's clear mind and *Pennies From Heaven* were on the cusp of all that. For example *Brimstone and Treacle* was the last studio made Potter and the two others that I made in that year, which were to have been transmitted at the same time, *Double Dare* and *Where Adam Stood*, they were filmed. And *Pennies From Heaven* was the last Potter serial that had to go the route of mixed studio and film. One of the great virtues and talents of Piers Haggard, which is why I chose him as director, is that he was very good at making it look like one thing. It looked so much like one thing that after transmission I got an anguished call from a BAFTA (British Academy of Film and Television Arts) jury chairman saying 'We are judging video lighting in part six of Pennies and we can't tell whether its film or video'. I could have lied but in fact it was film not video and I think we didn't win in that section. It was a tremendous technical achievement'.

The success of the serial stood alone for a surprising eight years. Between this and *The Singing Detective* (1986) there were four single screenplays, *Blue Remembered Hills* (1979) for the BBC and the London Weekend trilogy (1980), as well as the lavishly produced six-part dramatisation of F Scott Fitzgerald's novel *Tender Is The Night* (1985).

There can be no doubt that *The Singing Detective* is Potter's serial masterpiece and is probably his greatest work or, as W Stephen Gilbert has put it, 'a summation of Potterana'. This being the serial with songs where the self pitying, pulp-thriller writer P E Marlow, like Potter an acerbic martyr to psoriatic arthropathy, lies in a hospital bed and lets loose the boiling, wounded turmoil of his mind and imagination. The illness is treated as a psychosomatic response to his mother's adultery, observed in the Forest of Dean when Marlowe was nine, and the songs arrive in his mind as unwanted hallucinations, musings and memories. The structure suggests mosaic, built with a mix of filmic styles, with several narrative layers nudging each other on and off the screen. Kenith Trodd's original production was memorable for several performances, including that which made Nurse Mills (Joanne Whalley) the first and most seductive of the desired young women found in all Potter's late works. Above all greatness was achieved through Michael Gambon, giving the television performance of his life as Marlowe, and director Jon Amiel. The sure craftsmanship of Amiel, long since disappeared into the Hollywood melting

pot, is always clear. On top of this is a layer of inspired detail which continually makes me for one want to stop the movement and relish the frame.

W Stephen Gilbert has recorded[4] how Jon Amiel, then occupying an office at BBC Television Centre, was hooked by the scripts. 'I was directing *The Silent Twins* at the BBC and Ken Trodd came into my office in that sidelong way that he specialises in and put these six scripts on my desk. So I started reading and I realised halfway through the first one that my hands were actually shaking. I felt absolutely convinced that I was in the presence of a masterpiece and I was terrified both that I might not be asked to do it and that I *would* be asked to do it. In fact I was only asked after five or six more eminent and obvious choices had turned it down for various reasons', remembered Amiel. There followed a pair of difficult meetings, Potter testing the water by being as provocative as he knew how, 'complicated by the fact that Ken and Dennis were in the midst of one of their full-scale marital splits and Dennis was turning to Rick McCallum as his new producing partner'. Even as Amiel decided he could not work with Potter the less than loyal McCallum opted to return to cinema work. After which meetings became easier.

The fourth meeting 'was the first time Dennis made me cry. He told me the history of his illness and the treatments he'd had and their side-effects, completely dispassionately and without any self-pity. It was so appalling that the tears rolled down my cheeks ... I found myself intensely moved by him. I did really grow to love him in a way that quite astonished me. I'd always expected to admire him, I'd never expected to like him and I certainly never expected to love him deeply'. It was now agreed that Amiel should direct and he felt able to be critical of the script. Though he was surprised to receive a 'phone call from Potter telling him that 'You'll be very pleased to hear I've decided to rewrite the whole lot'.

'What he did was the most amazing feat I've known any writer accomplish. He actually did what he threatened. He literally rewrote every episode from beginning to end. There was not a scene he didn't touch in some way and many he changed dramatically. He was beginning a very severe attack of his illness at the time. Yet he did one episode a week in ledger books in his beautiful longhand with hardly a crossing out. I've never known a writer edit himself like that. He got to the end and the last episode, though greatly improved, still wasn't quite right so he sat down and did it again. I had location managers tearing their hair out because they didn't know what to look for for episode six'.

Potter would sometimes drop in on rehearsals. At one he spied analytical actor Patrick Malahide trying to find the boundaries of the three characters he played. 'What you have to understand about Mark Binney', Potter explained, 'is that he simply doesn't exist, he's a figment of somebody's imagination'. At which all the Malahide boundaries crumbled. The actor was much disconcerted but was eventually assisted by such intervention.

Amiel thinks Potter was conscious of having written his masterpiece. Also 'he vigorously denied that it was autobiographical but it was at the very least intensely personal. After the read-through – which was an event in itself, Dennis read the role of the schoolteacher, quite brilliantly – he was absolutely

4 *The Life and Works of Dennis Potter*, page 267

white. I asked if he was OK and he said 'I hadn't realised it was so close to the bloody bone'. He had meant to fictionalise more but in practice that white glint shone through every page'.

During production Potter criticised some of Amiel's detail but never the kind of wholesale cuts as can be found by comparing the tape of episode five with the published text. 'One of the traps of his work is that he writes with such specificity and authority that the temptation is to treat the text as some golden treasure map that must be adhered to', observed Amiel in his February 1995, interview with Gilbert. 'If you want to change it, you damn well better replace it with something as specific and as intensely felt. That was what I discovered in working on it and it was an incredibly liberating discovery. That he never intervened in that was another of the many surprises of working with him'.

After this great television event Potter's last eight years were mainly a story of gradual decline and mounting disappointment. He was not content with his unofficial position as television dramatist laureate. New drugs, bringing some relief from the symptoms of his illness, fed his desire to be best at everything else: television director and producer; cinema writer, producer and director; even screen businessman. His four-part dramatisation of his own novel *Blackeyes* (1989) presented a would be sympathetic account of women diminished through the demands of male sexuality, widely interpreted as a lascivious assault on womankind, mainly memorable for Potter's directorial debut.

An interesting debut in the way that an apprentice work by a promising film school student, determined to pioneer with a camera ballet of six-minute takes, is interesting. Despite drug-controlled illness he completed his 35 mm shoot for the £2.4 million production in an impressive eighteen weeks, only eleven weeks longer than it had taken him to write the novel. Alas his attempt at a light and playful condemnation of the porn trade, and its manipulation of women, was seen through the most vitriolic newspaper response Potter ever received, as exploiting the sickness it deplored. Tabloids began calling him 'Dirty Den' after the disreputable contemporary character in the BBC soap *EastEnders*. An insult that hurt almost as much as the later decision of Channel Four, represented by brave commissioning editor Peter Ansorge, not to allow Potter to direct his final six-part serial with songs *Lipstick On Your Collar* (1993).

Potter wrote three original novels before admitting 'I'm not a novelist'[5] and going on to pronounce the form 'almost' dead. His *Hide and Seek* (1973) played with the question of authorship: a despised protagonist called Daniel Miller, a precursor of dramatist Daniel Feeld in the farewell serial *Karaoke*, traverses familiar Potter territory and gradually takes over as author. His *Ticket to Ride* (1986) and *Blackeyes* (1987) were, he suggested with hindsight, springs for drama. Both were driven by his own conflict between a craving for, and disgust at, female sexuality. In quick succession Potter dramatised both books and then used them as his directorial toys. He would never readily admit 'I am not a director'. His style may be glimpsed through the dark eyes of Gina Bellman, who played 'the object of desire' in both productions, when interviewed by W Stephen Gilbert[6] about her working relationship with the

5 Graham Fuller (ed) *Potter on Potter* Faber, 1993, page 127

6 *The Life and Works of Dennis Potter*, page 278

writer-director:

'Dennis was always incredibly specific about shots and the costume and the look, very involved in every visual detail. But he didn't know how to get a performance out of an actor. So it became an intellectual process. We talked for hours about the content of the piece but creatively you were out on a limb, really. He was such an intense human being and so brilliant in so many areas but he had the concentration span of a child. When he was shooting he got bored with the writing and started to change it ... The flaw in *Blackeyes* is that it ended up being a different serial from the original script because he got bored and started changing his mind. That's when Dennis's voice over narration appeared, supposedly a "filtering device" to distance sexual manipulation. I think it would have been much more lucid if he'd stuck to the script.

'His moods reflected his state of health. If he was feeling unwell he'd be in a bad temper and then he'd want to change things ... Other times he'd be in less pain and then he was really sweet and we'd have a thoroughly wonderful day's shoot. He was in his element and thrilled to be doing what he'd longed to do ... He'd been a recluse for a long time and suddenly he was God. I was completely in awe of this brilliant man and I think he was in awe of my youth and energy. I would race around on my roller-skates. We struck up this weird and wonderful friendship. He became very possessive of me and I had to make myself available to have dinner with him every night on location to discuss the next day's shooting. He was being a Pygmalion character.

'He would talk literature and poetry and tell me about his old involvement in politics and his childhood and parents and family life and rave on about journalists ... And he encouraged me a great deal with my acting. I found it an incredibly dark piece and felt enveloped in darkness by it. But he was always ready to talk about it. He was such a contradiction because there was part of him that really was a dirty old man and another part that was so honourable and gentlemanly and so he wanted to address an issue that he thought important. He was always going on about being a puritan but a true puritan couldn't have come up with the stories he did. I think now there was quite a lot of nudity that was unnecessary but at the time I trusted him implicitly. And I'm still committed to the message of the piece. I believe we had to enter into exploitation to show it'.

Potter did not hide his love for Bellman and, while agreeing with his wife that this was in part the reflex of a 'silly old bugger', claimed that it was professionally essential. And anyway 'nothing happened between us'. It was not a relationship that survived Potter's second, less interesting directorial failure, his *Secret Friends* (1992) cinema dramatisation of *Ticket to Ride*. Here the artist-protagonist is an amnesiac illustrator, called John (Alan Bates), in full mid-life crisis. He invites call-girl Helen (Gina Bellman), a fantasy twin of his wife, to his hotel room. For his sexual satisfaction he needs to see her as a prostitute but then discovers himself so disgusted by her performance that he feels driven to kill her.

Much hurt by the hostile reception of *Blackeyes* the writer-director approached *Secret Friends* with his nerves on edge. 'I started to represent the

7 *The Life and Works of Dennis Potter*, page 283

failure of *Blackeyes* for him, Gina Bellman told W Stephen Gilbert.[7] 'As soon as I was hired Dennis started taking out all his frustrations on me. He had become quite controlling of me on *Blackeyes* but I'd gone off for a a year and a half and worked with other directors and done some theatre and that was difficult for him to accept ... He was bitter that I had grown and moved on and found other experiences ... And the bullying and the little comments were constant through the shoot. He'd go out of his way to intimidate and undermine me. We fought miserably and that rubbed on other people involved. He had his entourage, his agent and so on. And I was definitely in the enemy camp because I wouldn't pander to his tantrums and his bullying. He was *real* bully.

'It was very difficult to bear and we hardly spoke after *Secret Friends*. I know what a complex man he was and I love him deeply and I don't think the two things contradict. We stopped being close when I couldn't cope with his mind-games any more'.

No television dramatist has dangled more of his sex drive, and the mind set which inhibited it, through his work. There is no doubt about his devotion to his wife and family. Equally sure is the pleasure Potter took, when sufficiently fit, in the company of those who played his later heroines. He was clearly a sexual obsessive, with a huge capacity for guilt, who lived in compartments. The rest can only be guessed through his work. Whether he used 136 prostitutes, as he told Kenith Trodd, remains as mysterious as the sexual assault suffered in childhood.

Gina Bellman, she who saw the writer as a mix of 'dirty old man' and 'honourable gentleman', was succeeded by the similarly young and beautiful Louise Germaine. As a teenage model Germaine had a walk on role in *Blackeyes*. Potter noticed and said 'See you in two years time'. Two years on she was cast as the 1950s cinema usherette Sylvia Berry in *Lipstick On Your Collar* and then took the cinema star double role of Amber Boyce and Mandy Mason in *Midnight Movie*. The latter a would be BBC cinema film, in which Potter unwisely sunk £500,000 of his own money, was seen only in BBC2's *Screen Two* at Christmas 1994. Finally Germaine was chosen by Potter to play the definitive 'object of desire' Sandra Sollars in *Karaoke*. At which point Germaine became pregnant and Saffron Burrows was cast as the substitute Sandra.

During the 22 weeks shoot Louise and Dennis became increasingly close. 'I just suddenly found someone I could talk to, tell him everything – someone I could cry with', she told *The Times'* Joseph Connolly in 1996. 'He gave me books and a beautiful black pen. But it was all so innocent. We held hands and things, but just as you do with your greatest friend. Dennis was wonderful, he changed me, he taught me to believe in myself. He was the kindest and truthfullest man in the world'. And there can be little doubt that he had Germaine in mind as, in his last days, he wrote Sandra Sollars of *Karaoke*.

In his last 1994 weeks Potter completed both *Karaoke* and *Cold Lazarus* as four-part serials plus an introduction, for the published version, explaining the process. 'I have for a long period now been exceptionally fortunate with my earning powers in a very frail trade', he wrote. But he found his account books 'much less healthy than I had been blithely assuming'. Unless he delivered on

BBC and Channel 4 commissions he would have to pay back £160,000 in advances and forego all the contracted delivery-and-acceptance payments and post-production fees. He felt he needed the money for his will and therefore had to deliver. An earlier version of *Karaoke* had been, according to Kenith Trodd, 'knocked back to him' by the BBC the previous year. Channel 4's *Cold Lazarus* was an idea 'spun out on nothing much more than what had felt like an inspired lunch-time burble where I thought I suddenly saw the myriad glistenings of a "great story" about half-way down my wine glass'. There were doubts to conquer. He calculated that he must start writing on 1 March and then produce ten pages a day until he finished. Each hand-written page in his A4 writing book represented a minute of broadcasting time. If he worked without a stop he could finish both six-parters by 11 May. Medical advice was that he would probably be unable to write until then and he decided to go instead for two four-parters, which should be finished by 15 April. In the event he lived on until 7 June. But it was as well that he opted for eight rather than 12 episodes. While he wrote his wife Margaret was suddenly tugged out of remission by the spread of breast cancer to her bones. After which she declined quickly and died on 29 May.

Before beginning to write Potter decided he must 'cast adrift all I had so far written of *Karaoke*' and start again on page one. He knew he had to be at his desk by five am to take advantage of the hours he felt strongest. So it was that on 1 March he sat down to write 'the word *Karaoke* in big bright capitals' and, in his words, 'almost immediately ignited'. His introduction to the serials goes on: 'As soon as I began to write I began to live again. Within hours I knew I was writing freely, within days I felt I was writing well, and I knew by the time the week was out that I was writing truthfully'. He was entranced by the look of things in his room and 'the wonderful slithers and curls made with the ups and down of letters and punctuation marks, and, above all, the curious little bite as the fine-tipped pen I work with made contact with the crisply writing paper'.

For *Karaoke* he decided, 'as I have often in the past', to 'use the outward forms of autobiography'. For the sake of engine power Daniel Feeld, the central character, 'had to walk alongside me' through the writing. 'He had to be ill, and in pain, and with an impending and intractable death sentence. He had to be more than a little withdrawn, a little sardonic and a little lost. And he had to be a proud writer'. None of which, Potter insisted, meant that he had to be me any more than the singing detective was him.

Missing from this introduction is any account of Potter's casting. As already described the heroine Sandra Sollars was written for Louise Germaine but played by Saffron Burrows. The part of Feeld's agent Ben Baglin, in some ways a portrait of Potter's 'redoubtable literary executor and agent' Judy Daish, was written for his friend Roy Hudd. A mark of the high approval Hudd had won as the lustful cinema organist Harold Atterbow in *Lipstick On Your Collar*. More questionable was the insistence that Kenith Trodd should produce in tandem with Rosemarie Whitman, under the banner of Potter's own Whistling Gypsy company, with direction by Renny Rye. Relationships within this team were never going to be easy but they were at once made worse when Trodd went public with his doubts about the choice of Rye. As he had demonstrated with his direction of *Lipstick On Your Collar* and

Midnight Movie the amiable Rye was at least a very competent craftsman. For Trodd that was not enough. He wanted a director who would dare to add the extra creative input with which Jon Amiel had lifted *The Singing Detective*.

There is no doubt that Trodd, with his artistic judgement and fighting spirit, had served Potter well through his best writing years. A service which began in the mid-1960s when Trodd was a BBC script editor, grew in 1969 when he produced Potter's London Weekend play *Moonlight On The Highway* and culminated with the productions of *Blue Remembered Hills* (1979) and *The Singing Detective* (1986). With an ego only a little less pressing than that of Potter himself the combative Trodd would stand up for the work and to the writer. As has so often been observed the relationship grew into a marriage where the partners found it hard to live together and harder to live apart. Their mutual respect had to withstand any number of intense battles.

Elizabeth Guider, an American journalist who lived with Trodd for a while in the 1980s, saw something of the relationship in close up. 'There was some love and affection, creative tension and mutual respect', she remembered in a letter to me. 'There was also a lot of jealousy and manipulation and incomprehension'. Yet she never knew Trodd to be ungenerous, either privately or publicly, in his recognition of Potter's talents. 'Nor did he ever try to do anything but enhance them and give them life'.

'My impression is that Kenith generally appeared oblivious to the growing slights and insults which Dennis heaped upon him in later years. What Kenith couldn't stand was being left out, or upstaged by some other individual who had, as he saw it, an undeserved hold on Dennis professionally. Dennis knew that and played upon it. As for Dennis I believe he was enormously envious, and sometimes disapproving, of Kenith for being "in the world"'. From his restricted existence he saw Kenith as being 'wonderfully free and dissolute, enjoying his power and position, surrounded by beautiful women, able to travel'.

Two episodes, as Guider saw them, illustrate the ups and downs of the always fractious Potter-Trodd alliance. The first was at a private rough cut showing of the 1985 film *Dreamchild*. The Potter screenplay was directed by Gavin Millar and Trodd produced in tandem with Rick McCallum. Among others also present were two BBC script editors, writer Howard Schuman, actor Anna Massey and agent Judy Daish.

'After the screening Kenith managed to conduct an informal post-mortem which, delicately but astutely, persuaded the principals to articulate what they thought was still wrong with the film. I was astounded at the deftness with which he managed to elicit ideas from people, including some from Dennis, which I believe did help at least minimally to improve the film ... They were then still working reasonably well together with Dennis letting Ken do what Ken does best, and Dennis making an effort to speak of his feelings about what to do to improve the film in the post-production stage'.

Two years later Kenith and Elizabeth, with director Roy Battersby, were in Italy doing a recce for a proposed film about the 1943 Marzabotta massacre. The relationship with Potter had deteriorated because Trodd had refused to devote himself exclusively to his old friend's work and because, in Trodd's phrase, Potter had 'become a control merchant'. In his suitcase Trodd had packed the newly delivered *Visitors*, a television version of Potter's 1983

Italian-set stage play *Sufficiently Carbohydrate*, eventually shown as a BBC2 *Screen Two* in 1987. Having delivered his first draft Potter felt he needed instant feedback and not necessarily in Trodd's normal mode of enthusiasm tempered by criticism.

'One night in Bologna there was a two-hour screaming match on the phone, Kenith and Dennis alternately hanging up on each other and then calling back, during which Dennis accused Kenith of abandoning the *Visitors* project', remembers Guider. 'Dennis was livid that Kenith was presumably running round Italy, on another project, having fun, drinking wine, feeling enthused, having a love affair, while Dennis's projects (including post-production on *The Singing Detective*) were languishing in dreary London. During the two hours Kenith tore the *Visitors* script into four pieces. Though I kept begging him not to do it because I knew that by the next afternoon I'd probably be stuck with the task of scotch-taping the pages back together.

'Next morning a rather sheepish Roy Battersby joined us for breakfast having been kept awake by the hostilities and assumed that Kenith and I had had a knock-down, drag-out fight. He was amazed to learn that the screaming had been between Kenith and Dennis'.

By this stage in his career Potter wanted at least acceptance, if not praise, unmixed with the awkward intellectual and emotional resistance that Trodd also supplied. With his wife Serena in effective support American producer Rick McCallum, executive producer on the failed *Pennies From Heaven* (1981) cinema version, met this need in full. Trodd felt himself gradually elbowed as Potter came to enjoy McCallum's support as producer of first cinema features and ultimately *Blackeyes* (1989). After Potter himself came to see this serial as a mistake he formed his own Whistling Gypsy company and installed experienced former BBC hand Rosemarie Whitman as his regular producer. Like McCallum she could be relied upon to be unreservedly enthusiastic about everything Potter wrote. Just as desirably she was strong on practicalities and knew how to make everybody on set feel they were doing a grand job.

After Channel 4 decided that *Lipstick On Your Collar* should be produced, and that Potter should not direct, one of Whitman's first Whistling Gypsy tasks was to help find a director with whom he could work. She drew up a shortlist of directors. Potter interviewed them all and chose Renny Rye.

'I had been in the Pacific making an Australian mini-series with a really bad script', Rye told me. 'Dennis was scathing about this and other popular dramas I had been working on, but I think he wanted someone who would help him regain the popular touch. By then he was very conscious of his mistakes in *Blackeyes*, which he had directed according to technical theory and allowed to become so introspective. On *Lipstick* he said we should have one lunch and then I would not see him again – he had become too emotionally involved with it to stand around watching somebody else direct. I desperately needed his help, but Dennis stuck to his word for weeks.

'Then I started getting little messages through Rosemarie: he was not happy with some of the things he heard I wanted to do. I was not keen on that so, before shooting started, I invited him to return as creative producer. It was difficult at first but after a while be began to trust me more. About 10 weeks

into the 22-week shoot we started to get really close, professionally and personally'.

When relaxing they talked of cricket and football, enjoyed looking at young women, but also found a bond in their similar family lives. They both met their wives in teenage years and never considered moving on. The bond, and Rye's willingness to serve Potter's scripts as written, ensured that he was retained as director of *Midnight Movie* and finally invited to make *Karaoke* and *Cold Lazarus*. Rye was among the colleagues Potter rang on St Valentine's Day of 1994 to say that he had terminal cancer and would spend the time he had left writing his farewell screenplays. He suggested they should meet every fortnight to talk about the scripts while he was still able to travel to London from his Ross-on-Wye home.

Rye vividly remembers the first of the five meetings and its aftermath. The meeting itself, in a Soho wine bar with film editor Clare Douglas also present, was surprisingly easy. 'He was a bit thinner but otherwise absolutely Dennis', Rye told me. 'Afterwards, watching him walk away, I thought this could be the last time I saw him. Having been capable and jolly at the meeting I just collapsed in tears, uncontrollably, for ten minutes or so'.

After this encounter Potter was as good as his word. He travelled to London for four more meetings until physical frailty won the battle against will power. 'The hours free of morphine were precious writing hours so the two hours spent with me every fortnight were not to be wasted', as Rye told me. 'It was very much a job in hand to be done. I had a few comments about structural stuff, some of which he addressed, and usually a page of notes, questions and comments. In a way he was inspired and released by impending death and once he got talking he was his old self and as fiery as I had seen him. At one meeting he admitted that he had gone wrong and had had to tear up 20 pages – "That's two days of my life". Generally he was content with what he had done and said "I'm revising as I go, you've got to trust me"'.

The last meeting on 27 April was in the flat, near the BT tower, where Potter liked to keep himself to himself when In London. 'By then he was physically diminished, skeletal with bulging eyes, and had to hang on to things when moving around', Rye remembered. 'His doctor and family said he shouldn't leave Ross, but he was still determined not to mix family and working lives'. Also present for the last hour of this difficult farewell was Kenith Trodd, still feeling himself a 'cuckoo in the nest' among the writer's new collaborators. He complained that most of the creative producers' duties had been taken out of his hands. Potter replied 'You have got to recognise, Ken, that I am the producer until I die and then you take over'. Generally the calculating Potter froze objections by saying that any changes would prevent him dying a happy man. 'He asked us to shake hands and after a moment of steely silence we did as he asked', Rye recalled. Underneath it all Trodd was glad that at the last his old partner had come back to him.

Just why Potter attempted to weld Potter with his Whistling Gypsy people remains arguable. Considering how seriously he took his work it cannot have been mere mischief or even an abstract delight in manipulation. Maybe there were elements of guilt and of his liking for patronage. When Rye put the question Potter replied that 'You will be able to stop Ken rewriting the whole

bloody thing and if you ever get lazy he'll kick you up the backside'.

In his *Karaoke* introduction Potter tells of the regular pattern in his thinking, or half-thinking, that 'the world going on out there right at the brink of one's self has somehow been momentarily prearranged so that even the present tense has been turned in upon itself and there is no point of equilibrium to be found anywhere in anything'. He wanted to widen this 'until, under the force of purely physical pain and sickness, plus plenty of alcohol, that old whole background murmur of writerly anxiety could become the long tunnel through which My Hero would have to crawl'. Writer Daniel Feeld begins to think of something he has just written as *Escaped* into the outside world, like a contagion, and that he is being fed back bits of his used dialogue. He bumps into a muddle of screen styles, arranged into an old storyline, and thus finds out about himself, his relationships and his work. This meant, as Potter put it, 'many a sly nod to my own working styles as well as a few deft gleanings from some of my other pieces … the one genuinely autobiographical strand in the piece'.

During the writing it came to him that Daniel was writing *Cold Lazarus* partly through fear of death, partly through the need to create a different world, partly as a way of facing his own life. Thus Potter convinced himself that the serials ran naturally in sequence and that 'the two works, so called, were actually *one*'. The more memorable parts of *Cold Lazarus* clearly occur when the cryogenically frozen head of Daniel begins transmitting pictures of his 20th century memories, childhood chapel singing of 'Will there be any stars, any stars in my crown' and the rest, to the group of 24th century scientists.

As the scripts were delivered it became obvious to most who read them, myself enthusiastically included, that *Karaoke* was both the best screenplay Potter had written since *The Singing Detective* and a vital conclusion of that part of his output which was more or less fictionalised autobiography. By contrast *Cold Lazarus*, an apprentice attempt to write into the science fiction genre which worked only in parts, would surely never have reached the screen if it had come from any other writer.

As in all Potter's best works *Karaoke* contains several strands and layers illustrating his hopes and fears and even, through the spoonerism addicted Ben Baglin, his demanding yet affectionate relationship with his own agent Judy Daish. In the sub-plot dwelling around post-production on Daniel's last work the director Nick Balmer represents all that Potter feared about those who wanted to use his work for their own creative expression. Though Potter was generous enough to let Balmer answer back: 'In his scripts they (words) are supposedly in a perfect sequence pre-ordained by Almighty God himself. Daniel Fucking Feeld. The precious bastard'.

Above all there is the central relationship which develops after Daniel finds Sandra, 'a young and sexily clad' hostess in a West End of London karaoke club. Daniel says he has 'no wife, no mistress' and confines himself to 'the occasional sleazy and all but commercial sneeze-like bonk, preferably with someone who has more to lose than I have'. That is certainly not a precisely autobiogaphical line but, in her fictionalised way, Sandra can be taken to represent all the young women who enchanted Potter in his last years. His last love Louise Germaine being uppermost in his mind. It emerges that Sandra lives with and supports her disfigured mother and is in the grip of monstrous

club owner Arthur ('Pig') Mailion. It has been observed that Potter liked to control his Sandras rather as Higgins controlled Liza in Bernard Shaw's 'romance' *Pygmalion*. Here Daniel moves on to disinterested love. He first makes a will giving Sandra and her mother, another Mailion victim, financial comfort for life on condition they give up prostitution. He then goes on to shoot Mailion dead. On one level this saves Sandra from executing the act of vengeance she has promised herself. On another layer Mailion and Feeld may be seen as opposite strands of Potter's personality. At the last he dismisses the dark side of himself to let the light and enlightenment prevail. Truly, as his introduction has it, the drama is a 'fitting summation' and 'a testament both to my character and my career'.

When Potter died on 7 June 1994, the media obituaries including mine in *The Times* were extended and fulsome. 'Dennis's work will go on speaking for itself for a long time, but I return to cliche to say that great writer he obviously is but I now think of him also as rather a Great Man', wrote Kenith Trodd for the *Guardian*. After which fellow writer Alan Plater, as so often, hit the nail on the head with the observation that 'we've lost the main man and there's a big question about whether there could ever be a new Dennis Potter'.

Some of this reverance lingered when, with the 1994 Christmas decorations still up, the cast gathered in the modest 'function room' at the Turks Head public house in Twickenham for the first *Karaoke* read through: Whistling Gypsy Productions being housed at nearbye Twickenham Studios. Nearly everybody connected with the production was present to identify themselves. Potter himself spoke, very appropriately, from a television monitor (a clip from his farewell interview) to demonstrate that even in his grave he remained 'the main man'. As his appointed representative on earth director Renny Rye called for 'a celebration' not deflated by too much 'piety'. The cast was at once seen to have strength in depth with Richard E Grant as the director Nick Balmer, Julie Christie as his wife Lady Ruth, Alison Steadman as Sandra's mother Mrs Haynes and Anna Chancellor as Balmer's producer 'more in title than in deed'. Above all there was Hywell Bennett who seemed to have arrived with his strong performance as the villain Arthur (Pig) Mailion already made.

Potter had left no guidance about the all important casting of Daniel Feeld. Brilliant but indisciplined Scottish actor Nicol Williamson was offered the job just as he had been with Arthur Parker in *Pennies from Heaven* and Philip Marlow in *The Singing Detective* but it seemed he still lacked the confidence his talent should have ensured. Michael Gambon proposed himself and would surely have achieved something memorable but it was considered important to draw more of a distinction between Marlow, Gambon's best television performance, and Feeld. Other luminaries were approached. Kenith Trodd for one considered Ian McDiarmid. He being so much a Potter lookalike that, working at the BBC during its 1978 transmission, he was sometimes congratulated for his *Pennies from Heaven* scripts. Such consideration was soon set aside by the need for a 'name' to help any international sales. McDiarmid was cast as Oliver Morse, the Feeld equivalent in the play within the play, and the budget was stretched by £500,000 or so to hire Albert Finney for the central role. Before his cinema stardom Finney was placed with one or two others as the great hope of the English stage. His television work had been very

limited and there was a doubt, not entirely removed by the first rushes, about whether he could tone down sufficiently for the more subtle and close-up small screen medium.

As an observer at the early rehearsals I was impressed at the way Finney dominated. His liberal flow of anecdotes, stemming from long and wide experience, appeared to swamp any Rye contribution. They were also to the point and helpful for the younger thespians. In the end the Finney performance won him no prizes and it was not always easy to see him as 'more than a little withdrawn ... a little lost'. But his acting had its usual vivid surface and was seen to have been nicely shaped by the director. Potter was not let down by Finney or his support.

During pre-production at Twickenham Studios there was an atmosphere, as one insider put it, of 'peace and harmony and smouldering unease'. During the early weeks of shooting, starting on 6 February 1995, there were some early tears as Trodd attempted to maintain standards as Potter would have wished. Gradually the unease was buried. At least until later in the year when the budget was found inadequate for the technical demands of *Cold Lazarus*. Whenever I visited Pinewood Studios or London locations the highly concentrated Rye was seen to be quietly in command of a more or less contented ship. Behind him tireless Rosemarie Whitman, left by Trodd to organise the nuts and bolts of the production, was always ready with reassurance and enthusiasm. The feeling was that the £12 million plus memorial to the great writer, with costs jointly met by the BBC and Channel 4, would be a worthy celebration. And whatever any last minute complications the works would be ready for continuous transmission from the end of April 1996.

There were questions about the wisdom of scheduling a Sunday evening run through late spring to midsummer instead of keeping the serials for the new autumn season. It was suggested that a gap between the serials might win a bigger audience for both. But there was little doubt among those involved that Potter's last works would, when on screen, live up to their billing as 'the television drama event of the decade'. Confidence was further boosted by the newspaper previews and interviews talking up the event. There looked to be no good reason why the Pottermania of two years before should not be revived. Then came the first reminder that the eulogies spoken, or written, on the death of an artist are customarily followed a year or two later by an exaggerated down rating. In the *Guardian* of 15 April, a fortnight before part one was due on air, ubiquitous critic Mark Lawson wrote 'I do not really want to write this' before knocking this 'peculiar, expensive, dicey project' as the feeble tailpiece of a talent in decline.

Where he led others followed. Whatever the mood of the obituary writers Potter now received little of the respect to which his record entitled him. Even the artificial mini-hysteria whipped up by tabloid reporters, who counted the four-letter expletives in the script and brought 'clean up' zealot Mary Whitehouse out of retirement, failed to work in the writer's favour. After part one of *Karaoke* was shown by BBC1 on 28 April 1996, with a repeat on Channel 4 the following evening, it was hard to find an approving newspaper review.

Able to look back through the entire Potter oeuvre experienced Christopher Dunkley of the *Financial Times* wrote that 'the pity of it is that no other

writer has learned to command the medium as Potter did – and, in these two final works, does'. *The Singing Detective* remained Potter's masterpiece 'but *Karaoke* and *Cold Lazarus* serve as splendid codicils'. Such a measured response was as isolated as a reviewer who had been around long enough to learn his trade. 'I admit it, I did not enjoy *Karaoke*', confessed politician Roy Hattersley in the *Daily Express*. 'One of the worst plays ever screened ... there was nothing noble about wishing to spend his last months writing drivel for television', postured A N Wilson in London's *Evening Standard*. 'The characteristically colourless invective and the lack of poetry in Potter's language are inscribed on every speech that Albert Finney's risibly bombastic Feeld utters', opined Stuart Jeffries in the *Guardian*. 'Some viewers (himself included?) are likely to feel dismayed to find quite so much that is familiar, so little that has the fresh splash of newness', suggested the *Independent*'s 'broadcasting writer of the year' Thomas Sutcliffe. For *The Times*' Matthew Bond 'the whole thing gets horribly complicated'.

The critical response, which became less friendly over the weeks and particularly when *Karaoke* became *Cold Lazarus*, was bad enough. Much worse were the audience figures. On the first night only 4.5 million switched to Potter while 10.3 million watched an ordinary episode of the ITV customs and excise drama *The Knock*. The addition of a further two million, who watched the Channel 4 repeat, gave a fairly respectable *Play for Today* total of 6.5 million. Not a figure Potter would have got near if he had been writing for the cinema, much less for a stage play or a novel, but nevertheless a very disappointing outcome in television terms. There had after all been a two year build up of expectant anticipation thanks to seemingly useful publicity. Set against the vast expense, around £5 million from the BBC and over £7 million from Channel 4 for the high-tech *Cold Lazarus*, the episode one figures came to the producers as a considerable shock. And they did not improve in subsequent weeks, far from it.

Karaoke			*Cold Lazarus*		
	BBC1	*C4 Rpt*		*C4*	*BBC1 Rpt*
Part One	4,500,000	2,000,000	Part One 1,600,000		2,200,000
Part Two	3,500,000	800,000	Part Two 1,300,000		1,700,000
Part Three	2,900,000	1,300,000	Part Three 1,400,000		1,500,000
Part Four	2,600,000	1,200,000	Part Four 1,100,000		2,200,000

It can be argued that the memorial was built and was as fitting as it could be in the circumstances and, if the archive keepers do their job, will always be available for the narrow and broadcasting future. It was made available to all 1996 viewers and how many chose to watch it is of no consequence. What does matter, for present and future writers, is whether the 1996 switch off, or failure to switch on, means an end to any television drama which dares to set its sights beyond simple one dimensional naturalistic narrative. A student of television drama looking back in 50 years time will certainly find *Karaoke* and *Cold Lazarus* the most original and psyche penetrating works of 1996. The student will also judge that the audience figures, together with the critical

response and the failure of the serials to win award nominations, tells that the works were too much for their times.

Asked for his ideas about possible reasons for the ratings failure Peter Ansorge, the executive producer from Channel 4, mentioned negative newspaper comment and the increasing trivialisation of television by the press, possible scheduling mistakes and, most importantly, the changing television ethos as 'both ITV, and alas the BBC, embrace the culture of the market place and provide purely formulaic drama'. Michael Wearing, his equally respected BBC opposite number, also thought the 'press agenda' had been influential. 'When not one but two television stations commit a lot of money to one thing there is unfortunately that rather British thing of wanting to puncture and to an extent order an agenda that comes to pass', he said.

'Would not the *Daily Mail* anti-filth campaign be expected to increase viewing figures?', I asked. 'Maybe if the drama really is about filth, then at least you deliver to that audience that wants filth. But of course Dennis was not about filth, he was about something perhaps almost too personal for the current culture. It required concentration and all of that. And what is undeniable about *Karaoke*, although Dennis was on much better form than he had been, is that it included in a rather pseud like way, a lot of things he had dealt with many times before. And I think in some way or other people understood this from the publicity'.

Six months after the start of transmissions Kenith Trodd admitted that 'the chemistry of the failure is still mysterious'. Whatever was thought of the press coverage it might be expected that half the potential audience, 7 to 8 million, would have been curious enough to try the drama. He placed his main question mark on the publicity effort, more sophisticated than of old but also more difficult to control. 'Up to the time of *The Singing Detective* I was able to influence the moderateness of the publicity and I think it was always a good thing that the expectations were lower or less vocal or less prolific than they now have to be', he said. Lynne Kirwin's publicist skills had been unleashed and the publicity for *Karaoke* had taken off. 'Her worry was in launching again with *Cold Lazarus*. As *Karaoke* was not a big success the problem became more difficult. Publicists' skills do not extend to reversing a tide that has been set. It's easy to get journalists to write pieces, sometimes spin doctoring to excess, it is much harder to moderate. In the past publicity was not as important or as frenzied or as expensive but it probably worked better. Certainly my long term sense is that Dennis's big things fell on the world without all that big build up, which I now think the audience resents in some way and you can't live down ... there are quotes from me for example which do set up expectations that couldn't be realised, the audience wasn't left to find it for itself'.

Other possible mistakes Trodd wondered about included starting on a Sunday in April. 'I remember having a discussion about an autumn start with Alan Yentob and him answering, not altogether frivolously, that by the autumn people will have forgotten who Dennis Potter was. A memorable moment from one of the master schedulers. Of course it should have been the autumn ... A later start would have brought a chemistry more independent of Dennis's own overwhelming and overbearing views of how his work should be done ... I certainly have a feeling that one of the chemistries of this whole

thing was that, running from the interview, all the hagiography about his death boomeranged rather than paid off'.

Our post-mortem moved on to the particular difficulties with *Cold Lazarus*. 'No I didn't like the casting of the Americans either. I am sure we could have done better but Renny wasn't for it, nothing to do with Dennis, just unambitious. I think *Lazarus* was a tough one anyway. I don't think by indulging Dennis to the letter we gave him our best shot. It's a very tough point this because you can't say there was anything incompetent, or any lack of commitment, just a lack of detachment. I don't know if this is a dialectic or some other chemical but you need to bring yourself to it in order to make it your own. As I once said to Simon Gray, over a book, I've got to hate it in order to do it justice'.

Trodd also felt, like Ansorge, that the failure might be partly down to social change. 'The replacements of the *Pennies from Heaven* audience may want different things from life ... Judging by the difference in letters from the past and now the old WEA (Workers Educational Association) audience has gone. Along with the cab drivers and strange people for whom Dennis Potter was God. People of 60 still mourn him but I just think the equivalents of people who were, say 30, when *The Singing Detective* came on are more stoney-faced about such things'.

The scale of the failure was marked by the wish of executives to pretend it never happened. 'I have not had a word from Ansorge since this happened, not a word, not a word from Michael Grade. Perhaps it is unrealistic to expect anything but a sweeping under the carpet, certainly the BBC feedback is nothing. There was one programme review board discussion which I more or less engineered, after the first episode of *Karaoke*, and to my knowledge it was never discussed again. And that's wrong, that is wrong. I suppose it is the failure syndrome, which is now apparent, a feeling it would have been better not to have done it'.

So departed the best of television dramatists, the main man. He at any rate had given the best shot he could manage in the time left to him. He had achieved his ambition of cleaning himself out, of saying everything he had to say through the medium he called the true national theatre. And, as Nancy Banks-Smith of the *Guardian* put it when celebrating Dennis Potters's absolute loyalty to television, 'I will always love him for making me feel it mattered'.

3 I was always second

Alan Bleasdale

It was when Lynda (La Plante) snatched my BAFTA out of my hand, when four of the jury voted for GBH *and suddenly we didn't have it … When we went into the room that night everyone knew we had won it but when they opened the fucking envelope it was* Prime Suspect. *I was shattered, second again, and I actually won this one.*

When in his teens and desperately wanting to be signed by Liverpool for a career as a professional footballer Alan Bleasdale got it into his head that his destiny was to come second. He was good maybe but never quite good enough for the top prize. As a television dramatist he laboured from 1982, when his *Boys from the Blackstuff* reached the screen, under the widely accepted rating that his talent and achievement placed him second only to Dennis Potter. With hindsight it may be reckoned that most of his best work appeared in the 12 years during which he held this silver position. Yet if anybody took over his laurels on the 1994 death of Potter, 11 years his senior, it was Bleasdale. On the horizon for 1995 transmission was his *Jake's Progress*, the six-part story of 'what parents do to children and what children do to parents'. Whatever else may be thought of this stretched drama its unreserved acceptance, with Bleasdale as his own producer, clearly demonstrated the clout of a writer then second to none in his ability to command resources and air time for his visions.

In some ways beyond the power of their writing Bleasdale and Potter might be considered similar. Both emerged from a working class background, with vivid forms of Christianity attached, and in their teens both were useful athletes. In their different styles both used comedy to relieve a disabused view of the human condition in middle and late 20th century England. On the surface Potter was the more radical in his determination not to be grounded by the prevailing insistence on the appearance of realism as achieved through one dimensional naturalism. Closer study shows that Bleasdale also uses the surreal and the expressionist to help make his comic seams black.

Are they similarly autobiographical writers? I put the question to Bleasdale when interviewing him for this book in early 1997. 'I haven't done what

Potter did', he replied. 'Much of my work is autobiographical but I hide it a lot better. I know where things come from but very few other people would know that'. 'Images from your life rather than threads?', I suggested. 'Yea, yea, that's true, maybe I've run out of them I don't know, I don't think I have, I'm pretty sure I've still got all kinds of things tucked away. What I do is make it so it is not me playing with myself on the telly, its dramatic and can appeal to other people'.

Did he feel he had anything in common with Dennis Potter? 'I am nothing like him either as a writer or a human being. I rated what he did before and up to *Pennies from Heaven*, *Cream in my Coffee*, those things he did for Michael Grade at London Weekend. *Pennies from Heaven* just knocked me over, I thought it was absolutely mesmeric and brilliant and showed you places you could go. I always knew I could go to those places, I knew it was in me, but without seeing Potter do it maybe I wouldn't have gone there. I don't want to get into a debate about Potter the man. Whatever it was it wasn't his fault. There was no need for Kenith Trodd to have snitched about him going to see prostitutes in Soho and all that. It was part and parcel of what had happened to him. Because of his illness Potter was obsessive about sex and beautiful women'.

The observation that it is not the similarities but the differences between the two dramatist laureates, which make both of them special, is soon seen to be truism. They are as different as the directness and clarity of 'the beautiful game' of football to which Bleasdale is addicted and the convoluted patterns of Potter's favoured playing days code of rugby union. As different, come to that, as the all embracing Liverpool Catholicism of Bleasdale's youth and the Forest of Dean Bible readings, sermons and hymns which left such an impression in Potter's boyhood. They were both subjects of sexual attack, or threat, in boyhood. Potter's rape, if that is what it was, remained a lonely mystery, a recurring theme in his drama never fully confronted. Bleasdale eventually found himself in company, as a particular teacher's object of desire, and was able to defuse any trauma by turning the once frightening moments into shared comedy. Potter turned out a clever and combative intellectual, rhetorical and witty, a unique talent and a feisty fighter twisted out of shape by illness. Bleasdale grew into a feeling man with a direct style, friendly and intuitive, passionate and sensitive, a notorious hypochondriac liable to bouts of tearful sentimentality.

Alan Bleasdale was perhaps the one and only fortunate result of the loss of HMS Hood, then Britain's most powerful capital ship, sunk by the doomed German battleship Bismarck in 1941. A young sailor who went down with the Hood was at the time engaged to the handsome and athletic young Margaret Grant who became Bleasdale's mother. Handsome and athletic but supposedly barren as a result of an accident during a pre-war cycle race. She married George Bleasdale during the Second World War in the certain knowledge that they would never have children. When Margaret joined the post-war bulge in 1946 the medical advice was that she was afflicted with a 'phantom pregnancy'. When the unexpected Alan was born into the Liverpool Irish tradition he came to his loving parents as a miracle. Unlike the jealous siblings of *Jake's Progress* he had the good fortune to be a much cherished only child.

He went to his local Catholic primary school 'where I was the cleverest boy very aware that there were at least five girls cleverer than me'. And where he

earned his first guinea as a writer, contributing two poems for the 'Kiddies Korner' of the discerning *Liverpool Echo*. From that moment his mother, an insatiable reader of fiction, convinced herself that young Alan would become a famous writer, perhaps even the next TS Eliot. Certainly he had potential and it was a matter of pride and hope that he would become the first of the Bleasdales or the Grants to go to grammar school.

It would have been a Catholic grammar school if the demand for places from Huyton children had not been so pressing. 'They were all full apart from one run by Jesuits and my father (a foreman in an oil refinery making margarine) refused to let me go there because he had been beaten black and blue by Jesuits', recalls Bleasdale. So it was that he was despatched to secondary education at 'a posh school in Lancashire', otherwise Widnes Grammar School. 'There were about 16 of us bussed in from Huyton and we definitely felt like trash. We were immediately alienated because the other kids had dads in the professions and we were lucky if our dads had jobs'.

Bleasdale was nevertheless admired by at least one first form science master who had seen his verses in the *Echo*. 'I didn't know the facts of life then, I certainly didn't know what homosexuality was. But whatever it was there was a very strong feeling it wasn't for me and it ended up with him chasing me round the lab one lunchtime with his dick in one hand and a Crunchie bar in the other. It was only when I said I'd tell my Dad that he stopped. He kept saying "I can see it, I can see it" but I could never see what he was seeing. I didn't tell my Dad, I didn't tell anyone, because whatever this thing was he was accusing me of it was some kind of shame. When we were in our fourth year he got caught with another 11-year-old down by the small stream at the back of the school. He wasn't arrested, that would have brought shame on the school, he volunteered to go away. After that we all began asking each other "Did he try it on with you with the Crunchie bar?". But it gave me writer's block for years. Christ almighty if I write these poems look what happens to me. Although he was a science teacher he was very wrapped up in literature and language, I think he was a frustrated poet'.

It was generally 'a dry kind of academic school with a fair degree of physical brutality knocking about'. In the years that followed 'I was always bottom of the bottom stream with monotonous regularity. I shared 26th or 27th place with a lad called John Stephens who went on to captain Wigan and England at Rugby League. We were the only two known later to have done something with our lives and we were bottom of the school'. Until the arrival of a teacher called Trevor Williams. 'I owe him almost as much, I think, as I owe my mother. He taught with a generosity of spirit, humour and passion sadly lacking in the other teachers. He was 22 years old and spoke as if he was auditioning for *Brookside*. He played football, he was one of the lads, he had a great kind of bawdy, Chaucerian wit and he taught English. And what happened was that at 14 I went up to first in English and the love that I had for literature was regained. So I got through the usual miserable adolescence through the love of my parents, my obsession with sport, and reading'.

Football was what mattered most along with his conviction that, small for his age but efficient at either inside or outside left, he was only the second best player in the school. The best was Jeff Long, a year behind him, a household name but for a serious injury that finished him at 18. Bleasdale and Long had

41

two years training with Liverpool under the then youth team coach, later a renowned manager, Bob Paisley. Then in 1963 Long was signed and Bleasdale told 'We think you are a bit slow over the first five yards'. 'I should have said "Well, why didn't you tell me two years ago, you bastard" but I just broke my heart crying and went home', Bleasdale remembers. It was a shattering moment but one that assisted the failed footballer to fulfil his destiny.

Back at school the careers teacher told him 'If I was you Bleasdale I would go to Padgate College in Warrington: all you need to have to get in there is a birth certificate and that's all you are likely to have'. Afterwards the man claimed to have administered a shrewd, psychological 'kick on the arse'. Certainly Bleasdale was angered enough to ensure himself a place on one of Padgate's teacher training courses where, under the influence of supportive lecturer Lewis Britton, he at last started writing verse again.

'It took me three years to publish my first poem in the College magazine and it was called 'The lamp-post is an inanimate object and cannot be heard'. It was absolute shite. Totally derivative from Eliot, the whole thing. I wasn't a poet, I just loved the written word', he soon realised.

Despite the continuing distractions of football, girls and his own writing he did well enough in his necessary work – including a thesis comparing Hemingway and Orwell because they were his then favourite prose writers – to secure a first job teaching near home at St Columba's, a Catholic secondary school. 'Of course the great beauty of 1967 was that I could have gone to any school in the country and got a job as what I wanted to be, a classroom teacher. I could have picked much better schools than St Columba's but there was something about the place and the kids. I could handle myself so I taught all the hard knocks and the trouble makers and the kids who were defined as 'educationally sub-normal' and it was through them that I found my own writing voice.

'In the mid-sixties there were few if any books and facilities geared to slow learners. The result was these 15-year-old kids, built like two dockers welded together, were given these Janet and John books and were throwing them back at you. So I went back home one night, 30 years ago and I can still see it, and I knelt on the floor and wrote using the seat of a chair as my table. I wrote what was the first Scully short story. I didn't write it for publication, I wrote it for the kids at school. Franny Scully is an amalgam of two boys called Brian Scott and Franny Culley. They were real hard knocks and tearaways but I had a great soft spot for them. And the first Scully stories were a complete lift from things they told me had happened to them. It was so cruel but it was brilliantly funny. I used the voice of a 15-year-old slow witted but streetwise Liverpool kid and that was my first true voice. It was probably the only voice I could cope with and have as my own voice. Otherwise I would have been sub-Beckett, sub-Pinter, sub-Chandler, sub-Hemingway, sub-Faulkner for the rest of my life. It was finding that voice with the character of Scully that allowed me to go on and have the confidence to bring the other elements of writing into being'.

While writing his first dozen Scully stories for his now more engaged pupils Bleasdale was living on £11-19s-6d, just under £600 a year. It was the autumn of 1970 and his Boxing Day marriage loomed. To escape the poverty trap he

began applying for jobs teaching overseas and landed one on the remote Gilbert and Ellice Islands in the Western Pacific. Before departing for a course in Surrey, to prepare him for his new job, he took his 12 stories to the reception desk at BBC Radio Merseyside and asked if somebody would read them. By good fortune his brown envelope was not deposited in a bin but handed to a Tony Smith, later to make his name as director of John Byrne's television serial *Tutti Frutti* (1987) but at this point a local radio assistant just out of university. He thought the stories suitable for a new Sunday afternoon series show-casing new Merseyside writers. Bleasdale was contacted and told that he was on but there was no money for him or a reader.

'I said I would hire a car in Farnborough, where I was living with my now pregnant wife in a dreadful B and B, and come back to Liverpool for the weekend. The BBC agreed to pay for a single day of car hire and petrol, £17.13s in all. So I had to drive the 280 miles up, record all the stories, have tea with my Mum and Dad and then drive all the way back'. The lucky streak continued and when broadcast the first story was accidentally heard by Granada documentary boss Jim Walker, impressed enough to ring Radio Merseyside and offer the writer-reader any help he could give. Introductions followed, the stories were heard on national radio and published in the BBC weekly *The Listener*, before being publicised on television by producer Melvyn Bragg. The Bleasdale family, Alan and Julie and 18-day-old Timothy, departed for the Gilberts with confidence in Dad's writing ability.

The island where they lived and worked at a state boarding school was 'about eight miles long and 60 yards wide, a matchstick in the ocean where we had to play football sideways'. Still short of his 25th birthday Bleasdale's salary went up from £600 per annum to £4,000 tax free, with gratuity at the end of his three-year stint. He proved an effective teacher and he also had time to write. Teaching finished at 12.45 pm. He was not keen on sailing, fishing and drinking with his fellow expats and so retreated under his mosquito net, in the place furthest on earth from his beloved Liverpool, and began work on his first Scully novel. Beginning to lose confidence he consulted his *Writers' and Artists' Yearbook* for 1970-71 and sent the first half to London agent AM Heath. A message came back 'First 260 pages wonderful, have found publisher, please send rest'. 'I hadn't written the second part, that was pretence. I had seven days to write the other 260 pages and catch the weekly flight off the island. I was hallucinating by the end of five days, it was a horrific experience'.

In the event the agent had proved too optimistic. The first publisher turned the book down, 'probably because of the second part', and so did 15 others. When the 17th publisher said 'yes' Bleasdale was on the point of returning to England. With £2,500 in the bank he was able to put down the mortgage on a Liverpool house and buy a second hand car and turn towards drama. He had become addicted to theatre, or at least Beckett and Pinter, at the end of his teens. In the Gilberts he wrote 'a pretty dreadful stage play, a story written out of his teacher training college days, a first draft of what was to become his *Early to Bed* (1975) television drama debut. By now,whether he admitted it to himself or not, he was more or less sure he was not a poet or a novelist, that his strength was in dialogue and character.

'Describing things, doing a D H Lawrence, is almost impossible for me because I don't think that way. I couldn't tell you right now what colour our

back kitchen is (in his shared London flat) and I've been here over a year. A tree is a tree to me, in the summer it is green and then it's leaves fall, that's the limit. I can't do it and I'm not interested. I am fascinated by people not nature or buildings. It takes places like Prague or Venice for me to start looking at buildings ... The two novels I produced in the mid-seventies, *Scully* and *Who's Been Sleeping In My Bed?* were both written by this 16-year-old Liverpool kid and that was the language I had been brought up with'.

On his 1974 return to Liverpool the moonlighting teacher had quickly built a local following with a weekly The Franny Scully Show on the newly opened Radio City commercial station. His reading on radio helped greatly in the development of his ear for dialogue and sense of comic timing. Later that year, encouraged by fellow Merseyside dramatist Willy Russell, he revised *Early to Bed* and sent it to English Regions producer Barry Hanson, based at BBC Birmingham. The piece was immediately recognised by Hanson, and his boss David Rose, as signalling the arrival of just the kind of 'regional writer' the department was formed to promote. Particularly pleasing to the pair was the vein of humour which gave the story an extra dimension beyond mere social realism. It was one of the few screenplays made for the *Second City Firsts* anthology on film. Although clearly an apprentice work, its bright moments helping over its rough patches, Bleasdale had the great good fortune of direction by Les Blair. With his unique method of improvisation, encouraging actors to evolve their lines, Blair had become a major adornment of the television drama 'golden age'. Here he used his method to identify and improve Bleasdale's rough patches. He 'made a script of some promise, but no great quality, into something worth watching', the writer later admitted to writer Bob Millington.[1]

'The play, about an adolescent's sexual adventures with a married woman in a Lancashire mining community, was a complete lift from a lad called Alan Hilton, one of my closest friends at college. His mother was a wonderful woman who had been blind from birth. She had a brief affair with a trapeze artist when she was 18 or 19. He visited with the circus, made her pregnant and then buggered off. Although blind she was racially prejudiced. When my mate Alan fell in love with a staggeringly beautiful girl he tried to hide the fact she was black. A cousin snitched and his Mum took it calmly except to say she was only worried about half cast children. So Alan said 'I haven't told you this but I play a lot of cricket and this ball hit me on the box, hit me in the privates, and I've lost the ability to have children'. His Mum was pacified 'until they began to have their three children', Bleasdale told me. Indeed the stuff of black comedy.

After this he moved over for a while to become one of the young writers attracting a new audience to the local threatre by showing Merseyside people to themselves. Using his brief experience working on the buses his first stage play, *Fat Harold and the Last Twenty-Six*, had its premiere at the Liverpool Playhouse Upstairs in April, 1975. He finally retired from teaching in July that year to take up writer's bursaries first at the Liverpool Playhouse and then the Contact Theatre, Manchester. His *Down the Dock Road* (1976) at the Playhouse offered a first sight of material later to be seen on television as Dixie's Story in *Boys From The Blackstuff*. Back on television *Scully's New*

1 Bob Millington and Robin Nelson *Boys From The Blackstuff, The Making of TV Drama* Comedia 1986, page 27

Years Eve (1978), a *Play for Today* from BBC Birmingham, led to the work that marked the end of the Bleasdale apprenticeship *The Black Stuff* (1980).

Did this switching back and forth mean that Bleasdale was undecided about whether he preferred writing for theatre or television? 'I am a television writer, no question, but the theatre is more fun. More fun when you can work in the threatre with, say, eight actors and a director for a month before the technical people come in. It's like a fabulous holiday. So the process of making theatre I love much more than making films because if you haven't got a job on a film set you are wasting your time and it is boring. But if you are in a rehearsal room with actors it's a great experience. When I was younger I never knew that kind of thing existed, watching television was part of growing up but I never set foot in a theatre until I was 19. The first thing I saw was a *Phaedra*, the Greek tragedy, done in modern dress. It was so awful I stayed in the bar after the interval. But then I went back and saw Harold Pinter's *The Birthday Party* which I thought was fucking unbelievable and could see was relevant to me …'

While we are on these comparisons do you draw any distinction between writing for television and cinema? 'Money is the difference, only money, and more so nowadays'. But don't you agree that, very broadly speaking, television is words supported by pictures and cinema is pictures supported by words? 'Yes I think there is some truth in that. I think also because television is considered less "important" than cinema the writer gets more of a chance. The writer is not considered to be just the typist in television. In cinema it continues to be that way. But it does sort of hurt me that even in television there are an increasing number of director-writers. Unlike Dennis Potter I know that I can't direct. I have enough self-knowledge to know that I would bollocks it, so why should I try? At the same time I don't think many directors can actually write, at least not as well as proper writers'.

On set Bleasdale has always known his place. That applied both before and after *The Black Stuff*, a BBC Birmingham *Play for Today* shot on location in Middlesborough and Liverpool and introducing the characters of the tarmac gang who were to become household names through *Boys From The Black-stuff*.

Asked at the time I write to name Bleasdale's masterpiece I would answer, with a little hesitation, *GBH* (1991). A more popular choice would probably be *Boys From The Blackstuff*. The latter being a series which, according to Liverpool cultural all rounder Bob Millington,[2] 'may be claimed as the television drama event of the eighties on the grounds of the exceptional intervention the programmes made in British culture in the autumn of 1982'. Fifteen years later most people who were adults at the time, and not necessarily television addicts, could still be brought to an immediate memory of the show by Yosser's famous catch-phrases 'Gizza job!' and 'I can do that!'.

Directed by Jim Goddard and produced by David Rose the filmed *Play for Today*, *The Black Stuff* was shown by BBC2 on 2 January 1980 and brought its writer a £2,500 fee. Working in the north-east the tarmac gang is tempted by ambitious Yosser to 'do a foreigner'. That is to take on freelance work with

2 *British Drama in the 1980s*, edited by George W Brandt, Cambridge University Press, 1993, page 119

materials and time paid for by the employer contractor. When the boss catches them out and sacks them on the spot the gang have no alternative but to return home and join the Liverpool dole queue, as dramatised in *Boys From The Blackstuff*. It has been observed that with his *Pennies From Heaven* (1978) the pioneering Dennis Potter led the move of serious dramatists from the single play to the series or serial. If so he was not far ahead. Bleasdale had begun work on his serial before the Potter show reached the screen.

After the screenplay for *The Boys from the Blackstuff* had been delivered and approved a 1978 letter from Bleasdale, to David Rose and his script editor Michael Wearing, included what the writer described as 'my seventh attempt' at a series synopsis. 'A year has gone by since the end of the last play', he wrote. 'Chrissie, Yosser, Dixie, Kev and George will be unemployed ... Within the framework of their search for new employment, and their willingness to do anything for anyone for a tenner a day, no questions asked, we will also see the workings of the Social Security system in this country'.

Bleasdale was and is far from being a political activist given to spouting slogans. Talking to me before the Labour landslide at the 1997 General Election he said he had 'moved from being apolitical to being just to the left of Tony Blair'. He added: 'I just hope that in the first week in May Tony Blair stands outside 10 Downing Street and rips off his mask and we see Nye Bevan, but I doubt it'. Yet, for all his party political detachment, he could not help but be aware of the destructiveness of Thatcherism from the start of her years of power. He was particularly angered by the Tory press campaign against so called 'dole scroungers'. 'I think it is very important right now to write about the Dole as seen from the point of view of those who are on it, and to side with them against the people and papers who would like us to believe, despite the million and a half out of work and mass redundancies at ever opportunity, that the majority of the unemployed are malingerers and rogues', he wrote in his 1978 letter to the BBC. 'It is my belief that at least 90 per cent of those who are out of work, want to work'. By the time the series reached the screen monetarist economics had bumped up unemployment to over three million and public concern was that much greater.

In his essay about the series for British Television Drama in the 1980s, the 1993 published collection edited by George W Brandt, Bob Millington asserts 'there can be no single author of a television drama and the success of the production depended fundamentally on teamwork on several different levels'. To say that no drama can reach the air without the help of a director, a producer and their team is truism. But only Bleasdale could have created *Boys From The Blackstuff*, just as in the works of Potter every page has his signature, the series is his vision. He was unquestionably the author even of episode three, initially rejected by producer Michael Wearing and director Philip Saville and then acknowledged by Bleasdale to be 'a load of rubbish'. At Saville's wise suggestion, about the need for a woman's point of view, the episode was rewritten as 'Shop Thy Neighbour', otherwise 'Angie's story'. 'Because I find it much easier to write about men than women, I'd dodged out of it', admitted Bleasdale.

After the prime importance of Bleasdale's contribution is acknowledged, and his derisory £8,000 fee noted, it is only fair to add that in this case he received more than usual support from producer and director. Michael Wearing had to be at his most tenacious to preserve the project in the face of an inadequate

BBC English Regions budget. To save money he decided that only 'Yosser's Story' was shot on 16mm film, the rest was made with the latest lightweight outside broadcast video cameras. To retain the interest of the writer he also engineered a lively separate film, about bankruptcy in a Liverpool gangland setting, rewritten from the series episode that would have explored the fate of the tarmac company's middle class boss. This was a great help. The single play, *The Muscle Market*, was rightly acclaimed when it was transmitted in early 1981. Its removal from the series helped to sharpen the impact of *Boys From The Blackstuff*.

Perhaps Wearing's most important contribution was to hook Philip Saville as director. He had originally assumed that the compliant Jim Goddard, who made *The Black Stuff*, would continue as director. Misunderstandings, to which the BBC bureaucracy was prone even in 'the good old days', meant that when Goddard was actually approached he was busy elsewhere. Saville was the obvious first choice as replacement. Already in his fifties he had a formidable track record going back to the start of ABC's Armchair Theatre. He had the charisma to mould the acting. Still more importantly he was an innovator, with his own sense of vision, who had the know how and confidence to cut through convention and achieve filmic effects with electronic equipment. With him on board it was harder for the sixth floor suits to turn down pleas for resources. He had to rely on Bleasdale to ensure his precise visualisation of the Liverpool scene but his distance from these realities helped him to make the drama clear to the outside world. Able to use the camera with as much high wire verve as the writer used his pen the sometimes over-assertive Saville was generally thought to have served these scripts as well as anybody could while also crowning his own career.

Although more than content to leave direction to others Bleasdale now became increasingly involved in casting. Over time he has acquired, in his mind if not on paper, his own repertory company of favourite actors. He identifies and writes for what he sees as their strengths, sometimes strengths they do not know they have. Writing the Blackstuff series he kept in mind the faces and personalities seen in the single play. Particularly so Bernard Hill who had made Yosser so much his own. 'Bernard strode. He was a colossal actor and I knew that I would always want to write parts for him that were colossal and very, very dangerous', he told Bob Millington.[3]. Also close to Bleasdale was Peter Kerrigan, a docker and a black-listed union branch official before he became an actor, who took the role of old school political activist George Malone. A character into which Bleasdale also fed elements of his father and his Uncle George.

Baffling as it soon seemed *Boys From The Blackstuff* was first transmitted by BBC2 late on Sunday evenings. Even in this discouraging slot the five episodes, ranging in length from 55 to 70 minutes, attracted a total audience of 20 million. Within eight weeks, in January 1983, the show had a prime-time run on BBC1 where an average audience of five million per episode jumped to nearly eight million for the 'George's Last Ride' finale. For once the enthusiasm of a mass audience and the the superlatives of press reviewers, even those writing in papers with right-wing reflexes, matched. Awards

3 Bob Millington and Robin Nelson *Boys From The Blackstuff, The Making of TV Drama* Comedia 1986, page 37

followed. Yosser became a folk hero, used to make slogans for pressure groups and chants for the choir on the Liverpool Kop. The social significance of Bleasdale's messages generated an unprecedented outbreak of academic writing. The former classroom performer found his work celebrated as a schoolroom textbook.

A less happy experience for Bleasdale was his first attempt to move over to cinema or at least the kind of hybrid television-cinema advanced by Channel 4's *Film on Four*. His screenplay for *No Surrender* (1985) carried a wry observation promising a 'normal night out (these days) in Liverpool on New Year's Eve'. A night in which the ducking and diving manager of the hopefully named Charleston Club tries to deal with a double booking by a Catholic pensioners' club, with members clad in fancy dress, and an Orange Lodge branch. A former grandmaster of the Protestant organisation attempts to harbour a fleeing gunman while the gangster owner of the Charleston looks to settle old scores. Peter Smith directed and Bleasdale favourites in the cast included Michael Angelis, Tom Georgeson and Bernard Hill. 'Monstrous and marvellous, it combines the disturbing, the disorientating and the downright daft', commented Paul Taylor in the Monthly Film Bulletin when the £2,337,000 movie received its cinema release.

The film was not a commercial success though it took the top prize at the Toronto Festival and received good reviews from the cinema critics. Either way it was his experience of being ignored over the making of the movie that led Bleasdale into becoming his own producer. 'I never had any control over my television shows but I was listened to by producers like David Rose, Michael Wearing and Richard Broke and the directors they chose. With my first and only feature film venture so far nobody listened, right from the start', the writer told me.

'It was directed by a former Australian civil servant and produced by a Mamoun Hassan: I don't know if he was Arabic or Indian or what he was but here were two people from completely different cultures, who knew nothing of the Irish question as found in Liverpool, inflicting on me their opinions about how this culture or situation should be handled. With the best will in the world I didn't think they were qualified to do that. And it was not just a question of editing, there was also the casting. I had written parts specifically for Bernard Hill, Michael Angelis and Julie Walters – I actually called them Julie, Michael and Bernard which gives you a clue. They told Michael he must lose two stone in weight, they rejected Bernard because they said he couldn't play comedy and they told Julie, who had just won an Oscar nomination for *Educating Rita* (1983), that she was not a big enough name. Realising she was not going to be loved Julie left, using the Bette Midler line, 'Fuck 'em if they can't take a joke'. The other two stayed in there, and Michael did lose the weight, and they were wonderful but it was a huge battle and I had to fight against the odds to get the casting.

'What happened was they ran out of money and 25 minutes had to be cut out of the film. It just bruised and I didn't think the director handled it. It was too turgid, very slow in pace. They bollocksed it up before they started to film. Peter Smith has done some fine work and I got some of the greatest reviews I've ever had but they were reviewing something which in the end wasn't related to me'.

This bruising experience was soon followed by the abuse from the 'patriotic right', orchestrated by rentaquote Tory MPs and their newspaper cheer leaders, which greeted *The Monocled Mutineer* when its four episodes were transmitted by BBC1 from 31 August to 21 September 1986. The serial was loosely based on a book by William Allison and John Fairley about the little known and still disputed story of a British Army mutiny at Etaples on the eve of the Battle of Passchendaele in 1917. Paul McGann effectively led the cast as the charming yet cynical ringleader, really stretcher-bearer Private Percy Toplis but able to pass himself off as an officer when off duty. Nearly 70 years on it remained a story which put the prickly officer class on the defensive.

Bleasdale had not set out to offend but naturally sided with the man in the trench, painting him as contending with both the enemy and his own brutal officers. 'The reason I wrote *The Monocled Mutineer* was not the reason that Norman Tebbit, and others on the Conservative right, alleged. It was, in a way, because I wanted to give my father back the father he never had. Grandfather George Bleasdale was killed in 1917 when my grandmother was six months pregnant with my father. We have a letter from him knowing he was going into battle and would die and asking that if the baby was born it could also be called George'.

After the difficulties of *No Surrender* in particular Bleasdale decided on another change of tack. 'My answer was to disappear into a room and write a novel, the great British novel as I thought, which was GBH'. This being a development of an abortive 1983 cinema script about a teacher having a nervous breakdown during what he hoped would be a peaceful holiday in the country, otherwise the "Great British Holiday". 'In a rush of hot blood, mostly brought on by the murder in cold blood of *No Surrender*, I began turning the holiday script into a novel. If it was a load of crap at least it would be my load of crap. I worked on it for 18 months. The trouble was I had written 640 pages without getting the Jim Nelson character on holiday. I was only half way through and had become financially and emotionally bankrupt', he remembered.

The next diversion was go to the Soviet Union for three weeks, researching a proposed Hollywood movie set in the glasnost era. The resulting screenplay did not find favour with the Americans but it put money in the bank and gave a breathing space before Bleasdale's documentary maker friend David Jones persuaded him that GBH was not a novel but a potential television drama. They approached perceptive producer Verity Lambert with the idea and she proved enthusiastic. Peter Ansorge at Channel 4 read the book overnight and felt the same way. As a result Bleasdale went to see the chief executive, Michael Grade, and read him a couple of extracts. Without more ado they shook hands on the project and Grade put up £5.5 million. 'I could have done that with the BBC or Granada but neither of them would allow me the position of being a producer.

'I wrote the series between October 1988, and October, 1989. It was originally intended to be a six-parter, 600 pages at the very most. My first draft was 840 pages. I then spent one of the worst weeks of my life, sat in Verity Lambert's office in Shepherd's Bush, taking 240 pages out. There was a lot of shouting and it seemed at the time like murdering my babies. By transmission time there was little I missed except for the reduction in length and importance of the relationship between Mrs Murray (Julie Walters), mother of

Michael and based to a degree on stories Julie told me years before about her own Irish mother, and headmaster Mr Weller (David Ross). The rewrites were finished by March 1990, and we started filming in June of that year. Only after the 31-week shoot, in and around Manchester, did David Jones and I realise we had a seven-part series. As we had no natural ending for episode six and no natural start for episode seven we shot two extra scenes in February 1991".

To retain the control he lost with his Film on Four, Bleasdale formed his own GBH Films. For the ten-hour plus drama which *GBH* became Verity Lambert was executive producer and Jones and Bleasdale were joint producers. Bleasdale himself did 95 per cent of the casting, more than half of the actors taking parts specifically written for them, and he also hired Robert Young as director. 'Young was fast, filmic and at ease with both company and crew, he was also very hungry for the success he had never quite achieved. It was an excellent working relationship in many ways. To my surprise he actually wanted me on set for the whole 31-week shoot. We only had two arguments of any consequence. They were about sex and violence. I thought the scenes too graphic and indeed obscene and neither made the final cut'. Most unusually 'our director made very little contribution to the editing process'. Bleasdale and Jones commanded the editing with two 'extremely talented, committed and obliging editors (14 hours a day, five days a week for 22 weeks), first by themselves and then in discussion with Lambert, Ansorge and 'our finest champion Michael Grade'.

It sounds like maximum interference? 'I have never done the technical side or hired the crew, nowadays my partner Keith Thompson does that. I do the casting in conjunction with the director. I wish for particular actors because I love them, they go out and make it, bloody hell I wish I had that kind of courage. When I am sitting at the typewriter, very much alone, I need to draw on my perception not only of the actors' qualities but how far I can stretch and push them. On set I go back to teaching. I'm only in the way if the director wants me to be in the way. Robert Young insisted I was there every day because he knew how to make films but he didn't know much of the political culture in the North of England. Also he knew that I had cast people I had known for 20 years. Julie Walters was the first actress I ever talked to, Michael Angelis is one of my closest friends and so on. There was a history there so Robert wanted my help'.

When it was new Bleasdale described his original seven-parter as 'one caring, liberal madman's odyssey through the appalling farce of life in Great Britain today ... trying to make some sense of the place'. Even with hindsight he has always firmly declined to join in the intellectualisation of his work. 'All I really wanted to do was to entertain and question. Laughter and tears are, for me, the essence of drama', he says. Here he mixed thriller and comedy techniques, an elliptical narrative and jigsaw puzzle plot, both to jerk laughter and tears and to confound expectations at every turn. Basically the story told how power and madness affected two opposite Labour activists: unscrupulous and charismatic council leader Michael Murray (Robert Lindsay) and obstinate and principled head teacher Jim Nelson (Michael Palin). If *Boys From The Blackstuff* took the pulse of its time and place, showing the rest of the nation realities most people attempted to ignore, *GBH* went a dimension beyond. It first showed the surface of conflict in a Northern city, not necessarily

Liverpool, and then surprised its loyal viewers by telling that little is as it first seems. Clearly the scripts were less contained, and thus further from perfection, than those for the earlier serial but GBH was by some way the more ambitious work. It used a larger canvas and warned that not just the one city but the whole state was in peril through its habit of secrecy in high places. Whenever we are allowed glimpses beside the facades of the unaccountable British security services, MI5 and MI6 in particular, it is seen that the concluding parts of *GBH* are not period fantasy but continuing reality. The Great British Holiday could become The Great British Hell.

Robert Lindsay's performance as Michael Murray brilliantly provoked both laughter and tears but then he was gifted one of the richest roles, left-wing tyrant turned victim of right-wing conspiracy, ever written for our television drama. Did the writer identify with either Murray or his apparent opposite, the teacher Jim Nelson? 'At first everybody thought Murray was a version of the Liverpool politician Derek Hatton and that Jim Nelson represented me. Really the more I wrote Michael the more I realised I was actually writing about myself. If you look at *GBH*, and take away the surface of politics, I am writing about a man like me who was attacked by a teacher when he was young. Of course the boy Michael had not written two poems that were published in the Liverpool Echo: I use things that have happened to me, things graphic and horrific in my mind, but I try to dress them up in a manner that is not biographical and have interest to other people.

'I went to the typewriter with a deep and utter loathing of everything that Michael Murray represented – corruption, crassness, casual adultery, conceit and ignorance. I lived with him so long that I fell completely and utterly in love with him. I couldn't write over ten hours about somebody I hated. If there was ever any lurking Derek Hatton I exorcised him by introducing elements of my childhood into his story. In all honesty the longer I lived with the two main protagonists the more I cared for Michael Murray and the more I questioned Jim Nelson's goodness.

'The main reason I write is to try and make some fucking sense of this life we lead. I constantly refer to death and madness because they're two things that terrify me. I know enough about myself to know that instability is close. In a way Yosser Hughes was Michael Murray in a blue collar. And, returning to your question, I did give Jim Nelson that neurotic and terminally hypochondriac element, that fear of bridges, which I also identify with. With Michael and Jim I was writing about two sides of me, the side which had a terrible thing happen to me when I was young and a man who thought he was going mad and worried about his mortality. Looking back on *GBH* now, five or six years after I finished writing, I think "Oh fuck, that's right isn't it"'.

The seven-part series was shown on Channel 4, from 6 June 1991, on Thursday evenings with a Sunday repeat. Regular newspaper reviewers gave Bleasdale the respect his track record demanded but were generally misled and a bit puzzled by episode one. Politicians and political writers took a less equivocal line. Responding to *The Monocled Mutineer* a *Daily Mail* article had characterised Bleasdale as 'a Marxist millionaire' in the pay of the Soviet Union. Now it was the turn of the left to be offended at what appeared to be an unqualified attack on Labour town hall power. Frank Allaun MP, a former Labour party chairman, suggested that clips from the drama would serve well

in a Conservative party political broadcast. It did not help that transmission coincided with the death of eloquent left wing MP Eric Heffer and a by-election in his Liverpool Walton constituency. In the excitement nobody noticed that Bleasdale had moved to the 'left' in sexual politics. Though the men still occupied centre stage it was soon clear that the women had the superior strength and command.

Was not the writer infinitely saddened that the point of his masterwork had been muddied in the clamour of political point scoring? 'It was never my intention that Eric Heffer should die at such an appropriate time or that there should be a Walton by-election as *GBH* arrived on screen. The irony, of course, is that the extreme left-wing element in *GBH* bore no relation whatsoever to Militant, was a figment of my imagination and actually turned out to be a far-right agent provocateur plot. I haven't really got any views on the way that *GBH* was used for political point-scoring except to note that there was egg on several faces as the series developed. I was mildly delighted and extremely surprised that the Labour MP Tony Banks, who had been foaming on the leash at the end of episode one, made an extremely generous and fulsome public apology on Channel 4 when the series ended. Better still Neil Kinnock (then the Labour leader struggling to remove Militant from the party) wrote to me four times during transmission and he at least had the perception and awareness to realise I didn't suddenly join the Monday Club'.

If there was one newspaper criticism that made its mark with the writer it was that which appeared in the Guardian's 'Hardy Country' column on 6 July 1991. Still floundering about where the drama was going Jeremy Hardy judged it as 'an unwieldy and uneven epic dragged along by the sheer hard work of the cast'. He had fun with Bleasdale's claims that his political references were imaginary as well as his admission that he had not read Marx. Was this fair? 'Hardy's remarks sum up the intellectual arrogance and emotional barreness of most critics. What I meant in that often quoted remark about not having read Marx is that I have never sat down and read any of Marx's manifestos, essays or books. However, as a keen student of history, I am completely aware of the philosophy of Marx and its historical perspective and effect. Also Hardy seems to have missed the episode five line where a Marxist character says "Never strike a match on butter". The butter being a reference to critical response. That tells you what a joke all this kind of column filling becomes. If I wrote for critics I too would become a joke'.

When it came to the BAFTA (British Academy of Film and Television Arts) vote for the best drama series of 1991 four jury members thought they had chosen GBH while three went for the first of Lynda La Plante's *Prime Suspect* two-parters. There was no need for a casting vote from producer chairperson Irene Shubik. On the night, to general astonishment, the relatively orthodox La Plante work was called up to receive the award. 'I know the true story of what happened and why but it can't be printed, you'd be sued and I'd probably be sued with you', Bleasdale told me. 'Before the event my agent and Verity Lambert both rang me up and said we'd got it. When we went into BAFTA that night the production team from *Prime Suspect* and, give her her due, Lynda herself came up to me and shook hands and congratulated me on winning. Everyone knew we had won it but when they opened the fucking envelope it was *Prime Suspect*. I was shattered, second again, and I actually won this one'.

The real vote, by Bleasdale's fellow professionals, demonstrated that GBH had justified its length. More questionable were the six episodes stretching the next Bleasdale serial *Jake's Progress* (1995), his exploration of 'what parents do to children and what children do to parents'. The two previous blockbusters had marvellously combined entertainment with informing and educational insight into the scourges of unemployment and unaccountable state power. While not issue led *Jake's Progress* took up the equally apposite issue of the family. It was written at a time when Conservative politicians in power, and their media supporters, endeavoured to present the family as the ideal unit. They talked it up as a moral bulwark to be defended by and to benefit from Thatcherism, the castle from where it was possible either to pretend that society did not exist or at worst to hold it outside the drawbridge. Following in the footsteps of John Hopkins's memorably claustrophobic *Talking To A Stranger* (1966) quartet it seemed a good moment for Bleasdale to use all his powers of pungency to show the self-inflicted pain, both for parents and offspring, that results from families turning in on themselves. The point was effectively made, the comedy more contained than usual, but was subject to diminishing returns, as length was sustained by twisting melodrama.

The drama began as a strand in Bleasdale's huge *GBH* novel and its genesis followed soon after the 1991 transmission of *GBH* on television. Taking part in a National Theatre forum he read extracts from the novel. Peter Ansorge of Channel 4, sitting in the audience, at once recognised the dramatic potential and suggested that a television piece could result. Verity Lambert agreed that there was potential drama in the strand but suggested the three leading characters would sit best in a Hollywood movie. The interest of 'a pleasant Hollywood producer' was secured and all was set to role when Bleasdale drew back. He became worried that his six-year-old hero Jake would be presented like Damien in Richard Donner's 1976 movie *The Omen* and its sequels. 'I said to Verity that, with the best will in the world, some dentist from Oklahoma with money in the thing would fuck it up'. Also the story was a big one, with a 60-page synopsis, and 'I knew it had to have nine hours if was going to have breadth and not be sensationalised'.

Channel 4 agreed and Bleasdale had another £5 million plus to spend. His new Diplomat Films took over from *GBH* Films as production company. Between the making of *GBH* and *Jake's Progress* Keith Thompson had joined Bleasdale and David Jones to work as Jab Films on *Alan Bleasdale Presents ...*, an anthology of four filmed dramas by writers new to television shown by Channel 4 in the autumn of 1994. It is hard to imagine many other averagely egotistical writers, still less the likes of Dennis Potter, giving such time and attention to bringing potential rival writers to the screen. Bleasdale, retaining the instincts of a teacher, positively delights in the pleasures of protege promotion. His series deserved more attention than it received, not least Andy Cullen's *Self-Catering* and Jim Morris's *Blood on the Dole* co-produced by Thompson. Pleased at their new working relationship Thompson and Bleasdale became regular partners as Diplomat Films. Co-producers on *Jake's Progress* the practical Thompson hired the crew, managed the technical backup and saw that the nuts and bolts were in place while Bleasdale controlled the casting and brought in his stage collaborator Robin Lefevre as director. Several of the *GBH* company were reassembled including Julie Walters and

Robert Lindsay at the top of the cast and with Lindsay Duncan, David Ross and Andrew Schofield among those in support. The 25-week shoot began in August 1994, and ended in March 1995. Transmission followed over six weeks on Thursday evenings from 12 October of that year. Though the drama was nominally placed on the Yorkshire coast the locations were Irish, mostly in the fishing village of Dunmore East, Co Waterford, with additional scenes in Co Wicklow.

With several surrounding sub-plots the central story tells of shifting relationships and allegiances among three generations of a would be comfortable middle class family running seriously short of funds. At the centre are wife and husband Julie (Julie Walters) and Jamie Diadoni (Robert Lindsay). She is an exhausted nurse struggling to be an adequate breadwinner but having no energy left for their five-year-old son Jake. He is an unemployed charmer, Jake's best friend and admired by the younger village women but otherwise lazy and incompetent in the role of househusband. Extra complications are provided by Jake's grandparents, easy going and evasive Alex (David Ryall) and his exasperated wife Grace (Dorothy Tutin), regarded with some justice as the grandmother from hell.

Once the money had been agreed the big difficulty in setting up the show was to find a boy actor who could deliver his many vital lines as the troubled Jake with a brightly natural surface and intimations of dark places underneath. The job of finding such a boy was left to casting directors John and Ros Hubbard. They trawled the North of England, both sides of the Pennines, without success. Then Ros Hubbard remembered a child performance she had admired in the television version of Roald Dahl's story *James and the Giant Peach*. She found the Californian born eight-year-old Barclay Wright at his prep school in Maidenhead, quite an experienced screen performer who had also played Prince Harry in the travesty that was the American mini-series *Diana – Her True Story*. Bleasdale was despairing of ever finding his Jake, and was preparing to advise Peter Ansorge to abandon the project, when he sat on a couch with Julie Walters to watch the Barclay Wright audition tape.

'Within two minutes I swear to you I looked at her and said: "We've got him, this is it"', remembers Bleasdale. 'What I was seeing on the screen was riveting. He just had that little spin, that danger in him that I don't think even he knows about. I sent a fax to John and Ross simply saying "Stop your search. We've found our Jake. Congratulations"'. It was a sound judgement. The acting in *Jake's Progress* was the equal of anything in previous Bleasdale shows yet there was nobody more electrifying than the eponymous Jake played by part-time drama student Barclay Wright.

As with *GBH* Bleasdale fed his own life into the screenplay in a variety of flashbacks, most crucially the father-son relationship. 'I was lucky, my Dad played with me forever, I suppose I couldn't have written as I did if I'd had the kind of distant father that many boys had', he says. The chilling scene in which Jake attempts to hang himself on a washing line, after watching *The Cisco Kid* on television, comes from Bleasdale's seven-year-old childhood. Saved by a distraught parent he also asked if the Cisco Kid would have rescued him. 'I had to wear polo necks for weeks', he remembers. He was an only child but when the wider Bleasdale family met there is often talk of sibling rivalry in childhood. Without knowing it he had been researching *Jake's Progress* for 25 years

by listening to his cousins. Other motivating forces were the painful business of helping his teenage son Timothy battle against epilepsy through the late eighties and the empathy felt for Julie Walters as her small daughter struggled with leukaemia. But Bleasdale's own three children, who played the raggedy trio following Yosser Hughes in *Boys From The Blackstuff*, were never directly cannibalised for the Jake show. Except that his youngest is also a Jamie and a rock musician.

Before the serial was shown Bleasdale braced himself for an expected outcry about his disabused view of childhood. It never materialised. 'The only thing that seemed to be controversial about *Jake's Progress* was the moment when Julie Walters bursts through a window to try and get her son out of his old bedroom and says "Jesus fucking Christ". I can't tell you the number of people who wrote to me about that. And yet there's the scene where the five-year-old boy ties his 12-month-old baby brother to a tree and sets fire to it. I never got one single letter of complaint about that. And if that doesn't tell you something about the society we live in …. it's a good job Julie didn't kick the dog as well, otherwise we'd have been truly fucked…

'That scene actually happened. I watched from the bedroom window of the house we were living in and this five-year-old kid tied his 15-month-old brother to a tree, dressed as a Red Indian, and set fire to lower branches of the tree. And I put the bloody flames out. The parents weren't at all bothered by it. The kids were running riot and the mother said "We don't believe in physical violence". I asked her to tell her kids they were lunatics … Later the kid that tried to set fire to his baby brother was on *Jim'll Fix It* and do you know what he wanted to be, a policeman. Merseyside Police took him around for the day, I can imagine him as a bloody policeman', Bleasdale recalls.

If for once Bleasdale entertained without quite touching the public nerve, or achieving great popular appeal, it was maybe because he had been there before and this was another case, in his words, of 'dressing the same body in completely different clothes'. As in *GBH*, where so much stemmed from what happened to Michael Murray when he was a little boy, he was back with childhood and madness. After which he needed a change, he need to make a television entertainment with no self-referential content beyond the impulse to pay homage to the Francis Durbridge thrillers he had enjoyed as a child. In applying for rights it helped that Durbridge's son Stephen was Bleasdale's agent.

'Francis Durbridge thrillers on Saturday night were absolutely required television viewing in our house during the fifties and sixties. He is unquestionably one of the reasons why I have ended up earning my living in front of a typewriter. Watching television and going to the pictures were my influences and I was unconsciously learning my craft all the time', says Bleasdale. He read Durbridge scripts while off set in Ireland during the shooting of *Jake's Progress*. 'The great quality of Durbridge's work is that it's a real page-turner, you are just desperate to know who's done it. Out of all of them the *Melissa* story stayed with me the longest, it has a haunting quality and such a brilliant twist that I knew it was the one'.

The original *Melissa* (1962) was a black and white BBC serial of six half hours with Tony Britton playing the put upon hero Guy Foster. The eponymous and

mysterious Melissa was never seen except as an initial murder victim. Bleasdale decided on a five-part serial with the first three episodes crafted as a prequel to the Durbridge whodunnit occupying parts four and five. The thought was that a mix of the Durbridge skills as a master plotter and Bleasdale's strength with character and dialogue something memorable should emerge.

'Attempting to write a thriller was an exercise in stretching my craft, another strand of learning for me. The actual writing process drove me up the wall. I'm not the kind of person who's good at jigsaw puzzles or crosswords, so I sat surrounded by hundreds of pages of notes listing where every character was at any moment and trying to make sense of it. I rang up Francis Durbridge one night because I became convinced that the only way he could have done this from scratch was by starting at the end and working backwards, but apparently he didn't. He did what I was doing, meticulously moving forwards'.

Bleasdale has told how he was faithful to Durbridge through January, February and March of 1996 before he asked for and received permission to play around with the original and hit upon his prequel idea. His final 73 pages were written in a frenzied 27 hours. 'Then I went to bed, convinced I'd ballsed it up', he told Maggie Brown of the *Guardian*.[4] 'I've got no confidence, it's a lonely business. When I start off on something I work office hours, 11 am to 6 pm, but towards the end I became totally obsessed. I'm so nervous, hesitant, then I have no option but to go for it. People are a mixture of granite and limestone. My limestone is utter, abject insecurity. It's only when I have no choice, because of the deadline, that I am released from worrying about whether I'm fucking hopeless. Panic, that's how I did Melissa'.

In the past Bleasdale had reached ten drafts. This time he was down to four plus two more with director and actors. Production was again from Diplomat Films with Bleasdale in overall command as executive producer, though filming was generally left to his partner Keith Thompson (producer) and Bill Anderson (director). Julie Walters had a fat part as public relations woman Paula Hepburn and Michael Angelis a lighter role as Detective Inspector Kilshaw. Andrew Schofield, David Ross and nephew Gary Bleasdale had cameos. But the Bleasdale rep were upstaged to an extent by Tim Dutton as journalist hero Guy and Jennifer Ehle as the doomed Melissa. Dutton had found time to appear unpaid in a student film by Bleasdale's daughter Tamana, then 'reading' film at Bournemouth University, and as for Ehle ...'I wanted to write a big part for Jennifer because I think she's the most extraordinary actress of her generation. She has a quality of absolute mystery, you have no idea what she's going to do next, which is so rare. It's fairly bloody obvious that she is extremely beautiful, but there is more to her than her beauty.'

Still more important to Bleasdale was his discovery of the thirtysomething craftsman who quickly became his favourite director. 'With Bill Anderson our roles were reversed. As soon as we met we knew we wanted him to do the job and I said to him "You should realise we're not auditioning you, you are auditioning me". He had not made all that much before but he had spent his life studying film and he's wonderful with people, its an admirable combination. Also he was fierce in the editing room which was great. I didn't think that

4 Maggie Brown 'The Worrying Kind' *Guardian Weekend*, 10.4.97

anyone could be more brutal than me with my work, when in the editing room, but he was even more brutal'. There were 15 weeks of filming, mainly in English and Welsh locations. The story opened in South Africa and continued on the cruise back to England where widower Guy meets the mysteriously seductive Melissa and her largely vacuous friends. The cruise sequences were shot over five days, sailing on the Canberra between Lanzarote and Tenerife and then crossing the Bay of Biscay towards Southampton. Bleasdale, terrified of flying and not too keen on any form of travel, enjoyed the voyage more than he expected. Both at sea and back on land he found himself deferring to director Anderson, 20 years his junior.

'I was working with a director who knew so much more than I did, frighteningly so, that he was educating me and I became redundant. I worked out that in the fifth week of shooting, a six-day shoot in London, I contributed 37 seconds of my thoughts. I knew then I had found not my master, not my equal, but someone who was there with me and could say it better than I could. He adored the actors and they responded. And I wasn't jealous, I was relieved. It's been great, I had been wanting such a thing to happen for a long time'.

Their five-parter was boldly scheduled by Channel 4 to be shown from 12-20 May 1997, with the three prequel episodes stripped across Monday, Tuesday and Wednesday evenings and the concluding two shown on Monday and Tuesday of the following week. Between them Bleasdale and Anderson had created a pleasing entertainment, mixing thriller and comedy techniques and adding enjoyable caricature of the London glitterati scene. The thriller seam was very sufficient, with five deaths before the detectives moved towards the unveiling of the killer. The comedy had its moments but lacked the sure consistency Bleasdale has always managed when on his Merseyside home ground. More seriously his attempt to give depth to the characters, generally wealthy or successful or both, failed to touch chords. Uniquely in a Bleasdale drama, though it is a standard failing in middle class set detective fiction, the viewer was not made to care about his people.

Fellow television dramatist Paula Milne has said of Bleasdale that 'I see him writing on a vast Dickensian scale'. It would be good to think he could go back to this and bring to the screen another £6 million epic that would again display the power of his vision and, within his very individual framework, help to define the decade. But through 1997 it became ever harder to see where he could place such work. The once all powerful BBC drama department continued to crumble and haemorrhage in the face of director-general John Birt's management culture. At Channel 4, the last bastion of total support for writers' perceptions, chief executive Michael Grade resigned and commissioning editor Peter Ansorge was pushed aside. With their departures Bleasdale also lost his power to command air space and resources. His proposal for a series built round the comic double act of Detective Chief Inspector Cameron (Bill Paterson) and Detective Inspector Kilshaw (Michael Angelis) of *Melissa* might still materialise. So might his idea for a drama about the high finance of football, the religion to which he remains faithful and from which he has gathered years of anecdotes accumulated at and around Liverpool's Anfield. Or the story of a teacher who takes a musical to London's West End much as Bleasdale himself did with his Elvis Presley celebration *Are You Lonesome Tonight?* But essentially Bleasdale must either disappear back into the theatre or attempt to join

the television mainstream of the day, reinvent himself with ideas which commercially minded executives see as potential continuing drama and better still promising big overseas sales. And in the process subjecting himself to rigid tightening of his generously sprawling style. With the ultimate danger that in trying to fit in with the new order the '18-carat original', as Michael Grade characterised him, will become just another writer. Albeit one who still prefers his Imperial 66 typewriters to any kind of computer or word processor.

4 From the heart and soul

Jimmy McGovern

In the Nineties along comes a guy called Fitz who says the only thing that matters is not the ideology you espouse, the slogans you chant, but what you actually feel deep down in your heart and soul. That is where you will find the things that matter.

When I wrote to the creator of *Cracker* and the historian of *Hillsborough*, asking if he would be willing to talk about his work for this book, he replied by letter in his own hand. At once showing himself a rarity among writers of today, armed as they are and he is with telephones, computers and agents. Like his screenplays the letter did not mince words. He was 'honoured and flattered' to be asked but he was 'not sure you'll like what I have to say'. He would not offer unqualified praise of Dennis Potter, much less argue that the system now prevented any writer with that kind of original talent emerging.

'I think Potter reached his brilliant best with *Blue Remembered Hills* and after that came gradual decline. *Karaoke* and *Cold Lazarus* were a disgrace. Those who purported to love and respect him should never have let those two pieces see the light of day. You talk about me having to protect my scripts "against producers, directors, actors…" So what's your thesis? Is it one about passionate, committed writers being reined in? If so it's bollocks. Producers would *kill* for a good, young, passionate honest writer. Sadly, there are very few around. Most writers working in telly today are tarts. They knock off a *London's Burning* or an *EastEnders* or whatever and take the money and run. Yes, I'd love to talk to you…'.

It sounded very promising. When we did meet, at the London launch of his *Hillsborough* and then at his home in a *Brookside*-like street set in a leafy suburb of his native Liverpool, he offered one or two qualifications. On Potter he did rate *The Singing Detective* but not as much as *Blue Remembered Hills*, 'there's not a flaw in that, its absolutely perfect from start to finish'. And admittedly *EastEnders* had some 'cracking' writers, Tony McHale for one, who 'put their heart and soul' into the work. As well as others who 'turn out shite'. 'The same applies to *Coronation Street* but there's much more

technique with the *Street* where *EastEnders* shows the difference a writer can make'.

He still thought it 'wrong for writers to whinge about the system'. In his time he had been 'frustrated at the BBC many and many a time' but he remained 'optimistic' that the best work would still be recognised. Even though he shared the prevailing bafflement about the failure of the BBC to sustain its drama department and stop the departure of its best talent...

'I do not understand the Beeb. There's going to be channel after channel after channel and the power is going to be in the producing and owning of programmes. They're going to be desperate for material and the cost of scripts is going to go through the roof. Why at this stage should the BBC say "We're just a broadcaster"? They should be producing more stuff and owning it. If I was in charge of the country I'd look at the profits made by Sky and say you can use crap if you like but you can subsidise good stuff elsewhere. I would tax Sky, not easy because it is a multi-national, but there must be some way of putting a tax on Sky. Which would go direct to the BBC for programme making', he suggested.

All of which underlines the contrast between McGovern and his scouse contemporary Alan Bleasdale. In conversation as in his writing Bleasdale is a generous man, prolix and discursive, given to long and funny tangential anecdotes, preferring to talk warmly of friends, colleagues and even relations rather than opinionate about broadcasting and its rulers. In conversation as in his writing McGovern is a focused man, spare and direct, sticking clearly to his theme more comfortable in his observations of the outside world than when talking of himself and his nearest and dearest. They are both immediately likeable but their different styles are advertised in their beards, Bleasdale's allowed unrestrained, free form growth, McGovern's facial hair severely cut back.

Though by 1997 McGovern's pungent naturalism had become the hotter ticket in the minds of drama department heads and majority channel controllers he will never be able match, probably would never want to match, the absolute power that Bleasdale has been able to exercise in seeing his work on to the screen. 'I found *GBH*, like Peter Flannery's *Our Friends in the North*, too long', McGovern says. 'I think that because Alan was so successful it became hard to criticise his scripts, I am sure that was the problem. After a man has done *Boys From The Blackstuff* it is difficult to start tearing his next script apart is'nt it. I don't think forming your own production company to guard your scripts is the best way at all. I think the best way is to show them to as many people as possible and get as many responses as possible, as critical and as hostile as they can be. If you are producing your own work who is going to have a go at you?'.

McGovern honestly welcomes criticism, where he can feel that the critic deserves respect, even from newspaper reviewers. 'Those critics on BBC2's *Late Review* talking about *Hillsborough*, they sounded unsure of themselves. I think they were confused, I don't think they were at ease either attacking or praising it. I always look at that guy in the Independent (Tom Sutcliffe) because he's the best. I think the *Guardian* reviews have gone so weird and idiosyncratic and personal, even Nancy. Nancy Banks-Smith is a brilliant writer

but I don't think she's a great critic. She doesn't say whether she likes a show, you have to infer it half the time. It is Tom who hurts most if he is critical, it hurts because most of it is truthful. You know you've made a mistake, it's there, he's seen it. I have got a lot of time for him'.

Bleasdale and McGovern share the same Irish and Catholic heritage, such fertile ground for the seeding of creative people in general and writers in particular, though they have flowered in such different ways. Far from being a cherished only child of Huyton little Jimmy was born into a large inner city family that knew extreme poverty. Others in the household were grand talkers but until he was eight or nine (he cannot remember which) Jimmy could only make noises, interpreted by his older brother Joey. When he did begin to formulate words they came with the difficult stutter which still returns to him, in more manageable form, in adult life. At school he was only fluent when writing but that proved good enough at 11 plus. Unlike Bleasdale, saved from the painful fate by his father, his reward was a Jesuit grammar school. Where the quality of his writing was praised, and he could enjoy ordering unpronounceable words on paper, but where even in the 1960s he still suffered more than the usual amount of ill treatment because his family was poor.

McGovern was not pursued like Bleasdale, by a smitten teacher with a crunchie bar in one hand and his penis in the other, nothing so openly exposed. Young Jimmy was one of those on the receiving end of a sadistic priest who expressed his repressed paedophilia by whipping boys in the showers. Other priests wielded whalebone bound in leather as their favourite aid in the prevailing system of learning through fear and pain. It was, as McGovern told Stuart Jeffries of the *Guardian*,[1] 'an absolutely horrendous school'. A series of dead end jobs made a welcome escape though he later took the Bleasdale route to teaching training college as a mature student. And then had a frustrating time trying to coax the written word from his often unwilling pupils at Liverpool's Quarry Bank comprehensive.

He was still teaching when Channel 4 launched itself and its twice-weekly, plus Saturday 'omnibus', soap *Brookside* on 2 November 1982. The creator of the Merseyside concept was Phil Redmond, already known for his parent unfriendly *Grange Hill*, determined to maintain such realism and distance his show as far as possible from *Coronation Street*. He bought a set of 13 estate homes, installed the latest television technology and let the people swear. It provided a target for the censorious right, and associated newspapers, but that was not necessarily proof of high quality. It clearly had its heart in the right place. 'The audience isn't stupid and we don't treat them as if they were', Redmond told Hilary Kingsley.[2] 'I wanted to highlight the issues in society at that time. I wanted to attack the black economy, unemployment, the demise of manufactuing industry, what's wrong with trade unions, the position of women'. A formula which gave instant satisfaction to sociologists but took longer to become a ratings winner. At one early point, with an audience measured at 250,000, it appeared to have no future at all.

Some 15 years on Redmond the youthful and challenging standard bearer of social enlightenment is seen as Redmond the middle-aged and tight-fisted

1 Stuart Jeffries 'The Sinner Repents' *Guardian* 22.8.97
2 Hilary Kingsley *Soap Box* Papermac, 1988, page 48

tycoon. The show has had a decade and more at the top of the Channel 4 ratings but the dictatorial style with which Redmond rules his Mersey Television empire makes for a high turnover of staff in general and actresses in particular. Alan Bleasdale has long had a low opinion of the soap, holding that it belittles the city he loves. Jimmy McGovern has come to agree with him. 'Its terrible now', he says, blaming its acceptance of the prevailing soap inflation where every sensational story-line has to be topped by the next one. Where 'writers are losing faith in the actors and actors are losing faith in the characters'. It was his favourite actors and characters who kept McGovern writing for *Brookside* for a seven-year stretch through the 1980s.

By 1982 teacher McGovern had gained some extra confidence in his writing ability through the use of his work by BBC Radio and the local theatre. When he heard that Redmond was trawling for scouse writers he applied. He was given a trial, the quality of his scripts was quickly recognised and he was on his way to becoming a television dramatist. Though he was cautious about resigning from his day job...

'For a while I combined teaching and *Brookside*. When the bell went at four o'clock I would get a *Brookside* script out of my bag and start writing in longhand. For 12 months I delivered my scripts like that, in longhand. Before leaving schoool what I had to be convinced about was that *Brookside* had a future. It wasn't necessarily so because it had a disastrously bad start. But eventually it became obvious that the show had a short term feature and I packed in teaching then. It's a different world, that of the soap opera hack, its that sheer sweat of waiting all day for the phone to ring and hearing you have been commissioned. I am sure its the same with all soap operas, there's one day when they phone all the commissioned writers. With *Brookside* it was once a month'.

'I presume the characters were all prescribed before you arrived even if you could to some extent bring your own perceptions to them?' – 'Yes they were all Phil's characters before I arrived but specially with Bobby Grant (Ricky Tomlinson) I could express my ideas. I could use him a lot for what I wanted to say partly because the actor became the character and the character became the actor. It often happens like that in a soap, there's insufficient rehearsal time, insufficient money, and the short cut is that the character evolves to become the character of the actor. And I liked him and he liked me and his attitude to things was my attitude'.

Ricky Tomlinson had been a building worker imprisoned for two years for offences associated with a strike. He achieved fame as one of the 'Shrewsbury Two' pickets so lionised by the Militant Tendency and the Labour left. On the employers' blacklist he turned to entertaining, first as a comic, before turning actor in Jim Allen's stirring television screenplay *United Kingdom*. His *Brookside* character was said to be the first soap hero to care for more than his family, his friends or his firm. He was a bearded and burly man who never bothered about his clothes but liked his fellow white, working class men and served them as well as he knew how from his leftward leaning position as shop steward of Fairbanks engineering. His Catholic wife Sheila (Sue Johnston), for years the star of the show, did not approve when he got himself a vasectomy as a response to her difficult and unplanned late pregnancy. His incipient male chauvinism surfaced in his inadequate response to Sheila's rape, his

disapproval of her taking on an Open University degree course and his accusations over her supposed affair with a lecturer. A messy divorce for his character was looming when actor Tomlinson walked out, saying he had to 'go on living with the working classes', leaving the writers to restructure three months of scripts.

'At that point, 1982, onwards, it was the height of the feminist movement', McGovern remembers. 'Bobby Grant was a character who not only saw the political agenda moving to the right but found the institutions he respected, the trade unions, constantly being attacked. He was always on the back foot and anything he had to say seemed to be treated as worthless because he was a man, a working class white man. Because he was white he was seen by a lot of people as part of another problem, the problem of the oppression of black people. He was a decent, hard-working, compassionate man seemingly under attack from all quarters. Politically what was happening was this massive attack on his culture. I'm sure that's the way he saw himself because that's the way I saw myself then'.

'What really made Ricky walk out?' – 'The official reason he departed was that there were contractual problems. I think he would have stayed but his face didn't fit for some reason, I never did get to the bottom of it. I was ashamed of myself. We all championed his cause and I remember standing up at a story meeting and saying 'If that man goes I go'. But he went and I did not go. I think if he had been sacked I might have been forced to leave but when he walked it gave me half an excuse to stay. And really I should have gone as well. I went a short time later but I didn't go then. The management said 'He's got to go' and in the end he walked with his head held high. Those contractual problems could have been solved if Phil had wanted to do that. It was diabolical, a fascinating character was needlessly lost'.

'The departure must have caused a bit of a strain for everybody?' – 'Yes, it causes mayhem if sombody walks out in a contractual period. That's why we made Gordon gay! *Brookside* got all kinds of applause and brownie points for featuring a gay character. The actor playing Gordon in the middle class Collins family walked out on us and some writer, in a fit of pique, said 'Make his character gay'. It was a ridiculous thing to do but the character was recast and suddenly became gay. There had not been an inkling of gayness before'.

'Was Phil Redmond a dictator at that time or was there some room still for the perceptions of writers in story-lines and character development?' – 'It was awful, it was really frustrating. The energy and passion of a *Brookside* story line was a joy to behold. People were in tears quite often, there were shouted arguments, the language was sometimes blue. Many writers thought the way to get a commission at meetings was to display passion and commitment and quite a few of the writers were totally involved in the show. There was a girl there whose job was to take down notes of all that was said but after the meeting the writers had no control at all.

'So the things you fought passionately for and thought you had won went into the machinery, which was really Phil, and often got lost. Lots of good stuff got lost. There was no point in threatening resignation because if you did he did not care. There were certain times in the mid-eighties when I was important because I was coming up with lots of good stories at meetings and

my scripts were OK and the actors quite looked forward to getting scripts from me. So I knew I was valued. But even then I couldn't threaten to go because, although my going would have harmed the show slightly, Phil ultimately did not care. It was not just Phil. It is the same at *Coronation Street*, where the writers have just a bit more clout, or *EastEnders*. Their main concern is keeping the show on the road, keeping the machinery ticking over, and if you're a pain in the arse, no matter how valued you are, you will go. ... I came to believe Phil's dictum that the show is more important than anybody and that takes away all your power, you haven't got the ultimate sanction and therefore you are powerless.

'I remember once being in tears around 1986. A brand new producer came and I was doing scripts for an episode in Portugal. I'd written a really good first draft but this producer wanted to show who was boss. He gave me these appalling notes on the scripts and I fought and fought and fought and in the end I said 'I don't want to do this'. I wanted the man to feel at home and all that but I knew that my points were right and I said 'We'll go and see Phil'. So we went to Phil and we gave our arguments, and by this time I was very experienced in the ways of *Brookside* and the characters and all that, and Phil said to me 'Do what he tells you'. I launched into this massive argument again and found myself crying, so I just packed meself up and blundered out. I analysed why afterwards, it was because I cared so much. I wouldn't have cried if I had not cared much about it. I felt meself so right, I couldn't believe what Phil was saying. It was a good example of Phil and if I'd been Phil I would have done exactly the same. He's put a producer in charge so he has to say "You do what the producer tells you, otherwise you go"'.

The last such argument came in 1989 and pointed to McGovern's future. He wrote a script in which a character burnt a copy of the Sun in protest against its mendacious coverage, putting the blame on Liverpool supporters, of the Hillsborough disaster. A producer cut the scene and Redmond supported him. It became obvious, if it was not before, that the boss now thought it wiser to maintain respectability in the eyes of the press than to take on difficult issues. McGovern had had a useful apprenticeship as a television dramatist, he had learned to write to length and how to keep a story moving at pace, he had found his own strategic way of dealing with producers and guarding his work against bad acting. It was time to bid *Brookside* farewell and find his own way.

Outside the soap the first broadcast drama McGovern had produced was a radio play about Gerard Manley Hopkins, the poet and Catholic priest, and the Liverpool farrier (or blacksmith) Felix Spencer he celebrated in his poem *Felix Randal*. Felix, a 'big boned and hardy-handsome' man until 'sickness broke him', died of pulmonary consumption with Hopkins as his spiritual comforter. 'It was one of the worst poems he ever wrote but it was the only poem he wrote as a parish priest on Merseyside', McGovern says. 'The interesting thing about Hopkins for me is that he gave communion to my grandfather. And the guy he wrote about lived on Birchfield Street and that is where my father was born'.

McGovern's first television single drama was *Traitors*, 'a glorious failure, the kind of failure the BBC used to do quite well', as he puts it. 'I was seizing an opportunity with this one because the BBC had just turned down a drama

series of mine, a thing about a scouser which I suppose ought to have been turned down, and as I had just left *Brookside* I had nowhere to go. I remember writing *Traitors* and thinking 'I've got to get this made' because if you get things made you get more money anyway. At that time what the BBC had in plenty was people writing screenplays set all over big cities. What they were not getting plenty of was studio plays and I reasoned that as they had all this studio space and nothing to put in it I should be in'. So, knowing 'there were times in that script I didn't give of my best because I couldn't see a way through it', McGovern completed his debut single about Guy Fawkes and the 1604 Gunpowder Plot. This the failure which became an annual exercise of Protestant triumphalism and is now an excuse for fireworks. Though really 'the only figure who emerged with reputation intact was Fawkes. They were all a shower of bastards but he was a soldier, a brave man… I saw his signature, he signed his spidery signature after his hands had nearly been torn from him by his torturers'.

In fact it was not Fawkes which brought McGovern to this story but the Jesuit priest Father Henry Garnet. 'He heard the gunpowder plot in confession, he knew that hundreds of people could have been killed, but he could not speak. When the state put him on trial with the others his defence was that he had a higher duty to the church than the state. He was executed just the same. It was the same dilemma that drives *Priest*. … People know me as this inner city, gritty, drugs writer but that is not all of me, I love big Catholic political issues'.

The drama was recorded at BBC Television Centre in late 1989. Still educating himself in the ways of the business McGovern was present for the three-day shoot. He knew he had written a real studio play. 'The worst kind of studio play is one which apologises for being in the studio. This was so claustrophobic and secretive, whispers in ears and things, that it was perfect for the studio', he says. He also knew better than anybody how much his screenplay was flawed. 'There was this army of people, swinging cranes, building things, all to realise my play. That brought on a massive feeling of guilt. You see all these people beavering away to realise your script and think there are parts of it which are not worthy of all these efforts… The producer was Simon Passmore – he respected the script, he was brilliant – and Malcolm McKay was director. Malcolm's a great writer who saw himself as the great director and I said 'You're making all your mistakes on my work and when you're a better director you will do your own stuff'. He agreed. He did a good job with *Traitors* but it was a glorious failure, he failed and I failed, we all failed.

'It was quite amusing at the end because everything that could go wrong went wrong. The cameras were flashing, poor Malcolm was tearing his hair out and we hadn't done these key scenes. Being the writer I thought the play was the most important thing that had ever been written and I'm saying to this studio guy 'You're just going to have to give us an extra two hours to get these key scenes in' and this guy is saying 'No, all this is going to come out on the dot of ten o'clock, its all coming out and a new thing is coming in'. I'm saying 'You can't do this, it is a very important play, you're going to have to give us an extra two hours' and he says "We can't because the next show in here is the Les Dawson Christmas Special"'. Somehow the hour-long drama was put in the can and shown the following year in the BBC2 Screenplay strand.

It was not shown until after McGovern's second delivered but first transmitted single drama, *Needle*, set very much in the inner city present generally perceived as his territory. 'It came about because years before that I had wanted to tell the same story about a gambler. It was still an addiction, just the substance changes. So I had it all up here and when I was offered this chance. I was desperate because I had only made the *Traitors* money since leaving *Brookside*. Again I was lucky. I got *Brookside* because I was a scouse and I got *Needle* because they wanted a port. It could have been Belfast, Glasgow or Newcastle. But in Liverpool we had a needle exchange scheme, which was avant garde at the time, and so I was in the frame for that reason, not because of my talent or lack of it, nothing like that. Except I had shown I could write a script with *Traitors*'.

The story of destructive addiction on Merseyside was well received both internally and by reviewers. As well it might have been with accomplished *Brookside* actor Sean McKee as the young protagonist declining through smack and the budding star Peter Postlethwaite as his father-in-law. But such success did not give McGovern the immediate clout that might be expected. His *Heart* was rejected and his *Priest* was emasculated. 'I have got an awful lot of time for George Faber (then in charge of BBC2's Screenplay) and I sent him the *Heart* story but what happened was typical of the BBC at that time. If you heard a story like it you would commission it. A woman loses her son and after she has signed a form his heart goes into the body of another man. The man finds the woman and they meet and meet and meet and eventually the woman decides that the man is not worthy of her son's heart, so she kills him and takes it back. They turned that down, so I'm doing it for ITV'.

It could be argued that it would have been better if *Priest*, a drama particularly close to McGovern's heart and soul, had also been turned down and kept for later rescue. He had been carrying this theme, priests struggling to practice what they preach, in his mind since he became a writer.

As he tells it '*Priest* was commissioned as a four-part serial and it went through rewrite after rewrite after rewrite and then languished on Michael Wearing's desk for a year before he turned it down'. A final rewrite turned the story into a single screenplay which found its way to executive producer Mark Shivas and the BBC Films arm which strives to follow the lead of Channel 4's *Film on Four* in making movies first for the cinema and only after then for television. In the opening credits McGovern is listed 14th, between music provider Andy Roberts and producers Josephine Ward and George Faber. After which there is a pause before it is suggested that if anybody authored the drama it was 'Director, Antonia Bird'. As a cinema piece the movie has its moments and Linus Roache gives a moving performance as the young protagonist, Father Greg Pilkington, torn between his priestly vocation and his other emotional and physical needs as a homosexual. But the piece is clearly television converted into ersatz cinema.

One sequence should be considered by every student who doubts whether there is any real difference between television and cinema grammar except in scale. The shot is of melancholy mudflats, beautifully judged as a cinematic mood scene, so beguiling that unless eyes are closed the words largely disappear. What matters about the sequence is that Father Greg is telling his lover

about the uncertainties of his faith. The words are at the heart of what the drama is saying and all important to the television screenplay.

'I question whether the BBC should be trying to make cinema anyway but whatever you feel about that you must be unhappy about the way *Priest* reached the screen?', I put to McGovern. 'I totally agree that the BBC should not be mucking round making cinema. If it becomes pay-per-view how dare they. My money as a licence payer has paid for that film and I cannot see it unless I pay some more money, how dare they. I had this out with George (Faber) when he became the BBC's head of singles.

'As to *Priest* I heard that George and Antonia Bird were putting it about that they 'always knew it was going to be shot as a 35 mm movie'. I wrote to George saying 'If you always knew it was going to be shot as a 35 mm movie why did you not think of telling the writer'. I wrote it as a television film with all the strengths of a television film. When you blow up a television film you do not make a stronger film you make a weak movie. In this case it was written as a four-part serial and that structure is still there, all classic movies have a three-part structure. I was appalled by it, it should have been a hell of a splash, it should have won awards. I am not interested in cinema awards, television is my medium, I love television. It should have got the praise it deserved as a television movie. And it didn't, it got the criticism it deserved as a lacklustre 35mm movie. Television is sophisticated, often under-stated, sometimes in your face...

'I had been writing *Priest* from about 1983 onwards, it had always been my mission to write something about a priest, originally using a ten commandments or seven deadly sins structure. I had been through hell with this screenplay, carrying the film round with me for donkey's years. Then in comes Antonia Bird about four weeks before she starts shooting, four weeks of pre-production, and then every time I pick up a bloody review its Antonia Bird's *Priest*. She did a really good job considering and all that but it is still out of order'.

After this it is hardly surprising that McGovern took the two series that made his name, Granada's *Cracker* (1993 onwards) and to a lesser extent Channel 4's *Hearts and Minds* (1995), to the opposition. The former formula, pushing out the boundaries of the police drama genre until it became original, was instantly dominated by criminal psychologist Fitz (Robbie Coltrane). Streetwise and cynical, heavily into gambling, drinking, smoking and all-round incorrectness Fitz stands as the most enduring character McGovern has created. Some 40 per cent of the big man's strength was down to Coltrane, the Scottish actor previously known for his sure way with comedy, but only 40 per cent. Fitz was also an extension of *Brookside*'s Bobby Grant and therefore, in some ways, of McGovern himself.

'Yes, I suppose Fitz is an extension of Bobby in a way. People were always sticking labels on Fitz and the most popular label was 'post feminist man' and I would say "He's not post feminist man, he's post-Hillsborough man"'... Hillsborough being the Sheffield Wednesday ground where 94 Liverpool supporters died, and 170 more were injured (at least two fatally), at an FA Cup semi-final on April 15, 1989. The disaster occured through police incompetence and indirectly, it is very arguable, through current police attitudes to

football supporters… 'This may sound clever-clever and all said with hindsight', McGovern continues talking at least as much for himself as for Fitz, 'but it was before I ever embarked on the *Hillsborough* drama. What I saw was other sections of society showing total contempt for people they thought of as working class scum. Because other sections feared and loathed 'working class scum', and included football supporters in that category, the Hillsborough disaster came about. The kind of people who died were the people Fitz grew up with. He is one of them, an inner city working class boy, a Catholic who passed his 11 plus. In the past he had an uneasy alliance with the Socialist, intellectual left. Because he was white, male and working class they found it easy to attack him on the grounds of sexism, racism, all those things. So suddenly he said "To hell with it"'. …

For McGovern the 1980s, from the Falklands War in 1982 to the Hillsborough disaster in 1989, was a crucial decade. The era when the Berlin Wall came down and when, as he sees it, many isms from socialism to feminism collapsed at the same time. It took a little longer for middle England at least to realise that Thatcherism, the dogma signalled by the euphemism 'liberal monetarism', was at least as destructive as any of the once fashionable isms that it followed. It was not directly spelled out on screen but taken as read that Fitz was well ahead of his time in that realisation…?

So let McGovern continue: 'In the Nineties also comes this guy called Fitz who says the only thing that matters is not the ideology you espouse, the slogans you chant, but what you actually feel deep down in your heart and soul. That is where you will find the things that matter…. Along comes Fitz at a time when I was feeling utterly fucked up by seeing the destruction of things I believed in and I now perceived as being lies. He was the kind of man it was so easy to attack in the late Seventies. You could use all kinds of misogynist, sexist, racist labels against him then but it was not so easy to attack him in the Nineties'.

Gub Neal produced the first series of seven episodes. Paul Abbot, who later took on some of the writing, produced the second series of nine parts shown in 1994. Barbara Flynn as his long suffering wife and Geraldine Sommerville as his equally put upon police companion DS Jane 'Panhandle' Penhaligon were consistently effective as the chief victims of Fitz's tendency to trample on the women who attracted him. By 1995, the year of the third series, the regular audience had built to around 14 million.

The first story of the second *Cracker* series, *To be a Somebody*, was particularly close to McGovern's heart. Here he was able to demonstrate his anger over the worst of English football disasters much more freely than in his later *Hillsborough* docudrama. Though in the fiction it was the serial killer Albert 'Albie' Kinsella (Robert Carlyle), rather than his remorseless hunter Fitz, who spoke in increasingly distraught terms for the constituency which McGovern represented. Albie is first met at the funeral of his father. Both were physical survivors of the crush at Hillsborough's Leppings Lane end but Albert Kinsella snr had gone into a decline and when he died his son saw him as the 97th victim. It was not a good time for an Asian corner shopkeeper to be difficult about allowing Albie a four pence IOU on his copy of the *Guardian*.

Albie goes home, changes out of his factory clothes, shaves his hair to emerge a skinhead, picks up his father's World War Two bayonet and returns to the

shop to begin his revenge. 'If you treat people like scum they start acting like scum... you robbing Pakie bastard', he explains to his first victim. 'A Socialist me, pal, a trade unionist me, voted Labour all me life, I admired the likes of you. But you just see me in my clobber, you hear the accent and you assume the right to treat me like scum, you robbing Pakie bastard, now I'm acting like scum'.

After this fatal stabbing Albie decides he must kill 96 more of the kind of people he can see as representing those responsible for the Hillsborough disaster and, as Fitz soothingly puts it, 'if there's any justice in this world most of them are going to be coppers'. Before turning to the police Albie targets a greedy freelance journalist, one Clare Moody, who is not above doing business with the *Sun* newspaper. When he has his bayonet at her throat , having introduced himself as one of those she saw as 'pissing on the dead' at Hillsborough, he starts his lecture. 'The police killed 96 people, I can understand them telling a pack of lies, but you believed it... you believed that people piss on the dead... Why? I will tell you why, we were animals to you, you expected us to act like animals, well now you are getting what you expect...'.

In this story Fitz is more than usually out of favour with both his wife and the equally disabused DS Penhaligon. It is a while before he is brought in to exercise his uncanny powers of psychological intuition and redirect the police investigation. The formula dictates that he must get his man, and secure a confession, in the final episode. Albie has killed three, and despatched what will be a fatal parcel bomb to the journalist Clare Moody, when Fitz finds ways of making him talk....

'People need to believe, people need to congregate, but there's nothing left to believe in, to congregate for, only football. They know do the bizzies, the politicians, they go to the matches, they march us around, they slam us against walls, they treat us like scum. We look for help, we're Socialists, we are trade unionists, we look to the Labour party for help. But we are not queers, we are not black, we are not pakies, there's no brownie points speaking up for us, the Labour party turns its back. We're not getting treated like scum any more, we're getting treated like wild animals and, yea, one or two of us start acting like wild animals, the cages go up and 96 people die. The bizzies and the bourgeois lefties, they caused Hillsborough and they are going to pay'.

Among Albie's victims was the ace copper Detective Chief Inspector David Bilborough (Christopher Eccleston), quickly replaced by DCI Wise (Ricky Tomlinson). The same Ricky Tomlinson who played Bobby Grant in *Brookside* and turned up with Eccleston as a bereaved parent in *Hillsborough*. It is plain that particular actors recur in McGovern's work though he denies he has any gift for, or has much influence on, casting.

'I am hopeless at casting. I was convinced that Coltrane could never play Fitz. For *Hillsborough* the director Charles McDougall picked Chris Eccleston to play Trevor Hicks and I said 'That's the biggest mistake you ever made, he's too young, he's far too young'. It turned out that Chris was absolutely stupendous. Charles saw that you need the force of energy that Chris brings. I only killed Bilborough off in *Cracker* because Chris wanted him to be killed off. As the writer you are asked about casting but I don't put people forward. You can say 'Oh, that's a great idea', you can encourage, but it wasn't my idea

to have Ricky in *Hillsborough*. He was quite surprising in that, he played it quite sensitive, he wasn't a brash scouser or anything. At certain times he lost his temper and was quite moving. But I have never gone in for casting. The only time I have fought for anybody it was to have Chris in *Hearts and Minds*.

This Channel 4 four-parter set in and around a tough Liverpool comprehensive school, transmitted from February 16, 1995, was essentially the story of probationary teacher Drew McKenzie (Christopher Eccleston). Formerly a car factory shop steward he had followed the McGovern route, a mature teacher training student who brought loads of enthusiastic idealism to his first year of trying to interest pupils in written English.

'That series, I know because I wrote it, is full of flaws and what carries it is that central performance. I was saying to Chris 'Its a lousy drama but its a brilliant part'. He was up for it then. As a drama I couldn't end it, there was no way of ending it. There were certain episodes I really loved but ultimately it was doomed because I couldn't end it'.

The school is a demoralised place run by a solemn headmaster who, though he goes home to a child bride just out of the sixth form, rules in a style of middle-aged inflexibility. In the staff rest room there is much grinding of special interest axes encrusted with cynicism and resignation. As an enthusiast Drew is on his own, first sent to Coventry and then accused of racism. In the last episode, unsatisfactorily ended certainly but also intensely moving, Drew is the only teacher who will take on the school play. Wanting to keep his job he at first obeys the head's instruction that this *Julius Caesar* must be 'Shakespeare as Shakespeare intended or nothing at all'. When the head also refuses to find a school place for Drew's nephew, a boy afflicted with the McGovern stutter and therefore classified as 'remedial', Drew rebels. He turns the Shakespeare play into a lively but disrespectful modern musical, too readily enjoyed by all but headmaster Maguire; he burns his books and his hopes and next day clears his desk and makes a silent, resigned exit.

Before transmission started the *Guardian Education* supplement assembled a group of literal London comprehensive teachers to disapprove of the Witz End produced serial's inauthenticity. In their schools and doubtless at Liverpool's Quarry Bank comprehensive, where McGovern taught, there was more order. And more teachers of at least average competence. But this was drama not documentary, all the events in the serial rang true as directed by Stephen Whittaker though they were obviously concentrated. Perhaps the only serious unreality was that a real school would fight to keep a teacher who could so enthuse children in the classroom and produce the kind of school play that should win plenty of approving coverage in the local press.

The next McGovern screenplay, though it won the BAFTA award for the best single drama of 1996, was also his debut (and probably his swansong) as a documentary writer. 'I think *Hillsborough* is the most worthwhile thing I have done', he suggests, 'but it was not satisfying for the writer in me. That is because you have to be more a journalist than a writer. Every page went upstairs at Granada to be lawyered and I found myself having to write stuff which I wouldn't normally write at all. There's a really good example of what I mean by that. At a crucial point in the story a senior officer is told that there is a crush at the turnstiles, that there's a danger of death and injury. The

crucial thing then is that he gives an order to open the gates. As a dramatist the way to write this is for the message to come: 'We've got problems outside the ground, sir, we've got problems unless you open the gates. Unless you open the big gate someone's going to die, sir'. The camera then pauses on the man who has to decide about the gates, then cut to the opening of the gates, that's standard filming procedure. The audience at once read it as 'the man said yes and the gate's been opened'. The lawyers said 'You can't do that, you have to show him saying he will open the gate and not only that but use every word he says he said when he was questioned at the first inquiry'. What he says he said was 'If there is a risk of death or injury I have no option but to open the gate'. Every instinct in your body is telling you 'This is rubbish, this is not how you write a film'. But that had to be in and there were many other examples like that. Though that was the worst example, the one that hurt the most. So the dramatist in me was not satisfied at all, the film had to be 100 per cent accurate on the inquiry transcripts otherwise you get done in the courts. One result was that *Hillsborough* was not as partisan as people think...'

'What was the genesis of this screenplay?' – 'I go on and on about this but Hillsborough has exercised me since the day it happened, with hindsight I saw that all the pressure on... all the contempt for working class white males would end up in something like Hillsborough. I always say that it is no coincidence that the South Yorkshire police that policed the miners' strike also policed Hillsborough. And I saw them as acting on behalf of one section of society only, having gone through the miners' strike and the enemy within and all that. So it always exercised my mind and I came back to it with that *Cracker* story.

'The people in the Hillsborough Family Support Group heard about the story and demanded a private screening. Their attitude, and quite right they were, was 'How dare you tackle Hillsborough in order to sell corn flakes?'. So we gave them a private screening. And it was just one of the most emotional nights of my life because I was meeting them for the first time. And they really, really moved me. I knew a fair bit about the injustices but to hear it from them, and to hear even more about the injustices, was really upsetting.

'The woman who moved me most was Joan Tootle. As soon as you saw her you said 'Irish or scouse or both'. You know, dark, very very attractive, deep deep eyes but a wee bit gaunt and you can just see the pain. She sort of hung back and then she came up towards the end and she said "I went to nearly every day of the longest inquest in British history (93 days) to find out how my son died and his name was mentioned once, in a roll call of the dead". But they all moved me, that's the trouble, to pick on one implies that the others weren't so important. They all effected me deeply. I said to them "If there is anything I can do I will" and they said "You should tell the full story"'.

Also present that evening was Paul Abbott, producer of the *Cracker* story. McGovern pressed him to agree to the families' request and, if possible, to keep together the team that made the drama. Abbott had already decided to move on from the 14-hour day that was often his lot as a producer to what seemed like the more restful and lucrative life of a fully employed writer. For a time the Hillsborough families' request stayed in the air.

'Then Andrea Wonfor (Granada's joint managing director) was the heroine.

We were sitting around the same table at some awards do and I waited until we were on like our fifth brandy and I said to her, I'll never forget it, I said 'You know what we should do next Andrea, we should tell the true story of Hillsborough'. And she said 'Tell me what you need, you've got it'. Just like that. She kept her word, she backed it to the hilt, she went straight to the guy in charge of ITV drama (Nick Elliott) and he backed it to the hilt as well'.

There was quite a gap while the project went through internal examination at Granada but McGovern set to work regardless. His ambition at the time was simply 'to tell the truth and silence once and for all commentators who had dismissed the fans as 'a drunken mob'. I did a lot of my own research at first but that only consisted of going round the families. I had a tape recorder, I would play it back and take all kinds of notes, ending up with pages and pages of notes. Then, when Granada officially agreed to go ahead, they put World in Action producer Katy Jones on the research. She was absolutely excellent. I am not sure now but I may have said 'Look I don't want to go round inter- viewing South Yorkshire police'. I think they thought it best to keep Jimmy away from the South Yorkshire police but in any case I couldn't go near them. So it was her and she went down and interviewed them. She's petite and blonde so all these macho coppers opened up and she got some marvellous stuff. The only trouble is that policemen spend their lives trying to get people to sign statements but are not prepared to sign themselves. So an awful lot of stuff she actually found we could not use.

'There was one meeting with the hierarchy, including the Chief Constable, where Katy went in with assistant producer David Price and they were searched in case they were miked up. It was at that meeting that the South Yorkshire Police said they would not co-operate. That is why all the quotes were from the first inquiry and the inquest. The later inquiry by Lord Justice Taylor was searching and very very good and put the blame where the blame belonged, on the South Yorkshire Police. But evidence given at the Taylor Inquiry was ruled out of the main inquest because it was not conducted under oath.

'Sheffield Wednesday football club refused to co-operate. I actually went to Hillsborough and we saw a man called Graham Mackrell, in charge for the club that day as safety chief. And one of the first things he said to me was 'If you talk about Hillsborough to the people of Sheffield they say Oh, not those whingeing scousers again'. I usually tackle that kind of remark head on, I think it's a form of racism, but because I wanted information and all that I smiled and nodded. But I thought 'Well, we'll see, but I hate that man'. He refused to co-operate and his evidence to both the Taylor Inquiry and the main inquest was a disgrace....

'I wanted the transcripts of the inquiry and the main inquest. I asked a bereaved father, prominent in the drama, called Eddie Spearitt. He brought them in his car one day. In my naivety I expected a fairly big book. And he said 'Jimmy its not like you imagined, come to the car'. He opened his boot and it was just full of these big A4 hard covered binders. My front room was absolutely chocker, for a long time you couldn't move for transcripts. I could- n't read it all, just the crucial stuff I read... what the coppers said, what a few family members said, taking longhand notes... I was also naive about inter- viewing parents and relatives, I thought I would interview a handful a day. But

then I went first to Jenni Hicks and it took about eight hours, I started in the morning and it was getting dark by the time I came away. So the interviews went on and on, just amazing, until I came to the time when I said 'I've got to write'.

'It was probably all in longhand first, before I went to the computer. In the first draft I made the huge mistake of trying to get in as many stories as possible. Joan Tootle, the woman who moved me most at that first meeting, survived in the second draft. Then in the third we had to lose stories and I had to go and tell her 'I'm sorry about your Peter, he's a casualty again, he's been dropped from my script'. I tried to console her with the assurance that I had told her story at great length in The South Bank Show, that was pushing *Hillsborough*, but when I got a rough cut of the show Joan's story had gone.

'The other temptation when writing was to be side tracked too much to Jenni (Annabelle Apsion) and Trevor Hicks (Christopher Eccleston). They lost two teenage daughters at the ground and afterwards their marriage broke. People readily identify with their story, people who know nothing about football identify with them'. And indeed, though McGovern did eventually settle for a script which describes the traumas of three families, it is in the marital tensions of the Hicks family that strong documentary most clearly takes off to become great television drama.

By the time the first draft was delivered clever producer Nicola Shindler was in place, with her very firm ideas about the proper boundaries of the dramadoc form. In early May, 1996, she with executive producers Ian McBride and Gub Neal and factual producer Katy Jones chose Charles McDougall, himself a survivor at the Leppings Lane end on that fateful Saturday, as director. Later that month writer and director met in London as McDougall recorded in his filming diary...[3]

'Wait to meet McGovern. Last time was at a *Cracker* wrap party when we were both drunk and I was attempting to discuss early *Brookside* episodes without falling over. Nervous now. Have to walk round the block to try to remember the names of the 1977 European Cup winning side in case of trick questions. He turns out to be attentive, very bright and seemingly without ego. Has a good knack of nodding and saying 'Yes... Yes' as you stumble through your point, and then saying: 'I don't agree with that'. Very positive and great later to have his judgment and jokes on set'. As McGovern remembers the earlier meeting with McDougall the director came up to him and said he had been there on 15 April 1989, and desperately wanted to make the film. 'I thought 'For God's sake' but it was the wisest choice we ever made, he was utterly committed to it'.

For her part Nicola Shindler received the first draft calmly enough. 'I had worked with Nicky in the past, with *Cracker*, so she knew I could turn things around. I can start off with a mess and turn it around because I work and work and work, I never stop working. So she wasn't that disappointed... I can't really remember about the second draft, I never keep them you see. I probably cut out lots of bits and pieces between the first and second. A big mistake in the second was this cracking scene when they had the memorial do at the Anglican Cathedral and Mrs Thatcher came along. As she met people

3 Charles McDougall 'Hillsborough Diary' *Guardian* 2.12.96

she kept repeating 'Did you lose someone? How old? Still it was a wonderful service'. And this went on until a woman held on to Mrs T's hand and gave her a piece of her mind, saying 'I wish a tiny fraction of the effort that went into finding your son when he was lost in the desert had gone into saving my son'. It was a wonderful speech but it was the wrong thing to put in, it would have been a bit of a distraction.

'But the key thing was that between the second and third drafts I went away on holiday. It was for our 25th wedding anniversary. This will sound awful but Eileen and I went on a cruise in the Carribean, it must have been about three weeks. I got *Hillsborough* out of my mind at least until a girl on board recognised me and the questions started, 'What are you doing next?' and so on. We were in the bar and Hillsborough got mentioned and the guy next to us was a copper and he came out with the standard thing about 'It was all drunken scousers wasn't it?' But generally I switched off like I could never do at home. At the start I switched off mainly because we had very heavy seas and I was more worried about the boat than I was about the work. I am a good sailor but I get nervous, I want to be on deck...

'Anyway I came back with plenty of vigour and the third draft was something like the final one, I'd honed it down to a handful of stories. I think it would have been a better drama with just one family but for a document, for a piece of history, you had to have three... I wanted a broad spectrum and even with that... I remember laughing, I said to Eddie Spearritt 'You're a pain in the arse, you fainted'. What happened was that as soon as the crush happened in the pen he fainted and that took him out of the drama. His son died in his arms and he fainted and I'm almost criticising Eddie for ruining my drama. He had been through hell but he was still up for that warped sense of humour'. The read-through took place at the Manchester Post Office Club on July 10, a complicated event with 70 speaking parts to be introduced. The power of the script was quickly evident through the tears of Ricky Tomlinson. Playing John Glover his character was the only one who, at the end of a gruelling and numbing two hours of television, is allowed to emerge from documentary precision and explode in dramatic rage. His is the fury of a bereaved relative at last free to confront the ill-informed inquest jury with the truth. 'That was the scene in which I gave myself a wee bit of flexibility', McGovern admits, 'it wasn't really like that at the inquest, the families internalised all that anger but I gave it to Ricky to say'.

McGovern attended the read-through and, unusually for him, stayed around when filming started at a Manchester factory location on July 15. 'Why change the habit of a writing lifetime?' – 'I have always said this, its strange this, I do all these writers' workshops and things like that and I always say to them 'You'll find writers who'll tell you that they would never let a single frame be shot unless they are there, that's a writer with nothing else to do'. Yet with *Hillsborough* I couldn't keep away. I wasn't there all the time but I was there a hell of a lot of the time. And I couldn't work on anything else. I stood around and watched and saw the rushes. I kept quiet until I met the director in the caravan with the rushes and then it was total support, I was utterly supportive of Charles and the actors. I just felt I had to be there because it was about a thing that meant so much to me.

'There wasn't much money in this. Normally at that time you received 100

per cent once the camera was rolling, a buy out for world sales. In this case Granada knew the film would not make money. The actors and I signed an old fashioned contract which meant we were only working for half the money. Chris Eccleston for one now commands massive fees, he's a popular star. Here he was working for peanuts, a labour of love, and that was part and parcel of me being there as well. That bloody guy in Yorkshire, explaining why they were not co-operating, said 'The only people who stand to profit from this are the television company and the author'. I had a press release ready, saying I would give my money to charity but that was not necessary, he stopped arguing that at a crucial stage. The film has been sold in Scandanavia but I don't think we are looking at American sales or anything.

The team hoped for uninterrupted transmission in a weekend slot but ITV were not that keen on the kind of programme that seemed to come from the network's public service past. In the event *Hillsborough* was transmitted on Thursday December 5, 1996, straddling *News at Ten*. 'It was a tense time. I had given up smoking but on December 4 I started again. I offered to do anything I could to push the show and widen the audience. I wouldn't do anything for the Sun but that's all I wouldn't do. On the morning after I would defend the show to the hilt and then I would disappear. On Radio Merseyside the big complaint was the adverts. People were saying that the adverts were intrusive, incongruous. My answer was 'Go out and buy, who ever advertised buy their products'. If you stop adverts in the middle of an ITV programme ITV will never want to do anything similar again. You should have said 'Support the advertisers because they had he gall to advertise in the middle of a harrowing programme'.

The newspaper response, both before and after transmission, was almost entirely encouraging. 'No one should doubt Jimmy McGovern's ability to write unremittingly raw, emotive drama. This was one of the most upsetting two hours of television you are likely to see, and yet one that was also expertly handled as a dramatisation of a real-life disaster, economical in construction, thanks to Charles McDougall's direction, impeccably performed, and born of high principle', as Stuart Jeffries put it for the Guardian. Other reviews were similarly favourable and, more importantly, the Hillsborough disaster and the subsequent cover up were brought back to front pages and opinion columns. 'In the end I was really pleased with the media response', remembers McGovern. 'We even had the Chief Constable from South Yorkshire, driven to Liverpool by car for some reason, singing the praises of the drama on local radio. He was saying 'Yes we'll look at it in detail and if there's anything new we'll investigate'. Whether he meant it or not, obviously a superb politician'.

As might have been expected there was no immediate response from Home Secretary Michael Howard, then trying to get his last, ill conceived police bill through Parliament, or from other members of John Major's tottering Conservative Government. There was what McGovern called 'a deafening silence' from Labour Opposition leader Tony Blair. There was still no apology from anybody for the bereaved familes. The families whose compensation, to the delight of the insurance companies, covered little more than funeral expenses. Rather less than the £3.2 million which could be the total pay out to traumatised police officers. Chief Superintendent David Duckenfield, found by Lord Justice Taylor to have 'frozen' at the moment he could have prevented the

disaster, was still able to move towards early retirement on full pension. Yet, for all this, Jimmy McGovern's screenplay had at long last brought national awareness of the second Hillsborough disaster, the mendacious cover-up which had rubbed salt in the wounds of the bereaved. The slow movement to justice had begun.

It was not surprising that, given the charged energy with which he approaches writing and the special pain and anger caged in *Hillsborough*, McGovern now found himself unable to put pen to paper. He had delivered his rites-of-passage four-parter *The Lakes* (1997) to the BBC earlier in the year but otherwise had devoted himself to the docudrama. 'The easy way out if you are feeling tense is to have a couple of drinks. I did no writing on the run up to Christmas or afterwards', he remembers. Then on January 5 or 6 I started writing again and, a bit to my surprise, suddenly decided that I can write still.

On the 1997 day McGovern talked to me at his Liverpool home he was nervously expecting a telephone call about the script he had written, and just delivered, after his writers' seize-up in the wake of *Hillsborough*. Happily the call came, the news was reassuring and we could both enjoy the rest of our properly one-sided conversation....

'Since January I've been working on a film about a lad who grows up on Merseyside in the early Thirties. Its an independent commission from an old mate of mine for the BBC. At the moment it is called *Liam* and is about him. That's only a working title, it might change. I have done a first draft and I was very nervous about it. It was meant to be an adaptation of Joseph McKeown's *Back Crack Boy* but I found I couldn't adapt it. McKeown died a couple of years back. And yea, his novel is quasi-autobiographical. I found the only way I could use it was to put my own quasi-autobiographical slant on it. The original was dole queues and the political unrest of the time and the central character was a streetwise young boy. The only way I could adapt that was to make him a shy boy with a bad stammer. The spine of my story is that the seven-year-old Liam has to make his first confession and take his first Holy Communion. And everything that happens round him is perceived through his eyes and his sister's eyes.

'It is about 100-minutes long so I think it should be a one-off film rather than a serial. It is a strange departure for me because I couldn't be the man who wrote *Cracker* and had that kind of pessimistic, black view. It doesn't fit in with my need to be an angry writer, no, that's why I was so nervous about it and appreciated that phone call so much. This had to be an almost enchanted view of the world. Because it is all filtered through the consciousness of a child I couldn't be explicit in any way. It couldn't have the dark wit of *Cracker* and other things... 'I am fascinated by Asians today because they are the Jews of the Thirties. They have the same social and economic pressures as the Jews did then. In the Thirties the man who comes round with the loans and the pawnbroker are Jewish. This'll make me sound fascist and racist which I am really not... There's a Catholic man who stands up in church because all the women have gone to extreme lengths to rig the kids out for Communion, the dicky bow and shirts and all that, even though they are poverty stricken. And this man stands up, with his very limited working class experience, and says 'The people who stand to profit from all this Christianity are Jews'. It is a problem isn't it? How you show the way fascism takes root. You've got to be

fair to the man who thinks fascist and yet at the same time this is evil. Also Liverpool was very sectarian still...

'There's a lot going on but as it is filtered through the consciousness of a child a lot doesn't register. The adults always speak as adults, there's no allowance made for the fact that he's a child. He sees a sexual act which fascinates him and horrifies him. That's probably the core of the film because he goes back to see the sexual act again and again and he cannot bring himself to confess it. And because you make a bad first Confession it means taking Communion is a sacrilege. And if you commit a sacrilege and die you'll burn in hell for ever. So there is all this. Fundamental Catholicism, I grew up under Pius XII, he was quite reactionary'.

At the time of writing *Liam* is still far from the screen but *The Lakes*, produced for BBC1 by Charles Pattinson, did begin four-part transmission on Sunday evenings from September 14, 1997. As McGovern describes him the hero Danny Kavanagh (John Simm) is 'just a lad who goes to work in the Lake District and comes across this community where things are happening. It's more social than political, definitely social. He's an alien, a townie, an urban scouse working class lad who goes to work in a small, enclosed rural community. He is almost 21, heterosexual, white, Catholic and a gambler.

'I think what starts the ball rolling is that places like that need tourism but they hate the people it brings in it's wake. So you get an old Lake District family that has struggled to bring up daughter Emma (Emma Cunniffe). They experienced hardship and they brought up their family and they have got this beautiful young daughter and they've got plans for her. And some scouse scully comes along and marries her. It's just 'Oh, God'. They thought they were safe in the Lake District from the urban filth of Manchester, Glasgow, London, Liverpool, and lo and behold tourism brings them in. And the local girls find the local boys boring because they have lived in this community all their lives. And the city lads come along and think they are fly boys... I'd always had plans for this. I was trying to do amendments to it right through *Hillsborough* but I found I couldn't, though in a way the serial is another legacy of Hillsborough'.

On air it was soon clear that the rites-of-passage drama, whenever parts of it were first put on paper, was material McGovern had been carrying round with him since he was in his early twenties. Between school and teaching he had been a bus conductor, had worked in car and chemical factories and had tried the life of a skivvy in a Lake District hotel. It was from there that he took his wife Eileen back to Liverpool. One thing that these jobs had in common is that they were entirely uncreative and left a void in young Jimmy's life. To fill the void he became an addicted gambler, capable of blowing his entire weeks' wages on a Friday afternoon. After his early marriage, as he has confessed to the public prints,[4] this was 'cash that your wife and kids ought to have had'. As McGovern sees it 'gambling destroys lives, it causes more damage to British homes than any other addiction' and 'that's why I wanted to write about it'. In his case he was cured through creativity, writing filled the void in his life. For Fitz and young Danny no cure is in sight.

4 Stuart Jeffries 'The Sinner Repents' *Guardian* 22.8.97

Though *The Lakes* turns into an entirely fictional tragedy its first episode is so packed with autobiographical content that, in my mind anyway, Danny becomes Jimmy. Though actor John Simm comes from the Manchester area and does not strive too hard to match the McGovern accent he even begins to look like Jimmy. And, apart from the factual similarities in the young lives of Jimmy and Danny, there are the customary McGovern concerns about guilt, blame and responsibility, leading from bereavement, the moral dilemmas of priests and the stereotyping of Scousers.

On screen there is some questionable use of music, specially at moments crying out for natural sound, but otherwise accomplished direction by David Blair and superb acting all round ensures an increasingly gripping result. Moving on from the hotel Danny takes a job looking after hire boats beside the lake. The tragedy unfolds as three young schoolgirls snatch a boat, while Danny is on the phone to a bookie, and drown. After this the part two pace naturally slows and there is an effective but uncharacteristic use of silences. The pacey part one bubbles with frothy wit and McGovern's delight in language and literature. Danny gets to quote William Blake's *The Sick Rose* and for comic relief has a nicely arranged chorus of colleagues from the hotel kitchen – one afflicted with the McGovern stammer, one constantly seeking a cure for premature ejaculation and the third speaking in stage directions.

Though Blair was obliged to shoot in an Anglican church McGovern set the drama in a Catholic enclave. Father Matthew, played by the same Robert Pugh who was the daughter abuser of *Priest*, is subject to the kind of human frailties expected in McGovern drama. He is smitten by his most devout parishioner, Emma's mother Bernie (Mary Jo Randle). The episode one confession box scene where they talk of how they tempt one another, without confronting their mutual attraction directly, is a small masterpiece of writing, acting, lighting and direction. It is intimate, infinitely touching, quintessentially television. It shows as well as anything that Jimmy McGovern is a dramatist who really does write television.

5 I was so excited, typing away

Lynda La Plante

What was so wonderful, and why Verity Lambert and Linda Agran did so much for me as a writer, was that they never broke my energy. And they never broke my confidence. What they said was 'Go away and write the first episode and if it ain't any good you won't write it'. But 'Go away and do it, have a go at it'.

Why do so many of the best television dramatists come from Liverpool? 'Because it is predominantly Irish and there is in Liverpool that sense of humour, it's always there, that repartee that goes on', is the characteristically simple and direct answer of successful writer Lynda La Plante. Her own Scouse credentials may be a bit suspect but even Warrington is near enough for at least some of that native, wry Merseyside sparkle to have stayed imprinted on her style. And if she does not sound even faintly like inner city lad Jimmy McGovern she readily admits: 'I was like lower middle class and at fee paying schools. For us there was that thing in Liverpool, "My daughter's not going to have a Liverpool accent". You had that sort of not quite accent. Then I met the mentor of my life, who was my elocution teacher...'

When McGovern agrees to talk to an interviewer you are invited to his comfortable, modestly proportioned house. He has that Irish way of suggesting he has all the time in the world for you, never stealing a glance at his watch or dropping hints that he has more important things to do, people to see. A meeting with La Plante has to be arranged through her willing but hard-pressed assistant Liz Fourburn who does not disguise the truth, that gaps in the La Plante diary are very hard to find. Several weeks later, when you are admitted to the swish Wardour Street office of La Plante Productions in London's Soho, it is clear that you have to be squeezed between two more vital meetings. This is not affectation. La Plante is her own chairperson, managing director, producer and researcher.

She really is a workaholic with no time to spare. In person she is smiling and welcoming, clearly fun and good company for anybody who can stay with her, and she talks fast and without inhibition. When Fourburn knocks on the door to tell the boss it is time she was somehere else La Plante talks on for a bit and makes you feel that she would much rather chat on but...And in a flash she is gone.

In her television drama La Plante has, for the most part, locked herself much more securely in the cops and robbers, or crime and punishment, genre than the more obviously individual McGovern. She works through research rather than imaginative leaps. She feels responsibility for those she employs and therefore stays within an area from which she knows broadcasting executives will buy. If she shares any of McGovern's anger about the way things are she mostly burns her own smoke. Yet her most famous character, Detective Chief Inspector Jane Tennison (Helen Mirren) of Granada's *Prime Suspect* (from 1991), may in some lights be seen as the obverse of Bobby Grant and Fitz. Where the McGovern characters felt belittled as men struggling against the knee-jerk correctness demanded by new age feminism so Tennison was introduced as the archetypal strong woman fighting to progress in the teeth of the hostile, male chauvinist, police locker room culture. In short McGovern spoke up for the oppressed white, working class male and La Plante for ambitious women in a men's world.

She was born Lynda Tidmarsh in March, 1946. Despite suffering from what was not then recognised as dyslexia she looked back in her fiftysomething maturity on an 'incredibly happy childhood'. Her 'word problems' were 'very frustrating' but 'I always felt like being two people, it didn't particularly upset me, I didn't worry about it and I lied'. In popular music there is the 'garage band' phenomenon – young, would be rock musicians who rehearse in garages because they are the largest available space where loud noises can be made without too much disturbance of neighbours. As a child Lynda Tidmarsh was a garage dramatist.

'I wrote scripts from early on. My father used to keep one, I wrote for Garage Productions, in his wallet. He had this extraordinary piece of paper, my play. A play that nobody could read but me because it was all back to front. At one time I played with a girl called Jane, we'd be about eight, and she said "My mother has got a whole, big basket full of costumes". So we pedalled over to Jane's place and found the basket was the size of a skip and full of these wonderful costumes. I took some home and cut all the hems off so that my production could cover different periods. And Jane's mother called and said "I'm very, very worried, I had lots of costumes for the local amateur dramatic production of *Camelot* and they've gone. You wouldn't know if Jane or Lynda took anything from the skip would you? Nobody could believe I'd done it. All the mothers had to spend the entire night sewing up the amateur dramatic costumes.

'After that nobody said "You should be an actress, you should be a writer" but I always wrote. And at 15 I went to RADA (Royal Academy of Dramatic Art), the youngest student ever to go there. I was far too young, it was a nightmare, but I learned. Until then the only professional production I'd ever seen was of a Brian Rix farce. It was only when I saw *Romeo and Juliet* at the Old Vic that I suddenly realised that acting was not just standing on a stage talking to yourself'.

With her new acting name of Marchal the highly rated young Lynda graduated to play in most of the best English provincial repertory companies. 'I spent a lot of time at the Liverpool Playhouse with a fantastic director called David Scase. Around the time of Terry Hands at the Everyman. It was a wonderful period for acting with Tony Hopkins, Susan Fleetwood, an exceedingly strong group of actors and actresses, very competitive, very exciting, we did tremendous work. After this it was very frightening to leave the security of continued employment and even more frightening to come to London. Where you'd be asked what you'd been doing and Ibsen and Chekov at Liverpool, Bristol and Birmingham meant nothing'.

Lynda Marchal's efforts to join the National Theatre, the Royal Shakespeare or any other London-based company proved fruitless. Then at last she was asked to read for Snoo Wilson's *The Soul of the White Ant* and, after the first choice actress had dropped out, was invited to play the female lead in a cast that also included Simon Callow and Nicholas Ball. Though limited to the fringe theatre the reviews 'tipped me into moments of glorious best actress fame'. Suddenly the Royal Shakespeare was bidding for her services in Eugene O'Neill's *The Iceman Cometh*. Television casting directors remained less impressed...

'On television I was constantly cast as a prostitute, that is all I ever played. The process of television casting is so strange. You could be playing Ophelia at the Royal Shakespeare, or starring as Hedda Gabler at the National, and when you went up for a television part they would say 'What have you been doing recently?' and invite you to read the two-line part of a prostitute from Liverpool anyway. I was divided because I was allowed as a stage actress to be "stretched", as they say, but on television, because I didn't physically look right I suppose, because I suppose I looked like a whore, that's what I got offered'.

Through this period Marchal retained the writing habit. She wrote a couple of locally produced theatre plays but 'they were so slaughtered by the critics that I kind of shrank back and said "I'm not a writer, I'm an actress"'. Having been discouraged in her efforts to find television or cinema work she never thought of writing for anything but the stage. Until in her mid-thirties she took her usual prostitute role in London Weekend's *The Gentle Touch* (1980-84). In a scene with the star of the show, Detective Inspector Maggie Forbes (Jill Gascoine), she had to answer the line 'We really should talk, woman to woman, call me Maggie' with the nearly unspeakable reply 'All right, call me Juanita'. Nobody knew why she was called Juanita and whenever they reached the scene both players collapsed in giggles. 'It was at this show that I said to her "I wouldn't mind trying to write something better" and Jill said "Go ahead and do it". I asked her "What do I do?" and she said "Well, you write a sort of treatment and send it to the script editor". Then came one of my downfalls. If you submit an idea you shouldn't really create a starring role for yourself, they've already got the star. Every single treatment that I sent in was rejected because I was so obviously writing these roles for myself, just like with Garage Productions. But one of my story lines, called *The Women*, came back with "This is brilliant" scrawled across it. It was probably a cleaner, I don't know, but that funny little scrawl was encouraging'.

She adapted her stories for BBC1's Ian Kennedy Martin created rival show *Juliet Bravo* (1980-85), in which Inspector Jean Darblay (Stephanie Turner)

was the woman officer commanding an all-male police station. And again her efforts were rejected, but she did begin to find her own method of research. 'I wrote about criminals and prostitutes because I played hookers on television. And suddenly I went out to meet a prostitute, something I had never done as an actress. It is something I should have done as an actress but it was only when I became a writer. It became the kind of process I used when I started work on the first *Widows* (1983). That idea came from a prostitute and a woman I worked with on the market, when "resting", and it is what I sent to Verity Lambert at Thames'. By this time Lynda had married her long term partner, the American heavy metal singer turned karate expert, boxing coach and novelist Richard La Plante. So the *Widows* treatment was first submitted to, and rejected by, London Weekend and then sent to Thames as coming from Lynda La Plante, her third name and the one with which she achieved her writing fame.

For Thames, and its Euston Films subsidiary, the timing was just right. The ITV company was known for its male-orientated, not to say macho, dramas like *The Sweeney, Van der Valk, Out and Minder.* Yet by the early Eighties it was being run by two women, Verity Lambert as overall boss and Linda Agran as head of scripts and development. In 1981 they had produced John Hawksworth's seven-part adaptation of Elspeth Huxley's novel *The Flame Trees of Thika.* This had opened their eyes to the possibilities of stories about women and Lambert, in her own words, 'put it about that I was looking for something with a woman protagonist'. Almost straight away 'I got the first *Widows* treatment from Lynda's then agent, and I just thought it was wonderful. I gave it to Linda Agran to read and she agreed with me. The only thing that worried me was that in the first treatment the widows didn't get away with it'.

The basic story concerned four women, three of whom were suddenly widowed when their husbands were killed in the car chase that followed an abortive robbery attempt. The women, mistress-minded by the formidable protagonist Dolly (Ann Mitchell), then decide to make use of the ledgers left by her husband Harry and containing a guide to what could be a robbers' fortune – ledgers being hunted by both the police and rival villains. In pursuing the guide the women proved at least as effective as their late husbands and it seemed right to both Lambert and Agran that they should win through. 'They'd worked very hard and got it all planned – why shouldn't they get away with it?', as Lambert put it. La Plante was initially hesitant about the morality of this and wondered whether the ITV regulators (then the Independent Broadcasting Authority) would allow such a result. But Lambert and Agran agreed they would not want to do the serial unless the ending was changed and La Plante agreed. Though, in memory anyway, none of them were thinking at that time of a second series. What happened next is best recounted in Linda Agran's words...[1]

'Well, Lynda came in and claimed she couldn't write. She said her idea was a six-parter and she outlined it again. She's an actress who has written little bits and bobs but certainly nothing as ambitious as this. And she said she could probably write the first one but after that she wasn't sure. So I said, well I'll

1 Manuel Alvarado and John Stewart *Made For Television, Euston Films Ltd* BFI 1985, page 106

commission the first script and if it's any good I'll commission the remaining five. And then you'll have to do it unless you want to be really embarrassed and start returning the money. So that's exactly what happened. The first one came in and it was terrific – I mean it would probably have run for about two hours – but it was terrific. It had great energy. So I set her off to write the remaining five and I realised that if I held her up – because its quite complicated in terms of its structure – if I gave her any rewrites at any point I would hold her up and she'd have to go back and start writing again and would probably get lost. So as she delivered the first drafts I would say, "Terrific, terrific, keep going". And she'd go "Nothing...?" And I'd say "No, just keep going, just great". And so when she worked right through we had this huge file, this big, and then I said "Right, now we'll start again". So she and I virtually locked ourselves away and went through it and I remember picking up the phone in the middle of the night and saying "Listen, how the hell did Harry know, etc" because it really is quite complicated'.

In production the serial became, as Agran puts it, 'a real labour of love... It was lovely casting blokes to do bits on the side. I used to fantasise with Lynda about having casting sessions with blokes – telling them to take their clothes off, you know, but of course we didn't do any of that... I think one of the reasons that *Widows* was as successful as it was, was that it was the first time women – real women if you like – were in the front, driving it on, casting the right way, looking the right way. And written the right way. You see the problem with series writing, and the problem with a lot of the differences between men and women and the way they're perceived and they way they're portrayed, is that male writers can't write women – or they think they can't so they tend to avoid writing them. So they write a lot of men because they understand blokes and they know how they work and they don't want to get the women wrong'.

Through the Sixties and Seventies a running criticism of British television drama had been that the majority of female characters only existed in relation to males. Now at last the pendulum was beginning to swing in response to the prevailing feminism of the time. By the end of the Eighties the drama norm, even in work where the male still nominally ruled, was strong women and ineffectual or confused men. As it now came about Lynda La Plante and her mentors, Verity Lambert and Linda Agran, contributed as much to this movement as anybody.

'What was so wonderful, and why Verity and Linda did so much for me as a writer, was that they never broke my energy', as La Plante now says. 'And they never broke my confidence. What they said was "Go away and write the first episode and if it ain't any good you won't write it". But "Go away and do it, have a go at it". They knew I hadn't any experience of writing for television at all. So I worked away. Now I was with the police, now I was in the prisons, now I was with the prostitutes drinking tea, now I was in the Thomas a Becket pub talking to the husband of my market stall friend and he was saying "You remember that one where he was feeding the bodies to the pigs..." And when I was not researching I was so excited, typing away. I had no idea that my first episode, which should have been an hour, was six hours long. Verity says to me "Fantastic, let's see number two" and Agran says "Great, bring on number two". And I was so enthusiastic and they're eventually getting about 25

hours of film. And I thought "I'm finished, my problems are over, I've done it". Then comes the process of editing, I had to watch them hitting that script. Verity Lambert has a genius eye for seeing what needs to be done and she knows how to explain this without making the writer feel diminished. One day, for example, she said "Your lead woman Dolly Rawlins, did you intend to lose her for 42 pages?" Not "This has to go, that's out". She has this patience and I was very fortunate. That's where I learnt my writing trade. Thank God I had her to guide me through, without Verity I would not have the career that I have'.

The first *Widows* six-parter, produced by Linda Agran and directed by Ian Toynton, was transmitted on the ITV network from 16 March 1983. During pre-production the Thames hierarchy were largely supportive but Agran also noted a fair degree of scepticism amongst her colleagues... 'People used to say "Oh, it's about women. Nah, won't work, people won't watch it...women won't watch it because they won't be interested enough and it will turn men off because they won't want to watch a lot of heavy dykes holding up a..." And it was interesting that they were proved to be absolutely wrong. Women loved the show'. And from episode two onwards the audience built to the point where a second series became more or less unavoidable. *Widows II* (1985), another six-parter with La Plante scripts, took up the story as Dolly Rawlins and her gang departed for Rio in search of her husband Harry and a life of ease and luxury. That showed more basic energy than the six-part *She's Out* (1995), in which Dolly has completed an eight-year jail term and goes in search of the hidden diamonds that could make her a multi-millionaire.

For Lynda La Plante the seven-year gap between *Widows I* and *Prime Suspect I* was extremely frustrating... 'In those seven years I must have had about 20 commissions, that's what I lived on. They were all television, invariably the same plot was required – variations on *Widows*, nothing was ever done, everything was shelved', she remembers.

Among the shelved series was *Civvies*, her powerful account of redundant paratroopers finding violence as readily available in civilian life as it was in the Army. She wrote six hours of this and it lay about on BBC shelves for the best part of three years. Only after the success of *Prime Suspect I*, instantly making La Plante the most marketable of women television dramatists, did the BBC come back to her. 'Doors began to open, one of them that of Ruth Caleb at BBC Wales. She called me in and said she would like me to write something for her and I said "Well, you know you've already got a series of mine on the shelf". So she took it off the shelf. I said "It has a very different ending now and it is a very different show, so much has happened to the original people it was based on, but I would like to go back to them and rewrite it". And that is how the six-part *Civvies* (1992) was done, piggy backed on *Prime Suspect*. Everything in my present writing career was piggy backed on *Prime Suspect*.

It cannot be claimed that Granada's *Prime Suspect* was exactly breaking new ground. It was in a sense picking up where the Eighties shows, *The Gentle Touch*, *Juliet Bravo* and indeed *Widows*, left off. Though it did so with an extended, pungent realism, and high production values, quite beyond the range of those earlier women cop shows. La Plante remembers how it came about:

'I was out of work and desperate. The success of *Widows* had not set my career upwards. In a way everybody was offering me commissions if I did another *Widows*. "What about four bank tellers and their husbands die in a car crash and they rob the bank?", they would suggest. "I have done that", I would reply. I had spent seven years in this limbo and by the time I went to see Granada that time I was desperate. I went in there and the script editor Jenny Sheridan said "We are looking for big dramas". So I said "Oh good, I've got one". "We really want another police show", she said. "As it happens I've got one", I repeated. I had absolutely nothing really and was trying to feel "What do they want?" I said "She's a policewoman and very tough". She asked for a title and I said *"Prime Suspect"* just like that. She said they were interested and would I send the treatment...

'After this I rang the Met and said I was very interested in meeting high ranking women police officers, not in uniform. They said "Oh yes, we've got a lot of them, no problem". I later discovered that the Met then had just four women Detective Chief Inspectors, just four. I asked to meet one of them and into my life walked my Jane Tennison. I tied myself to her for six months and was very fortunate, Detective Chief Inspector Jackie Malton was an extraordinary lady. She took me into forensic, pathology and suddenly the world was opening up again and I was putting it on the page. It was an astonishing way to work. I kept my eyes open and as with *Widows* I felt I had a safety net. There is no question that Jane is the most successful character I've created. I get very emotional about anything of mine, every character I create, but Jane is the one who opened doors for me'.

'And Jenny Sheridan?' – 'Yes, without her there would have been no *Prime Suspect*. Its extraordinary the belief she had in it when, up to a point anyway, the rest of Granada did not share her belief in it. They felt the character was too strong and she was the one who kept answering them "It's real, it's real". And so it was. Its model, DCI Jackie Malton, has remained a constant support and now checks every police script that I write'.

The award winning *Prime Suspect I*, in which Tennison conducts a murder inquiry in the teeth of male sex discrimination ranged against her, was a four-hour drama transmitted by ITV on the consecutive evenings of 7 and 8 April 1991. Two years ahead of *Cracker* it introduced an extended realism to the police fiction genre, even stronger on squalor than violence. Here, it was soon clear, Jane and her similarly fallible subordinates would pursue serial killers, multiple rapists, child stranglers and the like through society's underside. Big on police procedure the new formula is also credited with being the first to introduce the autopsy as an obligatory feature of police methods in the wake of murder. Don Leaver produced, Christopher Menaul directed and Helen Mirren's tough, ambitious, vulnerable Jane was supported by a cast including Zoë Wanamaker with Tom Bell, John Benfield and John Bowe as the leading men.

The production quality was maintained with *Prime Suspect II* (1992), where Tennison commands a still more difficult inquiry after the exhumation of a skeleton is followed by a detailed, on-the-spot forensic discussion. This time La Plante only supplied the story line and characters before acting as script adviser. High ratings quickly convinced the Granada accountants that there was clearly a market for as many more of the dramas as Helen Mirren was able and willing to perform. The formula became an annual event, despite an even-

tual rift between La Plante and the production team, with *Prime Suspect V* reaching the screen in the autumn of 1996.

Lynda La Plante is the first to recognise that it was this continuing formula that helped her to the fame she now enjoys. But sadly it was *Prime Suspect III* (1993) which also brought her to the realisation that even television writers in demand are liable to be regarded as outsiders once they have delivered. In her interviews promoting the show Helen Mirren made it plain that she did not personally feel much sympathy for the character of Jane: 'I don't like her brutality, I don't like her extreme selfishness, I don't like her job'. Tennison, she observed, 'walks on men and uses them, just as men often do to women'. Such remarks merely recognised the truth. What really hurt La Plante was the lack of respect shown to her before and after the launch and transmission of the show.

In the story Tennison is transferred to the Soho vice squad and ordered to revive 'Operation Contract', targeting the under age sex trade in London's West End. She despatches her lover back to his wife and makes an uneasy truce with her old adversary Detective Sergeant Bill Otley (Tom Bell). More difficult is the battle against the prevailing police homophobia and the feeling of a need to protect men in high places from a too thorough 'Operation Contract'. When the four-hour production was shown by ITV, on the consecutive evenings of 19 and 20 December 1993, it was clear that the script had been as conscientously researched as any previous La Plante screenplay. What was not so obvious were the changes made without her approval by director David Drury and producer Paul Marcus.

'Writers are very, very abused', she told Andrew Billen.[2] 'What made me particularly angry about *Prime Suspect III*, particularly, was how could they take the original prime suspect and say he was innocent. It meant Jane Tennison's original police work was flawed... Without even consulting me? And casting another actor in the role of the suspect? Killing off his wife? You think "How can they do this?". It is the cheapness'. But it was what happened later that she saw as the last straw leading directly to her decision to form her own La Plante Productions...

'It was one of those stupid things. I had a very emotional, sad time doing *Prime Suspect III*. The starting point of the script was a woman pointing to a man and saying "Well, of course, he's homosexual isn't he?". I had to answer her "He's not actually, he is a transexual". This led me to think about the confusion. So I just started on that. And then I met all these rent kids and particularly one little boy, a very chilling little boy of 12, and I was with him when he came out and was told he had got full blown AIDS. He said to me "I thought I was too young to get it". I was very upset and asked if he would now go home. He said "No, I'm going to fucking give it to every fucking bastard I can". Suddenly he was an unexploded bomb, he was lethal. You saw the weeping sores on this child and had the strange emotion of feeling so motherly towards him and then suddenly wanting to back away from him.

'So it was a hard time writing that one and, whatever the changes, I felt incredibly proud when we won the EMMY again. It was astonishing to be embraced by America as well as everywhere else. I went to the EMMY The-

2 The Billen Interview, *Observer Life*, 10.3.96

atre and was holding the award as we came down the steps. Then the Granada people abruptly told me that the award did not belong to me but to the producer. Sally Head, the executive producer, actually snatched it from me. She had one in one hand and used her other hand to snatch the award and give it to Paul Marcus. If they'd had the generosity of spirit to say "Let her have it for tonight, you can take it off her later" I would have felt less aggrieved. But they didn't. It just hurt so much, it was as if everything that I'd just done was nothing, as if I didn't own *Prime Suspect* at all. And it was at this moment I saw how easy it was to dismiss the writer and told myself very firmly "This isn't going to happen again".

'What made it doubly hurtful was that I had already conceived the future of the character. I had bought the story of a female commander and I wanted Jane to go up and up and up the ranks, so that she would look to be unstoppable, and then she'd hit the glass ceiling and they would destroy her. She would have ended up like Deputy Chief Constable Halford, the woman high flier destroyed by male power. I had all this carefully constructed in my mind when suddenly I was told that Granada wanted a much more commercial product. I hate to sound as if this is sour grapes because I am very aware that *Prime Suspect* has changed my life. I think it changed everybody who was involved in it. So I will be for ever thankful to Granada, to Sally Head, to the wonderful first director Chris Menaul, we created something very special between us, but...'

As La Plante consequently set up her own company she was far from being short of other commissions through the early and mid Nineties. For Ruth Caleb and BBC Wales she followed up *Civvies*, violently criticised by those who refused to believe that former paratroopers would behave so badly, with the less contentious or effective nine-part *Lifeboat* (1994). She wrote *Framed* (1992) for Anglia, *Seekers* (1993) for Central and most resoundingly *The Governor* (from 1995) for London Weekend. Best of all was a haunting and rare single screenplay, *Comics*, the true story of a man unable to leave behind a suicidal drowning that he had witnessed when he was young.

La Plante's prison formula, *The Governor*, was built round tall, statuesque and eponymous Helen Hewitt (Janet McTeer). She had a lot in common with Detective Chief Inspector Jane Tennison, being a lone female in a brutal male world, a dominating figure gritting her teeth to avoid signalling vulnerability, coldly dismissive of colleagues who have yet to earn her respect. The first six-parter, opening on ITV on 14 May 1995, did not entirely ring true. As Governor of HMP Barfield the cool Helen, with her one-dimensional prickly relationships, did not develop. La Plante was as meticulous as always in never including incidents which had not occured in real life but the method of reproducing such happenings did not always convince.

The second six-parter, opening on 23 March 1996, was more obviously certain in its intentions and execution. More of Helen was revealed and La Plante generally provided a timely if unwelcome picture of a prison system close to boiling over. In doing this she became very frustrated about having to fudge language, in particular the constant real life use of the word 'fuck' and its variants. If Billy Connolly was permitted authentic, expletive-spattered speech patterns in his comedy routines, she reasonably asked, why were they censored in serious drama? She hit on an editing method which allowed the actors to speak naturally but not to be heard doing so by the audience. 'I didn't want

to stop the actors' flow. So I avoided all those "flippin hecks" and the ridiculous "frigging", which you know these hardened criminals would never use, and I squashed the line so that although they were saying "fuck" and the rest it was not coming out'.

This proved acceptable but La Plante was also forced on to the defensive about her use of violence, in particular a sequence of the series two opener where a prisoner repeatedly smashes the face of a 'screw' on the edge of a wash basin and so breaks his nose. It was this, she believes, which caused ITV to axe the show after the second series. Quite unreasonably as she sees it. 'You can see somebody breaking somebody's nose at virtually every football match, at every boxing match most certainly. You can see it in Soho. To me it is not a terrifying act of violence but there was an outcry about that scene. Nobody asked if this had ever happened to a prison officer: it had and in the true story the hostage prison officer lost his marbles. It seems we are accustomed to rape on television. Not a single complaint came in about the rape of the drama teacher in the series but shoals of appalled letters came in over the incident with officer Russell Morgan'.

As she endeavoured to fit her perceptions into the prescriptions of her genre, and the marketing men who had come to control British television, La Plante had become more pessimistic. 'Oh God, the television drama scene is in a terrible state at the moment. The BBC people take longer and longer to make up their minds about a project and there is almost as much dithering around at ITV. A classic example was that I bought ten books by the mystery writer Ann Perry and took them as a series idea to the BBC. They were very excited by this but kept changing the length of the pilot episode. I submitted, I think, ten different scripts for episode one. During this period the true facts about Perry were emerging, that she was Juliet Hulme of the movie *Heavenly Creatures* and had been in prison for murder. The BBC people were completely unaware of all this and when they did catch on it was too late, the options had run out and had been bought elsewhere. That was two and a half years of indecison, a waste of money and a waste of time. People in one office never know what people are doing in another office'.

Lynda La Plante is a workaholic quite capable of locking herself away with her computer from 5.30 am until well into the evening and forgetting to eat. Her work rate was the reason for her 1995 divorce, after a partnership lasting 23 years and a marriage of 18 years. She credits Richard La Plante with giving her the confidence to achieve what she has. She regrets his departure, and that she was unable to have children, but understands that he needed to get away from a life dominated by her work. Specially when her work came to include care of her employees and the actors and directors she casts.

How does her system now work? 'Each project takes a considerable time so I can be working at the office on one and researching the next. All being well my next production on screen should be *Trial and Retribution*. In the build up to the writing of that I spent two hours every day in the courts. I banked myself up by watching defence lawyers, the prosecution and the rest. Nowadays I also employ a permanent researcher to cover my back. When I have written I have three very good editors to bounce off. There will probably be ten to 12 drafts before we show anything to anybody. So the edit period for me is very lengthy, cutting, reworking, rewriting until we have done.

'You probably spend two years writing a stage play. Television writing is a faster process, so you must leave yourself open to criticism and discussions of the script... I choose a director and keep my finger on all the casting as long as she, or he, agrees. I have Steve Lanning as line producer, a man of tremendous experience. He will assemble the crew and use the same costume and set designers, forming a family that move from production to production. By the time the director is on the floor I don't go anywhere near the set. I feel there should be only one governor on the set and that is the director. The only time I will go on the set is if there's a major problem, an actor has had a nervous breakdown or something. I have the rushes every night. If there is something I'm unhappy with I talk to the director directly. And then we go to edit. I do spend a considerable time in edit, it has been a learning process over the last two years. Now I look at something and say "Oh my God, why did I write those five extra lines, it doesn't need them". It is a wonderful process for a writer because you see how you put energy into a scene as you edit. You may spend months on scenes one to six before you realise that scene six should have been following scene two. So you have to be very open to the production group and the expert advisers'.

La Plante has been critical of other shows, particularly Jimmy McGovern's *Cracker*, because of their failure to get police procedure just right. 'Fancy allowing that drunken, fat Fitz, in his Armani jacket, to interview suspects without a lawyer present', she will say. Her *Trial and Retribution*, covering a single child murder from crime to trial verdict, makes a determined effort to be accurate on the latest police methods. This is as important to her as the innovative split screen technique, developed with 'talented, dedicated, calm, supremely artistic' director Aisling Walsh, to show simultaneous police and legal work in different places.

This does not mean to imply that all is cool and detached. 'As I see it *Trial and Retribution* has some very draining scenes. Certainly it was draining to write, draining to produce, draining to film, draining to act. It has 85 actors in all, two two-hour segments for ITV. A big show but the police interviews are crucial. These days everything is taped to try and prevent miscarriages of justice sneaking through. The days when you could have a *Cracker* attack on a suspect are gone because immediately the evidence would become inadmissable. The police have all been trained in methods of interrogation which are softly, softly, quietly. I asked an officer "When you're interviewing somebody in this slow process at what point do you have a suspicion that you have the right person". He said "I concentrate on the eyes and gradually they form a pattern which tells; if he has something to hide the eyes will deflate". So we homed in on that and we use eyes a lot. Right from the start. You don't see whodunnit, you see as much as the eye witness saw, you are the eye witness. Then after the crime you see the spider effect, how it effects all the characters you are getting to know, how the waves of professionals become involved, how the murdered little girl loses her name to be labelled a victim, how the jury responds...

'I explore how emotional the 12 jury people can be and the drama ends with the verdict. When we shot the trial no jury member had a script, no jury member had any preconceptions, they just came in as fresh extras. We canned the trial as a continuous action like a play and kept a camera on them as they watched. In the end the verdict was mine but the story was based on a real case and then distorted to that it could not be identified'.

In the event *Trial and Retribution* was stripped by ITV over two evenings, Sunday and Monday 19 and 20 October 1997, and proved to be a triumph. It perpetuated the squalid turn of police fiction set up in the early Nineties by *Prime Suspect I* and *Cracker* and which has since permeated almost all original television drama down to the most humdrum detective and doctor constructs. The London borough of Newham was shown at its least salubrious, the texture of gloom intensified with lots of rain. A bare minimum of humour was as dark grey as the high rise estate which was the main location. But in terms of its capacity to grip the viewer and then screw up the tension this was La Plante's most effective drama since *Prime Suspect I*, certainly the best thing she had done as an independent producer. The dysfunctional family background of the five-year-old girl victim, the blighted life of the murderer, the by-the-book precision of the police investigation, the responses of carers, neighbours, cops and lawyers all rang true. Director Aisling Walsh turned out to be as good as La Plante thought she was, her use of eye contact and split screen effects actually pushed out the boundaries of the genre. Nothing is perfect but with this as with everything else she has done since the Garage Productions of her childhood, Lynda La Plante could never be accused of laziness in the matter of getting things right.

6 · Designated trouble maker

Alan Plater

One of the things it seemed to me right and proper as President was to spell out what seemed to be happening in our industry, particularly to regret the erosion of the individual voice, which is really the only thing that matters in the long run.

Conscious of his sixtysomething years and of the stereotypical attitude associated with people of his age, constant complaining that everything is getting worse, Alan Plater has adopted the disarming habit of describing himself as an ODBOF. That is an Officially Designated Boring Old Fart. There is no justification for this. Those who observe that policemen are getting younger are talking about themselves not the policemen. Of all the television dramatists, who have left a strong impression over the last 35 years, Plater has been the least self-preoccupied. Whether as a committee member or President of the Writers' Guild of Great Britain, or simply as a lone voice, he has spoken for all who toil in his trade. In lectures and print articles, at conferences and seminars, at home and abroad, he has said things that badly need saying. If one of his creations is badly treated, or not treated at all, by obtuse executive decision he will whinge as furiously as any other member of his craft. But, famously generous in his catholic recognition of other talent, he has mostly spoken of ideas to benefit all. And more often than not the 'all' has included viewers as well as writers.

There is a case for arguing that a trades union for creative writers is a contradiction in terms. When President Plater finished his term of office at the Writers' Guild, in early 1995, a count showed a paid-up membership of 1,708. That presumably meant 1,708 points of view about the best way forward. And at least 1,708 more individual ways of looking at the world among professional writers who declined to join. If writing teams on the American model become the norm here, sitting together in offices and churning out conveyor belt drama to the prescriptions of all powerful producers, the organisation of a strong union for television dramatists should be easier. Such a surrender of imagination and independence is the last thing Plater would ever advocate. The Guild he led managed the practical functions of dispensing useful advice

and, as far as its weak bargaining position allowed, negotiating at least some improvements in fees and conditions. Just as importantly he was able to use the extra authority given him by the Guild to challenge the destructive ways, and often impenetrable jargon, marking the new breed of chairmen and executives who stole the commanding heights of broadcasting on the back of the Eighties market forces dogma unleashed by Thatcherism.

As a speaker and a polemical journalist his dry, wry wit was much less highly coloured and attention grabbing than the vivid rhetoric of Dennis Potter but the precision of his arguments was just as impressive for all who had ears to hear. His rare quality and value as a provider and advocate of imaginative television drama made it all the more depressing that by the autumn of 1997 he had virtually given up hope. 'I don't mind doing a bit of carpentry for the BBC, like the *Dalziel and Pascoe* adaptation I am working on just now, but anything original I will do for the theatre or cinema', he told me. 'We have reached the point where it is easier to set up a cinema movie than a television film or series. I have just been sent a lovely autobiography by a man who grew up, like me, in Hull. Once I would have taken it to David Rose at BBC Birmingham and he would immediately have spotted its potential. Now, supposing you could capture somebody's attention, it would be thrown back for being short on detectives and doctors'.

Bouncing off an assertion by his actor friend Alan Rickman, to the effect that 'We are the first generation since the war to teach our children less than we know', Plater once wrote[1] that 'we are the first generation since the war to hand on a broadcasting system with a narrower range of imaginative possibilities than we inherited. We've got a multiplicity of channels all saying the same thing and signifying very little; there are few opportunities for new talent and, incidentally, for existing talent: there's a denial of access to the richness and diversity that's out there on the streets; and there's less democracy'.

Alan Plater was not born in Liverpool. He went one better, he is a native of Jarrow, which also means Geordieland. Just as importantly, like so many of the writers celebrated in this book, a significant portion of his genes stem from Ireland. And his 1935 birth occured in the year before 200 unemployed men of his father's generation set off on their famous march from Albert Road to Downing Street and so etched the name of 'Jarrow' for ever on the heart of the political left.

'I was born in Jarrow and credentials don't come any better than that', as he told the audience for his 1993 LIRA (Dutch fee collecting society) lecture in Amsterdam. 'My grandparents lived in a trim terrace house with a backyard. There was no garden. My precious memories of childhood are of sitting in my grandparents' backyard listening to stories from my grandfather, an Irishman and a steelworker whose ring I wear; from my grandmother, who left school at 12 yet adored paintings and books; from my parents and from an assortment of aunts, uncles and friends of the family. The stories were about all manner of subjects: about war and peace, cats and dogs, ship-building and unemployment, football and greyhound-racing, the life and times of friends and neighbours. Some of the stories were sad and some were funny and

1 Alan Plater 'People's Showdown' *New Statesman*, 16.6.95

mostly they were both, at the same time. It often seems to me that most of my writing, during 35 years at the desk, has been a re-telling, with variations, of the stories I heard in my grandparents' back yard. Beyond that, it also seems that the proper, decent future for world television should be based on the very simple notion that I should tell you the stories from my backyard and you should tell me the stories from yours'.

Before British entry into the Second World War the story enriched Plater moved with his parents to Kingston upon Hull, otherwise simply Hull, and that became his home town. Today he feels obliged to live and work in London, in his spare time 'juggling with crazy projects, hanging around jazz clubs and willing Hull City to show some form'. He still thinks of Tyneside as his patch and, according to his second wife Shirley, whenever 'my foot hits the pavement of Northumberland Street my accent reverts back'. But it is the Hull City result, not the Newcastle United one, he anxiously awaits every autumn, winter and spring Saturday.

Like his fellow pupil and lifelong best friend, the actor Tom Courtenay, the young Alan was a scholarship boy at Kingston High School, now a comprehensive but then a grammar. He also won a scholarship to the posher Hymers College, where the sons of the fish merchants went. The crucial drawback there was the snobbish preference for Rugby Union over Association Football. He indicated his early good taste by choosing Kingston purely on the grounds that they played 'proper football, which is all I cared about as an 11-year-old'. He started there in 1946 but it was not until he reached the fifth form that he fell under the influence of the kind of inspiring English teacher who so many writers credit with sparking their vocation.

'It must have been 1951 and we had to do a homework essay on something linked to the Festival of Britain. I tried really hard with this, I wrote a little story and wanted to get a good mark. When the exercise books came back the master, John Large, read my story out to the class. It got a few laughs and it got my writing started. Jokes have been a fairly constant theme in my work since this discovery that I could make people laugh. Mr Large had a way of referring to people in the third person, he had a kind of Noel Coward self image and these days would seem a bit camp, and he did the trick for me. In one report he wrote "'This young man could possibly have a career in journalism or something of that sort". He also used to produce the school plays and, of course, quickly cast Tom Courtenay.

'Tom is younger than I am but we were part of the same gang, half a dozen of us, going through that wonderful period in mid to late adolescence where you discover Shakespeare and jazz and all the things your parents don't approve of or are a little nervous about. I think my parents didn't like the noise jazz made but, though I loved them very much, there was nothing else to rebel about. Until I saw Humphrey Lyttleton's band at the City Hall one Sunday night and Humph had those big long sideboards and I thought "I want to have sideboards like that". That used to bother my parents a bit, it's pathetic when you look back'.

Leaving school in 1953 he went back to Tyneside to train, at Newcastle University, as an architect. In 1958 he returned to Hull to work in the profession and marry Shirley Johnson. Their 27-year partnership brought them two sons

and a daughter, a fecundity which made the 1961 decision to become a full-time writer all the braver. Though, looking back 36 years on, his list of over 200 credits in radio and television, theatre and cinema, as well as his five novels and neatly turned journalism, shows that he never lacked writing energy. By the mid-Nineties all television channels could between them muster only 50 slots for single dramas throughout the year. In 1961, the year in which Plater made his debut as a television dramatist with *The Referees*, there were 300 slots and any number of producers searching out new writers and cherishing experienced ones.

'I had done a couple of radio plays with Alfred Bradley at BBC Leeds when he asked "Have you thought about television?". I said "Yes, but...". At which he kind of introduced me to Vivian Daniels at BBC Manchester. That's how it worked in those days, they all shared the talent around if they thought they had found some. So I met Vivian and he encouraged me to show him any television ideas I had. It was all very amiable, very much an open door policy. He had to find eight plays a year which was not easy even if some of them were television adaptations of stage pieces.

'The thing about *The Referees* is that it starred the great, much lamented, much loved Donald Churchill. I really didn't know what plays were about and I think that first play came about because a kid I'd been at school with had been round to my house to ask me to write a reference for him. I was technically a qualified architect and so could write a reference with ARIBA after my name. The plot, as with all my plays at that time, was built round young men with poetic souls in a strange town, me in fact. In this case the young man searches for a job, is offered one, they shake hands on it and the boss says "Oh, by the way, you will let me have your references, drop them in in the morning". So in this strange town he has to find three referees. He gets desperate and drunk and ends up in a kind of Salvation Army hostel where he meets an amiable lunatic, played by Harold Lang, who forges the references for him. Next day he takes the references in and gets the job. That was the plot. I think we were allowed 45 minutes in those days'.

In fact Plater was not so ignorant of drama, specially television drama, as he will sometimes claim. He was well read in stage plays and anything in the way of television drama that had been published. By then two Granada collections were already in print and at least one BBC anthology. Still more important to the Hull writer were scripts written through the short-lived American Fifties 'golden age' of television drama, particularly those of Paddy Chayevsky. Plater was smitten by *The Bachelor Party, Marty and Printer's Measure*. 'They were brilliant, the Chayevsky plays, and I was writing stuff that looked like them and wanting to write for television rather than any other medium', as he now remembers.

'Dennis Potter said this so memorably in his 1993 MacTaggart Lecture at Edinburgh. About how he saw television and his heart leapt. I think there was a kind of missionary zeal that this could be the drama of the people. We were all kind of leftish and saw that this could be the most democratic form of drama ever known to our civilisation in measurable time. And I think it was true. I think for 15 years from the early Sixties to the mid Seventies we had the most democratic form of drama we've ever known in this country'.

'As I remember it this wonderful period lasted until the middle Eighties but perhaps I am too generous with this estimate?' – 'Well yes, Alan Bleasdale was flourishing with *Boys From The Blackstuff* (1982) so something carried on into the Eighties. But I think by then there was a kind of internal problem that it was much harder to make an impact than it had been in the heyday of the Wednesday Play and Play for Today. And I think it was then that some of us probably decided, not consciously maybe but sub consciously, to write groups of plays. We were encouraged by BBC2 to do trilogies and quartets and things. John Hopkins did *Talking To A Stranger* (1966) much earlier and I did my *Shades of Grey* (1968) trilogy and with this kind of experience I think we were becoming increasingly conscious that if you wanted to make any kind of impact something longer than a one off might have to be the answer. So I think we were partly the cause of our own demise'.

Apart from his Sixties singles for the BBC like *Ted's Cathedral* and *Close the Coalhouse Door* (originally a stage musical) and his *To See How Far It Is* (1968) trilogy the productive Plater learned his television drama craft as a contributor to the pioneering *Z Cars* (from 1962) and its more cosy *Softly, Softly* (from 1966) police fiction spin-off. By the time his notable *The Land of Green Ginger* (1974) was produced as a Play for Today he had become respected even more as a television writer than he had been for his radio and stage work. He contributed an episode to Verity Lambert's heartfelt *Shoulder to Shoulder* (1974) six-parter, dramatising the story of the suffragettes. But it was his six-part *Trinity Tales* (1975), his cheeky and charming up date of Chaucer, which really established his individual voice and perceptions in the minds of he viewing audience. Such character carried the comedies even if the tall stories, told by Rugby League supporters on a pilgrimage to Wembley, sometimes flagged in David Rose's BBC Birmingham production directed by Tristan de Vere Cole. More respectful adaptations followed with Yorkshire's nine-part *The Good Companions* (1980–81), dramatised from JB Priestley's novel of Thirties concert party life; the BBC's seven-part *Barchester Chronicles* (1982) running together two of Anthony Trollope's Anglican teasing novels, *The Warden* and *Barchester Towers*; and the BBC's four-part *The Consultant* (1983), a medium rare thriller drawn from John McNeil's book. At this time Plater also wrote a group of biopics including the Gracie Fields story in Yorkshire's *Pride of our Alley* (1984) and the life of nonsense versifier Edward Lear in the BBC's *On the Edge of the Sand* (1985).

It was in these middle Eighties that Plater's life changed. In 1984, leaving his first marriage behind, he and Shirley Rubinstein, who would become the second Mrs Alan Plater in 1986, 'ran away together' and became reluctant Londoners. This was not entirely dictated by romance, it was also practical. 'By 1983 I was making 30 trips a year to London and, aged nearly 50, was getting aches in places where I hadn't realised I had places. Yes, it is more comfortable professionally to be in London, sadly. I don't rejoice in the fact. Tyneside is an enduring passion, two of the six kids we have between us live in Newcastle, and we whizz up there at every opportunity. I think the best work I've done in theatre has been Tyneside based, we've got a great bunch of actors up there with whom I've worked several times now. But apart from that all the people I work with are based in London and as long as I am working the way I do now we shall stay'.

The move south co-incided with Plater's most successful patch as a television dramatist, the period that started with *The Beiderbecke Affair* (1985), leading into Yorkshire's *Beiderbecke Trilogy*, and went on to the BBC's *Fortunes of War* (1987) epic and Channel 4's *A Very British Coup* (1988).

Leon 'Bix' Beiderbecke, the white cornettist from Davenport, Iowa, who died from alcoholism and pneumonia aged 28 in 1931, was one of the most celebrated jazz performers of the Twenties. He left enough evidence of his bell-like tone and lyrical solos on record to enchant generations of jazz buffs as yet unborn. Including Alan Plater and his best known and most reluctant hero Trevor Chaplin (James Bolam). In the original four-part *Get Lost!* (1981), for Yorkshire and ITV, Plater had hit upon a format in which a pair of teachers, male and female, became inadvertently involved in missing person mysteries. He adapted this formula for his six-part comedy-thriller serial *The Beiderbecke Affair* (1985). Leeds comprehensive school woodwork master Chaplin searches for a set of Bix records following a mix-up of his mail order. His teacher girl friend Jill Swinburne (Barbara Flynn) seeks election to the local council on a greenish ticket. At which fate, and their battered old car, drags them into a mildly surrealistic world of underhand dealing and corruption.

The popular success of this created a demand for the six-part sequel, *The Beiderbecke Tapes* (1987), where Trevor buys some jazz tapes from the barman of an empty pub and discovers that one of them contains not the much loved tone of Bix but plans to dump nuclear waste in the Yorkshire Dales. Having somehow survived the pursuit by oddball characters that follows this discovery Trevor and Jill again attracted the interest of the authorities, after bumping into a Russian refugee, in the four-part trilogy conclusion called *The Beiderbecke Connection* (1988). What mattered to Alan Plater almost as much as his scripts was the musical accompaniment, something which it took a while for unmusical directors to take on board. The Beiderbecke sound was convincingly recreated by Kenny Baker and Frank Ricotti provided additional music.

'Yes, I have had one or two run ins with directors, particularly over the Beiderbecke serials. It was because I like to do some of the director's work, I like to say what the music is and when we should hear it. We had such a good team on that trilogy and I had actually given stage directions to Frank Ricotti who I knew would be arranging the music. There would be these little stage directions, saying "Frank, a little blues here I think"', Plater remembers.

At this time Yorkshire was still a reasonably supportive company, permitted by the system to make original programmes as well as money. By 1995, when Plater suggested a fourth Beiderbecke serial, ITV no longer even pretended to uphold the public service ideal. 'I rang Jimmy Bolam and Barbara Flynn and asked if they would be up for another one. They said "Oh yea, great". So we got on to Yorkshire and the people there were also thrilled to bits, having earlier asked for a fourth serial. Yorkshire took the idea to the ITV Network Centre and were told to wait. What ITV market men did was to analyse the viewing figures for the first three series and conclude that there would now by no audience for such things. Never mind that we got from eight to ten million as far as I recall. Right up to the end we got great notices and I still get fan letters now'.

In the midst of his Beiderbecke originals Plater returned to adaptation, this time undertaking the massive task of reducing, or strengthening, Olivia Manning's six Balkan Trilogy and Levant Trilogy novels to seven hours of television. The BBC top brass was feeling wounded by the Granada and ITV success with *Brideshead Revisited* (1981) and *The Jewel in the Crown* (1984). They were persuaded that the Manning stories, of people immobilised beyond the Balkan and Levant battle grounds in World War Two, would win similar esteem. They set aside £6 million and agreed to producer Betty Willingale's plan for international location shooting. They agreed to the casting of Kenneth Branagh and Emma Thompson as the newly wed protagonists, Guy and Harriet Pringle. It was not the fault of Plater's flexible scripts, or the bold yet sensitive direction of the experienced James Cellan Jones, that *Fortunes of War* (1987) was a commercial success which fell just short of its Granada models in critical esteem. It was probably more that Manning's characters, and their adventures, were simply less engaging.

For Plater the show was 'in crass commercial terms, perhaps the most successful dramatisation I have done' which won good pay and prizes. It was also a signal to him of the growing 'minor lunacies in a changing industry.[2] 'My job was to write dramatised versions of six novels, amounting to around 1,600 pages of paperback: say half a million words. The first three novels are longer than the second three. My immediate response was to suggest to my producer, the patient and gifted Betty Willingale, that we make six films, based on each of the six books. In general, the longer the book, the longer would be the film. One film for each book – what could be simpler? It sounded very sensible to me and it sounded equally sensible to Betty. It did *not* sound sensible to the industry.

'The laws of the industry said we must have seven episodes, each of them exactly 55 minutes in length. And the laws of the industry must be obeyed and that is what we delivered: seven episodes, each of them 55 minutes in length and of a very high quality. Six into seven *must* go, whether it wants to or not'.

Talking to me for this book in late 1996, with Shirley a generous host at his London NW3 home, Plater interrupted work on a projected three-part dramatisation of George Mackay Brown's 1972 novel *Greenvoe* for Channel 4. At that time it was to have been his last big television work 'for the forseeable future'. For this he was to take an associate producer credit and had 'a consultation clause' in his contract – 'which means I shall sit in and have my say in the choice of director and the principal casting'. He has always wanted to be in on the central casting but has never had time or inclination to be the kind of writer who hangs about on set, much less become his own director.

'When television drama was a studio thing, a studio product, the writer was the boss. He was the true author. The minute you go out on location with cameras then the director has a huge burden of responsibility. When they were shooting *Fortunes of War* in what was then Yugoslavia we went out for just one weekend. Jimmy (Cellan Jones) was directing in Zagreb and was under absolute siege from morning to night, with actors, with problems and whatever. He'd decided he wanted this big opening shot of the train. I didn't write

2 Alan Plater 'People's Showdown' *New Statesman* 16.6.95

the helicopter shot, I couldn't say to Betty Willingale "We have to have a helicopter shot", I just specified a train. But Jim wanted the helicopter shot and in the end I think he was thoroughly vindicated.

'On the other hand when we got there they'd just made a first attempt at the shot. It had been a really windy day and after a long, long look at the rushes it was clear that the shot was not usable. We spent most of the weekend eating and drinking with our Yugoslav friends, it was very cold out of doors. Betty and Jimmy had to spend the time trying to set up a retake of the air to ground shot. They were told they could have the train the following Wednesday but not the helicopter, they could have the helicopter on the Thursday but not the train, it was one of those things. They coudn't have the train and the helicopter on the same day, this being Yugoslavia and a bureaucratic nightmare. That's the kind of thing that directors have to worry about, I couldn't be doing that...'.

'But having been so often mucked about, specially over things close to your heart like casting and music, have you never thought of going down the Lynda La Plante route and forming your own production company?' – 'Yes, I think if I was 20 years younger, if I was nearer the beginning of what I laughingly call a career, I would form a production company. And then get somebody else to run it...

'If the industry goes the way it seems to be going, if you project forward from where we were ten years ago to where we are now, we are heading towards the American situation where somebody like Stephen Bochco becomes his own producer as well as the principal writer of a team. All the best American shows now have a creative type of person who is the producer. Socialising in Toronto we met a couple of the *M.A.S.H.* writers. They said the reason why *M.A.S.H.* (1972-1984) sustained a very high quality, more or less throughout its 12 years, was that the last person on the script was always good. For me though this notion of having a team of writers and the script being handed round and eventually landing up with the head writer is just anathema. Which is why even the best American television, and in its best shows like *Homicide* and *Northern Exposure* it leaves us gasping, there is an absence of writers' finger-prints.

'Five minutes into a Bleasdale show you know you are watching Bleasdale. The same with a Dennis Potter or a Jack Rosenthal, any of our generation and the next one, you can spot them within five minutes. Now a whole bunch of writers on both sides of the Atlantic are going back to the theatre because that is where they are allowed to sing their own songs in their own voices. And increasingly that is what I am doing. My work for television has become mainly dramatisations. They are nice books but If I want to let out a good yell...'

Though it was adapted from the novel by the admirable Labour MP Chris Mullin there was a satisfactory exercise of the Plater voice in his three-part political thriller *A Very British Coup* (1988). Vividly directed by Hollywood bound Mick Jackson for enthusiastic producers Ann Skinner and Sally Hibbin this arrived on Channel 4 as truly pungent satire. It told of the arrival in power of radical socialist Prime Minister Harry Perkins (Ray McAnally), a former Sheffield steel worker, and the efforts of the Whitehall based reactionary establishment, and their American allies, to destabilise him.

'This serial should have been a total disaster from the conventional commercial point of view', Plater said five years later.[3] 'Most people find politics and politicians boring, and the politics of the British Labour Party are, to steal a line from Gwyn Thomas, a cocoon of spinning absurdities. I am a party member and I know. So we used a little low cunning in our approach to the subject. Rather than a thesis on the inner workings of the party, Whitehall and Westminster, it became a traditional story about a guy from the sticks who takes on the big city slickers and almost wins: a combination of Dick Whittington and Robin Hood with a little of Frank Capra's *Mr Smith Goes To Washington* (1939) thrown in.

'The result, thanks to marvellous direction by Mick Jackson and a stunning central performance by the late Ray McAnally, was a very British piece of work which, paradoxically, travelled all over the world with ease. It became Channel 4's most successful overseas export and won major awards all over the world. We briefly considered entering it for the Wimbledon Singles. There are at least two cheerful morals to be drawn from this success. First, that the audience will always take you by surprise. Second, that the stories which travel furthest are those that are most deeply rooted in their home soil. You can only be truly universal if you are local and particular'.

The trilogy was shown again at the National Film Theatre two days before the Labour landslide of 1 May 1997. Trailing this a fortnight earlier,[4] Plater wrote that 'in retrospect what seems to differentiate *A Very British Coup* from most political drama is a central character who is, and remains, an honourable man. He is toughened by his experiences but maintains the rage and his dreams. He is also an old-fashioned, unapologetic socialist. He makes Old Labour seem New. He would regard the present election campaign with a mixture of amusement and contempt. But what would his manifesto be? My feeling is that just as Harry's Eighties socialism was inspired by the past, his Nineties socialism would be inspired by the global future: by the idea that the very survival of the planet depends on collective endeavour rather than competitive free enterprise. Market forces, by definition, have no conscience'.

It was market forces, ridden by BBC executives unable to see that the local and particular was the best way to international appeal, which led to the Plater decision that television was no longer the place for his original work. When his original five-part BBC1 comedy thriller *Oliver's Travels* opened on 11 June 1995, scheduled against the penultimate episode of Lynda La Plante's *The Governor* on ITV, Plater had already made it plain that the production team had got it wrong. It had ignored his judgement on casting, locations, music and running times. The eponymous Oliver was a middle-aged university lecturer who responded to his redundancy by embarking on a search for Aristotle, his favourite crossword compiler. The search took him from his Welsh base in the Rhondda Valley to the Orkneys. His companion for the road movie, travelling in an antique yellow VW, was a policewoman (Sinead Cusack) in need of escapist romance.

Much like the BBC itself the University of Rhondda Valley had lost sight of its proper function in its efforts to formulate a 'market strategy'. Oliver, nom-

3 Alan Plater 'People's Showdown' *New Statesman* 16.6.95
4 Alan Plater 'Politics is Like Dog Shit' *Guardian*, 12.4.97

inally a don of Comparative Religion, was not too distraught at being despatched from such an establishment. He had after all been inspired by and written for Plater's oldest friend Tom Courtenay. And it was at once easy to hear Courtenay's wry tones in the self-deprecatory yet loquacious style with which Oliver declared his retirement from all rat races. Unfortunately, using the shaky pretext that he would be better for international sales, the BBC chose to cast Alan Bates in the role.

'Writing the novel was fun. Writing the television series was fun. Making the television series was not fun', Plater wrote in the week before transmission.[5] The scripts had originally been developed under the wing of David Cunliffe, formerly the Yorkshire producer of the *Beiderbecke Trilogy*, at WorldWide. 'C4 loved the scripts but felt them too downmarket, ITV loved the scripts but felt them too upmarket, BBC Wales and Scotland loved the scripts and didn't mention markets', as Plater put it. Eventually it was decided to go ahead under the BBC Wales umbrella though there had to be a London rubber stamp. And sadly 'the man with the rubber stamp was also carrying a sledge-hammer'. Plater and WorldWide were given 24 hours to accept Alan Bates as Oliver or see the whole project collapse.

'The arguments in favour of accepting the deal were: a year-and-a-half's work was at stake; Alan Bates is a wonderful actor; WorldWide and BBC Wales could use the jobs; and most persuasive, a passionate plea from a fellow playwright, that the original, writer-led, popular drama series, which gave us *Pennies From Heaven*, *Edge of Darkness* and *GBH* was under threat and *Oliver's Travels* could be the equivalent of Custer's Last Stand. The argument against acceptance was the inevitable betrayal of a valued friend. After 24 hours I called my agent and said: take the pieces of silver. The friendship survives but it's been a damn close-run thing', Plater wrote.

The BBC rationale was that Bates was 'sexier casting' than Courtenay – 'sexier' having nothing to do with sex, still less acting ability, and everything to do with marketing concepts. The same applied over the choice of director. Both the Plater and Cunliffe suggestions were rejected without explanation and Giles Foster, best known for his handsome views in *Silas Marner* and *Hotel du Lac*, was imposed.

'There are a million broad acres in the world of television drama but any objective analysis will tell you that Giles and I come from very different parts of the forest. It is therefore no surprise that he and his team, though highly-talented and well-intentioned, misunderstood the tone of the piece. My work tends to be low-key comedy, charred at the edges with melancholy and the remembrance of something precious that was lost so long ago, nobody quite remembers what it was. It flourishes best with invisible acting and direction. You can't be noisy and laconic at the same time. The golden rule is: the characters never know that what is happening is funny. Getting it right is tough and about ten times harder than it looks on the page'.

When the production moved underway the first demand made by Foster and his team was cuts. Protests were over-ruled, cuts were made and the serial was reduced to a five-parter because not enough material was left for the sixth episode. Later it became clear that the locations were chosen, against the grain

5 Alan Plater 'Writers and Wrongs' *Media Guardian*, 5.6.95

of the screenplay, on the basis of 'never using a small, dog-eared location if a big, spectacular one was available'. A key element in the screenplay was the gradual change in speech patterns as the action moved north. Incompetent casting meant that Plater had to work on extra rewrites 'explaining why, for example, a kid born and bred on the Welsh borders speaks with an East End of London accent'.

Finally Plater took exception to what he calls 'the Big Moment Syndrome', a spectacular sequence in the final episode. During the Orkneys finale the script indicated that the local legend of Magnus the Martyr, a metaphor for the whole serial, should be told 'clearly and simply by word of mouth'. Foster asked for this to be opened up and made visual with mummers in the market place. Plater claims to have given the change his best shot but still felt, rightly as I saw it, that the device confused the message of the legend.

Right or wrong on such details it was clear to Plater that he was no longer trusted. And that, before producers and directors start their shoots, television writers in general 'have more people telling us how to do our work than ever in the history of the alphabet... In the formative stages of any project there are now at least six chiefs to every Indian. Is it any wonder the tribes are restless?'

'Eighteen months later have you learned any more about the Bates for Courtenay swap?' – 'Not really, but I think in part it reflected that limited vision at the executive level of someone looking at Tom and looking at Alan and saying these two are inter-changeable. Which is profoundly insulting to both of them. The idea that, because they both happen to come from north of Watford and are around the same age, they are inter-changeable is just total bollocks. The order about this came from quite high up the tree. Michael Wearing, as head of series and serials, accepted responsibility but I believe it was Alan Yentob, thinking of ratings and sales...'.

'Given the relative success of the show here and in the US, where the reviews were so cogent, informed and respectful, do you now take a more indulgent view of Giles Foster's work?' – 'He has done some good work but in this case, after he went his own way with casting, it all got ever so messy and became a bit of a shambles. We ended up doing damage limitation'.

'Did you ever consider taking your name off?' – 'I could not take my name off, that would have been a total nonsense because the novel was already out with my name on it and the paperback had a still from the show on the front. I have only once taken my name off anything and that was an episode of *Spender* (BBC1's 1991–93 introspective, undercover detective formula, set on Tyneside and created for himself by Geordie actor Jimmy Nail with help from comedy writer Ian La Frenais). That was because of rewriting by Jimmy Nail. I didn't know that was the way it operated and in total innocence I went in and wrote a script. It was a very nice script I thought, about a thinly disguised Paul Gascoigne, probably a rather nicer human being than Mr Gascoigne appears to be when you read about him in the papers. It was a script about this footballer who goes AWOL and detective Spender has to track him down'.

Alan Plater stems from a trade union background, his father and grandfathers all belonged to the craft unions of the Geordie shipyards and steelworks. 'My maternal grandfather had his certificate of union membership framed and

hanging on the living room wall and I suppose that impinged on my perceptions', he says. When he moved to London and began his voluntary work for the Writers' Guild he was at least half in sympathy with the dissidents, of the Troy Kennedy Martin tendency, who attacked its failure to operate as a proper trade union. 'The problem about that is that we are not allowed to have a closed shop even if we could organise one. Also if the television writers did pull the plugs the lights would not go out for at least two years. So, as a negotiating body representing no more than 1,800 writers, we have to go into bat against highly paid lawyers from the companies who frankly try to bully us. I think the way forward, and this is a personal view which I haven't shared with many people, is that we should be looking to have the first international trade union in the entertainment business, an English speaking Writers' Guild that covers the entire world. If we could deploy lawyers from New York and Los Angeles the BBC, ITV and C4 would have to listen...'.

'In my days of trying to persuade people to join the Guild I said you can either do it on he basis of simple craft union solidarity, like my father and grandfathers, or you can join out of avarice. I could make out a case that any television writer will benefit financially from belonging. If neither of those approaches had any effect I just said "Screw you". As human beings I was interested in what they were, as writers I was profoundly interested in what they wrote, but in a collective sense I couldn't give a shit what happens to them'. In the end it is not the collective, not the choir, that Plater seeks to nurture, but individual voices, his own and all the others. If he complains about the ways things are it is 'because we, the writers, are all in danger of losing our voices. We have become very skilled at singing other people's tunes but we forget the music we were born with'.

7 Have confidence ... and don't believe them

Paula Milne

There is great unease about writers, about the person who has the idea. It is like what you find when you look into the origins of revolutions, that the people who had the idea are the first to be crucified as it were. The very fact that you had the idea makes you a reproach.

If the generation of televison dramatists born in the post-war years has the equal of Alan Plater, as a doughty fighter for the talent brought to the craft, it is the diligent and thoughtful Paula Milne. Her contribution also extends beyond the Writers' Guild, where she has been particularly strong in defending the author's mandatory right to communicate with directors and attend rehearsals instead of this being left to individual good graces. She has been generous with the time and energy she has given to workshops for aspiring writers. Taking every chance to make herself clear and then clearer she gave two of her precious writing mornings to travel into the West End, from her London home, to talk to me for this book.

She has a strong altruistic streak and does her writers' workshops, at home and abroad, partly 'because I think you should give back'. She also has the more base instinct of objecting to script editors and producers running workshops for the system – it's very very important that writers do it for each other'. When we first spoke in late 1996 she had lately been to a forum presided over by then Controller of BBC1 Michael Jackson. He admitted that the management had become less than user friendly to writers. In future there would be quarterly seminars and 'we'll bring you in and tell you what we need'. To which Milne responded: 'Don't you see Michael, that presupposes you know what you need'. For her it confirmed that writers' perceptions were no longer welcome, that the prescriptions of broadcasting managers ruled. 'I believe absolutely that workshops run by script editors and producers are designed to provide cannon fodder for the system. I talk to writers as another writer and

say "Have confidence, be mercurial, be angry, have something to say, learn the craft and don't believe them". It is our job to be outside the system and to ask questions. Now, particularly now, we must be dissidents. We were once the vanguards which the system followed, now we must be dissidents'. Dissidents, she will add, who guard their talent. She likes to echo a remark by Alan Plater, at a writers' for writers' workshop, that 'You have to have a talent for your talent'.

Milne also attempts to correct the conviction among a proportion of young writers that television, as opposed to cinema, is intrinsically contemptible. Screen vocabulary was part of her early education. That was partly thanks to Robin Wood who, when not developing auteur theory as a film critic, helped in her upbringing. It was also down to the much used family televison set. She became very aware that cinema and television have different strengths and weaknesses and should be approached with equal respect. Alan Plater will argue that 'there is less difference between television and cinema than people imagine'. He remembers that when he was on the cinema supporting advisory panel that became British Screen he heard people say 'Oh it's a good idea but its television' and 'I sat there waiting for someone to explain the difference'. Paula Milne, who like Plater writes for the large and small screen, knows the difference.

'My shorthand generalisation is that television is words supported by pictures and cinema is pictures supported by words, I wonder if you would go along with that?', I put to her. 'Yes, that's very good, I think that's absolutely correct. There are similarities in the visual vocabularies but I think that's absolutely right. If you look at the recent hybrid cinema and television things, particularly the BBC ones like the serialisation of *The Mill On The Floss*, even movies like *Priest* and *Safe*, I do think they fall between two stools. They are neither fish nor fowl and I think that is precisely because of what you said. For me *Priest* actually worked well as a cinema film and worked less well on television because the very visceral power of it and the visual quality of it was inevitably reduced on television.

'This leads me to the worry that television controllers, and their audience, are losing their grip on ideas led drama. Somebody who is in cinema but saw my Channel 4 serial *The Fragile Heart* (1996) said "You have to recognise that ideas now rest more in the cinema than in television". I had to agree, very reluctantly, that with the single exception of C4, which is more of a minority channel in terms of its dramatic output, this was true. I think it is possible that if you and I were talking ten years ago we would have been talking of *Trainspotting* as a television piece like Gordon Newman's *Law and Order* quartet. With all its aggression and rawness and language it would simply not be possible to do a piece like *Trainspotting* on British television now. Apart from anything else the guy who wrote that movie wouldn't necessarily be recognised as a name by television world today. It is still OK for a few people like Jimmy McGovern and me, we've slipped in under the net. But they are no longer going to attract the energetic new writers like those who used to come in with ideas and something to say'.

Paula Milne was born in Buckinghamshire in 1947. When he deserted his family her father, once a budding philosopher but blinded during the war, left his wife with four children under four. At least in middle class terms a long financial struggle stretched ahead. Paula's disciplined twin sister Claudia went

on to become a notable current affairs producer running Twenty Twenty Television. A less disciplined but highly spirited teenager Paula contrived to leave school before her 15th birthday, with no academic qualifications.

'I was very good at painting and drawing but was bottom of the class at everything else – unlike my sister who was always at or near the top. My Mum said "It doesn't matter as long a you're good at one thing"', recalls Paula. 'When I was nearly 15 it was suggested that no further money was wasted on school fees. I went to secretarial college for a year and then to High Wycombe School of Art. I did a foundation year there with some graphic design but I didn't like that and went on to do painting at the Central School of Art and Design'. Altogether she spent the best part of nine years searching for her true vocation, knowing she did not want to teach, happy to enjoy student life for as long as possible. From Central she secured a place at the Royal College of Art film school and, though she did not know it at the time, her future was secured.

'As part of the film school course you had to write and make a film. I had not written a word up to that point, I didn't consider myself a writer at all. It was called *Casualist*, which I suppose it proved to be. It took place in a Rolls Royce on a motorway and was about the end of a relationship between a man and his mistress. My eldest brother was working for CBS News at the time and he said he would give me colour short ends if I got some decent actors. I asked if I could prove that I had tried and failed to get good actors would he give me the stock? He agreed to this and so I wrote dummy letters to Richard Todd and Nigel Davenport and Anthony Quayle and all sorts of people and, to my astonishment, about four of them said they would take part. So Nigel Davenport did it with Julia Foster and it was in colour. And I went and asked Walter Lassally how to shoot it, limpet mounts on cars, lighting and things like that, so it had a sort of professional look to it. It wasn't very good I hasten to add, in fact I think it was gob smackingly vacuous. But the ever vigilant Renée Goddard, who ran the ATV script unit at the time, must have seen something which I didn't...'.

Paula Milne's reward was a three-month script reading attachment to Goddard's unit. And this was followed after her graduation, and a depressing period of unemployment, by an initial 1975 three-month contract to work for Robin Wade and Betty Willingale at the BBC Script Unit. 'The system was that you read the material that came in and if it was good or showed promise you sent it on for a second opinion. Towards the end of my three months a trusted outside reader told the unit that I had a fantastic ability to analyse and understand scripts. So I was sent to the series and serials department to be a trainee script editor. And that's how it started really'.

Her serials department monument was the creation of *Angels* (1975–83), a likeable series of grittyish 50 minute dramas about student nurses at St Angela's, Battersea, developed later into a twice weekly soap. Here early producer Julia Smith learned things which she later used as founder producer of *EastEnders*. For all this success and the useful training she received for her future Milne 'didn't really enjoy the BBC, the climate at the BBC, I didn't find it particularly creative – not even then and certainly not at the bottom end where I was lurking. At that time there were separate plays, series and serials departments and there was a kind of snobbism about the toilers in the vineyard, single plays and their writers were the thing. I think I missed being

alone really, the creative part, the solitary part of the work I had done as a painter. The people I made a real connection with were the writers. They were nearest to the people I'd known at art college. They were much more wayward and unstructured and deconstructed than the suited personnel at the BBC. And I can remember thinking "'Well, I'd rather be like them'".

She left the BBC, pregnant with her first child, with the question mark of whether or not she was capable of writing still whirling round her head. 'I couldn't just crash into writing theatre plays because at that time it was very much David Edgar and Howard Brenton and so on. I had no university background, I thought I was probably rather illiterate. I did have some experience of popular television drama and thought it best to see if I could write in that area. I did not want to produce something that did not get made, I wouldn't know how good I was like that. So I applied for and eventually got to write for *Coronation Street*.

'I did that for about 18 months. I would go up to Manchester for script meetings every three weeks. They were good to me because they rarely used a southerner. I learned a lot and they saw an ability to write humour. I had to write trial scripts, half episodes, whole episodes, then you'd go up for the script conference. At that time on the *Street* there were two divisions of writers. There were contract writers who were the old guard and there were guest writers who, on the whole, were younger and not under exclusive contract to the Street. An actor once described them as those on the way up and those on the way down. I was a guest writer.

'The script conferences were a kind of weird democracy, planning three weeks of episodes. The producer would explain where stories stood and the person who came up with the most incisive and decent continuation would usually get the episode to write. The writers were very generous about that. It would have been possible, if I came up with the idea of a character going under a bus, for others to say "Oh, that's rubbish" so that I didn't get the commission. Actually that didn't happen, it was quite an idea led affair. There were two aspects: one was the lack of bitchiness, the other was that Granada at that time (1977–78) supported *Coronation Street*, they regarded it as a bit of a treasure and were very proud of the show. So, unlike at the BBC, there was no sense of snobbery putting down the serial form'.

'At the same time was there not, for a creative writer like yourself, a sense of frustration that your perceptions were chained by the format prescriptions?' – 'One of the inhibiting things about writing for *Coronation Street*, like more or less any popular format drama, was that you were always dealing with dramatic incidents and never the consequences. Buried in that was a sort of dramatic lie. A car crash or a rape or whatever it may be may last only 30 seconds, the consequences can last a long time. All you could do about it would be two lines of dialogue, say, "She's looking a bit down in the mouth, why doesn't she cheer up" – "Well, she was only raped last week actually". Another inhibition was that you could never put a character through an irreversible crisis. Drama can be at its best when examining issues in reverse...'

'Would you not also agree with the persistent criticism that *Coronation Street* is set in a time warp, old-fashioned even when it started in 1960, an inner city Weatherfield impervious to events and social change?' – 'Yes, well I did raise

the issue of why there were no black characters. I was told the problem would be that if you actually moved a black family into the Street, as opposed to having one black guy running into a story and then disappearing, the other characters would have to be intrinsically racist. And you couldn't have that, it would be fuelling racism. I accepted that, I thought it was right, though a convenient get out. The same argument was used when I attempted to get a few of the characters in the Rovers discussing Cruise missiles. They simply wouldn't do it... there was a real reticence about dealing with the real world. Of course the fact that the thing was written three months before it went out lent a natural inhibition to reflecting anything in current affairs. Elections came and went, we were all going to the polling station, and they would all be sitting in the Rovers discussing anything but...

'Those factors were a huge reason to go. There had been an excitement, it is a great thrill to connect with 15 million people, but then the thrill wears off and you wonder what is the connection. You also feel that if you wrote something like that for too long, and adhered to the very marked discipline that's required of writing a show like that, you would blunt the imagination and pick up as many bad writing habits as good ones. I think it is a good training up to a point but only up to a point. You do learn from your audience and you do learn from seeing it performed. And you learn things about your writing skills. I did learn that I could write humour. I was rather seriously intense at the time, ex art student, Grosvenor Square demonstrator, all that sort of stuff, and in the Street you do have to find funny lines. I found I could write Bet Lynch (later Bet Gilroy, played by Julie Goodyear). I used to love her, I looked at my characters and said 'Great, I've got Bet'. But... in the end, after I had done a panoply of work in popular drama, *Shoestring* and *Minder* and *Juliet Bravo* and all those sorts of things, I decided to try and write original plays and my own series'.

'There comes a moment I suppose when the genuinely creative writer, the ones who have a "talent for their talent" and remain vigilant on its behalf, must leave the safe shallows and plunge into the deep?' – 'The craft side of it, the actual business of learning about nuts and bolts, structure, the problems of plotting, come through practice. I learned that though my training as a painter I suppose, my relationship with the idea of work. I was a writer now, I wasn't pretentious about it, it took me some time to admit it, but I was a writer now. As a painter you didn't have to interface an industry, you just did it and it got hung on a wall or it didn't get hung on a wall. Coming from such an artistic background the problems for me have not been the writing, which I love, or the ideas and so on. My problems have been in interfacing with the industry, with people who don't believe in new ideas or want to be prescriptive, people who think the audience is more passive and duller than they are. That has been the most irritating and frustrating element of the whole thing'.

'In this soap period were you exercising your own visions somewhere else or just holding them in check?' – 'I was a breadwinner by then and had three children. All the imagination I had was going to my family and the work I was doing, and rightly. I think the person who pays you to do a script should get the best you can deliver. I wasn't dashing off those scripts in the day and secretly writing the great tome at night. I would not have had the energy or the time. Perhaps it was the same default mechanism that guarded me against

becoming a teacher. I gradually realised that the work would always be there and I was good enough to do that. The question in the distance was how good was I, had I reached the downside of bad habits, I could only discover this by progressing to my own serials and plays'.

'Could you now identify some of these bad habits?' – 'As I said there was the habit of deciding that the consequences of a dramatic incident were not compelling enough for an audience and so stopping writing them. A hold up in a wages office, for instance, would exist in isolation. I would suggest that the people living close would buy burglar alarms, become jumpy. But the prescription was forward thrust, move the story on, though this did not connect in my mind with the way people are, how their fears work.

'The Street had a very short structure. You were told you had to use 12 of the regulars in an episode of 24 minutes. You could not give actors just one line unless it was the key, funny pay off at the end of a scene. In a half-hour play you would concentrate on two or three characters and the rest would merely occupy the dramatic arena needed for the story. On the Street there was no alternative, you were told you had got 12 and must use them all. You might do a story that would gobble up six of the 12 but they could not be on the periphery of the action, they must be brought into the scene. Also prescribed was the structure, you've got the Rovers, you've got Rita's house, you've got this, you've got that. So the structure of the episode had to utilise the set. Those are bad habits. The execution is all very professional but I think sets and actors should follow the story and in something of the kind I have described the story does tend to service the logistics of the show'.

Married for the second time, to a children's surgeon, and pregnant with twins, Paula Milne began to make her name as an original television dramatist in the early Eighties. Her first original single, *A Sudden Wrench*, was shown as a BBC1 *Play for Today* on 23 March 1982, with direction by Jon Amiel. Christine, its 43-year-old protagonist, was bound to her terraced house with varicose veins, stretch marks and inertia. Her husband and teenage son treated her as part of the furniture, her daughter was unsupportive, her depression caused her to ring a radio phone-in and be advised by agony aunt Anna Raeburn to "find an interest, go out, participate". So she did. She became a plumber and reunited her family. 'It just goes to show that a family that plumbs together comes to together', as Peter Fiddick put in the *Guardian*. A feminist fairy story 'that might have been designed as an antidote to the cartoon hopelessness of those inhabiting Mike Leigh's *Home Sweet Home* in this slot last week', I suggested in the *Daily Telegraph*.

An apologetic paragraph in my faintly dampening review tells something of Paula Milne's energy. She is 'a productive writer. Her four-part *Love is Old, Love is New* begins on BBC1 tomorrow (25.3.82) and her adaptation of Jane Gardam's *The Sidmouth Letters* can be seen in the BBC2 *Playhouse on Friday* week. All the same she cannot be everywhere and it was stupid of me to credit her last week, instead of her twin sister Claudia Milne, as director of that absorbing *Disappearing World* documentary about the "Asante Market Women of Ghana"'.

As previously noted this was the moment in television drama when the pendulum at last swung and, instead of plays in which women only existed in rela-

tion to men, women emerged as the stronger and more interesting sex. It was a time for 'women's issues' and Milne was superficially identified by many of us as a standard bearer. She recalls meeting a male writer in a studio corridor one day to be told: "I expect you've come in to do a play about women's issues, haven't you; what are women's issues except men's issues with tits on?".

'My perception at the time was of women theatre writers being brought in to write about rape or of women being battered. Women as victim had become the PC (politically correct) style. It was importrant to do these stories, I'm not knocking that but I did wonder what women in the audience made of it. Of course there were women who were victims but the needs and tastes of a woman in the audience were very much like those of men. They'd had a hard day, they wished to be entertained, they didn't want to be preached at. They didn't want a full expose of elements in their own life, which they had spent a lifetime trying to avoid, when they weren't empowered to change anyway. So I wondered about that and thought I'm going to write a comedy about a wife and husband good at buying radiators and things but never quite plugging the central heating system together... I was also embarrassed that this comedy was sandwiched in the *Play for Today* running order between Mike Leigh and Howard Brenton and so on. But it got a huge AI (audience appreciation), 88 out of 100 or something, and the connection with the audience seemed to be a complete validation of the thought processes that had gone on behind the play. Out of this I wrote *Driving Ambition* (1984), an eight-part serial for BBC1, a humorous look at the nature of ambition in women, the story of a woman who decides to enter her car in a saloon car motor race'.

Otherwise a 'bleak feministic serial about a housewife determined to muscle in on the male preserve of motor sport', as Philip Purser describes it in the third (1986) edition of Halliwell's Television Companion. Donna Hewitt and Gavin Richards played the leads and Michael Simpson directed Carol Robertson's production.

'How did you get started in this "women's issues" seam?' – 'Well the idea for *A Sudden Wrench* came out of my head more or less ready born. I took it to my agent and he suggested Alan Shallcross as a likely producer. Alan commissioned it. There was no need for self censorship, no call for explicit sex. I did have the middle aged husband and wife sitting in the bath, you saw a bit of bum and a bit of tit, there was a bit of apprehension about that. But really the only limitation was that I was told it had to be on video. At that time they were developing OB (outside broadcast) lightweight cameras and quite a few plays were done that way. Those were the days when producers were empowered. You could go and see Alan Shallcross with an idea and if he liked it he could commission it and it would get made. They were told they could do ten plays in a year or whatever the number was and the producer could green light those plays. Something that is absolutely not the case now. Alan had a light touch, he understood that the lightness was what I was after as a balance to the other women as victims stories'.

Before the end of the year *A Sudden Wrench* was followed by *John David*, shown as a BBC1 *Play for Today* on 23 November. There was no light touch about this painful, semi-autobiographical screenplay and Milne was specially grateful for the support of channel controller Michael Grade. The story told

of a couple struggling with feelings about their new baby, born with Down's Syndrome. Both determined Judith (Dearbhla Molloy) and her wet husband Patrick (James Hazeldine) were tormented by guilt over their rejection of the infant. Rodney Bennett directed for producer Brenda Reid. After which there was quite a gap before the telling *Queen of Hearts* (1985) in which Lorna Heilbron played the protagonist at the centre of a dispute over prostitutes taking over an Islington square. This time Tim King directed for producer Brenda Reid. There were moves to take the drama out of the Sunday schedules, even though its view of violent marital sex did happen under a duvet, but Michael Grade again held his ground. And would later become a helpful Paula Milne supporter at Channel 4.

Finally in her group of BBC singles came her turn away from 'women's issues' to the conspiracy thriller that was the compulsively watchable *Frankie and Johnnie* (1986). Two teenagers commit suicide. Police and press conspire to write this off as a love pact but crumpled, local Somerset newspaper reporter Allan Blakeston (Hywel Bennett), once a Fleet Street foot-in-the-door man, digs out the truth that the pact was meant to be a protest against the secret stock-piling of chemical weapons. The Milne starting point was an article she had read about 'a couple of kids in the States who were so outraged by the Vietnam War that they decided to kill themselves as a gesture. They left 14 suicide notes on the dash of their car but these were hidden by the police and the authorities because there was an election coming up'. Producer Graham Benson at once saw the point and included the film in his BBC2 *Screen Two* strand. Martin Campbell, who had just directed Troy Kennedy Martin's somewhat similar *Edge of Darkness* (1985), had just the right directorial touch.

By the middle Eighties the energetic Milne was no longer confining herself to television. In 1984 she was part of a cultural delegation visiting Central America. She went on to the rain forests of Brazil to research her first cinema screenplay, *Terra Roxa*, for Dag Alveberg. Other work for cinema and theatre followed and the only pity was that her *Earwig* (1990), a pungent play about television deregulation, was commissioned and produced by the Royal Shakespeare Company and thought too near the knuckle for actual television adaptation. Viewers had to wait until 1994 for BBC1's *Chandler and Co*, a return to her television theme of women making a mark in what had hitherto been a male area. Though it was less a feminist agenda than Milne's fascination with surveillance technniques that led to this creation.

Thanks in particular to Lynda La Plante's *Prime Suspect* women police detectives now had their place in the landscape. But after Agatha Christie's genteel *Miss Marple* (1984 onwards) had done her bit towards the solution of Thirties and Forties mysteries, in various BBC dramatisations, female private eyes were hard to find. Learning on the job Paula Milne's *Chandler and Co*, handsome young Elly Chandler (Catherine Russell) and her somewhat older and more characterful sister-in-law Dee Tate (Barbara Flynn), opened their detective agency primarily to investigate the marital infidelities of others. Larry Blakeston (Peter Capaldi) was the necessary male who knew about surveillance and taught the women how to bug rooms and tail suspects. Milne wrote most of the first two six-part series, recruiting Kate Phillips (Susan Fleetwood) as a new partner when Elly Chandler herself dropped out. Ann Skinner produced both the 1994 and 1995 series.

Thanks in the main to actors Barbara Flynn and the late lamented Susan Fleet-wood the suburban detectives offered moderately enjoyable entertainment, easily digested if as easily forgotten. It was really Paula Milne's next creation, arguably her masterpiece so far, that elevated her into the top six of British television dramatists now active. Her three-part *The Politician's Wife*, shown on Channel 4 from Tuesday 16 May 1995, won a mantlepiece of awards including both the BAFTA best serial award and the International Emmy for best drama. Never has her signature theme, of strong women emerging from their dolls' houses to rearrange the dominating but weak surrounding males, sat better. Fragrant Flora Matlock (Juliet Stevenson) is introduced as the ideal wife for the Rt Hon Duncan Matlock MP (Trevor Eve), sitting in the ruling Tory Cabinet as Minister for the Family. Her blindly single-minded invest-ment in husband and marriage, and the Conservative party, means that her discovery of Duncan's adultery shatters her world. Her revenge is to destroy his political career and, spitting into his wounds, to take his parliamentary seat. The skill of the drama is in the way it first wins unqualified sympathy for Flora and then gradually turns to show that, apart from his pursuit of sexual plurality, she can be as ruthlessly nasty in a bad cause as her husband.

'Specially telling in your drama I thought was the characteristic old Tory divide, the men still emotionally at their public schools and the women serv-ing yet excluded. Were you scoring party political points?', I asked the writer. 'I am more left than right but as a writer I have always tried to steer clear of agit-prop. As a woman writer that was particularly true when I wrote on women's issues, that is why *A Sudden Wrench* worked. Politically I think the same is true. When the idea for the story came into my head I knew I had to steer clear of agit-prop. You had to see that these people were bad by identi-fying with them as characters. Flora was the most difficult to write and indeed for Juliet to play. You had to be very sympathetic to her while recognising that she was a true, dyed-in-the-wool Tory. Then, as she started to perceive the callousness she was infused and infected with, her anger had to start sexual and become political. I think that sort of thing does happen with women'.

'Would you have been able to write exactly the same story about the Labour party?' – 'No, I don't think Labour have the same degree of philandering as the Tories are prone to. It has much to do with upbringing, the public schools, being brought up in an institutionalised life. I think it would be equally possible to write something about Labour politicians but more to do wih ideology and the shifting balance. In fact what Dennis Potter and Trevor Griffiths have done in the past about the ideology of the left interfacing with the reality of actually trying to carry that through when in power'.

'I hear New Line have bought the film rights for *The Politician's Wife*, does that mean you writing the Hollywood screenplay?' – 'It can be a lot of fun writing about the politics you know but you have to know it. It is fine to go to California and all that stuff but I would not be writing what I know. On *The Politician's Wife* I have a strong instinct saying "When you've done it leave it alone, don't write the American movie". It is doubtful if they will admit any real politics anyway but the characters will be Republicans and I know I could never get the political attitudes just right. Here, for instance, child benefit is a hoary old political potato, you don't have to explain anything to the audience. I don't think I would be able to find the right political issue

there. But I do consider that this story could make a film because it's got a great burning narrative, a great north road of a story charging through it, pulling everything in its wake behind it. Something like my next serial, *The Fragile Heart*, I hope equally robust, wouldn't survive a blow up for the large screen, it would collapse like a souffle in the cinema. That does not make one serial better than another, just different.

Paula Milne's *The Fragile Heart* was a drama of three 65-minute episodes shown by Channel 4 on Wednesday evenings at 10 pm from 6 November 1996. It was produced by Brian Eastman and directed by Patrick Lau on locaton in Taiwan and Britain. Nigel Hawthorne played the protagonist, cardiac surgeon Edward Pascoe, and Dearbhla Molloy was his GP wife Lileth. Brian Eastman and his independent Carnival Films had previously made *Traffik* and *The Big Battalions* for Channel 4, expensive international serials respectively dramatising the illicit drug trade and, less convincingly, Christian (or at least Anglican) witness. In 1995 he proposed to complete a loose trilogy, dramatising international contrasts in the practice of medicine, and approached Paula Milne. As a for instance the rest of this chapter is a question and answer explaining, through Milne's own words, a writer's view of how she brought her perceptions to such a loosely prescribed serial.

Genesis ...

'Did you have a previous professional relationship with Brian Eastman?' – 'No, I'd met him at a couple of things, he was at an advance showing of *The Politician's Wife*, he called me shortly before its transmission. I think he knew I was married to a doctor but I assume that wasn't my only credential. He runs a broad church so you are looking some time ago at *Traffik* and *Porterhouse Blue* but more recently *Bugs* and *Agatha Christie's Poirot*. He asked for a series about medicine. I did not groan, I was dignified at the meeting, and then he said he did not want another parochial piece centred around a hospital but wanted to explore the idea of medicine itself. He said he had always seen *Traffik* and *The Big Battalions* as the first two parts of a trilogy that would end with medicine and I wondered "Is this commissioning with hindsight?" I thought this trilogy concept would be meaningless to the audience. So I didn't quite get off on that. And when he talked of "global medicine" I wondered what that meant, was it like global gin and tonic. He talked on about the holistic approach, the idea that one disease may get treated in different ways through different cultures, and I thought "Well, that's all very well but where is the drama?". But Brian is a distinguished producer with a good track record and I listened on...

"I had after all been in the pin-striped corridors of power. I had been married to a children's surgeon since 1988 and so already had a starting point. Children's surgery is fairly benign but I had learned things about the upper echelons of medicine, what a deeply conservative establishment medicine had. I didn't know about medical dynasties until I met my husband and went to dinner parties and hospital functions. I found people were astonished, not that I was a writer particularly but that I wasn't in medicine. Writing is so much about taking the audience into a world they don't know but may be curious about. As a writer you think in this way, what can I bring to the table? In the end I asked Brian "What is it that you want to say?" And he said "I suppose

I would like the audience to feel more empowered". And I thought "If you think of the audience as a patient that's quite an interesting starting point". So I said to Brian "Give me £2,000 to research for a couple of months and if I don't come up with anything dramatic enough you can keep the paper work and take it from there. If you don't like what I come up with I will have been paid for my time, if you do like it the money can be offset when the commission comes'.

'So you at least had a pleasant two months before you needed to write a single word?' – 'Yes, with the help of a researcher, Kirstin Lass, I set about examining various aspects of medicine to see where the drama and story could lie. I started out very sceptical, well not very but pretty sceptical, about alternative medicine and the new age thing. So I went round examining "holistic" or alternative approaches to treatment. I was astonished by the dismissive and scornful reacton of many doctors whenever the topic was raised. Though they could not argue with the fact that so many were voting with their feet and turning to complementary practitioners.

'One such practitioner, who said that doctors used to be society's sorcerers, told me the haunting story which, whether true or apocryphal, summed up the themes I was exploring. It was about a young Australian doctor travelling in the outback. His money had been stolen so he jumped on a passing goods train. After he closed the truck door he realised he was locked in a refrigeration unit and, on such a long journey, would certainly die. For the benefit of medical science, he decided to write down exactly what it felt like to freeze to death. When the train reached its destination the railway workers found his corpse and the notebook beside it. They were puzzled because the refrigeration unit had never been turned on. I decided that this story could be used to haunt my central character in his bad dreams. But it also seemed to embellish the puzzle of why it is that some people get cancer and some don't, why it is that some people can live for years with a condition and others roll over and die, and so forth.

'I put the story to my husband, who's really pretty good about these things and fairly kind of relaxed, not too much stuck in the temple of science, and he just laughed. "Why are you laughing?", I asked. And he said "I cannot believe there is such a thing as a mystery. If I go in to operate on a child I must believe that if I do A something will follow, if I do B something else will follow, and so on. Mystery is no good to me". I thought that was fair enough as far as it went but the pipe line of disease was still mysterious'.

'By this time you know something about your central character and the shape of his story?' – 'Yes, I knew from the start that there were medical families and soon decided that the father of my family would be a cardiac surgeon, one of the high priests of surgery and the medical establishment, the protagonist who became Edgar Pascoe. He would be a man who had centred his whole professional life around clinical and scientific imperatives, a charismastic and articulate man who had learned to use the medical hierarchy for his own advancement, a man who – in protecting himself from the terror of his patients – had lost touch with his own humanity. From this I conceived the story round heart research and the contrast between the Western approach and that stemming from the Chinese tradition. I spent my two months reading and meeting people. I didn't actually go to China but I travelled all round

the UK, meeting heart surgeons in and outside of London.

'There was no problem about this. On the whole people like to talk about themselves. Of course you don't go in saying "I'm thinking of doing a piece about a heart surgeon showing his complete lack of humanity". You go in saying "It's obviously the absolute pivotal job in medicine, I'd like to know the upsides and downsides". Possibly as a woman, particularly if you are dealing with men of a certain age, you can flatter. I would never flirt but you can flatter more easily than a male could in that situation. And to be honest their innate chauvinism worked to your advantage because they think you're harmless. And of course they are all men, there's only one woman heart surgeon in Britain. Or there may be two by now because another has graduated'.

'I suppose that is what you had in mind with Edgar's daughter Nicola and her maybe necessarily ruthless attempts to follow her father up the tree to the grandeur of becoming a qualified cardiac surgeon. Anyway you now had something to show to Brian Eastman?' – 'Yes, he asked for a treatment. I don't do treatments. I did a sort of sketch of the rough areas. He wanted to do six hours, I didn't. He commissioned four hours and I further reduced it to three, there was a kind of returning of money in the contract element. He was very good about that actually, he did listen to me. I just felt there wasn't enough material for six hours'.

'That must be virtually unique, a writer actually wanting less space?' – 'I think my background as a painter is probably part of that. As a painter you start with a drawn sketch and you start to conceive the painting. The most critical decision you make as a painter is on how big the canvas is going to be. When I was broke as an art student in London I would go into the shop in Chapel Street and say "What bits have you got that I could buy?" and I would make a picture that size. But usually the crucial decision was a large painting or a small painting, the scale of it. In writing it helped a lot knowing people like Betty Willingale, through her you could see when a serial had really been given too many episodes. A long time before, when I was writing the eight-part *Driving Ambition* for the BBC, the head of serials said "Make it ten". I said "I can't, there isn't the material there for ten". The other thing is you have to respect your audience, knowing it should be "Never mind the width, feel the quality. I agreed to take the commission for four episodes but always knew it would be three'.

'I suppose another aspect in judging the length of things is to decide how much an audience wants. With the experience of those last Dennis Potter serials, and their rejection by a large part of their potential audience, maybe there was a climate asking for things to be kept short?' – 'Yes it is important, as far as that is possible, to know whether the audience is up for stuff. I recognised that this would be a thematically led drama, in other words that the theme was the story. The theme was lack of humanity, its rediscovery and renewal, and that was also the story. There is no other story. So I recognised that the story would become extremely boring and, worse still, portentous if it had too many hours devoted to it. In fact my serial was well written by the time the Potter ones went out, I was well into episode three when they were shown, but Peter Ansorge at Channel 4 was already quick to recognise that the audience might not be up for these long, six-hour slabs any more. Specially so where work, like *The Fragile Heart* and indeed the Potters, was right outside genre.

Writing ...

'You have done enough research to know, in outline, what you want to write. What happens next?' – 'Well, as I said there is this 15 page sketch for Brian, telling what dramatic ground will be covered in each episode. Discussions of character didn't really enter into it much because we had talked about that.

'You talked about that before you started writing?' – Yes, the character arc, the change in Edgar, was obviously very important. Change is the essence of drama but it is also a kind of dramatic lie. How many times have I said "Give him up love, people don't change". We say to each other "People don't change, if he is a shit now he is going to be even worse when he is older". So I wanted to write something that was really truthful about how hard it is to change, particularly if you are immersed in empirical scientific dogma. I wanted to do two things about this. First was to show how hard it was for a man such as Edgar to change. Second to ensure that only the audience had that information. So that when he comes back from China, his mind-set altered by the experience, he still sounds very gung ho on the telephone to his secretary. He asks her to ring round and get his list of patients together and so on. Only when he's finished does he sit there and you see the enormous effort this has cost him. This is about dramatic strategy and inviting the audience into the sole confidence of knowing what is happening with Edgar. He hides his vulnerability from his wife until the very end and never shows it to his patients'.

'Was this always going to be a Channel 4 show?' – 'Brian felt pragmatically that the best place to go was Channel 4 because that was where he had done the two previous parts of the "trilogy". I was clearly happy to go there. My presence there had been established by *The Politician's Wife*. And I was extremely anxious not to go to the BBC because I didn't want to write something where the statistical chances it would not get made were greater than the chances of it being made. Which in 1997 is the case at the BBC. I had no reason to think that it would be any different for me than it was for Jimmy McGovern with *Priest*. And even if it was made as a serial it might well sit on a BBC shelf for a year. So *The Fragile Heart* went to Peter Ansorge at Channel 4.

'I presume that did not promise riches for you?' – 'Brian commissioned the piece out of his own money. That is a very good thing that he does, showing that he is a truly independent producer. Only then did he take the proposal to Channel 4. As to the amount I can tell you it was a labour of love on my part, I got less money for this than when I was writing *Chandler and Co* for the BBC. There is no real money for the writer in this kind of original televison drama. Any repeat is part of the original fee. I was on no percentage of sales or anything like that, it was a straightforward writing assignment. Obviously I got much less than for *The Politician's Wife*. It was a fee from Brian and that was it but I wanted to do it. This kind of big budget thing doesn't make anything until it recoups its costs.

'As we speak (in early 1997) I don't think they've gone into profit with *The Politican's Wife* and that had a much smaller budget (nearly £2.5 million) than *The Fragile Heart* (between £3 and £4 million). Each episode of *The Fragile Heart* occupied a 75-minute slot and there was extended shooting time and the Australian stuff. That accounted for any slack, it was a good budget, I don't think it was too tight at any point'.

'So you want to write your first episode even though, in financial terms, it is a labour of love. Research done, outline sketched, do you now put pen to paper?' – 'This is very important Sean because people confuse the activity of writing with writing. The activity is setting down what you now know. It took me weeks to get Edgar in my head. Just walking around, living with him in my head. And then another week or so to name him. Names are frightfully important and not just because of the negative checks with lawyers to make sure nobody exists with the same name, somebody who could sue you'.

'But eventually you do start writing your first episode. What is the physical process in your case?' – 'I handwrite, which comes from being a painter. I handwrite with an italic felt tip pen. It's not that I'm a calligrapher or anything but my handwriting is terribly scruffy and this forces me to be very legible. It varies on how much is crossed out, how many bits of paper are thrown away, it depends a bit on the research. I describe research as being like a six burner cooker, everything on it all at once, like you are cooking a Christmas dinner. You get everything to the point where it is just simmering. Until you write you don't know which you are going to use, that is why treatments are no good.

'I have these brown sheets of wrapping paper that I buy from WH Smith or wherever and I blue tack them on to the wall and write headlines like "Cardiologist inferiority complex" and "Fee splitting" and "Only one woman heart surgeon" and put a ring round each. We know it is going to be a medical family, so you write "twins, twins" and put a ring round that. I then start joining things together with arrows. I ask myself questions, "How do you lose a patient?", "Why would someone get to fee splitting, who would do that?", and so on. Then with the arrows I connect things up and get the rough picture of an episode. Including ideas, whole strands maybe, which in the end never get used.

'So there are loads and loads of balls in the air and I sit down and start with my best writing. Specially now that I am older I am best in the morning. So as soon as I have got the kids to school: the eldest is 17 and taking his A levels, the twins are with my ex-husband but they're with us in the holidays, and then there's Harry who was six when I was writing this, and I have a nanny, I'm not one of those people who feels so guilty they can't... So from about 8.30 am to 3 pm it is all nice and quiet. I have this time that I've bought by having a nanny. But in fairness to her and the children the idea is that I stop writing at 5.30 pm. So I am very focussed about that writing time because I've got to use it. I envy the male writers who don't have this problem, who can go for a nice long walk, sit in a pub and ponder. At about 4.30 pm I put what I have handwritten on to a computer. It helps that when I left school at 15 my Mum sent me to that secretarial college for a year, it means that I can copy type. After I've put in on the computer and saved it I go downstairs and cook the supper and do all the usual stuff like that. But that's all so routine, doing the housework and cooking and things, that I am still thinking...

'Then at about 9.30 pm, when Harry's in bed and the others are doing what they want to do, I go upstairs and have a little fiddle. I have put it on to print while I am downstairs and I now review what I've done that day. For me a lot of writing is about editing. Take out, take out, cut, don't need that line, cut, cut, cut. Then I've got that printed in front of me and that becomes the script.

And next morning at 8.30 I'll read the script again and think "What have I done with the nurse?" sort of thing and start the handwriting process again. The brown pieces of paper on the wall remain there until I have done a first draft of all three episodes. The volume varies. I can write 30 pages in a day or I can write two. It completely depends on what I am writing.

'I write with a lot of stage directions and comments. In the States they find my stage directions incredibly beguiling, they are not used to them at all. But in *The Fragile Heart* it was necessary to write the visual resonances of the dream sequences, for example, because they had their own journey. They had their own resonances. So that, for example, the stage directions on the dream went something like: "A domed sky, a vista of the Australian outback, cracks in the red earth like veins, a figure is running, running away from us, it looks like he is running for his life... and in the distance is a train". So the directions are very evocative and they get me excited. I do them as much for my own sake as for the director. What it does is to help me inhabit those scenes visually and give the visual element an emotion. You give the scene an opporunity to have a life of its own. And if you don't do that it'll never come back to you saying "What about me as a story, what about me as a strand?".

'Once I have put all that information in, haemmorhaging out of it the sound of voices, I start to get the transition of the scenes and discover the best way to do a junction between disparate images... cut from Australian outback to the harsh light of an operating theatre and so on. You do a hell of a lot for yourself as a writer. You are saying "OK this is going to be a very unpredictable narrative, the audience is either going to recoil or be engaged by this unpredictable nature" but having set it up I believe its very important to honour the audience. So at the very beginning you make it clear: "This is not going to be a very easy ride, it's going to be difficult". You make it as engaging as you can, you are not presenting them with homework, and as compelling as you can, but I think it's wrong to pretend it's one thing and then suddenly turn it into another.

'One of the things about cinema I learned as a child, sitting at my Uncle Robin's knee, was about Hitchcock. He used to show us how Hitchcock honoured the audience, how he knew instinctively how to be a story teller. That kind of organic method helped me with the structure of *The Fragile Heart*. The pre-title train sequence helped me with the structure. I thought "Well if I have the boy running and I've got this train story, which carries within it intimations of mortality, when do I reveal my story?". And it is quite a dangerous game to reveal part of episode two in episode one. It made me think of what people would make of it, would they find it annoying, confusing, pretentious or what? So at least you think even if you don't actually know how something is going to work until it's done.

'I wonder how the idea of a dream sequence came into your mind, it is something quite unusual at a time when television drama has reverted to relentless naturalism?' – 'I had a dream once after I had separated from my first husband. I was sleeping in the office in my house and I dreamt that I woke up. Really, I thought I was awake, I thought it was true life, and there was a woman sitting on the sofar. She didn't look terribly like me but she had my jumper on and I was terrified. And I looked at the end of the bed and there was like an SAS guy crouched, dressed in black clothes, at the end of the bed.

Then I reached for the light, I had to switch the light on, and then I woke up. I never had that dream again. But I thought "Well, if I've had this dream then other people have had this dream". So I always knew that Edgar would have a dream about mortality. It was only when I was writing I realised that the boy in the dream was not Edgar as a younger person but the boy on the train...

'When I came to write the stage directions of Edgar's death I had to convey that this was the first time he had seen the boy, as it were, when he was awake. When he was dying. I wrote all the stuff about the boy sitting forward, the eyes as pin pricks of light in the darkness. As he sits forward you see his face for the first time, the boy in the train, and if he comes as death he comes as a friend. In my excitement over this, over the dream and the train story, I believed absolutely that it would be the stage directions that would infuse the director and give those sequences their proper place in the story. If you under-nourish something like that, if you just write "Interior – Edgar has his dream again and wakes up in a bit of a sweat", it is not going to occupy the same position on screen. You could argue that it is over-egged but I say that in a piece like that it is better to over-egg it, and then maybe bring it back a little, than to undernourish it...'

'Obviously some scripts are harder to write than others. I guess it is hardest to write quickly about something close to your heart as this story became. How would you compare the facility you found when writing *The Fragile Heart* with, say, that which you brought to *The Politician's Wife*?' – 'There is no doubt that *The Fragile Heart* was much more difficult to write than *The Politician's Wife*. Not particularly because of writing about mortality. Except that they are very gossamer those things and elusive, much more difficult to pin down without being over explicit. The thing about *The Politician's Wife* was that once I had done the research and got all the pans boiling I had this great north road of a story thundering through it, which was the story of her. With *The Fragile Heart* I didn't have the benefit of that. I wrote episode two of *The Politician's Wife* in three days, it took me a month to write the first episode of *The Fragile Heart* and that was probably the best episode.

'All the time I was having to find the story as I was writing. I was trying to make the story of Edgar's daughter Nicola (Helen McCrory), which is really quite adjacent to his, fit in so it was satisfying to the audience. To what degree I succeeded in that I'm not sure but it was obviously a problem in the dynamic of the writing. It got better as it went along I think, she started to haemmorhage into the piece. I was floundering around a bit with this. I had this idea in the bubble on my wall of Nicola and Daniel (Dominic Mafham) being twins. Brian Eastman was a bit resistant to this. I was open to it but, being a twin myself, I did not want to force my own thing into something. In the end maybe I did too much force feeding of their duality and the duality of the medicine they represented.

'In the first draft Daniel was Nicola's husband. But he just sat at the edges of the piece and anyway why should Edgar give a shit about his son-in-law. I knew it wasn't working and I went back to Brian and said "This is not work-ing, Daniel's got to be his son". And he said "That's all right, Nicola can be Edgar's daughter-in-law".

And I said "Then we've got the same problem again, why should Edgar care about her?". I knew where she was going. But when you start in this organic way you've got to be very clear when you are wrong and have the courage to face it and say "Well, that's a third of an episode out of the window, I've got to start all that again"'.

'At this time were you constantly on the phone to producer Brian?' – 'No, I was not much on the phone to Brian. I just rang him if I was changing something that I had already discussed with him. Because common sense tells you, particularly with someone like him, that they don't like too many surprises. It was his money, not too much of it, but it was his...

Pre-Production ...

'We are now at the fateful point where you have arrived at a first episode draft you feel you can show around. What happens next?'. – 'I send it to Brian, there is some tinkering around with bits and pieces and we send it on to Peter Ansorge at Channel 4. At this time I talked quite a lot to Brian. He would question some of the detail, ask whether the first episode ended in the right place, that kind of thing. At this point I wasn't sure what was going to happen in episode two. He is more prosaic in his thinking than me, asking these direct questions. We had this other strand in the episode about Edgar's wife, Dr Lileth, and an old woman called Carla. Brian was worried about the length. I said "Let's not worry about the length now, let's get all three episodes written". I wanted to fill a 75-minute slot and I had probably written 90 minutes, which was much too long...

'I certainly don't overwork scripts, that used to be my fault as a painter, I know when to stop. Baby and bathwater time. When I have done the first draft, when it goes in that brown envelope, it must be as good as I believe it can be. I have done workshops with writers who will say "I just get down the first draft and then we all pitch in together". I don't do that. I am certainly happy to hear people's views and so on but it is my script I believe and my vision. I make it very clear that there are things in the first draft that are essential, that is the tone of the piece, if you are taking a noir or dark kind of approach, the genre, the structure. If you get the structure right then really you are just visiting the internal dynamics of particular scenes, which is great. It's really good fun to do that, if you've got the structure right. And obviously the same applies to characterisation, the key characters. If you've got these things right in the first draft than everything is OK. It doesn't matter how much more work there is to do, it can only get better.

'Also it allows you to be sure that the person you are working with, the producer in this case, wants to make the same thing as you do. If it's all a bit wishy washy and still up for grabs it can be taken out of the writer's hands. If it was completely a producer's idea, if they've bought the rights of a book say or if it is based on their personal experience, I think that is fair enough. It belongs to them and the writer is servicing their idea. I have done projects like that and my relationship to them was different to this one. With this Brian Eastman concept I asked myself how much drama it contributed and fell back on the Hitchcock generalisation that there are only three ideas in the world, what matters is how you treat them. So I did consider this my idea because I

119

had inhabited it to the extent I had.'

'The first draft is now at Channel 4, did they keep you waiting long for a firm decision?' – 'After a week Peter Ansorge came back to Brian to set up a meeting. When we met Peter said "Assuming Paula doesn't die or wobble off on quality this is now green lit". He also named a day on which he would like production to start and said he wanted the show to be ready for transmission in the autumn of 1996. After which I had to be serious about deliveries and deadlines and stuff like that.

'I had an extra problem with episode three. Susi Hush, my producer friend from *Coronation Street* days, only two years older than me, was dying of cancer. She was alone. She had a son at university but it was difficult for him to carry it alone. So myself and two others took the responsibility of looking after her through the last eight weeks of her life. That was eight or nine weeks where, for all sorts of emotional reasons, it was quite hard to write. To make it worse I was also adapting the Daphne du Maurier novel *My Cousin Rachel* as a cinema screenplay for Fox 2000.

'So after Susi died I was rather behind on everything. I used to do Rachel in the mornings and the final part of *The Fragile Heart* in the afternoons and evenings. It was the first and only time I've ever written two things side by side. But curiously because of Susi the themes of *The Fragile Heart* became much more real to me, the aspect of somebody dying, so that didn't make it harder to write, it made it easier in a way. In the end I got the three episodes in on time but it was clear they were all too long. So I removed the story of old Carla and Dr Lileth entirely. I did it with a slightly heavy heart because it meant that Lileth would have less screen time. On the other hand I felt that her material, particularly in episode one, was so strong that she did still have a proper and rightful place in the drama. Though in the end it did have to be Edgar's story'.

'Having delivered the scripts did you have a real say in the casting?' – 'The director and the cast were discussed with me, yes. Brian had a couple of ideas about possible directors and I'd seen Patrick Lau's work when we were looking for *Chandler and Co* directors. He was not available for that I think but I knew his work, that he had a great visual narrative sense and was very good with actors. The fact that he is Chinese was a huge bonus. I suggested him and it happened that Brian had been watching his work and thinking about it. Lau wanted to do it and he came on quite quickly.

'Nigel Hawthorne was already on board by then. We started thinking about him as soon as we got the green light. I don't write for particular actors. But when I wrote that scene at the end of episode one, about the operating theatre being the one place in the whole system where everything comes together, I knew that Nigel was the man. It is what outsiders see as arrogance and doctors see as confidence, my certainty is my greatest asset and all that, and what Nigel could manage with authority. He is a consummate actor and there are certain things he has which can be taken as a given. I thought he had the range to cope with the tragedy and the funny stuff, Edgar does have some funny lines. Also surgeons are built in a certain way. You don't get many heart surgeons who are florid and weigh 17 stones and have hands like bananas. There is a punctilious sort of presentation to them. Nigel fulfilled that, I

believed in him as a surgeon. If you think of, say, Albert Finney, he's not a heart surgeon.

'Again it was very important to me that Edgar was a moral man and that he was a good surgeon. The patient did not die because Edgar made a mistake, he didn't fuck the operation up, he just hit a statistical rock and that absolutely just happens... So he was in my mind before the director and I think he came on board before the director. Brian sent the first episode to him and he didn't commit, I don't know why. I just carried on writing and Nigel was sent all three episodes and he did commit...'

'And the rest of the cast?'. – 'Brian and Nigel and a casting director would think about this and then ask me "What do you think of...?" I don't tend to come up with many casting suggestions, partly I think it is their job, partly I am not that good at it. But I'm bloody good at knowing who is wrong for a part. So if they ring and say "We've just thought of Nyree Dawn Porter as the wife" I say "That is entirely and completely wrong". But if they suggest Dearbhla Molloy, who played the role, I say "That is entirely and completely right". If you bring along a cast list I think it will effect the director's involvement. My stand off style is risky because you can get well shafted by the wrong people but that becomes less likely if they really understand the material. I believe that, just as I inhabited the scenes when writing them, I think you've got to allow the director to do the same thing during shooting.

Production ...

'Are you a writer who likes to be present through the shoot?' – 'I go to the read through and two days at the beginning of a shoot. I don't go to rehearsals. I go on location as a courtesy but it is like watching paint dry. I want the actors to defer to the director, it is a relationship of trust. And I need the time for writing. I kept in touch with this one because Channel 4 sent me the rushes. But I think at this point a writer who keeps a distance carries more weight. There is also the question of logistical rewrites. Messages come back "We can only be in Taiwan for x length of time, we failed to get a conference room at the top of a hotel as specified, we think we are going to have to do the scene in a tent, that sort of stuff. I have no problem at all with nuts and bolts rewrites. More cuts were needed and I always do those myself, I won't let anybody else do the cuts... There is not much point in cutting within scenes because once you've set the scene up, and lit it, the length of time it takes for the actors to say lines isn't a great issue.

'What you are looking for are set-ups (the correct disposition of equipment), what is necessary and what can be eliminated. Brian quite liked exterior shots, showing where the action was. I'm passionately against this, I like the audience to discover where they are. So he'd write them in and I'd cut them all out again and that took time to resolve. Another fact was that Patrick had some really good insight into the Chinese cultural element and I don't just mean spitting into a spitoon. He was able to refine my thinking. He didn't offer dialogue. He would just talk through saying things like "I think this Chinese boy who comes in at the end of episode one, he's going to be very sophisticated because we are a nation of actors". So I am able to change lines, give a more authentic feel'.

121

'Once all the material is in the can I think you like to make your presence felt again. Your style is to resurface in the cutting room where, almost tradition-ally, strong and opposite positions may be taken between writer, director and producer. To take an example which I found with episode one, the Australian train sequence was all very well but what was the link to the rest of the drama? Did anybody take that up in the cutting room?' – 'Yes, well here I think I have to stray into some of my problems with Brian Eastman. He said the audience would say just what you did. What is the link? I didn't want to supply them with the answer, otherwise they wouldn't want to try and find out. And I wanted to avoid the conventional cliff hanger. On what scale I succeeded in thus arousing curiosity I shall probably never know, the scheduling told against a build-up of the audience. My thought was that viewers would see the show, or read about it in their paper, and say "I must see the next episode, I wonder what that dream was about?" I thought that the connection with the audience would be more primal and visceral and interesting than a simple nar-rative connection.

'Brian always liked the dream in the script and never questioned it. But he began questioning it seriously in the cutting room. So there were several ver-sions. One where the sequence wasn't there at all, one where it was there far too much so that it became intrusive and portentous, one where it was there too hesitantly. I had to take very strenuous positions on this. What I kept say-ing was "We have to use it *confidently*". That is why I wanted it used as it was in the script and not arbitarily flung throughout the piece, which I am afraid is what was happening. I also wanted it to be used very *confidently* so that the audience knew it was there for a purpose and accepted that it was unresolved. It seemed to me that what was coming out of the cutting room was Brian's confusion about the dream. I was in no confusion, I was clear about it, I was clear it was a dream about mortality. I always knew that when Edgar died the boy would be in the room with him.'

'You seem in the end to have more or less got your way and, for my part, after I had seen the whole trilogy I was glad that you had. *The Fragile Heart* was never going to be a ratings blockbuster but I think it was mostly well received by those who watched?' – 'Yes, well around 50 per cent of the reviews were excellent and 50 per cent less so. I was very pleased that the trade papers, the Lancet and Pulse, were favourable and certainly the enthusiastic letters I got from viewers made the whole thing worthwhile for me'.

8 EastEnders

Tony Jordan, Deborah Cook, Joanne Maguire, Simon Ashdown

I remember trying to sell him a Filofax because I had about 40 cases of them at the time. I was good at what I did but I didn't sell him one for some reason, I think it was because he offered me £1,200 to write an episode for EastEnders. *My eye was slightly taken off the ball, of selling a £4.99 Filofax.*

The pendulum swings back and forth, all long running soap operas have their highs and lows, but on any objective judgement there can be little argument that BBC1's *EastEnders* was the strongest of the open-ended drama serials through 1996 and 1997. This position may well change as we approach the millenium but until then the writers of the London-set soap have good reason to think of themselves as the craft leaders of the genre. The pre-eminence of their show was rightly confirmed with the BAFTA 'best series' award for 1996. Whether the *EastEnders* are also the market leaders is less sure. During the 1997 summer season the average audience for ITV's dubiously pepped-up four episodes a week *Coronation Street* was 13,670,000 (down 4.4 per cent from the previous summer). The thrice-weekly BBC show mustered 13,220,000 (up 1.8 per cent) viewers. Searching for painless modernisation the Street, stylistically and actually 25 years older than its rival, introduced some gently racy story-lines in the period under review. But it was its continued distance from 1990s realities which almost certainly maintained its greater hold on the part of the audience that likes its entertainment to be comforting.

Opening her new 'soap watch' column in October 1997, Nancy Banks-Smith of the *Guardian* characteristically got the state of play just right. 'A filial fondness and a preference for jokes always inclined me to *Coronation Street*, but recently it seems to run about, this way and that, like a lost dog', she wrote. 'This week *EastEnders* was deservedly voted the most popular soap at the National Television Awards. It is also the bravest and the best. I have loved *Coronation Street* for so long I feel quite bereaved'. Clearly, in seeking an

impression of what it is like to be a soap writer, it is most fitting to hear from a cross section of *EastEnders* providers. All of whom argue that, despite the unavoidably prescribed nature of their work, they are still able to bring individual perceptions to their scripts.

It was in early 1983, when Julia Smith was devising BBC1's *The District Nurse* (1984–87), that she and writer Tony Holland were asked to think about a bi-weekly soap. Having done so well with, and learned so much from, Paula Milne's bi-weekly *Angels* the combative Smith was just the right person to demonstrate that a soap could be both gritty and popular. But a year passed before she and Holland got round to presenting their 300-word format to the BBC1 Controller. And another year passed before the first night of 19 February 1985. There were thoughts of using real East End locations if not real East End extras. But in 1984 the BBC had bought Elstree Studios, previously devoted to cinema production, and its wasteland was clearly ideal for Keith Harris's £750,000 permanent outdoor set representing the crumbling Victorian 'village' that is Albert Square, Walford, London E20. As this was being built Smith and Holland, now her designated script editor, set about creating the characters that would soon become household names: Den and Angie Watts presiding unharmoniously at the central meeting place, the Queen Vic public house; Pauline and Arthur Fowler, failing to control the Lou Beale dynasty at No 45; Sue and Ali Osman, dispensing tea and bacon sarnies at the Bridge Street Cafe.

For the first month the writing team – Gerry Huxham, Jane Hollowood, Valerie Georgeson, Bill Lyons, Rosemary Mason – had reasonable scope for invention but as week followed week the characteristics and the background became more settled. The appetite for new writers was insatiable but they had to fit in with the script discipline laid down by Julia Smith...

Tony Jordan

Joining the team with episode 430, transmitted on 6 April 1989, Tony Jordan still regards his arrival as a writer as 'something of a mystery'. He was born by the sea at Southport in Lancashire, his family moved to Bristol when he was 12 and his schooling ended in expulsion at the age of 14. He went to work at 15, tried a variety of unpromising jobs and found his feet moving round south coast and Bristol Channel resorts as a market spieler, a barrow boy come auctioneer, gaining confidence and expertise over a 15-year stretch. He was never a great television watcher but, recognising the truth of market fly-pitcher Derek 'Del Boy' Trotter (David Jason), was particularly struck by John Sullivan's 1981 launched sitcom *Only Fools and Horses*. He had no idea what a script looked like or how to present one but was nevertheless moved to write one, rather in the shape of a school essay, about a market trader on his travels.'I sent it addressed to BBC London, no more specific than that, and forgot about it. I had no intention of being a writer, it was just one of those things you try and get out of your system I suppose... I got a postcard from the BBC, after about four months, saying they'd received it. I got a second postcard about three months later saying they were trying to find somebody to read my script. After three more months I got a third postcard saying that somebody had read it, liked it, didn't want to do anything with it and was sending it somewhere else. I got 12 postcards over about 18 months, telling

me where my script was at the BBC and who was reading it at the moment', Jordan remembers.

Eventually he was invited to attend seminars, addressed by comedy writers like John Sullivan, Carla Lane, Lewis Gilbert and Paul Jackson, run by the BBC Script Unit – 'now closed down, a crazy decision'. There was a period of about six months where he went to such functions, but was 'still not taking it seriously', before he received a positive postcard from *EastEnders*. Mike Gibbon, who was taking over from Julia Smith as executive producer in 1989, said he had read Jordan's much thumbed script and had liked it and was able to offer chances to new writers.

'He called me to a meeting and I remember trying to sell him a Filofax, because I had about 40 cases of them at the time. I was good at what I did but I didn't sell him one for some reason, I think it was because he offered me £1,200 to write an episode for *EastEnders*. My eye was slightly taken off the ball, of selling a £4.99 Filofax. So that was it really. After I had got the appointment with Gibbon I started to watch every episode, so I had some idea what I was talking about. And on the way out of the meeting I stole a script so that I knew what one should look like, that went under me jacket. On the markets I knew that presentation was everything. If I was selling cut glass crystal I would put it on a board to look good. I figured that if I did a script that looked like a script that was half the battle. That way, I thought, it would look as though I knew what I was doing despite the fact that I didn't.

'They gave me what they call a story document, which tells you what they are looking for in that particular episode. I had to take on this cliff hanger after Arthur Fowler had at last found out that the departed 'Dirty Den' was the father of Michelle's baby. Michelle's mother Pauline knew before then but not her father Arthur. Normal *EastEnders* stuff. I felt I knew the characters, or knew people like them, so it wasn't difficult to write.

'One of the things I did, probably because of my nature and my arrogance, was to include a lot of my own stuff. I squeezed what they wanted into about 17 minutes and nicked 13 for meself and me own gags. As an afterthought on the story document I was told that Mike Reid, playing Queen Vic landlord Frank Butcher, had to go into hospital for a back operation. They asked me to make Frank hurt his back in the show, explaining why he would not be visible in later episodes. My episode became that. I had him unloading a lorry, putting his back out early in the script, and then did a running gag through the episode of Frank being upstairs and unseen and having a button which made a bell ring in the bar. In effect that became my *EastEnders* style, with the big story in the foreground and another layer behind. I had a scene in the Vic where two of our main characters were having a huge battle and in the background you'd hear this bell. I went for it wholeheartedly, I threw myself into it, and I think that was they key to why it worked'.

'How about the timing, that can't have been uneasy without any experience at all?' – 'I looked at the other script that I had taken, not just for the layout but the length. I think it was 83 pages, so that gave me my target to hit. I wrote the 83 pages and then timed it with a stop watch, speaking all the dialogue myself. I wanted everything to appear professional. We have to deliver 28 minutes so I didn't want to deliver 12 or 47 minutes. Also I am quite labo-

rious over my stage directions. Since that first episode I have always written in the same way. I put the characters in a room in my head and report what they say. I don't write anything, I just report what they say, what I hear. I report what's happening, I see them move and as I have to write that down my stage directions are quite detailed'.

Tony Jordan's first draft was found good and his third draft better and he was quickly commissioned to write a second episode. Now an established member of the writing team he remains grateful that his first script editor was Jane Galletly. 'I felt myself a bit of a fish out of water, surrounded by people from Oxbridge, people who had always wanted to write and had not done anything else. And I was a jack-the-lad trying to earn a few quid, still on the markets because I didn't think writing was a proper job. Jane was wonderful because she admitted she was also a fish out of water, saying "It's better than working in a tap factory, luv". She is a typical northern woman who spoke to me in a way I understood and gave me notes on that first script in a way that I understood. With some other script editors, even now that I am eight years down the road, I still don't understand what they are talking about. If I had started with one of those they could have chalked me off'.

As it was the Jordan style became recognisable, to the sharper viewers as well as working colleagues, as containing a generous element of comedy. When he was clear of one episode he was booked to do another. By the summer of 1989 he was writing his first pair of consecutive episodes, something reserved for the soap's established writers. Also in that year he was entrusted with two wedding episodes. In June the nuptials of Frank and Pat Butcher (Pam St Clement) was marked with a street party, a summer event recorded in the gale force winds of late spring. Comedy was built round a gate crashing stranger who never got a line to speak. In October this was followed by the ill matched registry office wedding of much cuckolded businessman Ian Beale (Adam Woodyatt) and pregnant Cindy (Michelle Collins).

He delivered nine episodes that year and 13 more in 1990. He goes along with the consensus that 14 scripts a year is a sensible output for an *EastEnders* regular but as an energetic thirtysomething he worked up to 26 episodes 'and other stuff besides'. He now sees the years to 1993 as the 'crazy period' of almost frantic writing, that ended in divorce, though the one did not necessarily follow from the other. By 1997 he was contentedly married again, living close enough to his previous Milton Keynes base to keep in touch with his children there, and pacing his writing better. Though he kept to the Paula Milne method of pacing round a story before moving it quickly from brain to paper.

'Everybody has different ways of working. Mine is not to put pen to paper until the day before a script is due. Sometimes I write on the day it's due, in which case it will be a couple of days late. I used to write overnight, starting at 4.30 in the afternoon and finishing by 10 the next morning. Not now but certainly, because I still write on adrenalin, the deadline being there gives me the trigger and the discipline to sit down and write. Now I also have the discipline of going to the office, that is my ten-yard walk to the garage here. I get in there every morning at 9.30 and stay until the school run, fetching our daughter home, and normally I would go back there for another hour or so until about 5.30 pm. I have come to write straight on to a computer screen.

I started with longhand, then I tried both manual and electronic typewriters, then a small word processer before somebody convinced me to try a PC. The trouble used to be that, because I change my mind so often, the script became unintelligible after a while. I was just surrounded by screwed up bits of paper and stuff'.

With experience Jordan reckons to carry most of the *EastEnders* 'Bible' (biographies of the characters) in his head. He sometimes checks the book but is aware of 'layers of people' down at Elstree who will spot impossibilities and tell him that 'You can't do that because they've only got one leg, or something'. He readily agrees that 'an awful lot of things happen to the characters of *EastEnders*, or any other soap, that don't stand up to too much scrutiny'. But he is impressed by the amount of research that justifies the treatment of issues and the way that characters are changed by events. Through the years to 1997 the Mitchell brothers, Phil (Steve McFadden) and Grant (Ross Kemp), have emerged as the strongest characters, the pair Jordan most enjoys manipulating. Yet it appeared, to the superficial viewing eye, that during that time they had exchanged characteristics. Phil looked to have changed from Mr Nice to alcoholic nasty and Grant from pure thug to Mr Caring. Before any of this happened research would have shown, Jordan is sure, that the birth of his son could be an authentic trigger for Phil's destructive alcoholism and that the departure of Grant's partner Sharon (Letitia Dean) could be a legitimate cause of his changing for the better.

Different executive producers have different styles but generally, as with other soaps, writers attend occasional story conferences. Here stories and character developments are suggested and discussed with script editors and producers. Anything said is filtered back to the script department, where the story editor may or may not take it on board. Extrovert writers like Jordan make the most of such occasions. 'I don't sit quietly and let the meeting go by, if I've got something to say I am confident enough to say it'.

At meetings and between them Tony Jordan has felt encouraged by the reception of his ideas. He, for instance, sparked 'the whole Sharongate thing', when Phil slept with his sister-in-law Sharon, by thinking 'wouldn't it be fun if Phil bonked Sharon'. At that time it had nothing to do with actress Letitia Dean wanting to leave the soap. He fought for the story-line at a script conference, against some concern over character inconsistency, and won a green light.

When I arrived to enjoy his domestic hospitality in early 1997 a BBC despatch rider was at his door to collect the final drafts of the pair of episodes that covered the wedding of temperamental Bianca Jackson (Patsy Palmer) and stolid Ricky Butcher (Sid Owen). In contrast to her predecessors executive producer Jane Harris was not a great believer in mass story conferences and preferred the telephone. So it was that highly regarded story editor, Ian Aldwinkle, had rung to offer Jordan the pair of wedding episodes.

'We talked about it and I asked Ian if I could write the pre-wedding episode purely as a simultaneous stag and hen night, juxtaposing and contrasting the two parties. He agreed and when the story document was issued it merely said 'Ricky and Bianca's wedding, plot to be invented by Tony'. So I had a free hand to do what I wanted for those two episodes. The only prescription was that the couple had to be married by the end of the second episode, that was

where the next writer was picking up from. In the first drafts I wrote 60 minutes of television with only four minutes for the actual wedding. In fact, to be honest, I had no wedding action, I showed it through a series of stills at the end of the second episode. I liked that but they didn't. When they called me in for a discussion they suggested I might like to make a little bit more of the wedding, they wanted to see Pauline in her hat and that. Not so good maybe but the episodes were fun to do and for once there were no cast restrictions, actors not available, so there are characters standing about looking pathetic without a line to speak'.

For his own convenience Jordan likes to give titles to his episodes. This pair he called 'High Jinks'. The hen party was a relatively sober meet, drinks at the Vic. For the stag night a reluctant Ricky was dragged off to a round of strip clubs and many more rounds of alcohol. As episode two started the Mitchell brothers, Nigel Bates (Paul Bradley) and Ricky were found asleep in a field, waking with no idea where they were. Panic ensued when the first voice they heard was French. How could they possibly get to the church in three hours time? Even when they discover they are not in France, but Kent, the odds seemed to be against them.

The third draft given a green light it 'goes to blue' next morning. Which means that it is printed on blue paper and sent to the director. In this case Philip Casson. 'I know Philip, I did my Spanish episodes with him, we have the same sense of humour and the same angle on things so I don't imagine any difficulty at all', Jordan comments. 'I have suggested directors in the past but the decision is taken by the producer. After Philip gets the scripts his team will start looking for locations. I might get some notes back from him saying 'I'd quite like this to happen' or 'I don't like the way this happens'. These will come to me through the script editor for the two episodes. I will sometimes refuse to make the changes and that is respected. At the end of the day it is my work and my vision. But you're not isolated, it's no good having something up your arse. You have to understand the way things work, the mechanics and the system. Which means that the producer, director and actors are usually quite reasonable in suggesting alternatives. My rule of thumb is if I care strongly enough about something I fight for it and don't concede. But if it's 50-50, six of one and half a dozen of the other, it's not really that important and you let it go. Otherwise you become a bloody- minded prima donna. I'm not sure what would happen if a writer and director were at absolute loggerheads, that hasn't happened in my experience. I assume the producer would have to rule on the dispute and in the end, if I still kicked and screamed, I would have to go to Jane Harris'.

Writers are invited to be present at the shoot. Jordan will go along as an escape from his computer on the rare occasions when he feels free. He has been known to say to his producer 'I'm sorry that wasn't the intent', a comment that will be taken to the director and discussed. But the process has become more hurried since the soap moved from a bi-weekly to a tri-weekly show. Each episode used to receive rehearsal, a day on the outside lot and two days in the studio. Now rehearsal is cut to a minimum and each episode goes straight to the studio. The occasional location shoot, which Jordan specially enjoys, brings welcome relief from the demands on studio time. The week long visit of the Fowler family to Ireland in the autumn of 1997, which appeared to show 'John

Bull's Other Island' as seen through English misconceptions from the 1950s, brought unwanted controversy but was a great help at Elstree.

In the years to 1996 Jordan wrote for Thames' *Minder* (1988-94) and Central's *Boon* (1986-92), as well as the failed BBC Nineties constructs *Trainer* and *Eldorado*, but considered himself primarily an *EastEnders* writer. From 1996 he began to branch out more seriously with his Hale and Pace vehicle for London Weekend shown close to 1 April 1997, and called *April Fool's Day*. Proposals being considered by the BBC in that year ranged from drama and sitcom to an ingenious dual show that would be both a soap and a comedy set behind its scenes. Thanks to *EastEnders* former market spieler Tony Jordan was on his way.

Deborah Cook

When Deborah Cook arrived to write about Albert Square and its denizens, her first pair of episodes being transmitted on 20 and 22 March 1990, she was already experienced in the ways of soaps. A child of the London green belt, brought up in home counties villages and settled in Kent since her 1973 marriage, she contrived to be expelled from school aged 16 and to stay decently rebellious in her subsequent years as an art student. 'I did a bit of painting, the trouble was that I was surrounded by people who were real painters. I'm a good craftsman but I'm certainly no artist. It just never occured to me that I could write instead, having been such a miserable failure at school, I thought you had to have two degrees from Oxbridge to write...'. Until 1980, when she heard a more than usually feeble omnibus edition of the 1950-born BBC Radio soap *The Archers* one Sunday morning. She said, as people do, 'I can do better than that' and her husband said 'Well, stop moaning about it and do it' and she felt sufficiently galvanised by the implied criticism to write a single script and send it in.

'I wouldn't have done it if I had known as much as I do now', she claims. 'I rang them up the next day and asked "Have you read it yet?" I think I must have rung them up every week for a year until I got William Smethurst (editor from 1978 to 1986) on the line and he said "If I promise to read it will you stop nagging?" After he read it he came down to see me quite quickly and asked if I would like to try a week of episodes'. He liked what she wrote and she contributed some 200 more episodes over the the next five years. At that time the show had two teams of writers who alternated every six months. It was 'five episodes a week, very tight, very enclosed, a little incestuous in fact'.

'Was writing for *The Archers* good training for a television dramatist?' – 'I don't think any radio prepares you for television. Radio is a very undervalued medium, the cliche about the pictures being better is true. Everybody has their picture of what the characters in *The Archers* look like. You can't get it wrong because the image people have in their heads is perfect. So you've got a head start, the audience is doing half your work for you. On television you don't have that so radio is no preparation and it is quite difficult to get out of the habit of stylistic radio dialogue'.

Nevertheless she did move over to television when William Smethurst was given the impossible task of trying to revive ITV's 1964-born *Crossroads*, the soap of cardboard people passing through a cardboard Midlands motel.

Bravely taking it on as it tottered towards final collapse Smethurst brought in some of his trusted writers and promised to take the show up market and make it 'unrecognisable in six months'. Before his plan was complete, in the summer of 1987, Central (the Midlands company that inherited the soap from ATV) announced that the motel would be closed for good nine months later. Deborah Cook was one of several *Archers* writers invited aboard the sinking ship. She thus had her first lessons in the making of the cheapest possible television drama, contributing three *Crossroads* episodes.

As a would be television soap writer with knowledge of farming Cook's obvious next step was the Yorkshire serial then titled *Emmerdale Farm*. This had actually been started in 1972 as a television answer to *The Archers* and at first its low-key scripts did include some authentic reflection of country life at least in the background. Cook met a good script editor in Andrew Holden and it was he who invited her to contribute.

'Before *The Archers* I only knew about farming in a generalised way. My husband was an environmental micro biologist and I had a fairly good rural background. I knew more through *The Archers*. Now the main thing was to learn about television techniques, how to use pictures and the multi layers that television gives you, how to tell two stories at the same time, what you see and what you hear. They can complement or contradict each other. Getting into all that was fascinating stuff, though I don't think you ever learn entirely to do it as well as you would like. There is also the added element of the director who has his own view of what things should look like. You have to compromise more on television than radio. On television there is this great twilight zone where things change between script and screen, some of which you can control and some you can't.'

Cook's first *Emmerdale Farm* episode showed her she had a lot to learn but was good enough to earn her an instant place on the list of trusted writers. She attended Leeds script conferences and proved as good as anybody at kicking stories round. The downside was that there was less room for her perceptions, and equally more prescription, than there had been as a radio writer.

'On *Emmerdale Farm* you delivered your script and that was it, you had no input or control of what happened afterwards at all, not on any level. They didn't like you on set, in the studio, at rehearsal, so once you had done your second or third draft that was it. Sometimes they would involve you about changes, sometimes they'd just do it themselves. You do get an input into the story-lines at script conferences. You have to be fairly assertive then, though those who talk loudest at conferences may be less good writers than those prepared to sit and listen. Sometimes I was good at speaking up, sometimes I couldn't be bothered. At *Emmerdale* there must have been about 16 of us, some more regular than others, some doing an episode every couple of months, some wanting to do a lot. I reckon 12 to 14 episodes a year was a happy sort of pace, allowing you weekends and an odd day off.

'I didn't particularly enjoy *Emmerdale*. When I started they sent me this vast wadge of scripts to read. I thought "Gosh this is good, this is smashing, from a lot of very very good writers". Then I saw the finished product and couldn't understand why, by the time the scripts reached the screen, they lacked anything exciting or dynamic. I was surprised by what I saw on screen and felt

frustrated in not being party to the process of getting it there. I hate slagging things off but it was frustrating at *Emmerdale Farm*. You would write stage directions to help you form a picture in your own mind but there was no assurance that they would be followed by the director or even that they remained in his text'.

In early 1990, when story editor Andrew Holden moved to *EastEnders*, his protege Deborah Cook was more than happy to follow. 'I already knew *EastEnders* was a fabulous programme, that it could be the worst in the world but when it got things right it did them better than anybody else', she remembers. After the *Emmerdale Farm* system the Elstree way seemed like a writers' paradise. 'I loved the way you could do two-handers, you could go out of the parameters of normal soap. And you did have such an input. You were as involved as you wanted to be, right through the process, even when the cameras were rolling. If something went out on screen that wasn't right it was nobody's fault but your own. And if it was good you could feel genuinely satisfied. We were almost required to go on set'.

In her early months Cook took full advantage of the open door policy, learning about the use of cameras and lighting, what was possible in mechanical terms and what was not. This gave her increasing confidence as a writer and a much better grasp of what works. Thanks to the goodwill of her first series producer, Corinne Hollingworth, Cook was at once added to the list of regular writers, contributing the sensible 12 to 14 episodes a year. 'I got on enormously well with Corinne, she's a very tough lady but she's not stupid, I have a lot of time for her', challenges Cook in the face of Hollingworth opponents.

The Mitchell brothers had arrived in Albert Square with Tony McHale's Episode 522 on 22 February. In her first episodes a month later, 529 and 530, Cook was asked to bring them on more. She echoes Tony Jordan in pointing to the strengths of the brothers but agrees their strange development may be down, partly anyway, to writers fighting against the boredom of repetition. 'To me the brothers were fun, they were rough, they were classic heart of gold East End types. Phil was the one who brought Grant up and Grant was the hooligan... until he went through his Damascan change. Like all characters they develop and get different sides to them as they go through. Writers get bored with saying the same thing and actors get bored with saying the same thing'.

'I suppose their sudden distraction of a mother, Peggy Mitchell (Barbara Windsor), helped the change of their style a bit?' – 'They always had a Mum, though the actress has changed. She appeared in 1991 when Ricky eloped with Sam, sister of Phil and Grant, she came in very briefly and disappeared again. But Peggy can't be blamed for Phil's sudden alcoholism. And when it comes to issues like that the producers do work very assiduously in concert with the appropriate organisations. They would have consulted Alcoholics Anonymous over Phil just as we worked closely with the Terence Higgins Trust and the hospice movement over our AIDS story-line. For my part I think Phil could be a lighter character and, like part of the audience, I yearn for a happy relationship whatever the pressures. It is probably not possible but it would be nice to see bits of it'.

Deborah Cook devoted the best part of two writing years exclusively to *EastEnders* before she began to divide herself between this and other work. Then,

thanks to her alert agent, she also wrote for BBC1's *House of Elliott* (1991–94), the Jean Marsh and Eileen Atkins created formula about a pair of impoverished 1920s sisters setting up a London fashion house. She was able to use what little she had learned about fashion at art school and wrote three episodes of the first series, three of the second and four of the third series.

'Was this show already prescribed when you arrived on board?' – 'Well, it was certainly prescribed by the perceived audience, a Sunday evening middle-aged female audience. The story lines were devised by the producer and story editor. The fashion house, the two girls Evie and Beatrice and their rags to riches story, were all in place. There was no chance of inventing subsidiary characters either, you took your story-line away and wrote it'.

'It sounds almost as if you had more creative flexibility writing for *EastEnders*?'. – 'Yes, in a way, there is no time to fuff around with a soap, you get it right first or second shot or you go under. On something like Eliott, where you have got more expensive production values, there is much more time for messing around with the script and letting other people involve themselves. And the more people involve themselves in a script the more prescriptive it becomes really'.

When we met in early 1997 Cook was enjoying a successful return to soap writing, with BBC1's *Casualty* (from 1986) as well as *EastEnders*. Before that she had spent 'every waking and sleeping moment of my life for two years' on her six-part dramatisation of Sir Walter Scott's *Ivanhoe*. It was the largest task she had undertaken and, in theory, a big step up in the hierarchy of television dramatists. It also showed how the modern BBC, with an eye on the supposed demands of the market rather than artistic integrity, had become unconcerned about trampling over the perceptions of its writers.

It seems that the serial was commissioned for a BBC1 Sunday evening slot because controller Alan Yentob admired the book, and thought it would dramatise well, but was not inclined to risk placing the story where it belonged in the Sunday tea-time family slot. Still less find the money for a version sufficiently sanitised for the censorious. Sex and violence, such as it is, was in the book but that was considered an inadequate defence against the minority who would protest at a showing of the story before the "watershed". 'This is where the extremes of the accommodations the BBC has chosen to make with the Poujadist (bourgeois) army clearly comes unstuck, because you can't put *Ivanhoe* in its most ideal place in the schedule', as head of serials Michael Wearing puts it. 'Even though the serial is not what the public expects, which is really adult television after 9 pm'. This mistake was compounded by the fact that what Deborah Cook wrote was, in several episodes, more adult than what appeared on screen.

At the start Wearing did his duty and invited producer Jeremy Gwilt to make the post-watershed serial, and Gwilt asked Cook to write. She had read a lot as a young teenager, in preference to her set homework at Bishop's Stortford Grammar School, and had loved Sir Walter Scott's *Heart of Midlothian*. This, and the tendency of her Scottish father to regard Scott as the only writer worth reading, made her turn with some excitement to her first meeting with *Ivanhoe*. With six 50-minute episodes prescribed she found the novel 'a bit of a shock'.

'Was the prescription to be true to Scott or to write a serial for today?' – 'Neither. The first thing Jeremy said was "Go away and see what you want to do with it". My first feeling was I would like to be as true to Scott as possible but after reading the book, and I can understand why nobody seems to get beyond page eight, I knew that wasn't entirely possible. There are narrative holes in it you could drive a bus through. There are inconsistencies of character, there is no motivation ascribed to people who do the most outrageous things for no reason at all, some drop through a hole in the floor half way through their own stories. Ivanhoe himself gets wounded on about page 50 and stays in bed for the rest of the book'.

Cook spent a long time searching for a theme and then subjecting it to analysis. She decided that her *Ivanhoe* would be a story of redemption and that the protagonist should not be the eponymous hero but the interestingly layered knight Bois-Guilbert (Ciaran Hands). He would be shown as the keen crusader who became debauched and profligate but redeemed himself when he sacrificed his own life for the woman he loved. And his love, the strong and resourceful Rebecca, would be seen more interesting than nominal heroine Lady Rowena.

'The danger with a book like *Ivanhoe* is that *Monty Python* has been there first, so has Mel Brooks. The giggle factor is enormously high and the minute you have pale blonde maidens wafting around and saying "My lord" you go straight into the giggle factor. You have to make them into characters who are at least rounded enough to make you see why people should fall in love with them. For a 20th century audience it is not enough to use words like "love", "chivalry" and "honour" you have to see your women as being capable of inspiring love'.

In building Rebecca the writer also looked beyond Scott's anti-semitic prejudices to the fact that Jewish women were better educated and had a more dominant role than their Christian counterparts in Saxon or Norman England. There was a consensus in the production team that Scott's anti-semitism should be toned down and, as Cook says, 'I would have felt very uncomfortable about doing the scripts if somebody had said to me "Stick absolutely to the attitudes expressed in the book". Despite the preposterous original this was a writer friendly project until the appointment, over Cook's head, of Stuart Orme as director. When the serial started airing, on 12 January 1997, it was soon clear that there was a conflict between the writer's care for character and the director's liking for action.

'At times I thought the show did become *Monty Python*esque, men hacking away at each other, so that you lost track of who they were and ceased to care. That was presumably not what you intended?' – 'I had an enormous problem with the director. It was fine up to the first read through, I was as involved as any writer can be, but after I began expressing my feelings about the director's story changes I was marginalised so that I could not cause trouble. I suppose it was the difference between male and female approaches to the story. I am much more interested in the characters and their dilemmas than action that is briefly exciting but dramatically sterile. The decisions he made in terms of story change and altered emphasis were entirely out of my hands. Large lumps of story and character just disappeared. Neither episode two or four would have been transmitted in the shape they were if I had had any author-

ity. I lost 70 per cent of episode two. There were lots of rewrites done on set, there were lots of rewrites done by the actors themselves. Actors, as they always will do, had their bright ideas and the director allowed them to put them into practice. So quite a lot of the serial was as much of a surprise to me as it was to everybody else. I asked to be in on the editing, and could have put a point of view then, but I was only allowed to see the rough cuts of the episodes'.

After which it was quite a pleasure to return to *EastEnders*, though the move to three episodes a week was more testing. And 'great fun' to do a *Casualty* episode. The self referential regulars are prescribed, along with the require-ment for accidents, emergencies and blood, but at least the writer is free to devise three or four autonomous stories and know that her script, and her subsequent input, will be respected.

Joanne Maguire

Another protege of William Smethurst the Belfast born and bred Joanne Maguire also arrived at Elstree, in 1993, with plenty of soap experience. Four years on she remained devoted to *EastEnders* but also determined not to be type cast as a television dramatist. As might be expected of an Irish convent schooled Catholic, who did nine years as a research biochemist before she became a writer, she cut her writing teeth as a stage dramatist. Having escaped from her native city and its 'troubles' aged 18 she had made herself at home at workshops of the Tricycle Theatre in London's Kilburn before she found herself on a course run by Smethurst. When we met in late 1996 she was writ-ing a radio play, looking forward to writing a second novel 'one day' and 'if I could get into writing (cinema) films obviously I'd be off like a shot'. But for the moment anyway she was content to devote herself mainly to the prescrip-tions of *EastEnders*.

After the terrestrial motel was pulled from beneath his feet William Smethurst went on to create *Jupiter Moon*, 'basically *Crossroads* in space' as Maguire characterises it, for the satellite station BSB. He had encouraged her on his writing course and four months later commissioned her to write for his new show. Always keen on sci-fi she took easily to this faintly camp formula, little dramas of people living in a space station near Jupiter in the middle of the 21st century. Before it was abandoned BSB made 150 episodes of the thrice weekly soap, Maguire contributing 20 of them. 'It was a wonderful training ground for me. Nobody was watching and so I had nothing to be embarrassed about, though it may well come back to haunt me one day', she says. 'I made a pile of money and was able to give up the day job and have a year off. I had some input on story-lines but really you just did first drafts and the script editors did the rest. They wanted a script in six days, then you handed it over and that was pretty well it really. They would chop and change and tweak the dialogue but I was never too surprised by the finished episodes'.

After her 'year off', which meant writing radio and would be cinema for her own satisfaction, a former *Jupiter Moon* script editor invited her to write for *The Bill*. Born out of Thames's *Storyboard* drama collection for ITV this spe-cialised soap centred on Sun Hill police station in London's East End, and the working lives of its cops, had been running in one shape or another since

1984. During a two year stretch in the early Nineties the hard-working Maguire wrote ten episodes before feeling herself 'pretty burned out'.

'Five a year is about as fast as you can do them. You had to come up with the stories and then go through premise, outline and script. Each story went into a group meeting to be discussed and it took at least two months to get a script through all the way. You choose your characters out of the 25 they have. The format demands that every scene has to be seen through the eyes of an on duty cop. It is a limiting format but you find devious ways to tell the story you want to tell. It is always a challenge, an intellectual puzzle in a way, not being able to show the incident, the burglary or whatever, only being able to show what happens when the police arrive. I had quite a high hit rate with my premises. At first I went through ten ideas before I got one through but once I was on the show and had more information about what they'd done, and what they were looking for, I got more clever. So in the end one in two of my ideas got through, about 50 per cent is the norm. I have also written for *Casualty*, much harder work because you need at least three stories per episode, and there I have put up a dozen ideas to get only three episodes through'.

'Are there some crimes so horried they are not acceptable for *The Bill*?' – 'Yes, I tried to do male rape and they wouldn't have that. The producer at that time didn't like stories about gays. My idea was about the reactions of the characters to the crime, it wasn't really about the rape as such, but still it didn't get through. It isn't really into issues. They've done racism but only from a very crime accented viewpoint. It's a very pro-police show, the police getting on with their job and getting their man. It redresses the balance with so much anti-police stuff around'.

Hearing that *Jupiter Moon* script editor Jane Fallon had moved to *EastEnders* the flexible Maguire sent a screenplay to executive producer Leonard Lewis in early 1993. It took a while for him and his 1994 successor Barbara Emile to consider this but they eventually decided to give Maguire a trial with three singles. Her debut Albert Square episode, No 875, was transmitted on 13 July 1993, and followed by No 895 on 21 September. With her first double, Nos 933 and 934 on 1 and 3 February 1994, she became a trusted regular. She was in good time to share the difficulties, and the dip in morale, when from Monday 11 April and a second 'Episode 1' the soap became a tri-weekly. Not all at Elstree cheered when, at the end of the year, an exhausted Barbara Emile stepped out and tough former producer Corinne Hollingworth returned as boss. But there was no shortage of work for the regular writers.

'For about a year I did triples all the time. It was pleasing but it was also hard work, 90 minutes of drama every two months. At that time I definitely had no room to do anything else. But it was a good living, from the financial point of view anyway. On soaps you can do very well, so much work is wanted. A comfortable £70,000 to £80,000 a year is quite achievable if you are working hard, writing your 12 or so episodes every 12 months. The best paid writers in television, the ones with steady earning power, are the soap opera writers'.

'Are you in constant danger of being dropped even when you are part of the inner core of writers and does it help to be a man?' – 'I found *The Bill* rather a boys' club but *EastEnders* is quite 50-50. Maybe just now there is a slight

male domination in the inner core but the producers and script editors are mostly female. The writing team changes every year or two, people move on and do other things, they come and go and sometimes they fall out with producers. There is never a big flushing out, nothing as naked as that, but there will be the occasional influx of new people. People who might take over key positions, get the commissions, which means that others are squeezed out. But that kind of thing takes a while, you have time to do something about it. Writers who can write soap month after month, produce good workable first drafts and are no trouble to work with, are considered a desirable commodity. So if you are on the ball and doing it well they are not going to kick you out for a trivial reason'.

'What do you mean by "no trouble"?' – 'I mean those who do not let their personal lives intrude, who say they can't deliver for another week because their baby has got smallpox or something. Fighting over the work, defending your vision, that is not seen as being troublesome, that is seen as being committed and careful about your work. So long as you recognise the contingency of the production line, know the point where you have to say "I'm not going to win this one" and let it go. There have been fallings out, as the Tonys (McHale and Jordan) will tell you, they've certainly had bad experiences and gone off in a huff for a few months because their scripts have been changed. But I have been fairly lucky with mine, I'm fairly pragmatic, I see the job as giving them what they need and want really. I don't get into a lot of hassles and I don't get very upset if I can't do what I want to do'.

But perhaps even the calm and pragmatic writers have to recognise that there is only so much they can give to one show?' – 'Yes, that is why my own work is still definitely on the agenda. You know you are going to be burned out eventually. I think anyone who wrote a soap opera for ten or 20 years, at the rate I do now, would go crazy. I am enjoying it now, it's as easy as it has ever been and is flowing, I am sure I will last longer on *EastEnders* than I did with *The Bill*. I hope I will be associated with it at some level for years to come but I don't want to become institutionalised by the show'.

'You make it clear that you owe no special allegiance to television as a medium and that if anything you feel more attracted to cinema, or at least the idea of cinema, but would you not allow that television also has its special strengths?' – 'I think television is a serial medium and one offs are better in the cinema. You are never going to get the kind of exploration of character in a two-hour film that you can get in a four-part series. The wonderful thing about soap is that every nuance of character is explored. The audience knows Pat Butcher (Pam St Clement) so well. We've lived with her for years so we know everything about her and how she's going to react. That's wonderful, it's a joy to write. To some extent, yes, everybody comes out with everything as we never do in real life, but this serves to explore character. You can say what you like about the plots but they are only there to give the characters something to emote about, for us to explore.'

'Although you are to some extent bound by previous story-lines there seems to be no limit on how much characters are pulled and pushed into change?' – 'Yes, that's the creativity of it. I might have an argument with the producer about how Pat or Peggy Mitchell might react to something but that's just part of the general discussion. The evolution of the Mitchell brothers over five

years has been totally natural, there has been nothing forced about it, it's to do with Grant's relationship to Sharon, what that did to him, and Phil getting involved with Cathy (Gillian Taylforth). When she started Pat was a slag, a brassy tart, now she's the Mother Courage of Albert Square. And I think that's the beauty of it, if characters stayed the same it would be terribly boring.

'Take David Wicks (Michael French). When he came on two years ago he was the flakey, long lost son of Pat, down on his luck. He was brought on to replace Richard 'Tricky Dicky' Cole (Ian Reddington) really, we thought we needed a baddie, someone that everybody was going to hate. He was brought on to be a wheeler dealer and shallow but because the actor was so good and the character was so interesting, and there was a big audience reaction to him, we started mining his depths and finding out why he was like he was. We stuck to the vision of him as a man who could never love anyone but a lot of people cared about him by the time he left. It 's a very chemical thing. The casting was wonderful and the character came to life. One writer will give the first idea of a character in a biography and then start writing him into the scripts. Four or five months later the casting is done and you wait for them to appear on screen and see what they are like and adapt accordingly'.

'Some characters do not materialise so well and have to be quietly dropped, others have to be written out because the actor insists on leaving, a disaster in some cases?' – 'Yes, we are lucky to have the Mitchell brothers for instance, it would be a disaster to lose them. Ted Hills (Brian Croucher) is a recent example of where casting just didn't work, so we're quietly shuffling him away into a corner until his contract ends, poor man. There is always a risk with kids of course, you just have to try and cast children who will pick it up quickly. Writers soon know who can act. Martin Fowler was a great problem for a long time, you had to do scenes where he has just one line. Then the actor changed, nothing like the one before, and the new one popped up one day and he was talking and having his own scenes.

'A different kind of problem we have is Mark Fowler (Todd Carty). The first actor in the role committed suicide. The present Mark is HIV positive and he can't go on for ever without becoming ill at some stage. He has had the condition for seven or eight years and its very rare not to develop full blown AIDS in ten years. It's not fair, we've got to be realistic, so every time we get together we discuss what to do about Mark. And he's one actor who doesn't want to leave the show, it's sods law. Likewise with Joe Wicks (Paul Nicholls). He was brought on just to be David's son and then the idea came from somewhere that he would be schizophrenic. That meant we were lumbered with a character who could not get better, who is stuck with his condition for life. It also happened that the actor turned out to be very charismatic and gathered an enormous teenage following, getting more fan mail than anybody else. So we want to keep him going and make him a useful character in other stories but we also need to be realistic about his condition'.

'Are you a joiner as far as the Elstree community is concerned or do you prefer your domestic desk?' – 'Well, I don't go to the shooting very much because I haven't the time. And it's quite boring watching other people working when you don't have a function any more. The script editor deals with any hassles that arise, though I may have to do some rewriting to get the length

right. I think writing for *EastEnders* is comparatively easy beside the work expected of script editors and actors. Script editors are caught in the middle, taking notes from producers, directors, the people who do the logistics of shooting, actors wanting to change their lines and complaining writers. It's very pressured and has a high burn out rate. They've got to keep the writer calm, get them to do what is wanted and then see that it is all published in time.

'I have attended the old six monthly conferences where characters are discussed. We talk about characters in general and where there lives are going and where we want them to end up. I am very bad at these occasions, not one to shout. They can be very raucous and dominated by the bigger personalities. I find that a bit hair raising. I tend not to say very much and go to the story editor later and say "Look, I've got some ideas, I didn't get a chance to talk about them". The conferences are interesting, you do get to talk about the characters in great depth, but I'm afraid I don't contribute enough and I feel guilty about that'.

'But on the whole you are happy in your work?' – ''Yes, the atmosphere is so bad at Television Centre just now, what with the commissioning log jam and generally low BBC morale, that it is good to be out in our own separate little enclave at Elstree. At the moment it is a very happy place and Jane Harris has done an enormously good job of turning it around and boosting morale again. It was not so good when Corinne Hollingworth was there. Actors started leaving because they didn't like the new three times a week regime. That was a destablising thing and it has taken a long time to recover'.

Simon Ashdown

Among the script editors, whose capacity to hold the show together Joanne Maguire so admired, was Simon Ashdown. Armed with an MA in screenwriting he did a year as an editor before executive producer Corinne Hollingworth gave him his chance to write. His debut episode, where Michelle Fowler (Susan Tully) found herself pregnant by Grant Mitchell, was transmitted in October 1995. A year later he was still relishing his inner core membership. 'I have job satisfaction, I really enjoy it. It is great to be working five or six days a week, just writing. And it's very seductive knowing that your stuff is going to get made, not just 50 per cent of it as with other television writers', he told me.

It took a while for Ashdown to discover his vocation. He had thought of writing in childhood but this 'drifted away' as unrealistic. Through his twenties he 'did lots of silly things, working on corporate film, a bit of directing, that kind of thing, very low grade stuff'. Feeling his way around he eventually opted for a course in screenwriting at the London College of Printing. Detached from the realities of making a living this way he had no initial interest in televison and lived with dreams of becoming a cinema writer-director. Aged 31 and faced with the need to earn a living he offered himself to *East-Enders* as a writer. Instead Corinne Hollingworth gave him a six months contract as an editor.

'Editing was a tangent but a very interesting one. It has been a fruitful training ground for lots of people. It is very rigorous and exhausting because you

are constantly producing 90 minutes of drama a week. The story editor maps out a month of episodes and then, with help from the series script editor, the ordinary editor has to get individual scripts from first to final draft.There are just six editors at any one time and the turn over of staff is quite fast, I suppose an average *EastEnders* script editor's life is about a year. Then they will go off in all kinds of directions, some to other editing jobs, some to become producers or directors, some to write'.

Given the chance to turn to writing, and knowing better than most rookie writers how the system worked, Ashdown soon showed himself a useful ideas man at the six monthly story conference. He, for instance, invented the Hills family. Father Ted proved an expendable character and in mid 1997 was despatched to a job in the Middle East but his teenage young, born again Christian enthusiast Sarah (Daniela Denby-Ashe) and gay apprentice newspaper hack Tony (Mark Homer), proved unexpectedly rich and fruitful.

'It is quite interesting to watch how this family has changed since I wrote the first biography, telling what kind of people they were, tracing their past lives and their key elements. Sarah's religious story wasn't there in the beginning, nor was Tony turning gay. Ted was a much bigger character than either of them. When inventing new characters you have to think about the patterns and groups in the show, where there are gaps in terms of useful conflict. I thought that Ted, as Cathy's brother, could push her and husband Phil Mitchell apart. He could also be an ally for Cathy's son Ian Beale. There was a need at the time for more young characters, at least one dysfunctional, quite bright but unable to cope. Somebody to reinforce all the worst feelings about herself of Bianca Butcher (Patsy Palmer). But then, once the newcomers have been cast and begin to hit the screen, everything changes'.

'When it comes to writing episode scripts how much is down to your perceptions and how much is prescribed?' – 'There are two things about that. If you have written an accepted ten-page story line, spanning three months, 12 months or whatever, you may well be given episodes which are the climaxes of the line. That doesn't always happen but it does tend to happen. It happened, for instance, when Tony Jordan invented the line which followed from Grant Mitchell finding out that brother Phil had been sleeping with Sharon. I find that if I have had something to do with the story lineing I have automatically got a bit more to say.

'If you are a regular writer you tend to get episodes in pairs. You may have had nothing to do with the original plotting and your job then is to make a number of different stories work together. Some story documents are more structured than others but you know you have to get characters from A to B, otherwise the whole thing would fall apart. The way you do this is kind of dependent on you, if you can make material more dramatic or improve it in some way that's good, but you only have complete control over the first draft really. After that all kinds of other factors come into play. Like what is happening with the other drafts on either side of yours, what other people think of in the way of improvements, good and fruitful collaboration when things are working well'.

'In contrast with, say, *Coronation Street* it appears to the outside eye that writers are free to build the structure, the length of scenes, in their own way?' –

'Yes, you can kind of structure it how you want. I would always try to find what was the one most interesting thing in the episode, or the thing I could most readily engage with, and try to make everything else work around that. It might involve building the main story, adding new elements to it, bringing it to a climax. So the proportions of an episode will change depending on what you are trying to do with the main story. A lot depends on what the writer has done in the past, how much he is trusted, there are so many variables. There are times when you are going to be frustrated but that's in the nature of soap opera'.

'What about deadlines, the time you are given to write your first draft?' – 'Well scripts are needed per month, if you are near the beginning of a month you might only have three weeks, if towards the end of a month you could have six weeks. If you write about 12 a year as I do you are overlapping and may have four on the go at once. There are contracts. I signed to do ten this year, leaving me free to do something else if I wanted. Last year I did 13. In my time I have done 15 and a *Casualty* but that felt like being stretched to the limit. There are probably 25 to 30 writers on the list at any one time of which eight to ten will be regulars'.

'I asked for permission to sit in on a story conference but was turned down, do you find these meetings useful?' – 'No outsider has ever been allowed to sit in. It used to be a weekend, we stayed at a hotel, starting on Saturday morning and going on to Sunday lunchtime. Now it has been reduced to one long day, stretching from 9 am to 6 pm. These meetings can be productive but they are not always. You can get stuck with a character or where to go with a character. But you do get ideas that would probably never come up with just one or two people in a room. People throw things in and you might get something which initially sounds a bit strange but turns out to have been a really good idea.

'Some people are good at these large meetings, others quieter. Basically it is a reassessment of the show, what do we do with these characters, what do we do with this couple, do we want to bring them up bigger or try them a different way, do they have problems, should they have a baby, are there other issues we want to deal with? There is a shared history among people who have worked on the show, some have written it for a long time, some have watched it for a long time, some have had experience as a producer or script editor. It becomes quite obsessive, when you work on it you become quite obsessed by the characters.

'A writer in this kind of television spends some of his time in the attic alone but you do go to meetings, commissioning meetings, meetings with the script editor about script drafts, there is a lot of contact going on, most weeks there is something if only a phone call. It's not like tucking yourself away to write a novel or even a book about television dramatists'.

'Is there continual pressure to be still more popular which I suppose in some minds might be interpreted as being still less subtle?' – 'I tell you what, nobody thinks like that when they are actually working on the show. If anything the pressure is to make it more subtle not less. I don't think there's any pressure to make something really clear so that everyone understands. Everyone is trying to make it as good as possible, they are not looking for a certain kind of niche, that's the way it has always felt to me. Three times a week we

are looking to see how far we can push the characters without losing the belief in the mundane quality of their lives'.

'Are you one of those writers who would like to guard his scripts after they have "gone to blue", are in the director's hands?' – 'You can be on set, I haven't been there much because of time. If there is a problem about a continuity thing, like you are pre-empting something that's going to happen the following week, you are going to lose that argument anyway aren't you. If it's an important word in a line that's another thing. We talk everything through with the script editor. We are pretty distanced from the director, I have only met about three. You just wait to hear the name of your director. You get to know who you like and who you don't like just by watching the episodes. It is hard to know exactly what a director does unless you are there for the shooting. You are already working on your next script, which is good, it makes you feel part of the process. You can see your episodes in advance, I prefer the trauma of watching it on air, there is more of a sense of event about that'.

'Sitting at home and watching your episodes on air are you ever surprised by ^ ^ou see?' – 'What's nice about it is that because you know the characters ^ ^et, because you know the different qualities of the different spaces, ^ roughly how it will look and how the atmosphere will feel. Of c^ ^irector will work in a different way but you rarely find scenes played in a different way than you imagined. Sometimes you are surprised that a scene works much better than you expected. Sometimes you think you didn't intend that or they missed a point or whatever.

'The worst things arise from timing because everybody's got a slightly different idea of how long scenes last. You write what you think is maybe a minute over and they tell you that you are three minutes under. Then you negotiate and rewrite. That may not be the end of the matter. When you watch the finished episode you may find something you have really gone into chopped down by three minutes. You are sure it is the wrong three minutes and the balance of the drama has been spoiled, though it is all personal choice and maybe no three-minute cut would make you happy. Nobody else notices any of this, of course, because only you know the original overall shape'.

'To what extent do the individual writers have trade marks which should make them indentifiable to attentive viewers?' – 'A certain number of writers, not all of them, have a recognisable style. Some have got a sort of trade mark and you know who they are. If there were lots of short scenes, lots of continuous action, following people into the Vic, into the street, into somebody's house, that kind of mix about them, you could make an educated guess about which writer. Probably the better writers are the ones you kind of notice. I don't think I could tell who a director was, maybe one or two but I find that much harder to detect'.

'For the moment you are clearly very happy in your work but is there not a danger of blunting your drive and imagination by staying in a rut? And what happens if you have some personal or political or social message you want to feed to the audience?' – 'There are two sides to this aren't there. After all Jimmy McGovern wrote for *Brookside* and Jack Rosenthal worked on *Coronation Street* both as producer and writer. They came through that apparently none the worse. For my part I think it would be interesting to see if I

can work intensely for *EastEnders* for a number of years and then combine the soap with other things, but I am not sure. I don't know what it used to be like when there was a greater variety of drama slots when, as people who were around then talk about, a writer could get his voice on air. But I do know that I have job satisfaction at the moment, I really enjoy it.

'I agree that if you have a personal, political or social agenda to put across, something you feel really passionate about, you can't do it on *EastEnders*. If the pressure of this ever gets to me I shall have to take six months off and do it. For the moment I'm enjoying the *EastEnders* process and feeling it will not stop me doing other things in the future'.

9 Early risers

Ol Parker, Phillipa Lowthorpe, W Stephen Gilbert

I know there is a fundamental policy about youth and it is tragic. I can't feel guilty about it because it's not specifically me shutting out the over forties but it is really sad. There are people who can write a hell of a lot better than I can but who may not know about the same things. I am sure it is not about the dearth of opportunities, more a fundamental ageism about the place.

The autumn dramas schedules of 1997 were largely business as usual, a continuation of the soaps, a return of familiar formulae dominated by crime, a preference for worn cinema material as against new television drama sitting on shelves. In this context Channel 4's *A Dance to the Music of Time*, Hugh Whitemore's ludicrously truncated adaptation of the 12-volume novel sequence by Anthony Powell, looked sadly out of place and time. As did Paul Greengrass's resonant drama about a Sixties football bribery scandal *The Fix* (BBC1), Kenith Trodd's last stand as a BBC housed producer. That single film together with the individual visions of Jimmy McGovern's four-part *The Lakes* (BBC1), Lynda La Plante's two-part *Trial and Retribution* (ITV) and Tony Marchant's eight-part *Holding On* (BBC2) stood out in lonely isolation. Though it should also be noted that both the London located La Plante and Marchant series were on message with their fashionably squalid urban settings. Even the McGovern quartet spread an ironic layer of Liverpool inner city grime over its eponymous rural landscape.

Of the three Marchant's gripping serial, a somewhat Dickensian portrait of 1996 London made like a mosaic assembled over the weeks to develop a picture, was the most ambitious. It presented eight apparent strangers whose lives touched as the story progressed. Each of the eight could to some extent claim their own customised television style though the prevailing naturalism was never far away. Except in the treatment of disabused Essex man Gary Rickey (Phil Daniels), a bulimic restaurant critic turned anti-football reporter, who functioned as an occasional narrator and was filmed by director Adrian

Shergold splattering his 'estuary' accent directly into a fish-eye pop video lens. Whatever may be thought of the monotonous gloom, and the reflex repetition of extreme violence, it was a brave attempt to portray London as, in Rickey's monologue, a 'crime-infested, decaying, paranoid capital'. It generated something of a texture to set beside the Liverpool dramas of Bleasdale and McGovern. It was a series that came about because then BBC2 controller Michael Jackson was suffering from costume drama fatigue and suggested to producer David Snodin that it was time for something 'hard-hitting, contemporary' and indeed 'writer-led'.

Before transmission Jackson had moved to become Channel 4's Chief Executive. One of the results of this was the departure of writer friendly drama chief Peter Ansorge and the arrival in his place of Granada's more commercially rigorous Gub Neal. 'There are many who would regard *A Dance to the Music of Time*, and probably me as the man who commissioned it, as part of a dying order; a throwback to the pre-Murdochian era when it was still possible to commission high-cost drama simply on personal enthusiasm', he wrote in the *Guardian* that October.[1] The central point of his article was the self evident one that things were not as they used to be. There were fewer slots for original or authored television drama than Ansorge enjoyed in the Seventies as a young script editor at BBC Pebble Mill. No wonder young writers were looking, as directors had in the past, to Hollywood. 'Jimmy McGovern is perhaps the last in a line of powerful dramatists who are committed to television', he coat trailed.

Tony Marchant took up the challenge[2] as his *Holding On* reached the end of its BBC2 run. 'I am part of a generation of writers including Alan Cubitt, Guy Hibbert and Debbie Horsfield who are at least ten years younger than the likes of Jimmy McGovern, Lynda La Plante at al and who are every bit as committed to the idea of challenging drama as I am', he wrote. 'The reception given to *Holding On* and the speed and enthusiasm with which it was commissioned surely undermines Ansorge's "all is lost" pessimism... but if the contributions some of us have made are either unacknowledged or simply denied we could not be blamed for voting with our feet'.

Rational consideration might well want to make us challenge the Marchant assertion that 'the future of television drama depends on the enthusiasm and energy of a younger generation excited by the idea of working in it'. Those in command ought to be keen to commission from writers of *all* ages able to produce fresh work. The Nineties reality is nevertheless as he suggests. If you want to be your own woman or man as a television dramatist it helps to be young, if possible even younger than the thirtysomething Marchant generation.

Ol Parker

Oliver 'Ol' Parker was still a Cambridge undergraduate when still younger BBC producer Elinor Day persuaded her department to give him his first commission. His *Loved Up* debut television drama opened the BBC2 Screen Two season in October 1995. 'It was extraordinary, and still is baffling to me,

1 'Prison's Too Good For Us', *Guardian*, 18.10.97
2 'The Young Writer is Holding On', *Guardian*, 20.10.97

that the first thing I actually finished was filmed. It was a fairy tale. I am a person that Simon Gray would hate', he told me. 'A week after they had the first draft I was given a shooting date, for several months later. So I got the chance to rewrite closely with the director'. And even before shooting on this one started Parker was rewarded with a second commission, filmed as *In Your Dreams*.

'I've been incredibly lucky that the only two films I have finished have been made and it looks a though the third is going to be', he said when we met in late 1996. 'Other writers get drunk and accuse me in pubs that I am the BBC youth policy. They say "Get above thirty and you are out". Things got made because E (methylene-dioxymethamphetamine or 'Ecstasy') is sexy and so gets ratings, it is controversial. I know there is a fundamental policy about youth and it's tragic. I can't feel guilty about it because it is not specifically me shutting out the over forties but it is really sad. There are people who can write a hell of a lot better than I can but who may not know about the same things. They may know more about structure or whatever but they aren't being given work any more. I am not sure it's about the dearth of opportunities that may exist. It is more a fundamental ageism about the place. If they don't nurture the people that write for them it is bound to be entirely unproductive'.

Parker was brought up mainly in London within a supportive upper middle class family. His father is the High Court judge Sir Jonathan Parker, 'a lovely guy, a good, kind and fair man' and 'of course I embarrassed him profoundly by writing about drugs'. In youth Ol was a keen reader who also watched a lot of television drama but never thought of becoming a writer. He thought of his older brother as the budding writer, the likely creative talent of the family. But at Cambridge the undergraduate Ol 'had a real problem reading English... I became very offended about slagging off writers who had done things I couldn't possibly do, whether I wanted to or not. It seemed absurd to be accusing Wordsworth of "emotional cowardice" and so on. So I stopped working at that, I got a degree but it was close'. His mind was redirected through a course on creative writing for theatre, run by once successful Royal Court playwright Charlotte Keatley. 'She turned me on, she invited us to write something and come back with it the following week. I brought a scene back, the first thing I'd ever written and performed, and it got laughs. It was a great moment in my life'.

Over the months the scene became a play, performed as part of the course and eventually a fellow student who was also a gifted actor asked if he could put it on and ask people to come and watch. A 'black, black comedy' unconsciously drawn from the territory of Harold Pinter's *The Dumb Waiter*, and called *Killers* it went well enough at Cambridge to be taken to the 1992 Edinburgh Festival Fringe. Where it was played with its companion piece *Get Up And Be Somebody*, characterised by otherwise encouraging Guardian theatre critic Michael Billington as a 'Beckettian rip off', and was also well received. Not least by the BBC's Elinor Day.

A variety of television people showed interest in *Killers* and the possibility of stretching it into a full length comedy or even a sitcom series. Ol Parker did not see how it could be properly extended beyond 45 minutes. He thought the plot, about two people planning to kill another, more interesting than the

characters. Elinor Day accepted this and engineered commission for him to write something else for the BBC2 *Screen Two* strand.

'I never finished that would be comedy because it was terrible. I didn't know what I was doing, I had never written for the screen before, I didn't know the people I was writing about. I got halfway through it and then admitted to the BBC people "This is all over the place, I don't know what I am doing". They were kind, they seemed to think it was the project rather than me that was poor and misguided. They asked if there was anything I did know about. I said I had been taking a lot of drugs. So it was that *Loved Up*, my first film, got commissioned for Screen Two'.

'When you say "film" I take it that you had television rather than cinema in mind and were able to recognise the difference?' – 'Well yes, it was very talkie and I was keen to use the television conventions as far as I knew them. But I had no idea how to cut, where to leave a scene, and that you should start a scene as late as possible. Myself I think once you are in a scene it is nice to let it breathe. In television now there is a tendency to go the opposite way, which is a real shame. I think in cinema you can go slow, where in television you have to give a shock before the credits. In fact you have to give shocks all the time to keep people watching. At the BBC these days they are very conscious of viewers with the remote in hand. So I think things I've written have moved a bit faster than I would like them to have done'.

'Statistically television is watched most by older or middle aged people. For them I wanted to demystify drugs and make them not quite so much of a scary, demon thing as they have been perceived. For the cinema I think you'd just assume that the only people watching would probably be under 30 and taking drugs themselves so you could write a series of in jokes. For television I had to try and serve the middle aged. That's why I used the structure of a woman coming to drugs for the first time. At home we were told to smoke our spliffs outside. So I was really writing for my Mum, to show her what her children got up to and that it wasn't as worrying as she thought'.

With Ian Hart playing Tom, the drug happy but rather empty protagonist, *Loved Up* was set in London's clubland and centred on habitual E takers. 'It was done from my own experience, very much so. I got some way with drugs. I was close to heroin but I did not actually descend to that so, a bit of luck, yea, I have no permanent ill effects as far as I know. Strangely I stopped using drugs after writing the film. I came to the worrying conclusion that I hadn't actually been living, I'd been researching. I didn't write the film to be an apologist for drugs. I wrote it because lots of people, including myself, were having a really good time on drugs and I didn't feel that was being addressed. I felt the coverage, specially in drama series like *Casualty* and *Inspector Morse*, was fundamentally negative. My piece was more ambivalent, it showed people having a nice time as well as bad times. It left you with an argument that was personalised, not just theories about drugs. David Thompson at the BBC asked me for a treatment and I just wrote "This is a film about E and nobody dies" and he accepted it on that basis'.

'If memory serves there was a lot of publicity and the easily aroused moralistic right was stirred to protest?' – 'Yea, it was a bit of a tough time because transmission coincided with the death of Leah Betts, that 17-year-old girl who died

after taking an E tablet. I was asked to go on various *Newsnight* type things and defend the use of E. I refused because, as I told you, I didn't write the film to be an apologist for drugs. I asked the publicists very strongly not to mention that I was a judge's son. The Daily Express found out, I've no idea how, and rung me and rung Dad for quotes. We both refused to talk. He was very proud of the film, he liked it very much but I didn't want to embarrass or compromise him. I had letters from Tory MPs, there was stuff in the papers, the Sun did a thing and the Daily Mirror did a thing and rentaquote MPs joined in. One guy said that "even if the second half of the film showed some of the possible downside to show drugs as good fun is fundamentally irresponsible". Which I just don't accept. The downside was not all that down anyway but the moral of the story was that drugs are not a basis on which to base your life'.

'Did the "fairy story" of how this film was commissioned and given such a fair wind extend to having any control, or at least input, with the production?' – 'Yea, the sickening fairy tale extended through the process. Elinor Day was producer and David Thompson was executive producer. I had a veto on the director... well I don't know if it was a veto but I met directors informally with Elinor. We met some and I went out to supper with the one we chose, called Peter Cattaneo. His track record was slight but he was about 30 and knew a lot about the scene and was ready for a single drama. He'd done the usual things, he had done his *Bills* and whatever, episodes of stuff. I had to trust Elinor's judgement about his use of the camera but I found him a really nice bloke and we got on great. I then rewrote with him and Elinor, who was her own script editor. Having met others at the BBC I was glad to be working with David and Elinor.

'I was in on every meeting. I had a choice of cameramen, I was in on casting, I was in rehearsal, I was on set and then I was in on the edit. Amazing. You meet the actors and you change things in rehearsal, lines they are not comfortable with or whatever. Pete and the actors were very respectful and saw that I wrote any changes in the dialogue. I was just there to help really, so that Pete could use me as a sounding board. Of course I wouldn't talk to the actors over the director when a scene was being shot, you have to keep lines of communication clear and not undermine the director's authority'.

Despite the advance publicity the audience for *Loved Up*, scheduled rather too late on its October Saturday to be seen by much of the middle aged or elderly viewers it was meant to inform and educate, was considered too small for the new ratings obsessed BBC management. 'Four million seemed a lot to me but it was thought disappointingly average and has been used as yet another stick to beat single drama', says its writer. But at least he already had another commission and was not suffering from the lack of continuity and support which has been the experience of most writers who have dared to work in the singles area. He also had mixed feelings on writing about date rape, the subject put to him by Lambert and Day.

'My idea was to write about a not very happy boy meets girl date and the power struggles involved. I wanted to write it from two perspectives, to show the same events twice from his and her points of view. David and Elinor said this didn't really go anywhere, that a sexual climax was dramatically inadequate. When they suggested rape as the climax I had lots of problems. I wasn't sure whether, as a man, I was the right person to write. I began asking my

147

friends and the consensus was that somebody should write about it because it was so appallingly prevalent. So many of my friends of both sexes, whether they were from college or whatever, had stories to tell, ultimately scary and horrible, and they convinced me that somebody should write such a screenplay and that if I wrote it would be more likely to get made. But like Jimmy McGovern, talking in *The South Bank Show* the other night about the Hillsborough victims, I felt very strange about exploiting these people to advance my career'.

A major coup it seemed was to secure the directorial services of Simon Cellan Jones, son of master craftsman director James Cellan Jones, who had lately delivered the best executed episodes of Peter Flannery's *Our Friends in the North* (1996) for BBC2. 'We were desperate for Simon to do it, I as much as anybody. We wondered if he would take it because he was being offered every tele thing going and was turning them down and waiting for the right feature. But he committed and was great. During shooting I was there all the time again and we were very happy. Elinor told Simon that this is what I did and would like to do.

'There is a risk about having the writer on set and it is a a really hard and difficult job for him. You have to respect what directors do and you have to trust them but you also know how things should be and the director does not always conform. Frequently I am wrong but it is not until later, maybe, that I realise I was wrong. It is hard to cut your own stuff and watch the edit. You have to make sure that the arguments you have are the ones you want to win. And you have to lose things with grace, knowing that you can be removed from the set at any time if you cause a problem. It's really exhausting to be so tactful.

'The only serious disagreement over the finished screenplay of *In Your Dreams* was over its final scene. The story is of two university students, 21-year-old Jamie (Oliver Milburn) and 19-year-old Clare (Thandie Newton), who meet on a first date. In court three months later their accounts of the date vary in almost every detail. Simon was very keen that it should be a thriller, ending in complete mystery, never telling whether the tearful Clare or the indignant Jamie were truthful. But I always knew the ending, that he had done it and should be seen to be guilty.

'The setting was a university college anywhere. Except that it couldn't be Oxbridge, we didn't want to represent that arena of privilege, that would turn people off. Something more red brick than white tile. I think Bristol was in my head but we didn't have the money to go there, we shot in London'.

The 75-minute *In Your Dreams* was eventually scheduled in the middle of a run of BBC2 *Love Bites* single dramas on Sunday 14 December 1997. Earlier it had as been shown at the Edinburgh and London Film Festivals. I asked Parker for his impression of the festival feed back. 'It went very well I think though it's a very depressing film and written to stir people up. I found it very difficult to make the rapist charming, somebody who the victim initially quite liked even if she was not sexually attracted. At both festivals the last scene aroused serious arguments, the truth about the black victim and the white rapist. I did not specify a black woman but when the actress came in I told the casting director that she could be any colour. I just didn't want a black rapist.

Jimmy McGovern can choose a black rapist for *Cracker* and a black teacher for *Hearts and Minds*, the guy who doesn't do any work but can't be sacked because he's black, but that shows a level of confidence I don't have. There are so many possible accusations over date rape that I opted for caution'.

Ol Parker's third BBC screenplay, *Push Your Luck*, an autobiographical election night drama with a leftward leaning perspective offering little expectation of New Labour being a significant improvement on the Tories could go first to the cinema. But not necessarily through his choice. 'I love writing telly. I think the fact that four million people watch something is extraordinary, that you can get into somebody's sitting room and possibly subvert what they think. And I am not sure that people would go to the cinema to learn about date rape and the the poisonous defence known as contributory negligence'.

Phillipa Lowthorpe

An Oxford graduate with an acute and original eye and an attentive and sympathetic ear Phillipa Lowthorpe was an early riser as a maker of television documentary. Her work in this field has given her both an entrance to drama and a developing style all her own, based less on a personal vision than in her conviction that in 'ordinary lives' there are stories to interest others. Her *Eight Hours From Paris* single, with its literally authentic view of Nineties life in the railway town of Crewe, offered BBC2 viewers a refreshing challenge to genre orthodoxy in the midst of the encircling television gloom scheduled for Sunday 16 November 1997.

Brought up in rural Lincolnshire and schooled at Market Rasen Comprehensive the teenage Phillipa was spotted by her English teacher as a likely professional writer. Her parents exercised a strictly selective policy over the family television set and there was no cinema within range so she painted and wrote stories, in prose and verse. Winning a place at Oxford, just as her teacher father hoped, she did not make the Ol Parker mistake of subjecting herself to English literary criticism. 'I read Classics, English is so academically based I think it makes you stop feeling, I am quite glad that I didn't do English', she remembers.

She graduated still innocent of ambition to work with film and had no thoughts at all of writing television or cinema drama. There were one or two false starts, 'thinking of becoming a barrister, teaching English to Italians, stuff like that', before she landed her first proper job as a Yorkshire Television researcher based in Leeds. She cut her teeth in the Eighties on *Where There's Life*, the inconsequential Miriam Stoppard and Rob Buckman magazine that regularly attracted early evening ITV audiences of 13 million plus. Next door were John Willis's team of serious *First Tuesday* documentary makers. 'They seemed really daunting and high minded and we thought of ourselves as rather frivolous, second rate people'. Until she and her script editor friend Anne Pivcevic decided to go independent and form their own Seven League Productions. Their film about a Spanish woman bull fighter -'we thought it would be a really wild idea to go and spend some time in Madrid and hang round in the bar that Hemingway had hung round' – made it to the ITV network under the *First Tuesday* umbrella. Two other traditional documentary shorts were shown locally in the Yorkshire region.

149

Led by her cameramen, Graham Smith and Mat Fox, Lowthorpe suddenly found herself in love with the screen. 'They taught us an awful lot, I suddenly realised how amazing it was being able to do this and make it look so beautiful. I had always done a lot of painting so I was already interested in visualising things. When I saw what you could do with film, even making very simple documentaries, it just seemed like a very exciting medium'.

Moving on to the BSB satellite station she found herself free to experiment. With little chance that she would ever meet anybody who had seen her work on screen she was able to use the station as a film school. 'You got £2,000 for a programme. I was supposed to do something about architectural interiors but they just let me do whatever I wanted. So I did stuff like a chair ballet and the history of the three-piece suite. It was really zany but it was excellent because you could make wild things on no money and experiment. It was all on tape and I was mad on it, working about 20 hours a day'.

It was a training capped by moving on to BBC Bristol and winning the support and encouragement of producer Peter Symes, the most author friendly documentary strand executive of the day. She made the first of his *Words On Film* series, marrying the arts of verse and film. Lowthorpe collaborated with poet Jackie Kay on the story of a woman driven to kill her husband. 'Peter is the person who really got me going, he's fab, he's the sort of producer who gives people chances and lets them sink or swim with them. I just had the one chat with him before I went filming, it was pretty scary. All he did was to take me out to dinner and I had to tell him what I was going to do. I said that the woman of the story was going to walk around with a suitcase and when she opened it there would be a court inside, a court with coat hangers for the jury and a judge made of a wooden block. He said "Remember to do this and why don't you track there a bit" and that's all it was. He gives you so much freedom'.

Lowthorpe's subsequent documentaries could all be seen as stepping stones to her later docudrama form. Her *Not At Their Age*, for the last series of the BBC2 40 Minutes strand, was about elderly couples in love. It was cut as if it were a drama of duets with spouses finishing off each others sentences. Her *Enniskillen*, filmed in the wake of the IRA Cenotaph bombing, extended the pattern to previously unsung groups of people united in shared grief. The latter particularly showed Lowthorpe's sensitive touch in persuading the naturally quiet to communicate. Still in the future were her twin documentary masterpieces: *Three Salons At The Seaside*, an acute, stylish and funny observation of female hairdressing salons at Blackpool; and *Remember The Family*, the sad narrative of a crumbling house and the once comfortable middle class family, broken and dispersed by bankruptcy, who previously lived there.

In between came Phillipa Lowthorpe's debut as producer, director and writer of drama. Made out of BBC Bristol the budget for her six-part *A Skirt Through History* was kept down to documentary proportions. The concept was a series of portraits bringing to life women who had contributed to English history but remained little known. At £70,000 an episode there was no money for design or any but the most basic props. Success depended on persuading local grandees to lend their houses and grounds for location filming and on persuading good actors to deliver their monologues 'for peanuts'. With players like Anna Massey and Lesley Manville giving their best shots at places like Corsham Court it worked.

'As it turned out those actresses really wanted to do it. They were nervous yet interested in doing these quite long pieces to camera, having this really intimate relationship with the camera. It is so hard to bring off from memory, without an autocue. Their close ups were cut with sequences from the lives. I don't know about you but I can't stand much reconstruction work in docu-drama, I think it looks completely false and plonky. So we did lots of documentary like shooting with a long lens. We used this very aggressive camera work with lots of zooms and whip pans to make it feel immediate. We were an eye spying on the women. When the first one went out there were lots of phone calls to the BBC about yellow lines on the road and all that. You didn't get authenticity but you got a lot of atmosphere from sending a man walking down the Strand where he'd really walked, it made people feel like ghosts of today'.

'This was your debut as a television dramatist but to what extent did you actually write the material?' – 'I put together the scripts of the two programmes I made and had an input into those made by other directors. What we did was to take the women's original words and then structure them into a whole story. There wasn't any written dialogue or anything like that, we very much took what the women had said to give the feeling of authenticity. I wrote most of the voice over commentary but it was more story telling than writing. I was playing around with other people's words still'.

Whatever the level of writing input the finished article attracted attention. Lowthorpe directed *The Spy Who Caught A Cold*, a Lucie Ellman screenplay about a single mother taking her daughter to a nudist camp where they fall in love with the same man, for the Channel 4 *Short And Curlies* strand of drama shorts. She also tried to begin work on a proposed semi-autobiographical *Film On Four* screenplay about two girls growing up in Lincolnshire.

'I was so overwhelmed by the fact that they had commissioned me to write a script I couldn't do anything for about six weeks. I still didn't feel like a proper writer. People who had written for ages are proper writers, I felt a bit of a fraud. I just said what I wanted to do, no treatment required, and they thought it was a lovely idea and David Aukin said "Go away and do it". Then I became terribly nervous. I remember crying and crying because I thought it was beyond me and when I did get down to it I just thought it was a pile of crap and wondered why on earth I had been so arrogant as to suggest myself to do the story. When I handed in the first draft I thought I would get told off, just like being at school.

'I was called back for a meeting and was amazed to be told they really loved my first draft. It was wonderful. I was so excited that I launched into a second draft saying "I'm really going to show them this time". I did something completely bonkers, I don't know what got into my head, I just did something really crazy with the story. I don't think I realised how much they liked the first draft. And I gave it such a good shake about that I destroyed a lot of the stuff they had liked. I tried to restore something of the first draft in a third attempt but when the *Eight Hours From Paris* project came up from the BBC I was quite relieved to put my Lincolnshire film in a drawer'.

Executive producer George Faber had followed the Lowthorpe progress and particularly admired *Remember The Family*. Then BBC2 controller Michael

Jackson specially liked *A Skirt Through History*. Both wanted her to produce a drama for them. 'I think if you are given an opportunity your confidence has to be equal to doing it and in the case of that Channel 4 script I don't think my confidence was up to it. I was able to approach *Eight Hours From Paris* as a natural extension of my documentary work and believe in my ability to carry it through. It is a kind of anthology of six stories. Middle England dramas blending Crewe people, who speak for themselves, with professional actors who were also given latitude for improvisation. For me (credited as writer, director and producer) it was a matter of authoring and choreographing a story out of other people's words, like the classic documentary makers getting a performance out of people. I chose Crewe as a place which everybody goes through and few stop, a place of many voices. In a sense it is a portrait of a town like Dylan Thomas' *Under Milk Wood*. There is the Mayor in his chamber, an 89-year-old who keeps his garden well and does not see why he should be supported by meals on wheels, disadvantaged teenagers, a Sheila stuck in a marriage that has lost its sparkle, a Janet keen to marry a Colin who is already married – to his job'.

'It sound like a huge task for a one woman writer-director-producer. How did you approach the creation?' – 'Well, I did eight weeks of research, which meant just talking to people. When you are chatting like this you haven't got long to make a relationship. It is no good sitting with your head down and writing notes. Fortunately I have quite a good memory and can jot down little reminders of what people have said when I am by myself. It is a matter of soaking up as much as you can. But of course concentrated listening is incredibly exhausting and more so when so much of what people say is similar to the next story. It might be just one thing that somebody says which really sticks out. The actual screenplay writing was quite quick and it stayed flexible, leaving room for both the locals and actors to provide their own dialogue'.

When we met at her Bristol flat in late 1996 the fertile Philippa Lowthorpe was expecting her first child and working on a second improvised drama for Channel 4. This time Macclesfield was her chosen town and she had spent 'several weeks being a sponge', with special attention to a school. She hoped to make a single story with a distinctive central character, building a narrative structure before improvising. 'I think it would be lovely to keep trying it and trying it, this improvisatory way of work. I don't think I've got to the bottom of it yet. But it is dangerous to try and repeat things, instead of trying to move them on, stretch them'.

W Stephen Gilbert

A schoolboy of Wellingborough in Northamptonshire, W Stephen 'Steve' Gilbert was 15 when he began writing for television. He and his best friend Tony Coult, both switched on early to the possibilites of the medium, jointly wrote a book called *Please Do Not Adjust Your Set* and then adapted it as a television series. Among those who were sent the manuscript was producer Humphrey Barclay. When *Do Not Adjust Your Set* began is first run in 1967, produced by Barclay for Redifussion and including the young Eric Idle, David Jason, Terry Jones and Michael Palin among its performers, Gilbert and Coult noticed three of their jokes and stopped watching. Challenged years later about stealing for his first show Barclay disarmingly came clean and was

instantly forgiven. 'Oh, I'm sure we did, I'm sure we stole them, we used to steal in all directions', Gilbert reports Barclay as saying.

The response of the younger Steve was different. He decided he must write a play, something which was clearly his and he could do on his own. He wrote his *Circle Line* aged 21 and it won the then BBC Student Drama Award in 1969. It was tele-recorded as a Wednesday Play and was eventually transmitted as a Play for Today. The piece gave some offence among the middle aged in spirit, as a passionate screenplay from a young writer should, but there was no doubt that here was a promising new dramatist who would be heard from a lot in the future. He was, but not as a screen writer. His debut was also his swansong. Early rising is no guarantee of future success, it may in fact set up positive resistance to future preferment.

Steve Gilbert was turned on to television drama, after his flirtation with comedy, by the Wednesday Play. The particular play that influenced him most was David Mercer's *Let's Murder Vivaldi* (1968), a comedy of manners written, in his words, 'rather like a string quartet, very tight and formal'. And never mind that Antonio Vivaldi, the Venetian genius of the baroque, never wrote in that form. It was a small-scale studio bound piece with a cast led by Glenda Jackson and Denholm Elliott. Gilbert, by now a student at University College, London, set about writing something similar. And hearing of the enlightened BBC competition he finished it over an Easter vacation and sent in his hour-long manuscript to the address signified. 'I just wrote it, I didn't know what I was doing, there was a long and rather gratuitous speech at the end and it had its quirky bits. It was not only influenced by Mercer, I had also been reading Camus and the existentialists', he remembers. In the summer vacation he heard he had won the prize, consisting of £500 and a guarantee of production.

The play was built round a student called Tim (Michael Feast) who not only amuses himself with marijuana ('pot' rather than 'spliff' being the then current slang) and sexual experiment but introduces a 14-year-old schoolboy to the same recreations. Tim, projecting things that Steve was thinking about that time, had a favourite image of life being like sitting on the London Underground's Circle Line, going round and round. He appeared numb, too bored even to drop out. He was, as Peter Fiddick put in in the Guardian, 'a moral blank sheet'. As he made plain, in his final speech of self-justification, he wanted people to get up and do things. Graeme McDonald produced with Claude Whatham as director.

'Claude was rather good, he went on to make a few movies, though he had some funny ideas. He had this crappy idea that he wanted Jake Thackeray to write a song for it. I absolutely put my foot down over this and he gave it up. He must have been in his forties but he looked like a student. Dear old Gerald Savory, then head of plays, having presided over giving the award had to tell us what we had to cut out of the script. There were a couple of lines about masturbation that had to come out and a bit of horse trading went on. It was like that conversation Peter Cook remembered at the BBC about swapping one arse for two buggers. After that it was sat on for quite a long time while the BBC worried about it. My sense of it was that Bryan Cowgill, who was then Controller of BBC1, objected. It went into the studio just before Christmas Eve, 1969. My Mum came down and sat in the gallery on Christmas Eve and then drove me home to Wellingborough'.

After this internal BBC debate continued and over a year went by before transmission on Thursday 14 January 1971. The response was very mixed but, as a three month postal strike followed immediately, the writer received no mail on the subject before the spring. A Scottish paper helped his fame along by calling the play 'pernicious muck'. Elkan Allen, who had just given the lead to the rest of Fleet Street with his Sunday Times television preview column, hailed Gilbert as a 'born writer'. In the Daily Telegraph I agreed that the lad had 'obvious talent... There were moments of gaucherie but his dialogue has a remarkable precision, with some exchanges that Harold Pinter himself would not have disowned'. Lord Arran, leading the campaign to decriminalise homosexual activity between consenting adults, mentioned the play in the House of Lords. After Gilbert wrote to him they met at Westminster. 'We had a very jolly lunch-time in which he got uproariously drunk and was very funny and kept saying "You must understand I am not trying to make a pass at you". By then, as happened in those bad old days at the BBC, the tape of the show had been wiped. Only a private audio, recorded off air, now survives.

Graeme McDondald had been impressed enough, while producing *Circle Line*, to commission a second play. Gilbert decided on a modern version of his favourite Shakespeare, *Henry IV* Parts One and Two, about a modern Prince of Wales. Prince Charles had just been inaugurated but its account, of a throne put at risk by bad behaviour and bad company, was not supposed to be biographical. It should have been produced but it was not. Then it was ahead of its time. Now, with the benefit of hindsight, it would appear far too cautious.

After graduating in 1971 Steve confidently set up shop as a television dramatist. His *Next In Line* screenplay, about a Prince of Wales, was just one of eight single dramas turned down through the early Seventies. Nothing if not prolific he also wrote for the stage, a play about the seven deadly sins, another about Noah's Ark, a third in rhyming couplets. 'I know what a trap couplets are but I will say *The Secretive Agent* didn't have a single false rhyme. Simon Callow, bless his cotton socks, set up a reading of it in his flat with a very good cast, so at least it was read once'.

Such activities did not pay the bills and by early 1972 Steve Gilbert had been obliged to turn to journalism, where he became a brave but under-rated feature writer, reviewer and previewer. He had three months in the BBC Script Unit, under the wings of Betty Willingale and Robin Wade, 'which was lovely'. He had less blissful months as a trainee and actual script editor, then finding Graeme McDonald a frustratingly costive master. At times he tried writing plays again and had one stage piece performed. 'It's all been one-one-one, I never repeat myself Sean, one television play, one stage play, one novel and one biography published, one quiz books, one stint as a television critic, one as a weekly and one as a daily previewer...'.

'In your own mind do you have an explanation for never getting a second television play on the screen?' – 'I think the trouble was that they felt that by doing the one play they had given me a chance that I should take. And it isn't as simple as that. I think you have to learn how to write for television. They would send a commissioned script back saying "This is not for us". "Not for us", what the hell does that tell you, I needed to know what I was doing wrong. You also have to learn how to deal with the BBC, you have to play the

BBC game, and I found it very difficult to play the BBC game, I never learned how to play it properly'.

After almost a decade of frustration Gilbert had his finest, if also most fool-hardy, hour after David Rose bravely and imaginatively offered him a pro-ducer post at BBC Pebble Mill. 'I knew nothing, I was so inexperienced, I was probably the least experienced producer since the Sixties', Gilbert admits. 'But David said he liked the way I wrote about drama and I wrote about it a lot because I was passionate about it and campaigned over craven decisions like the censoring of Roy Minton's *Scum* (1978)'.

He improvised well and got together a promising series of six singles under a generic title of *The Other Side.* Ian McEwan's *Solid Geometry*, an adaptation from one of his short stories was the last of the commissioned six and went into the studio in March, 1979. 'I was always trying to do something Sean, this was a real mission for me, I wanted to do stuff that you could only do on television, stuff that wouldn't make any sense on stage or in cinema... The BBC2 controller Brian Wenham was a McEwan fan and delighted to have one of his scripts on his channel. The reason we fell down was that this was obvi-ously a major piece of work doing something rather strange. I was trying dili-gently to take everybody with me and the service department at Pebble Mill had been reading the script and saying "This is a bit weird, what's this?". One of the things they had to do of course, the props department, was to make the famous pickled penis in a jar, something I never saw... I wrote a memo to the production team explaining what the play was trying to do and why it was important. But the script was passed to the head of department, a terrible man who read it through, thought it an outrage and showed it to Phil Sidey, the Pebble Mill boss. I really liked him but he saw trouble and decided he must get the play stopped...'

Positions were taken up, the support of good liberals crumbled, Steve Gilbert committed the ultimate sin of going public and was sacked. He did two years as a Euston Films script editor, more journalism and his acute critical biogra-phy of Dennis Potter but he remained a wasted television dramatist.

10 Late developers

Ronan Bennett, Lucy Gannon

... for me it was just a question of them and us. It was really the idea of the state ranged against you. The whole experience (imprisonment in Long Kesh) was tremendously important for me in what I have subsequently written about... Yet I think writing about Ireland from my perspective is, ironically, actually easier in England than it is in Ireland.

At first sight little about this book could be more unexpected than a chapter shared by Ronan Bennett and Lucy Gannon, different writers approaching their work from what might be seen as opposite directions. He is a clear headed interpreter of Irish Republicanism, three times wrongly imprisoned in British jails. She is a daughter of the regiment, a child of a British Army NCO whose sentimental affection for the military led her to the creation of the popular ITV drama series *Soldier, Soldier*. He the late developing intellectual, she the intuitive writer.

Since Shakespeare's time the British stage has been dominated by the Irish from Sheridan and Goldsmith, through Wilde, Shaw and Synge to London's Royal Court writers of the 1990s. Likewise in the short history of British television drama. Dennis Potter was entirely English but scratch the writers interviewed for this book and some Irish blood will most likely seep on to your nails. If there is thought to be bias scratch Kay Mellor, the most in form and in demand television dramatist not interviewed for this book. This gifted *Coronation Street* graduate who has created such an uncompromising dramatisation of prostitution with ITV's *Band Of Gold* (1995) had an Irish father. Though she is audibly a native of Leeds and was brought up by her Jewish mother she got to know Dad in her twenties. There is no need for Ronan Bennett to claim Irish origins, they are obvious in every word he speaks. It is more surprising to hear Lucy Gannon say that 'my family would probably regard themselves as English but I am very conscious that I am at heart Irish. I think I look Irish, I talk fast like an Irish person, my family is Catholic, Gannon is an Irish name, I grew up at various times of my life surrounded by Irish Catholics'. Drama is in the blood of the Irish and, it seems,

even a touch of green somewhere in the circulation is a great aid for dramatists.

Just as importantly, if more by accident than design, Bennett and Gannon both found their vocation late. Bennett was approaching his mid-thirties when he started to write fiction. Gannon was 39 when, having never written anything but letters before, she entered and won the Richard Burton Drama Award. Both started their careers with a rich education in the university of life, plenty of useful and often painful experiences from which to mine their dramas. Both somehow flourished late despite the climate in which the cult of youth has taken such a firm grip.

Ronan Bennett

Born and bred in Belfast young Ronan was by no means the most politically active teenager on his block. 'I was brought up in a very politicised atmosphere and I would have been sympathetic to the idea of a united Ireland but I was 18 and I had other things on my mind', he remembers from the days before his life was suddenly changed. 'I was charged with taking part in an IRA bank robbery and the subsequent shoot out in which a policeman was killed. I was arrested a week or ten days after this took place and held on remand at Long Kesh. After a year I was tried by a "Diplock court", without a jury, and convicted and sentenced to life imprisonment with ten years for the armed robbery. No matter what you felt your politics were before you went in I can tell you that within a very short time, of being in Long Kesh, you had become totally Republican. Even more so after the 1974 fire and riot and the brutality with which that was put down'.

Two decades on and living contentedly in North London with his journalist partner Georgina Henry the mature Bennett speaks of these events with an assured calm and lack of bitterness beyond so many of his political opponents. We spoke at a time of relative quiet in the north of Ireland, though before the 1997 cease fire. Two decades earlier he had had to wait for a year after his conviction before his appeal was heard, making for a stretch of nearly two years. 'The original convictions were overturned on appeal but I wasn't released immediately because by that stage I had attempted to escape and was on remand for the escape charge. I think I was in for another two or three weeks before getting bail. After that I had to go to court on the escape charge and received a discharge of some kind. They took into account that the original conviction was a wrong conviction'.

'Did you have anything to do with that IRA robbery?' – 'No, I wasn't involved in the original thing at all. They didn't just come for me, they pulled in quite a few people, a policeman had been shot dead so they put a lot of effort into finding people they thought suspect. I was convicted because I was picked out at an identification parade. There had been half a dozen witnesses or more who hadn't picked any one out. So the whole appeal turned on this one woman's identification evidence and they found some funny things about her and the way the police had handled this. They overturned the conviction and I went in one day from being a life prisoner to being on remand on the escape charge'.

'Did you receive any compensation for wrongful imprisonment?' – 'No chance. When you think about it the term "miscarriages of justice" did not

arise at that time, it wasn't in the public consciousness. In Long Kesh I certainly wasn't the only one in for something I hadn't done and everybody there felt wrongly imprisoned. There was no point in going round saying you were wrongly imprisoned or anything like that. I very much came to see myself as a political prisoner. The other thing, and it was very important for my writing, was the sense of identification with the other prisoners. A lot of what I have written has given the view of people outside the law'.

On his release Bennett moved to Yorkshire and work in a wine bottling factory. It was only a temporary escape from Irish 'troubles'. One day his home was raided by Special Branch detectives and he was held without charge under the Prevention of Terrorism Act. He was eventually transferred from Leeds to Brixton where he managed to convince a Home Office representative that he was not a threat to the state. He opted now, in the late Seventies, to live in London but soon found that he was still under suspicion.

'This sounds terrible Sean but it's one of those things, once they're on to you they stay on to you. The Special Branch officers who had engineered the Yorkshire arrest were fairly unhappy with the way things had worked out. So the next year they raided again and took in a whole pile of people. We became known as "The Persons Unknown". We were charged with conspiring with persons unknown, at times unknown, at places unknown to cause explosions. There were no explosions so after about ten months on remand they substituted conspiracy to rob charges. I was in Brixton on remand for about 20 months. Then came a three month trial at the Old Bailey. I defended myself because I kind of wanted to have a say in all this, not a chance that defendants usually get. We were called anarchists and I can still hear the prosecutor saying at the start that we conspired to overthrow society. I remember looking round my three co-defendants and thinking we couldn't have conspired to order lunch'.

'Your political sympathies are naturally with Sinn Fein but do you think you have it in you to be active in "the armed struggle"?' – 'Sad to say I am a writer more than an activist. I admire activists. I admire people like Gerry Adams and Martin McGuinness who have given their whole lives to something they believe in. I have spent a lot of time round both of them and I don't see any sign of them having profited from what they do. I do find that admirable. I find writers much less so. The book I am writing at the minute, set in the Congo, explores this very tension.

It tells what I feel inside myself about the relatively easy and pampered life of writers and the much more difficult lives of activists of that particular kind. You hear writers complaining about interruptions of their working day, like the telephone or the baby crying, and then you think of Adams. Who writes and has many more interruptions including shots fired at him, being wounded on one occasion, and grenades thrown at his house. He doesn't complain, he gets on with it. I find him an admirable person and I have absolutely no problem in saying that. I am also sure that during the cease fire he wanted a settlement and that he still wants a settlement and it was the blinkered response here, and by the Unionists, that sabotaged the whole thing.

'And yes in certain circumstances I think I could use a gun. I am not a pacifist so in certain circumstances I'd like to think I would be able to use a gun. I'd

like to think I would have opposed the First World War if I had lived at the time, but the Second... A good version of myself might have gone to the Dublin GPO in 1916 but who knows. I am not out on the streets now, that is the thing about this tension I have been talking to you about... I also find it deeply depressing the way revisionist journalists and historians in Ireland have maligned what people did during the Easter Rising and the War of Independence'.

After winning his case at the Old Bailey – 'more impassioned than legally competent I would say' – Bennett went to university. His degree from King's College, London, was good enough for him to do a PhD in 17th century law enforcement. Having completed this he took a job as a paid researcher on the Guildford Four campaign. At the same time, after concentrating for a decade on history and politics, he began to read fiction again. And to jot down memories of his years in prison. By the time the Guildford Four were, at long last, cleared Ronan Bennett had decided that he wanted to write. In 1990 he co-authored Paul Hill's account of his trial and imprisonment in the aftermath of the Guildford bombings. A year later he published *The Second Prison*, his gripping debut fiction of murders, betrayals and wrongful imprisonment in the Irish north. One of the calls he received as a result of the book was from Robert Cooper, head of drama at BBC Belfast. The book itself had been optioned by producer Kenith Trodd who had invited Lynda la Plante to write a dramatisation. Cooper did better and asked Bennett if there was something else he would like to write for television. By the autumn of 1991 his mind was turning to his first screenplay, his 90-minute Screen Two single called *Love Lies Bleeding*.

'I had written a couple of newspaper articles arguing that the Government should talk to Republicans, that the time had surely come for a negotiated settlement in the north of Ireland. The atmosphere at the time was very hostile to the idea, it was said to be giving in to the men of violence and all that. So I thought to write a thriller with this at its core, with an IRA ceasefire at its heart. The cease fire would be followed by talks with the British Government, engineered much more quickly than in real life...

'It says a lot for Robert Cooper that he was willing to go with this. I imagine there were other people at BBC Belfast who had doubts about encouraging you?' – 'Yes, there were BBC people who gave me a very clear impression that they thought this was a dubious undertaking and that I must be on my best behaviour and not let the side down and all that. Robert wasn't like that, he has always been very supportive. I don't think he is a mad Republican or anything like that. He has produced a lot of Graham Reid's work, which is essentially anti-Republican... well, on the surface Graham's line is very much a plague on both your houses but I think there is an element of masking his fervently anti-Republican position in all that. He would dispute the point but I find that his plague on both your houses applies to one side more than another... Anyway Robert is open minded, he looks for things that work as television drama and if that happens to have a particular political point of view then so be it. A problem that characterised a lot of television drama set in the north of Ireland, through the late Seventies and the Eighties, was that it came from the middle position. The reality is that it is a position that barely exists outside a small area around Queen's University, Belfast, and Robert knew that the bland middle ground was unlikely to make for interesting drama'.

'But presumably you never saw *Love Lies Bleeding* as a way of disseminating Republican propaganda?' – 'For a dramatist propaganda just isn't an option. Republicans have done wrong things, done bad things, there's no getting away from that. After the film was shown Republicans criticised it for showing them settling their own disputes violently, they asked where that had happened. They felt that the drama was playing up the stereotype. There was an element of their complaint that was true but generally I would stand by what I wrote'.

'Having delivered your script did you have any say over casting and the choice of director?' – 'By and large television drama is quite writer friendly. I know writers have a bit of a martyr complex, always complaining about not getting enough money or credit or about not being allowed enough creative input. I have to say that hasn't been my experience by and large. In this case it was my first film so I didn't know what the score was, I was pretty much content to sit back and listen and try to learn. Robert certainly consulted me. We met a couple of directors and he asked for my view on them. But I was inhibited by my lack of experience in this field and he made most of the running.

'Michael Winterbottom, the chosen director, is one of those who considers that the writer's role should end with the delivery of the final draft. That is just the way he works. Other directors I have worked with since have involved me much more. But with *Love Lies Bleeding* I was in on the read through and rehearsals and during filming in Belfast and beyond they paid for me several times to go over and watch. Location filming in the north of Ireland was one of the film's claims to fame. We even filmed on the Falls Road, knocking on the head all those excuses about it being too dangerous... So I was on the set for a little bit of that though I didn't much like it because there was nothing for me to do. Afterwards I saw some of the rushes, during editing in Soho, and then I saw a rough cut. Robert was very good about keeping the writer involved'.

'When you saw the final cut on transmission were you at all surprised?' – 'I find it very difficult to judge my own work. I write in pictures but I lose those original images on screen and can only think of characters in terms of the actors that I see in front of me. Similarly with set ups and scenes and so on. They shot the script, they didn't change it, there was very little improvisation. This was partly that Mark Rylance, playing the lead, is a theatre actor and has great respect for the script. So I felt it was still my piece. There was some things I wished had been done another way but I felt Michael had done a really good job, that he had kind of honoured the piece as it were'.

Ronan Bennett's second television drama, *The Man You Don't Meet Everyday* for Channel 4, was more modest in scale but equally valuable in its insights. It was a kind of Ireland meets England piece in which the truth about a quartet of Irishmen, that they are IRA bombers, only dawns on the female lead (Harriet Walter) and the audience towards the end. 'You can go through any number of books or films where the stereotypes recur: you find the coward, the thug, you find them in *Cal*, you find them in *The Crying Game*, it's endless. What I wanted to do was to give the audience these characters, let them find out about them gradually, let them find out about them as human beings before they are seen as IRA men. The argument was not profound, it just tried to show that the people who do these things are quite ordinary and if you

bumped into them in the street or they were living next door you wouldn't know...

'The piece had a funny genesis. Waldemar Januszczak (commissioning editor for arts) commissioned it as a showcase for the Pogues. When I got involved I decided the Pogues music should say something about the situation. There was no political problem, on that level Channel 4 have always been great, they've let the author say what he wants as long as it works as drama'.

Bennett's next two screenplays were television ideas but pushed into initial cinema release, though *Face* was made through the BBC and *A Further Gesture* under the wing of Channel 4. The former takes a thieves eye view of the London crime scene and the latter is about a wounded IRA man who flees to New York. The move from television to cinema had less to do with preference for the big screen, more to do with money and practicalities. In fact the fate of *Face* in some ways echoed that of Jimmy McGovern's *Priest*, both first conceived as television series and both finishing as cinema movies directed with her special feel for crumbling urban texture by Antonia Bird.

'On *Face* what happened was that David Thompson, the BBC producer, came to me about three years ago and asked me if I would develop a series featuring a police detective. I just said 'No, that is not my world, I have no interest in police psychology'. But I said I could give him detective stories from the bad guys' point of view. So on the basis of a short story I had written, featuring an armed robber David got this thing commissioned. The series was going to be called *The Crimes of Harry D'Souza* and I wrote the first episode of that. David liked it very much, as a kind of parody of a villain thing, but by the time he got it there was no money left to make a series. I was asked to rewrite it as a single film, for *Screen One* or *Screen Two*. I was quite disappointed but they were offering a script fee again so I did what they asked. And by the time I had finished that script they had decided to make it as a "feature film" only partly financed by the BBC.

'On *A Further Gesture* an independent producer called Chris Curling asked me if there was something I wanted to write for television. Again I came up with a serial idea and his company paid for script development. I was very keen on the idea of having Stephen Rea playing the lead, it was at the time when he had an Oscar nomination for *The Crying Game*. So Chris went to see Stephen in New York, where he was in a play, and Stephen said he did not want to work for television, he preferred the cinema. He knew my work and asked if I would come over to meet him and discuss a feature film idea, the idea that turned into *A Further Gesture*'.

'As a writer do you recognise distinctions between television and cinema drama and adjust accordingly?' – 'There are a number of differences. One is that there is more space and more time to pursue things on television. In television you are less concerned with the need to state big things all the time. It can be more personal. In *Face* I had the same problem as Jimmy McGovern had with *Priest*. The important thing in a scene was the dialogue and because it was shot in a particular way the impact of what's being said was lost, it's been sacrificed to the picture. For television it was a wordy script and I realised I had to tweak this and come up with cinematic themes. What I hope I achieved is to retain the ideas and intimate moments while giving the narra-

tive the drive and force cinema audiences expect...

'This is an important question isn't it, whether television can still be used to carve out it's own niche or whether it is content to see itself as the poor relation of the cinema. Whatever writers may think it is hard to find others prepared to take television seriously enough to secure its drama as a distinctive art form. Because the financial rewards are obviously much greater and, if it works out, the prestige is much greater you know that nearly every actor, every producer, every director at the BBC really wants to be making cinema movies. Now that it is easier to get finance for movies than it is for television writers have to recognise that the general push is in the cinema direction. At the BBC now it is a nightmare to get television drama green lit'.

When we spoke in late 1996 Bennett was still reasonably confident about returning to television, under the supportive eye of Robert Cooper at BBC Belfast and produced by the independent Picture Palace, with a four-part serial called *Rebellion*. Already half written by then this was planned as a six-hour epic of Irish history with a background of events stretching from the 1916 Easter Rising to the defeat of the anti-Treaty IRA in 1923. It is built round a Catholic middle class Dubliner already attached to the cause, 'a kind of follower of Padraig Pearse', as an 18-year-old in 1916. The events from that Easter to the burying of IRA guns in 1923, with resonances for 1997 British and Unionists demands about decommissioning, are seen entirely from the Republican ground level point of view. 'Maybe I am being naive here but I think that if the drama works as drama, the impression I am getting from Robert and others, that it will get through to the screen'.

Asked if he still writes about himself Ronan Bennett replies: 'Less so these days, I think that's got to do with increasing confidence as you write more and as the work receives a certain amount of attention'. But it is also sure that his early imprisonment, at the same age as his latest hero was in 1916, to some extent marked him and his work for life. '... for me it was just a question of them and us, it was really the idea of the state ranged against you. The whole experience was tremendously important for me in what I have subsequently written about. Although I think writing about Ireland from my perspective is, ironically, actually easier in England than it is in Ireland'.

Lucy Gannon

There is something to be said for leaving the great asexual experiences, the first visit to Venice, the first hearing of Bach's Mass in B minor and so on, until at least early middle age. Youth usually carries less context around, less background against which to set and therefore heighten the wonder of the greatest discoveries.

For Lucy Gannon the great discovery, on the approach to her 40th birthday, was her vocation for writing. It was a natural talent which burst through with all the more force and energy for being held in check through her early decades. And at first there were no thoughts of markets and money, still less commissioning editors and controlling producers, to write was a delight in itself, it was its own reward.

Gannon had a mobile childhood as the daughter of a British Army NCO. A creative writer fictionalising her life might have her father pointing a gun at the young Ronan Bennett somewhere in the Irish north-east. This would

probably require a lot of bending. What is known is that her Dad is an intel-
ligent and witty man, like her mother one of the Lancashire-Irish, who at one
stage was in training for the Catholic priesthood. And it was father who even-
tually lit the match which led to her career as a television dramatist.

'My second husband George and I had been in South Africa for two years and
came back absolutely broke. We were both looking for jobs and I started
going in for competitions. My father knew I was doing all these silly things,
these difficult competitions, and he wrote to me enclosing a newspaper cut-
ting and saying "You've always been good at letter writing, why don't you
give this one a go?". It was the first and last Richard Burton Drama Award
and I thought I would give it a go. So I borrowed a typewriter and scrounged
some paper, we really were broke at the time, and I started to write a really
dark stage play called *Keeping Tom Nice*...

'And as a result I discovered this was it, this was what I loved doing. It was
the most fantastic experience, it was wonderful. Just after I'd started writing
it I got a job as a care assistant in a mental health ward. So I'd go on duty for
24 hours, start at one o'clock one day and come off at one o'clock next day.
We were allowed a sleep on duty, we were just there for emergencies and were
called in when there was a need for a supervising hand. I would take the type-
writer in with me and instead of going to bed I would sit up writing through
the night. Because it was just... I can't describe the magic of it... it was just
wonderful to discover... I didn't know if anybody would ever read this bloody
thing, I had no idea whether I was doing it right, wrong or indifferent... My
husband had gone and got a book out of the library for me, so I could see
how a page was set out, and I set it out the same way. I just found it so excit-
ing... When I had finished the play I stuck it in a bag and sent it off. But I
couldn't stop writing and started my next play, *Wicked Old Nellie*'..

The first play drew on her years of nursing experience, which extended from
old people's homes to the mentally handicapped. The eponymous Tom was a
mentally handicapped young man of 24, living in a bungalow with his parents,
a lad who had to be bathed, fed, watched and generally needed everything
done for him. And his play won the award.

'The prize was two thousand quid which was very nice, it bought a bit of car-
pet for the front room, got the car through its MOT, things like that. There
was also a residency with the Royal Shakespeare Company which I couldn't
afford to take up. That is I couldn't give up work to use what I thought at the
time was an arty farty residency. So I carried on at the mental health ward
until I got a phone call from Sally Burton asking why I had not taken the res-
idency. I told her why and she offered me my nursing salary for six months so
that I could take it up. The Royal Shakespeare people asked me what I wanted
to do and I told them "I've never been on a residency before so I don't know,
all I really want to do is write my next play". So I stayed at home and wrote
Raping the Gold. 'I was never in residence at Stratford or London. I stayed at
home and wrote and they gave me free tickets if I wanted them and talked to
me about getting *Keeping Tom Nice* ready to go on tour. I was never part of
the theatre, they asked me what I required and what I needed was time to
write. I wasn't a theatregoer, in fact I'd only seen one stage play in my life and
that was because I'd been given free tickets. I don't think that first one really
had a plot at all. Pam Gems on the judging panel was very nice and said I was

a natural dramatist but looking at *Keeping Tom Nice* now it is looks to be an unconscious outpouring, just a mass of words'.

It was nevertheless put on at the 'Not the RSC Festival' in Newcastle before transferring to the Almeida in London. Meanwhile the Derby Playhouse, alerted to the fact that there was an award winning writer living only two miles from its premises, beganto get interested and produced *Wicked Old Nellie*. Her *Raping The Gold* was produced at the Bush and her *Janet and John* was introduced through the RSC's 'Short Stages' at the Barbican. So, within 18 months of starting work as a dramatist, Lucy Gannon had had four plays on in London.

Among those who went to see her drama at the Bush were television film-maker Louise Panton and producer Ruth Caleb. They asked if Gannon would be interested in writing for television, specifically a child abuse docudrama reflecting on the 1987 dispute at Cleveland. This being the dispute over the actions of social workers taking 202 children into care after their examination by paediatrician Dr Marietta Higgs and her colleagues.

'They'd been to several writers and not had any success with them, either the scripts weren't satisfactory or the writers chickened out. There was so much controversy in the air and so much confusion and because I was so ignorant I took it on. Ruth and Louise were very interested in what was then a hot news story and desperately wanted to do something about it. So there it was, *Testimony Of A Child* was my first ever drama for television. It was a fiction drawn from my imagination but, before writing, I had to read the official report which went on and on and on for ever. From my years of nursing I had got a lot of experience anyway. I concentrated on just the one child in a family of two children'.

Gannon's next big break arose from the Eileen Anderson Award, given by Central Television for new plays put on in its English Midlands region. Nominated for this was *Wicked Old Nellie*, so admired by Central script editor Harriet Davison that she alerted the company's drama developer Tim Whitby. Who in turn asked Gannon if she would like to write something about the British Army.

'They had this idea of doing a series about Army wives. I said I wouldn't do a series about wives because, for me, half of the fun of drama is men and women together. I offered to do a series about an Army company, men and women together. And that's how *Soldier, Soldier* (1991) was born. Within about three years of starting to write I was doing my own first television series, which was incredible. I really enjoyed the fun of creation, and also that you get very well paid for doing it, and wrote about half the first two series. There have been four or five series since then, I am not sure which, I don't have anything to do with it now except I get a deviser's fee'.

Gannon was now well launched as a television dramatist considered reliable in her rare capacity to deliver quality and popularity. She was an early contributor to the BBC's *Casualty*, that had been running since 1986, and her *Small Dance* single for Thames won the Prix Europa. Meanwhile at Central's Nottingham studios the long running *Boon* (1986–92) was approaching its natural end and drama boss Ted Childs was looking for a new series to keep his people there employed.

'Ted came to me as a provider and told me that the actor Kevin Whately was coming free from his role as Sergeant Lewis with *Inspector Morse*. Ted said it would be good to use him. I was very keen on using Kevin myself because I think he's a good actor. I also knew that I must use a setting in the Central region, if possible not too far from Nottingham. All taken into account in my initial treatment for *Peak Practice*, which they liked. It was not such a happy time as it should have been because, as I was writing the first episode, my husband George died.

'I had wanted to keep some kind of watching brief on *Soldier, Soldier* but I couldn't do everything. Our daughter Louise was 14 at the time and obviously needed me. So I left *Soldier, Soldier* to concentrate on *Peak Practice*. I do believe that such things have got a natural life span and I think it's a shame that like an old athlete they are left to go on too long. I am no longer so concerned about *Soldier, Soldier* in this context because I no longer watch it but I do know there are only so many ways you can tell a story in any one environment. I also think it's a great shame that other writers are not given a chance to come in with new things. There's great excitement in starting a new series and it's a pity when they always go to the same people all the time'.

For *Testimony Of A Child* 'I was far too inexperienced to help select a director' and the BBC chose the same Peter Smith who had so enraged the writer with his treatment of Alan Bleasdale's *No Surrender* movie. With series the choice of directors is largely outside the deviser's hands though Gannon was in on the main casting of *Soldier, Soldier* and helped to choose Jerome Flynn as Paddy Garvey and Robson Green as Dave Tucker. 'Sometimes it's a pleasure to be on the set, sometimes it's an absolute agony, it depends who's directing really', Lucy Gannon told me after a read through of her *Bramwell* third series finale in early 1997. 'Tim Whitby, the television bloke that first discovered me, is directing. So I shall be on set quite a bit for this because he's such a delight. He welcomes me to the set, he's very writer orientated. Some directors don't like writers near the set and all you do is just create an atmosphere, so I just steer clear'.

'Are you still as much of a compulsive writer as when you started, do you feel you have to start like Lynda La Plante at 5 am?' – 'Whether you get up at 5 am or not is completely irrelevant. It's not the hours you spend at the word processer, or the days the hours you spend producing, it's how well you do it when you are there. In brackets yes, I moved on from the typewriter to a word processer after my first play. And yes I do still write for 18 hours a day sometimes. I write until about 4 am if I'm on a roll. But it's no good staying at the word processer if you are not on a roll, if things aren't bubbling. So I can work very happily until 4 am and other nights I'll go to bed at 10 pm and sleep straight through.

'In the morning I'm usually at the word processer by 8.30. Sometimes it is earlier, sometimes I give myself a treat by sitting at the kitchen table and reading the paper until 9 am. During a writing day I'll have a break to walk the dog and have a supper break to watch *Coronation Street* or *Brookside*, something like that, and then go back to work. Right now my daughter Louise is sailing round the world in the Clipper '96 race so I only have my dog and my friends to worry about. As soon as I started writing it took over my life. My husband got very used to me coming to bed at 2 or 3 am and his

only complaint was that my feet were always cold because they were always very still at the word processer. He was a very early riser, sometimes I would get to bed at 4 and he would get up at 6 am, we just had to get used to it. If you need to write, if you are as driven as I am, it doesn't matter whether you are married or not, you somehow do it all, you have to. It's doing the writing that makes everything else worthwhile so you don't want to give that up'.

Her *Peak Practice* creation, Dr Jack Kerruish (Kevin Whately) sharing a rural practice in Derbyshire's Peak District with Dr Beth Glover (Amanda Burton) and Dr Will Preston (Simon Shepherd), was launched in a 1993 time when medical shows beyond the BBC's *Casualty* were hard to find. Two years later the need was for a medical show with a difference and Gannon hit on her idea of Victorian disaster limitation at an ill funded and barely equipped hospital in London's East End. Dr Eleanor Bramwell (Jemma Redgrave) was drawn as the progressive heroine presiding at the Thrift Hospital while her widower father Dr Robert (David Calder) maintained the family bank balance treating the rich up west. Harriet Davison and Tim Whitby produced for Carlton and ITV.

'What was the genesis of *Bramwell*?' – 'Well, Harriet and Tim had gone independent and they came to me saying they desperately wanted to make their own series with the script, production and drama values they believed in. They wanted to do something about Victorian times, we discussed the options and settled for a Victorian doctor. It was a role which looked rich and promising and has proved to be so. It gets audiences of 12 to 13 million here and has done fairly well in the American *Masterpiece Theatre*. I wrote all the first series, half the second and just under half the third. I've also been the series editor on the third, which has been really interesting, it is the first time I've done that. I think my writing has been more appreciated in *Bramwell* than on anything else because its idiosyncratic as well as being very structured and dramatic. There are many writers who can do many things that I can't do but there aren't many writers who could do that'.

'As we speak you are generally becoming your own producer, yet you seem more than content to submit to the Whitby Davison owners on Bramwell?' – 'Yes absolutely, they are so script orientated. They don't let you get away with anything in the way of lazy scenes and lazy lines. That is wonderful, it makes you run all the time. As a writer I want to be made to run, I don't want to amble along all the time. They look intensely at every script, we spend hours on them, I just love that. There are huge rows oh yea, both by fax and face to face. For the face to face I have to be feeling quite well because I know it will end in tears. I think that's one of the disadvantages of being a woman, I will cry, I am a very emotional person and I think most writers are very emotional. But I know that Harriet and Tim care about what I care about, which is the script. And they care about me, we're very close, I am their child's godless mother. I love to say you're wrong, wrong, wrong but afterwards we are best friends and I've usually learned something'.

Through the mid-Nineties the hard-working Lucy Gannon did not limit herself to popular ITV series. In 1996 her single film for BBC1's *Screen One*, *Trip Trap*, provided as truthful and gruelling a view of wife bullying as has ever been dramatised for television. The following year her six-part *Insiders*, also for BBC1, looked into an open prison with a lot of unstrained subtlety in

its depiction of motivation among jailed and jailers alike. On both dramas she secured her vision and her voice as her own producer. She found she had a taste for handling a budget and the logistics of extras and equipment. 'I enjoy these things because I am at heart still a nurse and I like practical problems and sorting them out, I love getting in the car and going down there and sorting things', she says. Usually with distinctive results. As David Aaronovitch put it, reviewing *Insiders* in the Independent on Sunday and intending high compliment, 'Gannon's success derives from eschewing the existing cliches of television drama – then creating her own'.

'You say you like getting into your car and driving down to London when there is some production problem, but living in Derby must mean a lot of time wasted on the road?' – 'Yea, I haven't really been so successful living out of London and I do object to all the time spent on motorways when I could be at home writing... When *Trip Trap* was filming there was one particular roundabout which I went round twice not able to remember if I was going to London or Cardiff. So I have now realised I've got to be somewhere down south and the most sensible place is London because that's where the meetings are. I have to be out of my present house in four weeks. I have a great affection for Derbyshire and for Derby, and many good friends there, but there's no reason why I should live there any more than anywhere else. I am a gypsy, I don't know where I belong, it's a lovely feeling in some ways. I have the money to root myself anywhere and there are no particular ties'.

'After *Trip Trap* went out, on Saturday 9 March 1996, nine viewers complained to the Broadcasting Standards Council about its sex'n'violence and the verdict was that "the relentless nature of the violence had been unacceptable, even for a serious post Watershed drama on this theme". A feather in your cap I should say. I was shattered by this drama and felt you probably wrote it with inside knowledge and consequent anger?' – 'Well yes, the drama came out of my fascination with the whole subject. My first husband had seeds of violence in him and it was a very oppressive marriage. I married at 19, too young. I ended it, I was terrified of him and still wouldn't like to meet him again. I am fascinated that somebody like me who is so self confident and all the rest of it has this attitude. People say things like "Why doesn't she leave him". You don't know why you don't, nobody knows why you can't leave, its part of the sexual chemistry, the balance of love and need. Any marriage is a complicated mechanism, even more so when there's violence there. In the end I was strong enough to leave him. I was very fortunate, I grew up with two brothers and a Dad from the age of six, and I always knew that men were yobs. If you have that background you are resourceful. And I had no children, that was my great strength, if I'd had a child it wouldn't have been so easy. Yes I think *Trip Trap* was an angry response to the question "Why did she stay?"

'As to the complaints and the BSC we have a proportion of the population saying we must have braver dramas, others saying we must not offend. The BSC complained about too much sex and violence in a film about sexual violence. The film is being used in women's studies and by the relevant charity groups and I have had a tremendous response, really touching letters. At the same time you've got idiots, people like Matthew Parris and the other members of the BSC, who can only say "Gosh, that's upset a few people". Nine

people out of an audience of 11.5 million, it's pathetic. All the same I doubt if the BBC would ever put it out again, not without editing, something I would discourage the director (Danny Hiller) from doing'.

'You clearly have a productive working relationship with Danny Hiller. Was *Insiders* to some extent down to him?' – 'Yes, we met on *Peak Practice* and then he did *Trip Trap*. It was hard to hand that over to anybody and I really valued his direction and understanding of the text. And it was on one of the weekends when we were working on *Trip Trap* that we agreed it would be good to get a series together for the BBC. We came up with the idea of a category B or C prison. We were aware that it is all too easy to get behind a wall and go for sloppy, easy drama. We wanted to do something more thoughtful and leisurely if you like.

'At the BBC Nick Elliot, then in charge of series, pointed out that Lynda La Plante was writing *The Governor* but assured us that ours would be very different. So we spent a month of research looking at prisons and getting more and more depressed about not being able to do what we wanted with category B or C jails. We didn't want any of the icons of prison life, we didn't want bars, clanging doors, guards in bulled shoes, the landings and all that... and then on the last day of research we went to Sudbury open prison near me in Derbyshire and we decided that was the answer. Danny knew a location sight at Broadsea, on the Suffolk coast, and I started writing with that in mind'.

Together they nursed it through to a BBC1 run, opening on Wednesday 19 February 1997, in the teeth of such disintegration at the BBC that seven executives handed on responsibility for it as they made for the exit. If Lucy Gannon enjoys solving problems this was tested to the full. As she made plain, in an article for the 1997 Edinburgh Television Festival programme, she was left understandably exasperated by the failure of the BBC to allow its drama department a practical and durable reorganisation.

Is there anything else that exasperates her? Too much imported television, the kind of politically correct rule by 'left wing, over educated idiots' she found when working for Derbyshire County Council, questions from commentators writing about television which seem to imply to her that she should be writing like somebody else.

'I am an ignorant woman, I finished schooling with my 17th birthday, I took my O levels but three of them were probably in art', she challenges. 'I am an ignorant woman so how can I possibly write anything but ignorant drama. It's what I do. I am not going to go to university to learn about all the things I should be doing. I do what I do and I am very fortunate that people want to watch it. Don't accuse me of not being Dennis Potter or Lynda La Plante, I'm me. I can't be anything but me. And overall I don't believe drama, even BBC drama, is a depressed area. Lots of good things are still coming out from British writers writing about our own world. How much television drama does France produce? Arty-farty films and that's it. I think our television industry is fantastic, it's the best in the world'.

11 Those in favour...?

William Ivory, Kieran Prendiville, Peter Flannery, Antony Thomas

My poor old mother was so upset when I got home but I said 'It's all right Mum, I'm going to be a writer, I'm really determined now'. And Dad was fair. He said 'Let him just do what he's got to do, just accept that'.

It is not quite unknown for a broadcaster who has worked in television drama to be appointed a channel controller but the number of producers who have been so elevated can be counted on the fingers of a single, partially dismembered, hand. In the era when drama departments were still trusted to fill their slots with only a nominal and minimal 'refererence upwards' this imbalance did not matter so much. In the Nineties, as drama heads gradually lost their authority and all meaningful decisions were taken by channel controllers or chief executives, the chances of inspired leaps into the unknown were hugely reduced. Some of these boss men, and yes they were all men, liked to be seen at the threatre and to make contributions to dinner party discussions about the latest over-publicised cinema movie, but few if any had much interest in, let alone feeling for, television drama.

What these men could do, and felt compelled to do in the interests of their own self preservation, was to read and respond to audience figures. From these they learned that after soaps it was 'tecs'n'docs, police'n'medicos or cops'n'robbers which seemed to attract the punters. Hence the orders for more and more of the same, the repetition of tired old formulae, the promotion of new constructs remixing ingredients of proven popularity. Most amusing has been BBC1's blend of food programmes with detective fiction in *Pie In The Sky*. Most predictable have been the BBC1 attempts to marry the police and medical genres through the pathology lab of the well crafted *Silent Witness* formula and the creaking stories of police doctor *Dangerfield*.

It is not that those in command particularly enjoy the rut,or ruts, in which their middlebrow drama is trapped. It is that, apart from their basic lack of

concern, they do not have the smallest idea how to move off in new directions without losing a part of the audience. This chapter is chiefly concerned with four unusual mid-Nineties BBC series or serials: William Ivory's *Common As Muck*, Kieran Prendeville's *Ballykissangel*, Peter Flannery's *Our Friends In The North* and Antony Thomas's *Rhodes*. Each of the first three of these have been greeted through the public prints as, at least, a succes d'estime. They became titles which the Director-General's speech-writer could list towards the end of his master's public pronouncements to show that John Birt was aware that the BBC also made programmes. The Prendeville comedy in particular was an instant ratings blockbuster. Though the Thomas bio-drama has sold well abroad it was largely written off by broadcasters and critics alike as an expensive mistake. What the four dramas have in common, as well as being departures from genre fiction, is that their arrival on screen was accidental. They were not green lit through some policy or plan, through an enlightened head of drama who knew what he wanted and had the power to achieve it, their preferment was largely a matter of lucky whim.

William Ivory

When I met William 'Billy' Ivory for the first time, before he went on stage at the National Film Theatre for a TV 97 session on 'Writing Popular Drama', I noticed first his generous height, then his warm friendliness, then his broken thumbs. He is a man fiercely and passionately committed to whatever he does, whether it is playing games or writing drama. One thumb was dislocated as he tackled a Rugby Union opponent. The other was put out of shape one Christmas when he punched the wall of his workroom during a telephone argument . An argument in which the producer of his 1994 first series of *Common As Muck* called him a 'sexist fucker' for refusing to include a female character in a particular scene. It was not the insult that hurt, it was the producer's insensitivity to the script.

Ivory is a Nottingham man, the son of a journalist who survived flying as an RAF Bomber Command navigator during World War Two to become Editor of the local Evening Post. His necessary Irish blood flowed down to young Billy through his paternal grandfather. Billy and his siblings were brought up as Catholics and, as his work shows, he is still to an extent tuned into the spiritual and metaphysical. But it was their mother Edna, herself obliged to leave school at 14, who really minded for her young about education and a proper job to follow. Billy's sisters were always sufficiently academic and duly went to university. He declined to read books, spent his time playing ball games and watching television, 'failed' his 11-plus and generally disappointed the family with his determined 'non intellectual streak'. It took Alan Cattermole, inspirational head of English at the Minister comprehensive, to set turn him on to the power of words. He began reading voraciously, began passing exams and was soon regarded as Oxbridge material.

Ivory opted instead for London University's Queen Mary College because it had 'got quite a left wing tradition', was situated in the East End and looked to have a fresh and dynamic way with English literature. He was greatly disappointed. He found the pretend EastEnders in his prettified square unexpectedly unfriendly to students. At college he found the desiccated attitudes of post structuralist literary criticism no fun at all. His dream of long discus-

sions with tutor Simon Gray, whose plays he so admired, never materialised. 'He was never there, he was always at rehearsals', Ivory remembers. 'It was a terrible time, it was just awful, really awful, instead of fantastic discussions it was just these cynical, academic teachers all planning to publish but terrified they might be found out if they did'.

In the end he spent a year in London, 'mostly spent just trying to keep out of the way of people', and then rode his 90 cc motor cycle back through pouring rain to Nottingham. 'My poor mother was so upset when I got home but I said 'It's all right Mum, I'm going to be a writer, I'm really determined now'. And Dad was fair, he said 'Let him do what he's got to do, just accept that'. After which, little knowing he was researching for the television series that would make his name, Billy Ivory went on the bins. He spent two and a half years working for Newark and District Council, picking up any amount of comedy and drama along with the garbage of the surrounding pit villages. One of his best episodes came to him ready made.

'We were driving along and I could smell something. Obviously somebody had put hot ashes on board and flames were coming out of the back. Fred, this old guy with a deaf aid screeching away after we had turned it up as high as we could, said he would blow the fire out. He drove like the clappers, the air was foul, everybody was screaming away and I said 'Fred, you're going to kill us all'. By the time we got to the tip everything was a mass of molten plastic and the wagon was burnt. We got into terrible trouble because we had to explain what had gone on and that'.

Through this period Ivory was writing stage plays and sending them to Kenneth Taylor at the Nottingham Playhouse and Peter Hall at the National. His first called *Sweatbox* expressed his anger and bitterness about his university experience and remained unperformed. He produced his second, *Cause For Concern*, at the arts centre in Mansfield. It revolved round the IRA's Hyde Park bombing and the moral dilemma (and whether it was a moral dilemma) faced by a man asked to hide in his flat the bomber responsible.

'At the dress rehearsal I kept thinking 'This is not working, I wish the actors would stop ranting and learn to act'. It was a turkey, terrible. But I had been determined to get in as many possible and my Dad had taught me about the benefits of publicity. So I decided to open with a bloke coming on bollock naked and leak to the local press a 'Do our arts centres really want to support scenes of nudity and violence?' story. It worked, we got a full house.

'My mother was starting to be quite poorly with motor neurone disease at the time. She had been ill for about ten years from when I was a teenager and had to take early retirement. I shall never forget, it's to my eternal shame, that when I started doing all right at school and got in with grammar school boys and my Mum's voice was a bit slurred, I actually said to her 'Try and speak properly'. Now I was very keen she should see something I had written. So I said to her 'Take it in your stride, it's the threatre, it's quite normal'. And on comes my friend Chris, flopping around the flat with no clothes on and suddenly there was this guffaw from my mother. That guffaw encouraged me to carry on writing and send more stuff off to theatre people'.

Maintaining contact with Kenneth Taylor at the Nottingham Playhouse, and impatient to leave the bins behind, Billy eventually landed a job as a scene

shifter and then a bit part actor. He supplemented his income writing sexual fantasies for men's magazines like Mayfair and Men Only – 'I always used to say that I got a hundred and fifty quid a toss' – as well as drama. But it was as an actor that he auditioned for *Coronation Street* and soon became better known by his Street name of Eddie Ramsden than as Billy Ivory. 'Eddie was a kind of thick brickie, an aggressive Northern tough, and he lasted for about a year. It was good fun and I was earning decent money for the first time in my life. But my Mum died just a few months before I got the job, so she never saw me doing it. And while I was up there... this must sound an odd thing to say...I began to find acting a pretty fatuous kind of occupation and acting in a long running show felt seemed most mind numbing. I blew a lot of my first week's wages on an expensive hardback edition of William Carlos Williams' poetry and I remember writing in the front of it 'I must remember to keep my brain alive. I desperately wanted to write something for my Mum...'

He had already written a first television play, *The Plumber Cometh*, and sent it to Central in Nottingham. The story was of a plumber who had taken a woman hostage in her bedroom after she had ended their affair. The police specialist given the task of talking the plumber into releasing her turned out to be the woman's husband. It was all influenced by Billy Wilder's *Ace In The Hole* and other such Hollywood mid-century movies. It was never produced but it did get a 'This is quite interesting... send us anything you've got' response. Encouraging enough for Ivory to write *Journey To Knock*, over three weeks in Manchester, for his mother Edna.

So it was that 1991 became the break through year in William Ivory's career as a television dramatist. He acquired an agent who showed the script to George Faber at the BBC and, this being the beginning of the decade, there was no hesitation about putting *Journey To Knock* into production. The result had its first airing in the BBC2 ScreenPlay slot on Wednesday 18 September and there could be little doubt, among punters and critics alike, that a lovely new talent had arrived. The form was a road film about a group taking a pilgrimage from a Catholic hospice in Nottingham to the Irish Lourdes, the Marian shrine of Knock in Co Mayo. David Thewlis played young Terry, suffering from motor neurone disease, the only one of the party travelling against doctors' orders. David Wheatley used a nicely under-stated directorial touch and, though there was no obvious supernatural intervention, the completion of the journey was seen in itself to be a kind of miracle.

Meanwhile at Euston Films the then *Minder* script editor Stephen Gilbert had been sufficiently impressed by a draft screenplay of *Journey To Knock* to invite Ivory to lunch and to write for Leon Griffith's, by then, 12-year-old Thames and Euston Films comedy drama. Ivory's first few ideas for the adventures of shady dealer Arthur Daley (George Cole) were not found acceptable but he had always been a fan of the show and relished the rhythms of its language. He persisted and in the end wrote nine *Minder* scripts between 1991 and 1994, more than anybody apart from creator Griffiths and Tony Hoare.

The 1994 demise of *Minder* left quite a space in Ivory's life happily but fortuitously filled when his *Common As Muck* reached the screen later in the year. At the BBC he had been pressing his idea of writing about binmen for three years. George Faber turned it down because he thought it suitable for series rather than single treatment. At the series department Barry Hanson com-

missioned a first episode before deciding that the formula was not working. The lucky accident was that script editor Catherine Wearing, bright daughter of producer Michael Wearing, found the script 'knocking round the office'. She showed it to fellow script editor Kate Harewood and both knew at once that they were on to a winner. They reactivated the project, drip feeding Ivory with commissions, but had to wait until he had written five episodes before they could get anybody else interested. Eventually producer John Chapman was persuaded and after he took the scripts to department boss Michael Wearing the first series was green lit.

'In trying to sell the idea of a series about binmen you have to overcome several levels of disbelief and most importantly you first have to overcome the disbelief in your own mind. I think the climate is such that people in the broadcasting organisations think first of reasons why things should not be made. It is awful really but people are scared of making positive decisions. One thing that is really depressing is to see the scripts on the shelves. They have labels like 'David Jason project', 'John Thaw project' and so on. If you go in with a proposal for a drama about Bosnian refugees the first question you get is 'Can David Jason be in it?''.

'Clearly you did not stick the name of David Jason above the title of *Common As Muck* but I presume you did have a central idea around which the first series was constructed?' – 'Yes, I always work on the premise of a central metaphor. In this case dirt. I had spent over two years doing a physically very dirty job but spiritually it was great. The bosses were terrified of you, it was a good life. And at the same time I could see people going off in their suits to jobs that were corrosive to their own souls and to the well being of other people. So the first six hours of *Common As Muck* were all to do with what's dirty, what's corrosive, what's spiritually damaging.

'And then at the start of the second series I got this idea from reading an obit about the dramatist Robert Bolt. It mentioned Thomas More, in *A Man For All Seasons*, talking of the law as the essence of an organised society. As I have said I am obsessed by the way we have lost our religion and with it any sense of the metaphysical life. The law has become the one metaphysical thing we are beholden to, which means there is a sense of right and wrong but not of good and bad. So that was the starting point of the second series, something to do with the way the rights of the law are now being used'.

The first series of *Common As Muck* won an initial BBC1 audience of ten million before settling down at over eight million. It also took a BAFTA nomination and won the Royal Television Society best drama series gong. The comedy and camaraderie of the binmen were popular and, as actor Edward Woodward has put it,[1] 'the characters are all heroes in a way, and all bastards, there's astonishing range in every one'. Strongly opposed to repetition, once everything has been said that needs to be said, Ivory was reluctant to write a second series. When he was persuaded he made his binmen redundant, struggling for survival, faced by choices of good and evil, participants and witnesses of a redemptive finale.

'I did not run out of bin material, I could have filled a lot more episodes with events on the bins, I just thought it was too easy to do another series of the

1 Caroline Rees 'Bin There' *The Guardian*, 2.12.96

same', he says. 'I thought if I made them redundant it would make a challenge for me that would make the writing more interesting. And I wanted to say something about the way society has broken up and people have become isolated. If you became disenfrancised both at the workplace, and at home because you can't pay the bills, that is a nice metaphor for what went on during the Eighties generally'

'It was a very brave decision not to repeat your previous success with the 1997 second series on air as we speak. But I believe the audience is generally 1.5 million down from the first series and, much as I personally relished the miracle episode, there seems to be some signs of confusion in the public prints?' – 'Yes, last week was really depressing because we dropped down to six million while Lynda La Plante's new masterpiece (the feature length *Supply And Demand*, a police drama set in the Mancheser drugs scene) got 11 million on ITV. I think she's a very talented woman but that was such a cynical piece of work...

'I am delighted if you thought the miracle episode (English Midlands reflections of Michelangelo and the ceiling of the Vatican's Sistine Chapel) worked because I personally think it is the finest thing I have written. If I drop dead tomorrow I would say to the world 'Have a look at that'. There was the question of can we do this, do we fudge it, do we make it very humanistic? We had the shot with the moon and the crucifix. You know that I'm a very lapsed Catholic, I've got very odd religious beliefs, but I believe in the soul and in people's potential. And that is what, in quite a Quakerish way, it was all about. A couple of people reviewed that second episode very very viciously, there was a kind of vitriol saying you can't do that on television, and I find it very depressing that people won't let television drama push the boundaries. Some of the other feedback asked 'What are you doing?... We know what *Common As Muck* is'.

'But television is fantastic, you can have ten million people at a time watching, and what I wanted to do here was something like an opera: you get lifted up at the start, you have to be on for a ride and if you are not on... well, tough, I can't do anything about that. The vitriol was all to do with the intepretation of television's potential. The idea is that because television is perceived as a working class medium it should only be allowed to do certain things. It is thought that the good art has to be reserved for middle class forms, that the cinema and theatre are the places to try new things. It is outrageously wrong but even broadcasting executives say, in effect, 'Don't you dare try and do that for television''.

William Ivory has dared to try new things for television. Sitting at his word processer (he long ago discarded his typewriter and pasted corrections) he can work no other way. He writes long, he takes risks and he fights his corner. Which means that his works are liable to get lost on the shelves of cautious executives. His *King Leek* single film for Granada, a reworking of *King Lear* set amongst Geordie vegetable growers and starring Tim Healy, was eventually made with a lot of pain and blood letting in defence of its script – 'It was a horrible process, it was really'. At the time of writing it had waited two years for an ITV slot. On his wall Ivory keeps a card from the ITV drama supremo Nick Elliott 'to inspire me'. It says 'People aren't interested in dramas about depression and problems, people are interested in dramas that make them feel happy'.

In late 1997 the Granada drama chief Gub Neal moved to Channel 4. At least he and William Ivory appreciate each other. After Ivory's three-part *Ready Steady Go!*, made for Channel 4 by Granada and saying useful things about the destructive waste that follows from ageism, it could be that he finds this channel a friendly place in which to extend his pushing of boundaries. There will always be tensions, no easy rides, but to rule out such a talented driver would surely be an unpardonable admission of failure.

Kieran Prendiville

There was a moment in the early Nineties when the British press was bubbling over with glee, and self-righteous scorn, because somebody had looked at the BBC books and found an apparent £60 million overspend unaccounted for. The next day the figure went up to £120 million. Whatever the truth about this it was taken as a good excuse to axe programme projects which appeared to be in danger of treading new ground or of treading familiar channels in a new way. It was a gloomy time for television dramatists. Not least for Kieran Prendiville who had written four episodes of his first *Roughnecks* (1994) series, on oil rig life, for BBC1. It was suggested that he carry on writing but the future was too uncertain and he felt himself unable to continue.

'So I stopped and to try and ease the depression I went away in my imagination to this little place in Ireland, near to where my father was born in Co Kerry. Ballykissanne Pier is its real name, on the south-west coast, the peninsula below the Dingle. It claimed the first two victims of the Easter Rising in 1916. Two volunteers were looking for Roger Casement, took a wrong turning and drove off the end of the Pier. There is a little monument to this day. But it wasn't a political point in my head, I had always been taken with the name of Ballykissanne, it was so magical. I doodled for about three days, inventing this bunch of characters who lived in a world without diesel fumes, no overalls or darkness or bleakness, for a change I wanted a bit of sunshine and light', Prendiville remembers. So was born the most unexpected ratings triumph of the decade, BBC1's *Ballykissangel*.

Kieran Prendiville was brought up in the English north-west and began work as a teenage copy boy at the Oldham News Agency. He quickly became a reporter and soon moved onwards and upwards to London and a Fleet Street agency before landing a job as a BBC researcher. He made his name as an on screen presenter, a familiar face seen in a variety of institutionalised BBC series including *That's Life*, *The Holiday Programme*, *Tomorrow's World*, *The Risk Business*, *Nationwide* and *Grandstand*. Even at this stage he wanted to write fiction but 'it is very hard to walk away from it when your contract keeps getting renewed and you've got another year of guaranteed work'. And there were memorable moments such as his *Nationwide* (BBC1 early evening news magazine) interview with Dennis Potter.

'It was the time when Potter was doing his stint as *Sunday Times* television critic. He was in terrible shape but mostly because he had a hangover. I remember trying to ask him how he reconciled being a dramatist and a critic and whether it effected the way he had a pop at other people's work. I also asked him what he thought of *Nationwide*. He said that 'as a reviewer I try to watch only programmes that work, which is why I never watch *Nationwide*'.

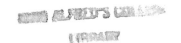

He was in a filthy mood, my God what a mood he was in. He was also terrific, he couldn't help being terrific, Potter would tell you the time of the next bus and it would be fascinating. I adored the man so much that I wanted him to be nice to me. I asked him if he ever censored himself, if he ever compromised his own work, this being the time when every other thing was being banned or whatever. And he said 'Well, I was on the sixth floor of Television Centre the other day and I smiled at Billy Cotton (Controller of BBC1) and as far as I'm concerned that's compromising down to my bloody boots'. The interview was used without the *Nationwide* crack'.

Still a utility presenter with a dream of becoming a writer Prendiville moved on from the BBC to TVS, the latest company to hold the ITV contract for the English south. He tried writing for the first, 1979 to 1985 run of Thames's *Minder* and then Central's *Boon* (1986–92), seeing both as popular and sometimes witty as well as comic. He got four knock backs from the latter show before, after his fifth try, the script editor wrote back saying 'I was quite impressed with this idea, I liked the way it started, the middle section is very good and the ending is terrific, what a pity Dick Francis thought of it first'. 'I thought 'Oh shit, he thinks I'm a plagiarist as well as incompetent'', Prendiville remembers. More encouragingly the letter also said 'Why don't you give me a ring?'. Out of the subsequent meeting came the suggestion that he should start by writing of the journalistic world he knew and a *Boon* episode based on the story of a retired spy that had come the way of his agency. Having run out of programmes to present, and 'a fairly amicable and inevitable parting of the ways with TVS', four *Boon* commissions came at just the right time for the now budding writer.

'After this I did a couple of years on Thames's *The Bill* (running since 1984). For a while I was one of the regulars there. The system was that writers came up with stories and pitched them to the script editor who said either 'I think that's a terrible idea' or 'I quite like that, I'll try it on the producer'. After which he would come back in half an hour and say 'You are on' and off you went to write a first draft. In my case it was about ten transmitted episodes. I think I wrote one that didn't get made, that was bound to happen sooner or later. I had a good run, then I stumbled and couldn't sell anything for about three months, then I was back in again. It was good as long as you kept coming up with the goods, but they were very hard to work for, very demanding. I wasn't making the same money as I did in presentation days but it was not bad. I had more work than many writers so what the hell. And it was a good training, I learned a lot or I think I learned a lot'.

This led on to writing for *Perfect Scoundels* (1990–92), the TVS comedy drama about two conmen conceived by actors Peter Bowles and Bryan Murray, and other short term formulae including the ill-fated BBC seaside drama *Westbeach*. As well as broadcasters' offices he was in and out of production companies testing ideas and sometimes being fed them. First Choice asked Prendiville if he could be grabbed by the idea of a series set on an oil rig in the North Sea. He could.

'I knew next to nothing about oil rigs but I went off and lived on them for a few weeks. It was very uncomfortable and hard-going and exciting. I also spent a lot of time hanging round bars in Aberdeen, which was more comfortable, though arguably more dangerous. When I came back to London

from all that I invented the characters and patiently explained to the production company the difference between an oil rig and an oil platform and basic stuff like that. In the first place I was commissioned to write a feature length film but then we heard from Michael Wearing at the BBC that they wanted a serial. First Choice paid up front for the first script and my research expenses, which was decent of them'.

The temporary writing halt, and the Ballykissanne diversion, followed. Then to all round surprise and pleasure *Roughnecks* was given a new green light, produced for BBC1 by Moira Williams and Charles Elton. Did the pleasure last through the production and the first view of the finished six-parter in June and July, 1994?

'Yes, *Roughnecks* was a success which did me a huge amount of good. It was not a ratings smash but it's absurd to call an audience of seven million less than a success, specially as it went out late on Thursday nights against World Cup football... I was made up Sean, I was pleased with it. More than anything I was pleased with how well it came out on screen, I thought 'Yea, that's what I had in mind'. I was not around during production, the script was my impact and being around doesn't protect it. Writers aren't generally on set because they've got to get on with their work and you are not paid to hang round. I was in on casting in that people asked me what I thought of their choice. If I am honest I would say that no writer could be better served than I was by the first series of *Roughnecks*. It was the first original series I'd ever written, it was the first I'd created and it was a big moment.'

'The second seven-part series, which followed in late 1995, was in several ways different, the move on shore gave a more soapy quality. It turned out to be the last series but seemed to be if bidding for continuing series status. Did you like it as much as the first series?' – 'The second series was in my view a cinder, much less satisfactory than the first. I wrote the first two of the seven episodes but there was a lot of BBC interference. I lost count of the number of executives who were clambering all over it, they went well into double figures. They were not managers or accountants they were executives, people who had a direct right of input. You got notes from script editors saying that So and So thinks we ought to do it this way and I was thinking 'Who is So and So, I've never heard of him'. The BBC had become much more prescriptive. It was very expensive, hiring an oil rig and filming in Aberdeen, and the BBC people seemed to feel that as they were spending all this money they had every right to come and shout the odds. It felt like committee rule.

'I agree that they wanted to make it more of a soap opera. My original vision of the characters was different from what the BBC seemed to be looking for. I don't believe in these strong, silent types articulating every emotion they have. And essentially that is what happens in soap, that is the distinction between soap and other forms of drama, in soaps the characters say everything they feel. In real life you don't do that, you keep things back... What was really different about the second series was that I got rewritten, I found myself looking at scenes and I thought 'I never wrote that'. I have no idea who did the rewriting, I haven't a clue, I tried to find out but everybody told me it was somebody else. It had never happened to me before and so far never since'.

By this time Prendiville at least had the consolation of knowing there was some interest in his *Ballykissangel* idea. He had sent a minimal treatment,

really only a list of characters and their characteristics, to his agent. Who sent the pages on to script editor Roxy Spencer, then working with producer Robert Cooper at BBC Belfast. 'Roxy liked it and took it to Robert. Since then she's worked on Jimmy McGovern's *Cracker* and Billy Ivory's *Common As Muck*, she's just terrific', says Prendiville. In all the idea took three years to reach the screen, meetings with RTE (Radio-Telefis Eireann) in Dublin as well as in Britain, and some of the processes remained mysterious to the writer. But he was delighted to hear from the BBC that the show was to be produced through Tony Garnett and his Island World Productions.

'I thought 'God! Wonderful!', I was absolutely delighted. I did a second draft of the pilot script and I had a meeting with Nick Elliott, then head of BBC series, I saw him for about five minutes of the three days he was there. And he commissioned it, God bless him, and off we went. The frustrating thing then was that having taken so long to give us a commission they wanted all the scripts in five minutes flat. That is why I only got to write four of the first six episodes when I wanted to write them all...

'Tony Garnett hired a producer called Joy Lale, who had done the last run of *Between The Lines* for him, to produce our first series. She was the biggest single influence on the whole thing. She died in a car accident a couple of weeks before the end of shooting the first series. What Joy did was to take the idea back from Pluto where I'd set it, if you like, it was so quirky in my head. She was wonderful on plot and character. We had an early Sunday evening slot and we had to start addressing the plot. Joy came in on the second draft and made it work, she concentrated my mind on the slot I suppose, I had not thought of the watershed or anything like that. My original was very quirky and whimsical, she brought it back into the real world but ever so subtly. If I ever meet her like again I will be very lucky and a lot of people said that before she died'.

'I know you like whimsy, at least Irish whimsy, in moderation but I guess you and Joy were very keen to avoid the 'Oirish' thing. Was there anything else about the modern Irish that you wanted to communicate?' – 'I wanted to explore the differences between British perceptions of mythical Ireland and what it is actually like, through the eyes of an English outsider. As it turned out through the eyes of a young English priest. Modern Ireland is a place where Rupert Murdoch speaks to more people than does the Pope, where even in the most remote mountain village the kids have got the right trainers and city attitudes. It is such an interesting collision that, the change has happened inside a generation. So there was this priest going there, perhaps expecting people to be doffing their caps all the time, and finding that 'things have changed Father and its about time you cottoned on''.

'I suppose there was never any chance of it being actually shot in Co Kerry?' – 'No it was understood from the start that it would be too expensive to do it in Kerry, it is still a long drive from Dublin to Kerry. All the facilities are in Dublin, a lot of the actors were based in Dublin, Joy soon opted for Co Wicklow. I didn't have a problem with that at all and in any case Kerry was perhaps a bit close to home. She went driving round Wicklow for about four weeks and then came back saying 'I have found this place called Avoca, which I think would be perfect'. I knew of it, I'd never been there. She gave me a little map of the town and I realised I'd have to move the church, all the geography was wrong'.

'Speaking for myself only, as one critic always liable to enjoy Irish comedy, I was instantly hooked by your first episode opening sequence of the confession box tumbling down the hill. Had you always meant to start that way?' – 'No, that wasn't in the first draft. The criticism of the first draft was 'This is fine, this is funny but it lacks something at the beginning, it starts too slowly'. And they were dead right, it did. The main story always concerned the confessional and I thought 'Rather than have it show up in town why not link it to characters arriving in a bus, why not have it fall off its truck?'.

'The idea of the state-of-the-art confession box joke came to me from the Observer about six years ago. They had a front page story about a Catholic Fair in Italy where you could buy the latest hi-tech Catholic aretefarcts, for instance a confessional. It mentioned a confessional box which was air conditioned and had upholstery. I read somewhere else that there was a fax machine in the wailing wall in Jerusalem and I thought it would be a good idea to add that. I put the cuttings aside, I put them in the file that every writer has got on Catholics and I knew I'd use it one day.

'The important thing about this was that it wasn't the hip English priest from the inner city that had the idea of installing this box it was the local Irish entrepreneur. That was the point I was constantly overturning, the perception that in some way rural Ireland is backward... '.

'Your English priest is a decent man, he had to leave Manchester to get away from a woman with whom he was falling in love and in Ballykiss has this struggle to maintain his celibacy in the face of the delectable pub landlady, but the rest of the priesthood is less attractive. Is there some agenda here?' – 'I was born a Catholic but when people say to me 'Once a Catholic, always a Catholic' I'm inclined to disagree. Of course you can't leave it all behind but one day you think one thing and one day another. I am not very fond of the clergy as it happens, as a body, but this particular priest is one I wish I had come across when I was a child. Anyway the point is that the series is called *Ballykissangel* not Father Clifford. It is about this community so arguably it could withstand changes, his departure, any departure'.

'Your show started at the same time as the last Dennis Potter serials. His *Karaoke* began on BBC1 with 4.5 million and dropped. Your Irish comedy, not a form that always travels well to Britain, started at nearly 14 million and rose. They had far more pre-transmission publicity. It is all a bit of a mystery?' – 'Yes we started under 14 million and built to over 15 million. Don't ask me why, I'd like to think the writing had something to do with it. I don't think our show got more or less publicity than the average drama series. I couldn't tell you even now what it was about *Ballykissangel* that got 15 million, if I knew what it was I would bottle it'.

Peter Flannery

William Ivory and Kieran Prendiville both had to wait years to see their most successful ideas, *Common As Muck* and *Ballykissangel*, brought from their minds to the screen. They have little cause for complaint once their experience is set beside that of Peter Flannery. It was 1980 when the 29-year-old Flannery, then resident dramatist with the Royal Shakespeare Theatre, conceived his epic stage play about British political corruption. Two years later his *Our*

Friends In The North was performed by the RSC at Stratford-upon-Avon, London and Newcastle. It won the John Whiting Award for the best new play of 1982. Among those who admired it was the young Michael Wearing, then producing Alan Bleasdale's *Boys From The Black Stuff*. Wearing persuaded BBC2 controller Brian Wenham that the drama would adapt well as a four-parter and Flannery duly received his first television commission. The series, finally expanded to nine episodes, achieved BBC2 transmission in early 1996 – nearly 14 years after the writer had delivered his first drafts. Episode one achieved instant critical and punter approval and the following spring *Our Friends In The North* won the BAFTA award as the best television drama serial of 1996.

Like fellow dramatist Alan Plater before him Peter Flannery was a child of Jarrow and Geordieland. In his case it was a grandfather who was one of the 1936 hunger marchers who trekked down to London to advertise the plight of the unemployed. Like Nicky Hutchinson, the most autobiographical of the four 'friends in the north', Peter wondered at the political apathy of his father and the committment of his grandfather – the marching Labour man. 'I have never been a member of any party but, as the drama shows, I have always been politically interested', he said when we met in late 1996.

Peter Flannery began his career in drama as a theatre director – 'I assumed that was what I was going to be, I thought that's where my skills were' – but was forced sideways into writing because he found himself more in demand for this than for directing. 'I thought I might be a writer when I was a child but I hadn't done anything about it', he remembers. Until he was commissioned by Manchester's Contact Theatre. His second play *Salad and Music*, actually written for students in Cheshire, mysteriously fell into the hands of the RSC, was produced by the company at the Warehouse in London and led to his residency and his first offers from television.

'I heard from *Coronation Street*, then going through one of its periodic revamps, and they asked if I would be interested in becoming one of their writers. I replied that I would like that if I could get rid of half the characters and if the Street could again roughly resemble the life of Manchester as it originally had in the Sixties. You can't have a serial set in Manchester during the late Seventies and no black faces, was one of the points I made. And obviously you've got to get rid of some of the comic turns masquerading as characters... Really what I wanted to do with television was to get in on my own terms. So I didn't do episodes of anything'.

Flannery continued his theatre work at the RSC and in 1984 delivered his first television version of *Our Friends In The North*. He had to wait until 1988 for his actual screen debut, his *Blind Justice*. This was a series of five 90-minute films, produced for BBC2 by Michael Wearing, in which radical lawyers played by the likes of Jane Lapotaire, Jack Shepherd and Julian Wadham beat their heads against the limitations of the legal system. 'This was television on my own terms', says Flannery, 'seven and a half hours all of my own on the dilemma of left wing barristers. The idea came from the barrister Helena Kennedy, so Helena became my solace and my partner in writing really. I wrote the scripts but she gave me the story ideas. There were no instructions from the BBC, we did as we pleased. In those days Wearing was working at Pebble Mill and he could commission'.

His original commission was to adapt *Our Friends In The North* as four 50 minute episodes. During the two-year writing process Flannery negotiated the length up to six parts of 60 minutes each. What he produced was about 18 hours of material, divided into seven episodes. When the BBC insisted he go back to six parts he simply tore the title page off the seventh and stapled its pages to the sixth. By 1984 Graeme McDonald had replaced Brian Wenham as BBC2 Controller and Wearing had moved on to single plays. Robin Midgley, the new head of series, was keen on the scripts and was attempting to place them on BBC1 when command of that channel passed from Alan Hart to Michael Grade. Looking to recover some of the mass audience from ITV the then combative Grade decided his remit did not extend to six hours of drama about political corruption. The project was shelved until 1988, when Alan Yentob succeeded McDonald as boss of BBC2.

Yentob was persuaded to recommission the project as an eight-parter, of 60 minutes an episode, stretching its time span to cover the years from the arrival of Harold Wilson's 1964 Labour Government to 1988. Flannery was happy to set to work on expansion knowing that, under the rules of writers' contracts, he would have to be paid again for his existing earlier scripts. This time production was stopped by BBC lawyers who feared libel writs from the Newcastle politician T Dan Smith and the architect John Poulson, who had both served jail terms, and from other politicians and Metropolitan Police commissioners of the period. In mid-1989 Flannery wrote to Wearing: 'We have to accept now that we'll never do *Our Friends In The North* because I can't have it hanging over me anymore'.

There was another four-year gap before Flannery was surprised to receive a phone call from Wearing with news of a rival epic series, Peter Ransley's *Seaforth*, taking different friends in the north from the Thirties to the Nineties. There was a proposal that the existing scripts of *Our Friends From The North* might be cannibalised to make the middle section of *Seaforth*. Flannery naturally protested, discussions continued and Wearing eventually persuaded Yentob to commission *Our Friends* anew, for the third time. The new version would cover the years from 1964 to 1991 and would consist of one 90-minute episode and eight more of 75 minutes each. Producer George Faber joined the project.

Flannery delivered the mark three *Our Friends* in February 1993, the month in which Yentob left BBC2 to take command of BBC1. The promotion of Faber as head of single dramas followed almost at once, leaving the epic once more without an effective champion. Michael Jackson, the new controller of BBC2 and a dedicated adopter of fashion, appeared to have fallen in line with the latest corporate craze for costume drama adapted from classic novels. Fortunately Wearing still regarded the serial as, to some extent, his 'pet monster project' and new producer Charles Pattinson proved a feisty and persuasive advocate. A first meeting between Jackson and Pattinson in January 1994 proved depressingly unproductive. The pressure on Jackson was maintained and in March he agreed to spend £6 million on the show, provided Flannery reduced it to six hour-long episodes. Pattinson was pleased but Flannery refused the offer. At the end of the month the writer met Jackson, Wearing and Pattinson for a combative dinner at the Ivy restaurant in London's West End. Bargaining continued until 1 am when Jackson made his 'final offer', six

episodes at 65 minutes and three more at 75 minutes, at a record BBC2 cost of £7 million. Flannery agreed the compromise.

'By my calculation you were 29 when you started writing this epic and 44 when you finished, and I know there were a lot of painful production moments after you had finished. So this was something unique in television drama history, a drama of organic growth where the writer grows old with his characters. Perhaps we could go through the later stages. First of all how do you write?' – 'Well, I live in rural Cheshire but I work in an office in Macclesfield two or three miles up the valley. I love my office, it is a lovely space. I still write with a pen and paper. I send my stuff to be typed, I can't type, I haven't even got a typewriter. I treated myself to a very expensive fountain pen a couple of years ago. My contemporaries are buying into vast amounts of new technology at great expense. So I asked myself why I was still writing with a biro and I sent out and bought the best pen I could afford and I just love it.

'I go to work in the office at 8.30 am and usually walk home around 7 pm. But it would be an unusual day if I write, most of my day is spent not writing, most of my time is spent thinking, quite a lot of it is spent worrying about why I'm not writing. On perhaps ten per cent of days I write and when I write I write very quickly. When our daughter was born 11 years ago I gave up the office to do the new man stuff. I liked bringing up the baby and that lasted seven years. But when she was seven and came home from school, demanding to play, that just didn't work. My partner was around but the daughter wanted to play with me and had no sense of my working discipline. When I am writing I can't really get started until 3 pm, it takes me that long to get concentrated and focussed. So I got an office again and I've been there for three years now...'.

'Going back to the genesis of *Our Friends In The North* were there essential differences between the stage play and the television serial?' – 'Originally it went from Wilson's first victory to Thatcher's first victory. It wasn't terribly difficult turning it into television because it always had multi strand stories and was episodic. For me then it was about people growing up in a corrupt society, it wasn't what *Our Friends* came to be. Originally it was much more about the politics than the personal. I belonged to that generation of writers and I began on the question of why it was that people were so hostile and apathetic about the political process. By the time I wrote it for the third time I was in my forties and my concerns were different. There's no loss of the political stuff, we are talking about something that became twice as long, but there's much more about growing to middle age, much more about fathers and children, mothers and children, because those became my concerns as I grew older. So, yes, the project changed as I changed'.

'You say nothing was lost over the years. Really, nothing?' – 'Well, there was a foreign element which the television version never had. There was stuff about what became Zimbabwe, stuff about Rhodesian sanctions busting over oil, which I thought an interesting example of the way governments behave. That is the one thing the BBC ruled out when it was first commissioned for television, not so much political censorship more a sense of unity, there being enough busting of scenes switching between Newcastle and London. I wasn't happy about it but I wasn't so unhappy that I wouldn't go ahead with the project'.

'In a way it was a pity you could not take the story up to the present, as we speak, the present of Tory sleaze that cannot be hidden and which should help Labour to power next year. Do you see it that way?' – 'Yes, my one abiding disappointment about *Our Friends* as it was transmitted was that there wasn't a big Tory corruption scandal, a specific one. But I did write it, it's just that they cut it. Episode eight was a very very big episode, nearly three hours long, and it had a construction scandal involving 10 Downing Street and Saudi Arabia and the DTI. It was a fictionalised version of the various smelly things, the arms scams, that have been going on'.

'Over the years you had various changes of producer, though Michael Wearing stayed steadfast, and then when you were at last green lit there were problems over directors. To what extent were you responsible?' – 'Well, I did choose to move Michael away from being producer which I think hurt him. He was head of department, it was no good, I was finishing off the scripts and I needed to work with someone who had time. It is one of the insanities of the system that people get landed with these incredibly busy jobs and have no time to do what they are best at, which is to work with writers. You volunteer to go up the tree in order to stop other people from fucking things up. It is not that you particularly want the job yourself, it's just that you don't want anybody else to have it. So Michael became executive producer and handed over to Charles Pattinson as producer.

'Our first director was Danny Boyle, he worked with me for three months and then left at short notice because he had been offered the movie *Trainspotting*. We had to replace him quickly and decided on Stuart Urban to do the first five and Simon Cellan Jones to do the last four. Simon was the location manager on my *Blind Justice* so I've known him for a number of years. This seemed satisfactory until shooting started and we had to get rid of Urban through what were called 'irreconcilable differences'. In my opinion he was not capturing the real meaning of scenes, I found his approach anthropological, he had developed a rather dispassionate camera style. Looking back Stuart, a Jew from Zambia, was probably not the right person to get passionate or get to the middle of Sixties Newcastle. Then Pedr James came in, took over and immediately turned the project round to what it became'.

'I suppose by then all the casting had been done and James mostly had to do a tidying operation?' – 'He did maybe do some minor casting but he also had to shoot an entire new episode. Charlie and I agreed that episode one would have to go, we had to reshoot. And Charlie suggested that I rewrite it. He suggested we might have a better first episode with more about the four young people. I agreed with that because I felt that episodes two and three might not be as strong as we'd hoped they might be. I took a completely hard nosed view about this, that I needed to write a much more grabby episode to get people through, to get people in. It was a blessing because it turned out to be a very good episode. It was the 14th draft after the first in 1982. And that was a terrific piece of creative producing by Charlie. He said 'I'll find the money, its going to cost half a million'. We didn't go and ask the BBC if we could have another £500,000 we just spent it. Showing it is still possible to be slightly cavalier within the BBC. I have no doubt that if we had asked permission we would have been stopped. They weren't monitoring us, that's the difference between now and then'.

'You obviously had a good relationship with Pattinson and your two final directors but were there moments when you wanted to be your own producer?' – 'Before shooting there were 20 hours of material for the nine episodes, we probably shot 13 hours and transmitted 11 of them. So obviously there were massive compromises, it couldn't have been any other way, whoever produced. I fought for longer episodes, I lost that fight, I won some things, I didn't win everything. You have to deal with the reality of that. You have to surround yourself with the right people with good opinions, intelligent and creative, a good script editor, a good producer, good directors. Then the process, although it is painful, need not be destructive. There comes a point where you move from serving the scripts to serving the production, that's a fact of life.

'It is not necessarily healthy to serve the scripts as with Dennis Potter's *Karaoke.* Myself I think Dennis was one of two writers, I won't name the other, who achieved massive power over their own material and did not use that power wisely. I am not in that position but I could be if I wanted. I am much happier having the producer and script editor I want to make me think twice and fight my corner. It may be painful but I think it's beneficial. I think there's a balancing act betwen the purity of the writer's voice and the business in which we work'.

'All the same it appears that you did not simply hand over to the business and the system but stayed around through the filming?' – 'When *Blind Justice* was finished I was fairly happy with the result on screen but I thought perhaps it would have been better if I'd been involved more, it would have been better if we had rehearsed more and if I'd spoken to the actors. And that was something I put right with *Our Friends*. I was there a lot. I had to be here early on because things were going wrong. But I asked for and got much more rehearsal time than is normal with television. It is a terrible weakness in television, a lot of people turn up on the set without ever having really rehearsed. Some actors collaborate with that and say they want to be freshly minted for the moment but we were very strict.

'We had a lot of very experienced and high powered actors and some of them started with that cavalier attitude. One said 'I only stick to the script if its Shakespeare' so he had to be disabused quite quickly. And the same went for everybody, whether they had one line or a major role. They all stuck to the script and if they didn't like that they were told to talk to the writer. I am very flexible about that, I know what I'm trying to achieve, if I haven't achieved it I'll change it, it's as easy as that. So I was responsible for 99.99 per cent of what was spoken in the end.... Nobody likes to get a reputation for being difficult, writers are not empowered, I can see why some hand over. But I had been writing for such a long time, I had had the experience, I knew I had something to offer. I knew I could improve things with my opinions and my judgement so it seemed to me that it would be crazy for there not to be that input and the producer took that view as well.'

'Though I suppose you must have had your occasional rows, even with the producer?' – 'There does come a point when you row about money. What he has to value, which scene has to be reduced, which location has to be changed, where to save money... I can remember getting into an impasse with Charlie about episode eight, about how much of it was going to have to go.

I did lose my temper and became rather petulant and abusive and then I went for a pee. And Charlie came in and we stood next to each other, both having a pee, and he looked at me and said 'You're a difficult bastard' and we had a laugh and we went back and got on with the meeting and sorted the problems out. In the end there's only a certain amount of money, you argue your case, you win some, you lose some'.

'I think it is fair to say that you were reporting the politics and the corruption of those years, mostly as seen from Newcastle where only Labour matters, rather than giving your ideas for a better future. So what was the message?' – 'I wrote episode nine a year after I'd written everything else and it was a time of acute difficulty in my private life. So I mainly wanted to know what happened to Nicky (Christopher Eccleston), the disillusioned idealist who returned to his childhood sweetheart, the New Labour politician Mary (Gina McKee), and found married life so difficult. I wanted to know if he could live with Mary, or any girl. In a sense I was concentrating much more on the personal stuff by the time I got to the end. You can only write about yourself, there's nothing else to write about. Everything else is technique.

'I remember that in your review you complained of a scene too far at the end, that the future of Nicky and Mary should have been left open. I profoundly disagree. Him running after her and catching her at the end was personally necessary for me. I had to say that despite all the difficulties you can live with the person you love. Or you can at least make a date to have lunch with them that day and not tomorrow, just that little note of optimism. The people became more important than anything you could say about the 1995 political situation, the probability of a Blair Government and that Mary would be part of that. I have been asked to update it with an episode ten but I think it would be a complete waste of time.... well, never say never, I might be interested in five years time when I've got something more to say, a nice way to get another repeat'.

'After such a prolonged battle to make yourself heard through television do you now want to return to the theatre for a rest cure?' – 'It's economics, its purely economics. I have been in discussion with all the major theatres for the past seven years but the pure fact is that none of them have any money. I must work in television where I'll be paid reasonably. And of course it is really not just the money. I came into television because it offers you a canvas which you can't find elsewhere, a multi episode piece is wonderful, the nearest a dramatist can get to being a novelist. So for the last 16 months I have been working on a 12-hour serial about Cromwell and the English Civil Wars called *The Devil's Whore*. I only had a very small amount of money for development so I have borrowed £30,000. If they don't repeat *Our Friends In The North* (they did, in 1997) and make *The Devil's Whore* I lose my money'.

Antony Thomas

In a sense Antony Thomas's £8 million *Rhodes* for BBC1 took at least as long to reach the screen as Peter Flannery's £7 million *Our Friends In The North* for BBC2. By the time they achieved transmission both could equally be seen as throwbacks to an earlier and more expansive era of television drama. Over the years the expenditure of toil and trouble, blood, sweat and tears, was

roughly equivalent. In both cases it was largely a matter of chance, or a series of chances, that brought them 1996 scheduling. In terms of passion if not presence both writers were equally committed to their shows. As executive producer Michael Wearing saw both blockbuster serials to the airwaves. The difference was that the Flannery drama won awards and was perceived as an unqualified triumph and the Thomas bio-pic was seen as an unmitigated disaster. 'Why have we had to wait so long?', was the welcome question that greeted Flannery. 'How on earth did it ever get made?', was the unpalatable cry which slapped Thomas in the face.

Antony Thomas is a child of the British Empire. He was born in Calcutta in 1940 and, aged six, was taken to live in Cape Town with conservative, Edwardian-minded grandparents. An abiding childhood memory is of often passing the Cecil Rhodes statue near the parliament building. 'For my grandparents Rhodes was a symbol of everything that was fine about their tradition and everything that was noble about being British', Thomas remembers. 'He justified our presence in this part of Africa and I was taught to thank God every night in my prayers for making me English'. When he came to England, first as a pupil at the Dorset public school of Sherborne and then as a Cambridge undergraduate, he was a fervent advocate for South Africa, its governments and its apartheid policies. He even called at South Africa House in London to arm himself with propaganda arguing the case for separate racial development. He knew from the age of 15 that he wanted to be film-maker and five years later, after graduating from Cambridge, he went on to make his first film school documentary.

When he returned to South Africa in 1962 he was welcomed home as a loyal believer in the political and social status quo and was asked by the Government to make a supportive film to be called *Anatomy Of Apartheid*. His conversion occured when he was researching in Soweto and was befriended by ANC man Bigvai Musekela. He completed his film but it was not one which the Government wanted shown in public. Soon afterwards, on the first day of 1964, Thomas had his own first taste of political imprisonment. He had attended a mixed race New Year celebration in Johannesburg eventually broken up by the police. He became so enraged by the brutal treatment of the black participants that he stood up for them and was himself arrested and briefly jailed. By the time he returned to England in 1967, to develop his distinguished career as a documentary maker, he had become at least a passive supporter of the African National Congress and its 'armed struggle'.

Antony Thomas's interest in discovering the truth about Cecil Rhodes (1853-1902), the Hertfordshire born politician, coloniser of southern Africa and exploiter of its minerals, was awakened in 1970. He was asked by the explosively opinionated actor-writer Kenneth Griffiths to direct him in a personal portrait of the greedy imperialist. Through the documentary *Rhodes* emerged as an opportunist who took a fortune in the Kimberley diamond rush and subsequently used his wealth, and political influence, to steal as much land and mineral deposits as he could reach. 'Making that documentary was a painful experience for me. It took me back to my childhood and filled me with a sense of self-disgust because Rhodes was part of my own identity', says Thomas.

The film gave him an appetite to learn more and through the Seventies he became a voracious reader of biographies, letters, speeches, diaries and articles,

a compulsion that became 'a descent into evil'. He came to see Rhodes as both monstrous and brilliant. 'As the evidence accumulated, the man took a stronger and stronger hold on me. I found myself marvelling at his powers of persuasion, his extraordinary ability to achieve practically anything he wanted. I was stunned by his brilliance, by his sheer audacity. He used what we now think of as modern methods of market manipulation and he knew all about public relations and the power of the press. His contribution to South African political development was immense. My grandparents had always told me that Rhodes was a 'father to the natives'. I now learned that if anyone could be accused of being the architect of apartheid it was Cecil John Rhodes'.

By 1975 he was having his first informal discussion with producer-director Don Boyd about the possibility of a Rhodes feature film for the cinema. An idea which soon faded from his mind as he realised that the story was too big for a single film and could only be told through a television series. Nothing concrete happened until 1983 when he went to Margaret Matheson, a brilliant BBC drama producer of the Seventies who had come to prefer an executive role. He told her the Rhodes story as he had put it together. The following year she and her newly formed Zenith independent production company commissioned what would become, 12 years later, Antony Thomas's *Rhodes*. It was significant, and would remain crucial, that Zenith was then headed by Charles Denton. The same Denton who had been a programme boss at ATV and had formed such a good relationship with Thomas as one of his star documentary suppliers.

Thomas did not immediately get down to writing. He was a documentary director who wrote his own commentaries but had never thought of himself as a creative scribe. He began by asking a professional to write *Rhodes* for him. 'This is not a story I particularly want to tell so let's just say that a very eminent writer was asked to write the scripts, a man I admire hugely, very popular, a very fine writer of novels but not a good script writer. He did a first draft of the first episode and it was just not good at all. I wrote him a long, long memo telling him what was wrong and he replied 'Antony, you should be writing this yourself'. He made the same point to Margaret and she took it on board and asked me to try writing the first 20 pages. And those original 20 pages were very good I think. They led to a firm commission.

'At that time I thought in terms of a two-year writing project. Between 1984 and 1986 I did a huge amount of additional research and had a full-time researcher to help. We ended up with four two-hour pieces, considerably longer if you sat down with a stop watch, but those were just first drafts. The idea was to shoot in Zimbabwe and I went out, even before I started writing, to discuss the possibility of doing it there. I spoke to the authorities honestly about my interpretation and it was clear that they would be very happy for the series to be made there. South Africa was still white ruled and ruled out'.

When the scripts were written Thomas and Matheson went back to Zimbabwe and learned of the disadvantages. There was no Georgian or even Victorian architecture, English interiors would have to be filmed in England, they would have to fly in a huge cast, a large technical crew and all the necessary equipment. They would not be able to trust the local laboratories to develop and process their film. The budget would have to be £18 million and that was

clearly beyond their means. For the moment, perhaps for ever, there seemed to be no way forward.

Revival of the idea happened in 1990, through a chance meeting between Thomas and Denton. The South African political situation was at last shifting. Nelson Mandela had been released from prison, President FW de Klerk seemed to be moving towards a change of heart, Denton asked whether it might now be possible to film in South Africa. Thomas flew there in October, showed the scripts round both to the ANC and the relevant ministries, and was heartened. By the end of the year Denton had moved to run BBC television drama, taking the *Rhodes* project with him, and the South Africans appeared happy to give it hospitality. Then followed a five-year slog to raise an international co-production budget.

'It was not until mid-1994 that director David Drury came on board, strongly recommended by Michael Wearing. David was shown the scripts and said he liked them, we had a successful meeting and we all got on terribly well together. David varied the scripts enormously but they were good suggestions and the original vision remained intact. My nerve broke towards the end of the year because one minute the finance was there and the next it was not and I was seriously compromising my career as a documentary maker. I met producer Scott Meek and settled on January 30, 1995, as the deadline date when I would have to move on if the finance was still uncertain. January 30 came, the finance wasn't there, I went to New York and made committments about my next documentary. Three weeks later the *Rhodes* finance was there'.

At this point Antony Thomas in effect lost control. His scripts had undergone many changes over the years. The questionable device of using Princess Catherine Radziwill, as it turned out as badly directed as it was acted, had been reluctantly added when Margaret Matheson was in charge because of her feeling that an all-male show would not raise international finance. Other aspects were completely out of the writer's hands. 'Towards the end of pre-production, in order to bring the budget down further from £10 million to £8 million, they made a number of script changes. Some I regretted but they were very courteous about it and they showed me what they'd done and asked for my comments. It was not a question of rewriting then but of cuts...

'But of course I was away from the whole process. My credit as executive producer was an acknowledgment of my setting up the project in South Africa. I had a couple of days of filming because I played the cameo role of the radical Westminster MP Henry Labouchere. I did see some of the early rushes, I was invited to see them, and I made the mistake of sending a long fax out to David and I was not popular for that. It was made clear I should not do that again, it was David's show. So the next thing I saw was a fine cut of episodes one to four on VHS tape. I was shattered and deeply depressed by episode one.

'I was terribly worried about David's choice of the young men gathering around Rhodes. I have always been sensitive to this thing about the sexuality. Not because it is important to me but because it seems to be terribly important to everybody else... I had nothing to do with the casting which was a shame, I could have made myself available for that. I think it would have been tremendously helpful to David if I had been there for the rehearsals of the principal characters. This is a very sensitive issue Sean and I can understand if

a director feels that he does not want the writer banging round, I am sensitive to these things, but I really think it hurt the series when the door was slammed in my face. I probably sound resentful and whingeing but there was a party given to the principal cast before they all went off to South Africa and I wasn't even invited to that.

'I know enough about directing not to have behaved like an idiot and created any form of divided loyalty, I think I'd have behaved properly. But, in episode one for instance, it needed somebody to step back and say 'Here, we can't hear what this dialogue is and it's a crucial, crucial moment which signals Rhodes' moral change of gear, we can't do this scene with so much action swirling round, so much noise that we are not going to know what's going on. The moments of punctuation are terribly important, let this storm scene play, that's great, but... There are so many moments in that first episode particularly where you just want clarity and stillness. We could talk about casting for ever and I think that's unfair because it means picking out actors and being critical. All I do say is that the first episode should have had clear signals and a sense of reality and the use of weird accents and all that is not helpful...'

'Would you like to have directed yourself?' – 'Yes, I would love to have directed it. It was on the cards for a long time. But then Scott Meek came to me, he was the MD figure at Zenith by then, and said we would have to have several directors, no director would have the energy to do them all. Then when David came along he was pretty convinced he could do the whole series himself and I was to be his producer. And when we were battling and battling for money I did realise that to have somebody like me who had never directed a drama series was probably weighing us down and prejudicing our chances... I think David is a wonderful director, I think he has done a lot of marvellous things with this series but I think if we had collaborated it would have been much better'.

For his part executive producer Michael Wearing acknowledges that 'for whatever reasons *Rhodes* did not work for people'. Does he have any explanation for the failure?

'I think, just on the level of its theme, that the series would arguably have had more relevance if it had gone out before the changes in South Africa. It was an extraordinary work of ambition and scholarship and clearly everybody thought Antony had created an abnormal piece that should somehow be rewarded. The problem was that he couldn't shoot it at that time. And don't forget it wasn't a BBC commission, it was Zenith taking a great big risk and that should be acknowledged. When it came here to the BBC I think we were perhaps all a bit blinded by its sheer scale and ambition and we didn't perhaps inspect it properly. With the benefits of hindsight it turns out to have been a mistake'.

'What did you feel about the use of Princess Radziwill as a kind of link figure?' – 'The problem about all this is that you have to present this arguably important piece of British history in a television business where co-production funds are essential. Co-producers from another television culture will complain 'There are no women in it'. So they came up with this rather overwrought device which they thought would solve some of their problems. And in a crude way it did take you through what, to any other country, would be an

191

even less well known historical story. But I do think now that we might have been harder about that and thought about whether we needed the device at all'.

'There have been rumours that this series was forced on you by Charles Denton and because of his loyalty to Antony Thomas, that Denton banged his fist on the table?'. – 'It's a little unfair to write of Charles banging his fist on the table. But to the extent that that is true there was a kind of quid pro quo. Charles had supported me and all of us in a lot of things we wanted to do and he did sort of say 'I do rely on your support over *Rhodes*, I have got that haven't I?'. At the time it wasn't difficult to agree though I now see our instincts were wrong. But it was a quid pro quo in that sense and really Charles did come to the BBC with some determination that he was somehow going to see it made. It was his show'.

'With hindsight I guess you would like to have put a strong script editor on the show. I suppose to some extent this demonstrated how the lack of care from above and from outside had so reduced the confidence, even the self esteem, of the BBC drama department and made it defer to outsiders?' – 'Well yes, it is not true that the scripts were not read but the editing had been done before they reached us. It is a hugely complicated thing but they were very sure of themselves at Zenith. And the feeling has grown at the BBC that the grass is greener outside. There has been a lot of impatience with internal executives, internal ways of doing things, and I think this series did come up at the height of the climate where there was a great question mark over whether we were capable of managing anything and could ever be right about our internal judgement of programmes. Also the independents, particularly the big ones like Zenith, didn't want BBC interference and it would have been difficult to achieve it. We should have interfered, there is no question that we should have, but we didn't '.

'The publicity about cost cannot have helped?' – 'Yes, the barrage of bad publicity about the cost was a bit of a shot in the foot. It was a BBC publcity mistake. They crowed about the £10 million cost and it came back on us in a really big way. The actual cost was nearer £8 million and didn't all come out of our budget anyway. It was a hugely complicated financial deal which the old management of BBC Drama was not allowed to have anything to do with. It was all the new super accountants sorting that out. Nobody ever knew how it was done because it came along at the height of bringing in all these people who were rubbishing the old management inside the department, it was the worst possible time for us all'.

12 Wasted assets...?

Simon Gray, Howard Schuman, Troy and Ian Kennedy Martin

At that time I could expect pretty much anything I wrote would get on. Now the BBC drama department is awful. They've become something else, byzantine in their politics, they've turned themselves into a mini Hollywood. Everything changed for the worse when they went in for making films.

It is not just morally wrong it is a sickening waste, the continuing failure of broadcasters and their drama departments to cherish and honour their mature writers. Dennis Potter contrived to die before his sixtieth birthday and, for better or worse, ensured that his last scripts were still respected and produced after he had gone. Most other television dramatists have been at best under-employed, more often entirely discarded, long before they reach their late fifties. Some of them have run out of steam or ideas or both, there is no point in pretending that any writer's creative talent and energy is infinite, but in reality few fall out of favour because of diminishing powers. The system allows nothing so just and logical. The main problem is simple ageism. Little or no value is placed on the authority of experience or long honed craftsmanship. In the broadcasting organisations the youth cult rules as an unwritten official policy observed internally as well as in relationships with freelances. The scramble for diminishing drama resources is matched by the turnover of commissioning and production staff. Young producers like to feel they are making discoveries from among their contemporaries though the work that reaches the screen may be inferior to that which the inherited 'old farts' could deliver.

It is true that to some extent this waste of assets is a natural, in some ways desirable, result of time passing and it is certainly not a phenomenon limited to the television of the 1990s. It is more obvious in television drama than it was before but that is partly because it is a diminishing area both in terms of volume and in variety of form and content. Some of the discarded, or largely discarded writers, interviewed for this book lost out in earlier decades. One

193

thing they all have in common is that they were not dropped because their work failed some objective test. In each case the cause was that producers, with whom they had a working relationship and who appreciated their worth, either moved on or lost power and influence.

Simon Gray, still active and valued as a stage dramatist and novelist, was once considered a television writer in the Dennis Potter class whose every script was produced virtually as a right. His last 'half commissioned' work for television, *Like Father*, was turned down in the earlier Nineties by the then BBC single play head George Faber. It was maybe not Gray's best screenplay ever but, measured objectively, half good Gray would have been more entertaining than the undistinguished, and largely forgotten, line up of BBC singles that were produced in that year. It probably did not help the Gray cause that his producer advocate was Kenith Trodd, a veteran whose pursuit of perfection did not make him a favourite with the younger and less experienced people then in command.

And if Simon Gray is discarded by television what chance is there for Robert Muller's swansong series *Bloody Foreigners*, even in the comparatively writer-friendly set up at Channel 4, now that instinctive backers Michael Grade and Peter Ansorge have gone? Muller was born a German Jew who escaped to England as a 13-year-old in 1938. By 1961 he was enjoying a distinguished career as a Fleet Street journalist, who had produced three novels, and was invited to try his hand at television drama. Brought forward by story editor Peter Luke he wrote a total of around 15 single plays – 'some very good, some dreadful' – for producer Sydney Newman and ABC's *Armchair Theatre* on the still young ITV network. When Newman went to the BBC the fertile Muller went with him. And when his imagination began to dry up he moved with success to adaptations, usually from classic French and German novels.

'If I were to be absolutely fair and neutral and objective I would say that of course I ran out of ideas', he told me when we met in early 1997. 'How many plays can you think of. You've done 15 in three years and that's it. You are used up. There are exceptions to this, most notoriously Dennis Potter of course, but they are few and far between. I started doing adaptations for the BBC and I found sympathetic producers and had good actors. Our version of Heinrich Mann's *Man Of Straw* (1972) had Derek Jacobi as Diederich Hessling. This, not the more successful *I Claudius*, was his first appearance on television'.

He continued to write for BBC drama through the Seventies, always it seemed a highly valued craftsman. He was specially proud of his brilliantly cast *Vienna 1900* (1973) – 'the best thing I've ever done for television' – putting together six Schnitzler stories; and his *Supernatural* (1977) – 'the BBC didn't like it, the reviewers didn't like it, my wife (Billie Whitelaw) didn't like it and she was in it, nobody liked it but I enjoyed it more than anything I have done for television' – eight completely original screenplays based on the myths of horror movies. Then bright young Martin Lisemore was killed in a car crash and other producers and story editors with whom Muller worked began moving on.

'And then it sort of stopped. The personnel changed and the telephone stopped ringing. I was writing a Berlin-set serial, *The Great Inflation*, for

Jonathan Powell as head of series. Seven episodes had been reduced to six and then four and he had resorted to message by minion. When I tried to ring him his secretary said 'He's kind of tied up at the moment'. That was the end of the BBC for me. They never forgive those they have betrayed. After 20 years of work for them not another word, no apology, absolutely nothing', he said. British television's loss was Germany's gain. He began 20 years of regular work with the German WDR station, 'where at the start anyway the writer was still top boy'.

When the schoolboy Robert arrived in Britain he had the choice of retaining his German identity and accent or reinventing himself as an Englishman. He chose the latter. In his later years he came to feel this was a mistake, that despite all his best efforts he remained a 'bloody foreigner'. He also became increasingly haunted by the fate of the grandmother to whom he had felt so close in childhood. She had been arrested in her native Hamburg, put on a train to Riga and was never heard of again. Just one holocaust victim but the one he cared about. His six-part farewell to television for Channel 4, *Bloody Foreigners*, tells this story and those of his Jewish friends, the Thirties refugees from Nazi Germany, some who stayed in Britain and others who went back after 1945. A fascinating drama which deserves to be seen but has the draw-back of a £4 million budget. When we met Muller had completed five episodes and his producer friend and colleague David Conroy was editing them for Channel 4 production. Soon afterwards Muller, who had survived a 1982 heart attack, went to hospital for a complicated but apparently success-ful by-pass operation. He then suffered a stroke, leaving him partially paral-ysed, and had a second heart attack. He clung to life but, declining to be 'falsely optimistic', felt in his bones that *Bloody Foreigners* would surely be a victim of the change of leadership and attitude at Channel 4.

Muller's 'not another word, no apology, absolutely nothing' experience is echoed by hundreds, probably thousands, of writers who have fallen out of BBC, ITV or Channel 4 favour. I draw two more, from different eras, out of the hat. Jean McConnell, a theatre person both as writer and actress, turned to writing for the BBC's one channel television monopoly in the early Fifties. It was the time of studio-bound, theatre-derived, live television drama. Her 1951 debut play, *Haul For The Shore*, unjustly attacked by reviewers as a rip off of Alexander Mackendrick's cinema version of *Whisky Galore* (1948), brought her an up front fee of £6-10s and the same again for a repeat. 'I did-n't know anybody at the BBC but I submitted the script and they were busi-nesslike and they were polite. There weren't so many people at it, they weren't being besieged by five million scripts arriving every minute, television had hardly begun. So I was lucky in that sense', she told me when we met in late 1996.

Writers then had to learn about the 'considerable technical things' of live stu-dio production as they went along. 'For instance you had to hold a scene to give the actor time to go to another set, so that the cameras could pick him up there. That made it much more exciting of course'. So exciting that there were almost bound to be errors. 'I could have done without the shadow of a microphone boom and could not make out why a character should say 'Good evening' when he was just about to serve breakfast', observed one attentive reviewer. In another scene people were seen walking outside a window that

was supposed to be several storeys high. The advantage for writers was that they were treated as in the theatre. They ruled and their relationship was with the director.

It could not last. By the time of McConnell's third television play, *Pick Of The Season*, a hop picking tale with Dandy Nichols in the cast, script editors had begun to intrude. 'I had over-written like mad and they sent a woman called Ada Cole to put me right. I knew it was too long and I was happy to cut it but she kept saying 'Wouldn't it be funny if we had this joke'. And I would tactfully say 'Yes, it's very funny but not funnier than the joke I wrote'. So we had to have arguments about whose jokes were funniest. But it was still civilised in those days, they always came down to my house to talk about things'.

She went on to write serials for children and episodes for the original Sunday evening soap *Dr Finlay's Casebook* (1959–66). By 1964 her fee had risen to £157-10s for a first transmission and the same again for a repeat. But she made herself unpopular after her 'Clean Sweep' episode and a review in The Stage which declared that 'Jean McConnell did a workmanlike job on Cronin's material'. She wrote pointing out that the scripts were all original, Cronin's six stories merely having provided the regular characters and their situation. The letter was printed large and the producer, who had found Cronin a difficult writer and in need of endless placating, was gravely displeased. The telephone stopped ringing. 'Here was somebody being naughty and it to would be a woman. But I thought writers should be given correct credits, we were being diminished. I put in a couple of ideas after that but I think I had become *persona non grata*'.

McConnell also lost out at ITV at around the same time, through the 1963 Equity strike. She had just completed her *The Twins At Number Twelve*, 13-part children's serial for Redifussion. The actors' strike, for better pay, lasted for nine months. When it was settled a directive went out that no new drama could include more than nine characters. Her serial had 14 characters and was one of those axed. 'And somehow that was the end of television for me'. She sold one or two televison scripts abroad and, as well as returning to stage work, turned to writing for radio.

'I had to leave television early because people I knew moved upstairs or were kicked sideways and then you had to try and sell yourself to somebody else. I am not very good at hustling and anyway new people coming in, even in those days, wanted their own writers. Television certainly was my medium but, as I say when I do writers' courses, there is always sure to be another door beside the closed one. If you are rejected by one market go to another'.

Her contemporary Michael Robson took rather longer to graduate to television drama. He always hoped to become a writer but spent nine enviable years in Norwich, teaching 'extremely attractive and capable girls who wanted to be taught', before taking a job as a writer-presenter at the local *About Anglia* regional news magazine for ITV. After this apprenticeship he moved to the BBC and work as a producer-director for *Cameron Country*, a vehicle for the pungent journalist James Cameron. He fell out with the BBC documentary chief Richard Cawston and had two years running the television and radio department of the Curtis Brown literary agency. It was 1973 before he committed himself to a full time writing career.

He began by writing radio plays, some 55 of them produced between 1973 and 1992, and cinema screenplays. Among his big screen credits was the script of *The Thirty-Nine Steps* (1978), directed by Don Sharp with Robert Powell playing Richard Hannay, taking the popular story back to John Buchan's original 1915 book. His first work for television reached the screen in 1975 after BBC producer Pieter Rogers let it be known that he planned to make a *Ten From The Twenties* anthology, ten 60-minute plays adapted from short stories set in the 1920s. Robson's contribution, a dramatisation of Stacy Aumonier's *An Adventure In Bed*, had the advantage of a catchy though teasing title and the young Lesley-Ann Down in the cast. It was bound to be a crowd puller.

'Rogers was the producer and he had a script editor but they left me very much alone, it was an extremely agreeable situation for a writer to be in', he told me when we met at his Dorset home in late 1996. 'Once Pieter trusted you that was it. All I had to do was to lose perhaps a couple of minutes when we had the read through... At least 60 per cent was shot in the studio and they normally wanted you there because they might suddenly find they were running short or running long when it came to the final things. You might then have to write or lose two minutes there and then. There was no time for the director (Paul Ciapessoni) and I to fall out. And in the event my first play was recorded absolutely as I had written'.

He followed this with *Mad as The Mist and Snow*, the title a quotation from WB Yeats, for another Pieter Rogers anthology called *Jubilee* (1977) and reflecting changing attitudes during the reign of Elizabeth II. Known as a writer who had written about the military for radio, and having at least one Irish grandparent, Robson was challenged to write about the troubles of the Irish north and had his first taste of television prescription. 'Michael must not use the words Catholic or Protestant and must not use any names which might seem to be overtly Catholic or Portestant', was the order passed down from the head of BBC drama. He chose outlandish names mainly from the London telephone directory and made his protagonist, an Anglo-Irishman serving in the British Army, a Major Lightoller (Daniel Massey). He also made his story as even handed as he could manage with an English view of Republican and Loyalist hostilities.

In production Robson won a furious shouting match over whether a certain scene should be played with the words he had written or in silence. He lost his struggle to retain his fancy title and had to accept the dreary *No Name No Pack Drill* instead. The real Special Branch were alerted by a real or imagined IRA threat to bomb White City if the drama was transmitted. And Robson received an aggressive visit from SB officers – 'seeming to think I was a Fenian in disguise' – demanding to know how and why he had hit on names belonging to real undercover agents working in Belfast and beyond.

In reality Michael Robson is as far from being a revolutionary, much less a supporter of Irish Republicanism, as any televison dramatist of his time. Over the years he contributed 25 screenplays of various middle-of-the-road kinds and came to be known as a reliable craftsman with a safe pair of hands. When early scripts for BBC1 series like *Howard's Way* (1985–90) and *House Of Eliott* (1991–94) were found wanting he was one of those brought in to help establish a surer foundation. And he was not restricted to BBC. He came close to getting his own military series, *Fit To Fight*, produced by Central. He was

paid to write its first six episodes before it was brushed aside in favour of Lucy Gannon's *Soldier, Soldier*. He was a contributor to Granada's long running afternoon show *Crown Court* and wrote five of the first six scripts for Thames's *Hannay* (1988-89) anthology with Robert Powell again playing the Buchan hero. But now, like Muller and McConnell before him, he is obliged to take his television writing skills abroad.

'Television had become my main writing area but then came a revolution at the BBC and all the people I knew were either retired or were so fed up they left. And once you're out, you're out. They seem to say 'Who wants a 60-year-old for Christ's sake, coming here with his Zimmer frame and writing for us. What the fuck does he know about what's going on'. And ITV is as bad with no more than three people making the decisions. We are all frantic, all the people I know, and when I go to meetings of the Writers'Guild or the Society of Authors I just see terribly long faces... I am sure most of us who were writing in the good old golden days are now regarded as being superannuated nobodys. I understand that each generation has to try and find new ways but we are finding it a bit humiliating to be written off while still capable'.

Simon Gray

Nobody who has had any contact with the literature, television or theatre of recent decades would call Simon Gray 'a superannuated nobody'. Though he has suffered from ill health and other misfortune in recent years he has remained, having achieved his sixtieth birthday, an active and serious writer. Read his dialogue rich prose or see one of his West End stage plays and it is clear that his vision, of close intense relationships, is particularly suited to television. He cut his drama teeth with television and has invariably provided excellence in his work for the medium. Drama departments should be begging him to write for them again but instead prefer to pretend that he really is a superannuated nobody.

We met in late 1996. There was still some rippling of the waves created by his mordently brilliant *Fat Chance*[1] memoir about what happened to his stage play *Cell Mates* the previous year. The drama puts together the relationship, forged in a Wormwood Scrubs cell during the early Sixties, of the convicted spy George Blake and Sean Bourke – the Irish petty criminal who aided his escape. The memoir tells of how the West End production was set up and of Gray's relationship with his actor leads Rik Mayall (Bourke) and Stephen Fry (Blake). But its main concern is the havoc wreaked by Fry through disappearing at the end of the first week and then declaring himself mentally unfit to continue. Tellingly it was a drama originally commissioned by the BBC for television, where it would probably have been still more effective than it was in the theatre and where production would have been no threat to Fry's mental stability.

'When I finally completed a film script that satisfied the BBC producer, the director of our choice and myself, I was invited to an interview with the head of one of the drama departments', Gray wrote. 'He sat behind his desk, cool and correct, a combination of school-master and Anglican minister. He said he liked the script a lot and so did his script editor. He nodded to his script

1 Simon Gray *Fat Chance* Faber, 1995, page 16

editor, a pleasant-faced woman in her thirties who struck me as someone out of the Workers' Revolutionary Party. She said she also liked it a lot, a lot more than most of my other work, yes she liked it far, far better than almost anything that had appeared on the screen under my name, and she didn't really have any reservations. Not really. The head of the department then came rolling around the desk in his wheelchair... and proclaimed that these days it didn't matter how good the script was, what they needed was stars, yes stars – his voice reverberating on the word as if he were talking of Christs – stars to put bums on seats. The producer made a counter-peroration. The script editor chipped in with some blatantly capitalist affirmations of her boss's spiritually resonant position – 'Get us some stars', she said, 'and we'll get the show on the screen'. We left, the producer, the director and I, with the head of drama rolling back behind his desk, the script editor smiling placidly at the thought of another job done, another execution faultlessly executed'.

Gray records that he and the director came up with the names of several actors who could do the parts, all delivered by the producer 'to the overlord and his script editor' and all greeted, he suspected, with the same 'sorrowfully disgusted shake of the head'. After which 'I gave up on the BBC, feeling that the BBC had given up on writers, and this one in particular'.

When we met Gray had thoughts, not altogether frivolous, of dramatising *Fat Chance* for television. The BBC had bought the rights and Kenith Trodd was interested and was still hanging on to his producer job, if only by his fingernails. 'Have you cast Stephen Fry in it?' – 'I doubt if he would be up to the part'. 'He couldn't play himself on television?' – 'He hasn't got a self to play, that's one of his problems in life I think'.

Born in 1936, the son of a medical doctor, the child Simon spent World War Two as an evacuee in Canada. For the rest he had an up market, middle class intellectual education moving on from Westminster public school to Trinity College, Cambridge, where he took a first and bought himself time with postgraduate grants to write novels and short stories. He taught at Cambridge and in Canada before, in 1965, beginning his 20-year stint as a lecturer in English at London's Queen Mary College. Disabused student, and later fellow dramatist, William Ivory complains that Gray was never around. It did not seem like that to Gray himself. His 1997 novella *Breaking Hearts*, the story of a lonely lesbian lecturer in English, is set around a London University college known as 'the Dump' and is placed like Queen Mary's in the Mile End Road.

Although a great cinemagoer when at Cambridge he did not pay any attention to the development of television drama. Even when he began writing for the medium he never accepted the Dennis Potter idea of television being the great democratic national theatre, the stage from which writers could address the millions of all classes, kinds and conditions. Always ruthless in his scorn for bullshit he admitted that for him the most attractive thing about television was that it was a medium which artistically and technically suited his work. In other words he was aware that 'there are things you can do on television that you can't do on stage or on (cinema) screen'. He also argued that audience counts in millions were false because only a minority were giving any one programme full attention. 'The thing about a television play is that it's just part of an evening, a blurred event in the minds of the people who watch it...', he told Ian Hamilton in a *New Review* interview of *circa* 1975. For all this there

has never been the smallest sign in his drama of the careless or the patronising, of a writer 'dumbing down' for the television audience. Maybe it was 'just habit' but he admitted spending 'as much time and devotion on a television play as I do on a stage play or a novel'.

He first moved to television in the mid-Sixties when one of his short stories caught the eye of BBC script editor Kenith Trodd. There was an offer to buy the story for dramatisation as a Thirty Minute Theatre play. When Gray heard that there would be more money for the adaptation than for the story he went for the double fee. 'I didn't have a television set and I wasn't sure how these things worked but the story was so full of dialogue that I didn't have to do much more than write the names of the characters on the left hand side of the page and put in a few stage directions. I think it took me two days or less and despite the awful title, *Caramel Crisis*, it worked. It had an amazing cast with George Cole in the lead. It was still live television then and you could see all these distinguished actors, sitting in their dressing rooms or sitting in chairs round corners and shaking with terror'.

When Trodd moved to become story editor on The Wednesday Play, 'we got on together very well', Gray was given the chance of a larger slot. He had come across an Edgar Lustgarten compilation of 'famous murders' and had been taken by a particular story, only six pages long. That became *Death Of A Teddy Bear*, produced by Lionel Harris, directed by Waris Hussein and transmitted as the Wednesday Play of February 15, 1967.

'What I remember of this was that I had failed to use a carbon so there was only one copy of the play. I gave this to Ken and he gave it to the producer (Lionel Harris), who remained stoically silent. Lionel was an Australian and he was what we then called queer and now describe as gay. And he had apparently lost the one and only script. Ken and I went round to his flat and there he was with his companion. We decided the only thing to do was to search his flat, being convinced it must be there. The flat was a complete shambles so he allowed us a cursory look round. Then Ken would go out and pretend to have a pee and search a room. And when he came back I would go out and pretend to have a pee and I eventually found the script under his bed. I suppose that's what they call the good old days. It was done with Brenda Bruce and Hywell Bennett and it won an award. There was an idea of making it into an opera but we didn't pursue that'.

This was followed by a BBC score of 11 'plays' and eight 'films' all developing the Gray television style of close, intense plots about friendship and fidelity and the lack of them. Particularly memorable were the early *Spoiled* (1968) and *Man In A Side-Car* (1971); the *Plaintiffs and Defendants* and *Two Sundays* pair shown in 1975 as consecutive Plays for Today; and his *After Pilkington* (1987) Prix Italia winner. All of these were broadcast almost entirely as written and if there were arguments they stayed mainly in the margin. It helped, according to collaborator-producer Kenith Trodd, that Gray habitually gave himself the insurance policy of two quite different drafts before he let anybody see either of them. In the case of *Plaintiffs And Defendants* and *Two Sundays* this system worked well as a dramatic double about the relationships of two men (Alan Bates and Dinsdale Landen) and their wives. Gray has never been interested in writing series and serials, he prefers enclosed stories, but each of his singles made a television event akin to the latest Potter.

Why he fell out of favour at the end of the Eighties, despite his Prix Italia triumph, remains a mystery.

'It all sounds quite effortless. Your stuff appears to have reached the screen smoothly and as written, without any of the angst which always seemed to afflict Potter and others. Were you never involved in controversy?' – 'I had my share, for instance, over *Sleeping Dog* (1968) which brought a great deal of unpleasantness for myself. It involved a black guy being chained up by a lunatic former (cinema) film administrator who thought his prisoner had been having an affair with his wife. In those days directors were allowed location filmed interludes, lasting up to eight minutes, which they mixed with the studio shot material. And every director was determined to have his eight minutes, however arbitary it looked. In this case the film was shot before anything else and included a sequence with this black guy strutting in a most manful way across a field, an absolute image of macho, aggressive maleness. People took up positions about that and I had to explain that the figure was actually camp and gay. The awful joke of the piece was that this camp black guy was picked on for having a go at the film man's wife. The eight minutes made no sense at all without the narrative'.

'But minor hiccups apart your work was used?' – 'Yes at that time I could expect pretty much anything I wrote would get on. Now the BBC drama department is awful. They've become something else. Byzantine in their politics, they've turned themselves into a mini Hollywood. Everything changed for the worse when they went in for making films. In the old days everything was so relaxed. In the Sixties and Seventies there was a feeling of everyone wanting to make the thing as good as possible. And you knew there were other things they were going to make as good as possible. So there was a life of coherent, continuos work. I mostly worked with Ken Trodd and producers like him used to have the authority to commission and expect to have the work done.

'Now it's a matter of jockeying for position all the time and I find that quite intolerable. Now if there are four people still able to make decisions they are each surrounded by about 20 script editors. The real curse of the BBC today is all those script editors. What are they? A script editor should be a beginner but now they seem to have almost complete power and it is hard to get past them. Often, I suspect, they make a decision to absolve a producer from the responsibility of having to decide himself'.

'I suppose you might have given yourself a better chance of staying in favour longer if you had followed Potter and Bleasdale and the rest into writing series and serials?' – 'Maybe but I can't do that. A 90-minute screenplay is not so short. The point is that I do truly love to see on screen stories that are complete in themselves, a single organism. I love the kind of work that's entailed in that, which is actually quite complicated. When I see it done well I'm very thrilled. The whole life of a drama recorded in one seems to me more like a living creature than a series or serial'.

'Do you at all go along with the idea that, although *Pennies From Heaven* was not the first up market drama serial, Dennis Potter's reputation meant that his move into the extended form helped to kill off the single drama?' – 'Potter was never a man of modesty and it wouldn't have occured to him that he was

depriving five other people of slots. And I doubt if he had given any thought to the wider implications...

'I knew him initially before he became Dennis Potter, so to speak, and I liked him a lot then. He was great fun and witty. We met each other at parties and had the occasional dinner. But latterly our relationship became dodgy. There was a fatuous feature which the Observer ran for a time, called the musician's musician, the composer's composer, the novelist's novelist. Eventually there was the television playwright's television playwright voted on by our peer group and I was the playwright's playwright chosen by Dennis. A little later I bumped into him and Ken. It was just before he let it be known that he was on the way out. We had a very alarming conversation, full of venom. He said 'One thing I know about you is that you've never sat through a single piece of mine'. And it was absolutely true, I never had. I am told by people who I respect that *The Singing Detective* was wonderful but...

'I thought he was by nature a terrific journalist who wrote for the papers with a wonderful eloquence. But I think the most repulsive, controlling image of television today was the sight of Dennis begging on television for his last screenplays to be produced. That last interview was eloquent in many respects and the beg became a command. What I think about his work is completely irrelevant. It was repulsive because he should never have had to think his plays might not be done. And it was repulsive of him to have begged. It was so immodest. I think when you are dying you would want to talk to your loved ones and not to the public'.

'It seems the writer's lot now is not a happy one and that the only way he can win back some of his power is to form his own independent company. Have you ever thought along these lines?' – 'You are right, I think things are pretty terrible for the writer now and its's very discouraging. I think producers should be forced to take responsibility again and should elminate all but one script editor. They should trust in their own tradition, which they are clearly denying. Otherwise it will not be the BBC we used to know, it will simply be another movie making organisation of no particular concern. And if not that the threat is that they will simply become another publisher with all the money raised elsewhere. And no I have never wanted to be bothered by a company. The problem in this for me is that I want to be telling stories and that is enough. I have mostly avoided adaptations though I thought that *A Month In The Country* (adapted by Gray from JL Carr's novel and directed as a Channel 4 cinema film by Pat O'Connor) went very well'.

'It seems extraordinary that after the success of *After Pilkington* and *Unnatural Pursuits* both *Like Father* and *Cell Mates* bit the dust?' – 'Well, they didn't really want to do *After Pilkington* but felt an obligation. Even after it had been produced the head of plays, then Peter Goodchild, said he didn't know how this one had slipped through the net. Though he happily collected the Prix Italia. When I was asked to the celebration party I noticed that the names of the producer and director but not the writer were on the invitation. Winning prizes is not necessarily helpful. I got some BAFTA writer of the year award through *Unnatural Pursuits* and I remember Ken saying 'Now we're in real trouble, nobody in power will want to allow your work through because you were discovered by others'. That proved right'.

'What is *Like Father* and what happened to it?'. – 'It is a kind of thriller where the important point is a son's search for a father and a father's search for a son. I had to do a treatment and it was sort of half commissioned. It is grotesque, I had been knocking around television for something like 30 years and they insisted on having a treatment. It was passed around, I don't know who would see it, the script editors I suppose. I wrote the script and it went through various drafts. Christopher Morahan, who I had worked with a lot, wanted to direct it. Alan Bates wanted to play the lead and Ken wanted to produce. But you have to satisfy George Faber (who left to go independent in 1997) and his entourage of script editors. He listens to them but wants to do his own thing. Like a Hollywood studio man he doesn't want to inherit things from the past. It is not that he is a bad man in any way. It is just that he's got too much power and not enough intelligence'.

Howard Schuman

It was 1994 but it was quite like old times in the large studio at BBC Television Centre in West London. As the American-reared and British-domiciled writer Howard Schuman rose tints it 'the entire process was a return to the old days, top designers, top lighting cameramen, completely committed crew, a huge beautifully equipped studio with everybody participating, everybody connected, everybody willing'. Schuman had suggested a studio play about a 14-year-old girl who sets up as a Jungian analyst, producer Richard Langridge had given him an immediate commission and in September of that year viewers of the Scene drama seam had seen the enchanting, telling and technically brilliant production of *Young Jung* which still lingers in my mind three years later.

It was not the sort of perceptive and unprescribed departure the Nineties BBC was going to encourage, much less cherish, for long. On the contrary. As an executive editor of BBC Schools Programmes the imaginative Langridge had been able to use his afternoon *Scene* slot to create a little oasis of fresh and original drama. Unlike the official drama department he had slots to fill and could commission without looking over his shoulder and waiting for decisions from channel controllers. It was something clearly too good to last. He soon got a rap over the knuckles and was told he should be doing 'less drama and more education'. He should be working on the set texts of Shakespeare and others who had commended themselves to curriculum compilers.

For his part Schuman was so enthused by the work on *Young Jung* that he went to thank the studio manager and was asked if he had anything else in the pipe line. Schuman, ever the optimist, said 'We are hoping to do a comedy of the future, set in about 2050, and we want to create wild landscapes in the studio and we would certainly like to use this studio'. At which the manager was pleased and hoped that the project would be put out to tender 'because we have been told we are now too expensive for BBC studio drama'. Thanks to the lunatic 'producer choice' doctrine, introduced by Director-General John Birt and his acolytes, the BBC had found it could no longer afford to make studio drama in its own studios.

Schuman wrote to Birt asking 'I don't understand this, I've had one of the best experiences I've ever had in over 20 years of working for British television and the manager of the studio says he thinks he has been made too

expensive for the next batch of BBC studio plays, isn't this madness?'. In reply Birt signed a letter saying 'I don't understand what you are saying, the last group of Performance (stage dramas adapted for television) plays were done in that studio'. The actual question which Schuman asked was completely ignored. Such transparent spin doctoring evasion appeared to underline the perception that the top management is simply not interested enough in television drama, and the BBC tradition in this area, to give it time for thought.

'The drama being a reflection on Jungian analysis we had a number of dream sequences. For instance we had to create the illusion of a woman walking into a vortex of light. This was simply done by turning off the studio lights and using a single revolving lamp at a cost of £10 or thereabouts', Schuman remembered when we talked at his London flat in late 1996. 'I have always felt that one of the reasons for the demise of studio drama, imaginative studio drama, is that the decision makers didn't want it known that you can make it rather cheaply. They claim that as audiences have become 'more sophisticated' viewers would only accept celluloid drama shot in real locations... It is a self fulfilling prophecy. There was very little of it at the best of times but if you stop producing any non-naturalistic studio drama, as we fondly used to call it, then of course the audience loses any taste for such work'.

Howard Schuman was born in 1942, a child of the Brooklyn district of New York. After schooling he went on to Brandeis University in Massachusetts where he developed his interest in politics and theatre and had 'a misguided notion that I might be an actor'. With a composer friend he developed a musical from the plays of Ben Johnson and formed an idea that he might also be able to write. 'My Jewish family had come to New York from the Austrian ruled part of Poland. I had a brother and lots of cousins and because I was the eldest I was frequently given the task of entertaining kids with story telling off the top of my head. Probably from the age of five I was making up stories to keep children quiet. Writing was something else', he recalled.

Graduation was followed by a fellowship in political science at Berkeley in California and an increasing desire to work in the New York music and revue theatre. He spent the best part of three years working 'off, off, off Broadway' before being given the idea of visiting England by an agent who had liked some of the songs for which he had written lyrics. He crossed the Atlantic in 1968 to find the agent, Douglas Rae, 'not thrilled' that he had taken the suggestion of an English visit seriously. 'What Douglas didn't know was that I had come to London because I had met someone I wanted to live with, there was an emotional reason for being here', Schuman remembered. So it was that he set up home with his lover-friend, the English stage director Robert Chetwyn, and started their long partnership.

Through the Fifties he had enjoyed the heyday of American television drama but 'it is fair to say the idea of working in television did not occur to me – I was a theatre person'. In London he became a punter enjoying the 'absolutely thrilling' television drama of the day, the complex scripts of the late David Mercer and the pungent comedies of wasted asset Peter Nicholls leaving particular marks. He became a fan of the *Monty Python's Flying Circus* (1969) comedy formula from the BBC and even the first run of London Weekend's *Upstairs, Downstairs* (1971) as an example of 'how good a popular drama series could be'.

'It isn't just romantic nostalgia to remember there was much more to watch in those days and I slowly became obsessed with the idea that I wanted to be in this medium. My writing partner (Robert Rosenblum) and I had written a number of (cinema) films which were never produced, probably wisely. I began writing what I thought was a theatre play until I saw that it was really television. I had never been inside a television studio but I knew that this was a television play. And so it was, amazingly enough. This *Verité* (1973) became my first television script to be produced by Andrew Brown at Thames ahead of *Captain Video's Story* (1973). Schuman's funny and strongly idiosyncratic style, derived from adult observation and adolescent memories, did not immediately catch on. His *Verite* actually collected rejection slips for over a year before Brown became interested. Then 'suddenly I was hot'. If his name was little heard before it became widely known through his first BBC commission, the censored *Censored Scenes from King Kong* (1974). Whatever the quality of this video drama the fact that Mark Shivas and the BBC produced it, before his bosses declined to show it, made it a cause that excited debate for the next decade and more.

The genesis of the drama was an article about the Cooper and Schoedsack *King Kong* (1933) in Esquire magazine and the cover flag carrying the legend 'Censored Scenes from King Kong'. The article explained that so much about Hollywood changed between 1933 and the first re-issue of the movie that certain scenes touching on sex and violence were removed. They included the shot of Kong sniffing his finger after putting it close to Fay Wray's genitalia and another few frames of somebody being crushed to death. Out of this came Schuman's personal spin on paranoia and censorship and, as he saw it, the recent death of the 1960s and its real or mythical freedoms. The protagonist is a tough minded journalist, played by Michael Feast, determined to discover what happened to *King Kong* and its missing scene, to do with German anti-fascists, that is a figment of his mind.

The screenplay was written in six weeks, Mark Shivas signalled his approval and the show was in the studio by December, 1973. They were rehearsing a song called The Lights Are Going Out All Over Europe when it was announced that all television must close down at 10.30 pm each night because of the fuel shortage created through the dispute between Edward Heath's Conservative Government and the miners. This meant that Christopher Morahan, then head of BBC plays, had an excuse to cut *Censored Scenes* out of a run of Eleventh Hour plays. A decision which for various reasons, never satisfactorily explained, meant that after its showing at the Edinburgh Television Festival the play disappeared.

'It has always been assumed that your play was censored, like Ian McEwan's *Solid Geometry* and its famous pickled penis, because of its 'specific sexual imagery'. This being, I have always rightly or wrongly supposed, a view of Fay Wray's vulva. But perhaps it wasn't as simple as that?' – 'No I don't think it was. I do know that Morahan had always been very worried about *Censored Scenes*, which he described as camp rubbish like *The Rocky Horror Show*... We should be so lucky. One of my beefs was that I was never called in and nobody explained what upset Morahan so much. I guess that he was worried that the piece implied more than it showed. It was directed in the big studio at BBC Television Centre by Brian Farnham on such a low budget. The designer,

Mike Porter, created a cabaret space using darkness, some beaded curtains, a stage and a piano. I honestly think the above the line cost was probably only about £200 for the sets. But we got this look that was a mixture of cinema and theatre which I was most interested in and which made for the real thing, television drama'.

Whatever the truth of this it did nothing to stop the Schuman flow. In 1975 he wrote and saw produced a decent episode for the much reviled BBC series *Churchill's People* and two singles, *A Helping Hand* and *Carbon Copy*. The following year the *Rock Follies* serials that made his name first reached the screen. It was the moment when his innovative use of the electronic studio, his mixes of words and music, coincided with popular taste. Giving a disabused account of the popular music business the narrative followed the fortunes of a women's rock band, belting out generous helpings of Andy Mackay's tunes. For a time the Little Ladies – Anna (Charlotte Cornwell), Dee (Julie Covington) and Q (Rula Lenska) – were as famous as any rock band of the period. Andrew Brown and Thames produced both the first six-parter and the *Rock Follies of '77* six-parter which followed over the next year.

The open-minded Verity Lambert had lately taken over Thames drama, was introduced to Schuman by Andrew Brown and commissioned the two series with some enthusiasm. Although location drama was her usual style she readily saw that studio work could also still push out the boundaries. 'It was a non-naturalistic piece which benefited enormously from never going outside', she remembers.

'What was the starting point of *Rock Follies*?', I asked Schuman. 'Well one of the interesting aspects of British television drama for me was that you could do the 'novel' as it was called in those days. Until they made *Roots* there was no US equivalent. The Americans didn't understand the concept until they named it 'the mini-series' and it was all right. For a long time I had wanted to write about non rock'n'roll people who wanted to become rock'n'roll people. Specially young actors and actresses who wanted to move into the music business. And that was all I had. I could only tell Verity and Andrew that I wanted to write six hours about a very unlikely three-woman rock group, manipulated by a man. It came out of a sub-plot in *Censored Scenes*. I knew right from the beginning that the story would be about image change, unlikely women changing their images'.

'Having got your green light did your writing flow and were the people at Thames immediately at your feet?' – 'Far from it. The first draft of episode one was diabolically terrible. Verity and Andrew had to call me in to say they were incredibly disappointed, which is not want you want to hear from friends. They said 'Have another go at it'. And after a month it sort of rocked into place. I saw what I had been doing wrong, that I didn't begin the story far enough back and it had to be more energetic. So I began to tell what the women were doing before they met and why they were on their beam ends'.

'So you completed your six episodes....?' – 'No, I didn't, that was another signifier for an earlier age. When we went into rehearsal we had three good episodes and after that I was writing on the hoof. My bacon was saved, quite frankly, by two technicians' strikes. I was saved by the strikes and Andrew Brown's incredible fortitude. Episode four went relatively well and then, with

episode five, I just hit an iceberg. It was very scary. The upside was that I was shaving events in the plot from what I saw in the performances. It was Julie, Rula and Charlie that were influencing the way the script was going.... But episode five, where they had to give up the rock'n'roll life for the glam rock life, was a killer. Andrew would look at five pages and tell me, in his New Zealand way, that it was 'absolutely marvellous'. I only learned later that he was in such despair he thought he was going to have to bring in another writer to finish it. Until you have attempted to write six hours of television you have no preparation for the strain. In this case I was also writing the lyrics. And they were very important, being related eliptically or directly to what was happening in the plot'.

'Did you have much input in the choice of directors and cast?' – 'I was very influential in pushing Brian Farnham as director but we had to have two. Verity insisted, and her instinct was absolutely right, that Jon Scoffield should be the lead director on the first series. He had come out of light entertainment and was famous for the Stanley Baxter specials as well as that wonderful visualisation of the Trevor Nunn directed *Antony And Cleopatra* from Stratford. When we met him he looked like a Frank Sinatra groupie. He said he hated rock'n'roll and I wasn't sure how fond he was of women. He seemed to be one of those (sexually) straight men who have trouble relating to intelligent women. But he made no distinctions between the labels of 'light entertainment', comedy and drama. So he wasn't phased by our mix and he knew as much about video as anybody I ever met. He taught me lots, not least because he simply used one camera. In the days of multi-camera schemes he would sometimes use just one for a whole dialogue scene. It turned out to be a happy collaboration once you got used to him going gruff.

'As to the casting we had three other women who famously dropped out and we were very much stuck. It is a long and unhappy story. The women who were optioned dropped out for too many reasons to go into. They weren't well known but in real life they were actresses who were trying to start a group. They had singing skills and would have been very useful. We had about six weeks to go and we had to find, at a time when there were not many around, people who could sing and act. Julie had been in two of my plays and was an amazing singer but after her we had open casting. Charlotte and Rula were found in open auditions and I had not heard of either. I didn't know Andy Mackay of Roxy Music, who wrote the music, he was brought in by Verity. The final decision never to leave the studio resulted from Jon's insistence that we should never break this alternative world we had created. It was all extremely collaborative'.

'Did you want to be around during production?' – 'I like to be around to the degree that it is useful. In that sense it is like theatre. I live with a director and have learned there are times when it is very counter productive for a writer to be around. My philosphy generally is that as long as producer, director and actors are on your wavelength you have to be trustful. At some point you have to let them get on with it and evolve it. My contribution in those days was very much during rehearsals. You were sitting in the gallery, they were doing rehearsal-record and there was time for you to comment afterwards'.

It became clear after episode one that this was not going to be a 'top twenty' show. The audience of 12 to 15 million was nevertheless huge by 1990s stan-

dards and even in the Seventies was considered impressive enough to deserve a more expensive second series. When this came along it disappointed some of the formula fans, it being considered more glossy as well as more innovative in its broader canvas and its movement towards the world of the pop promo. Much of the impetus was lost through one of Thames's many strikes, dividing transmission between spring and autumn.

'You probably don't remember episode six, called *Jubilee*, featuring a savage and sardonic song attacking the notion of trying to ignore economic realities in Britain by celebrating the Queen's Jubilee. That episode should have gone out on the date of the anniversary when all hell would have broken loose. But you couldn't generate the same impact in December, after the Sex Pistols had done their version of God Save the Queen. There wasn't a single protest except from that old guy who used to write for the Daily Express, Jimmy Thomas, and said he was horrified by the episode. When the National Film Theatre showed the whole lot, four or five years later, it was clear that, although the first series still had an impact, the second series was actually more energetic and in some ways more moving. Troy Kennedy Martin left in tears because it is so much about friends falling out rather than forces outside yourself'.

Since this high Howard Schuman has battled to survive and some of his work has proved fruitful. His notable *Nervous Energy* single, a naturalistic and semi-autobiographical single film about an American living with an AIDS victim who makes a manic and tragi-comic trip back to Glasgow, took a Screen Two slot as recently as December 2, 1995. But he has never been sufficiently encouraged to explore the possibilities of the video world opened up by *Rock Follies* and that is a sad waste.

Troy Kennedy Martin

There was never any doubt about the BBC's six-part *Edge Of Darkness* (1985). It was almost instantly and universally recognised as one of the best British drama series of all time. Though its first run was on BBC2 it quickly received a repeat showing on BBC1. Its title was frequently included in the speeches of BBC mandarins as evidence of the Corporations's continuing superiority as a programme maker. Twelve years later it still sits unchallenged, with the best of Potter and Bleasdale, in my personal 'top ten'. Even before the final episode was shown there should have been a competition amongst all alert executives, in a position to commission drama, to give its writer whatever money he asked before nailing him to his workroom floor and demanding his next television work. Instead Troy Kennedy Martin felt obliged, with VAT men hammering on his door, to flee to California. Apart from one single screenplay, from which he became semi-detached in production, *Edge of Darkness* has so far proved to be the last small screen work from the writer who changed the face of television drama with his 1962 creation of *Z Cars*.

Born in Scotland in 1932 young Troy spent much of his youth in Ireland. At Trinity College, Dublin, he liked to think he was a poet. 'But then in Dublin you can take on any disguise and people just take you at face value... I grew a beard and I looked a bit weird so I was always introduced as 'the poet''. He changed image a little for his National Service in the British Army and 'peace

keeping', as it is now called, in Cyprus. This experience served him well for his first novel, *Beat On A Damask Drum*, actually set in Indo China at the 1954 time when France famously lost its Dien Bien Phu fortress to the Viet Minh. More particularly it was used in his first BBC television drama, *Incident At Echo Six* (1958), about a platoon of conscripted teenagers under fire in the Cyprus highlands. Not only was his play produced it secured him an invitation to join the BBC Script Editors' Department in West London.

'When I joined the department was at Lime Grove but not long after that we moved into the new Television Centre building at White City. At that time television was still being run out of Broadcasting House, an impertinent arm that was subordinate to what was going on in radio, and the people in charge were really wireless broadcasters. Those who had moved over to television, like Eric Maschwitz and Donald Wilson, were all ex-officers who had been in the Army in the war and still had their pipes. They had that sort of very relaxed, slightly self congratulatory way with them, because we had won. The place was a bit of a shambles but coming in right at the beginning one was able to get some ideas for television produced pretty quickly. I had no training, I kind of missed all that, I had to discover all about cuts and montages and collages by myself.

'After writing a novel and getting a decent review from Graham Greene I suppose part of me thought I was slumming it at White City. On the other hand writing the book had brought me close to insanity I think, I ran my brain down and it was very difficult and lonely. Television was not like that, in a sense, though there was always a point where you got locked in a room and actually had to do the work. The good thing was that there were fellow spirits, first John Hopkins and then a whole influx of people like Roger Smith, John McGrath, John Arden, Kenith Trodd and Tony Garnett, all script editors when they started', Kennedy Martin remembered when we met at his West London workplace in late 1996.

As he remembers it the script or story editor's job then was 'giving writers cups of tea and gently timing their stuff, we didn't go in for the kind of interference there is now'. His real training as a television dramatist was in writing adaptations. 'I adapted lots of books and short stories, Graham Greene, Somerset Maugham, Bernard Malamud, Raymond Chandler, lots. Its very good training because you don't get the hang ups or blocks you might have when you are trying to resolve your own psychological crises through writing. That is always the problem with original work. Which is why, when I talk at film schools, I say 'Get people to do adaptations rather than their own stuff because otherwise they always get hung up on their Mum or their Dad or something like that'. These days there are soaps for training but the trouble with them is that you don't get room to manoeuvre and experiment the way you do with adaptations. You have to invent a lot as well as get the similarity with the text and it is not compulsory to use the same dialogue or the same approach. I think they have a rule on *The Bill* that you are not allowed to write any jokes. Whether that's true or not it certainly misses out on the blokeish wit that goes with policemen and which was one of the good things about *Z Cars* and *The Sweeney*. And that lack is no good for a young writer in training'.

By the time his *Z Cars* pilot was transmitted, on 2 January 1962, Kennedy Martin was, by his own realistic estimation, 'a very competent writer'. He

wrote the first six episodes and edited the next seven, all scripts by Alan Price. But even before his cop show began running his keenest interest had passed on to his six-part *Diary Of A Young Man* (1964). He soon came to see *Z Cars* as 'a bread and butter series', gradually becoming more prescribed and less perceptive.

'They ordered 13 and once it started they bumped it up to 39. It became an impossible task to get the others written, so around episode 17 or 18 I resigned from the BBC and the show. There was a lot of bad blood between me and Elwyn Jones, who was the first series producer. The problem really was that they hadn't thought far enough ahead and they didn't have enough confidence in what was being done. It was just bad management.

'The other problem was that there had been this big row at the beginning with the Lancashire Police. They had come down and talked to the BBC top brass who had, at the time, stood firm and said that the show would proceed as it was. But quietly they passed the message down and there were lots of modifications and excisions. We had to show how criminals were properly caught and then got off in court one way or another. Or else the word would come down 'You've got to change the ending so that the crooks are caught and punished'. Later on, when John Hopkins took over, they put the realities back but it was too late for me'.

Troy Kennedy Martin would rather be judged on *Diary Of A Young Man*, a rites of passage piece about a young man arriving in London and the blunting of his idealism. John McGrath had quite a lot of input as potential director. 'He then decided he didn't want to direct it and after a bit of a row we agreed to take a joint screenplay credit – which was fine except that nobody took it seriously because there were two names on it'. But the young Ken Loach did some of the direction and, set beside *Z Cars*, 'it was more experimental, it used narration, it had lots of collages and a huge energy. When you see the opening episode it still works quite well today. Of course it got wiped but the editor saved part one. And it was quite an important show because Trevor Griffiths saw it and decided to become a television writer'.

Troy Kennedy Martin's most resounding achievement in the late Sixties was writing and setting up director Peter Collinson's hugely entertaining and popular cinema movie *The Italian Job* (1969). This made him Hollywood marketable and enabled him to follow up with *Kelly's Heroes* and *The Jerusalem File*. It also gave weight, somewhat paradoxically, to his earlier contributions in the continuing debate about television drama aesthetics, politics and censorship. His 1964 article *Nats Go Home*,[2] a play on the slogan Yanks Go Home, was a fulmination against the habit of naturalism in television drama and made a big impression at the time and is still to be found in every film school library. It was theory about an alternative drama which he and John McGrath later put into practice with *Diary Of A Young Man*. It attacked heavy handed dialogue, the feeling of characters going about with balloons coming out of their mouths, and recommended collage, montage and narration as better ways forward. 'In a kind of way it was the first theoretical piece about television drama beyond How to Write a Television Play', he estimates. 'It came out of the sessions we used to have in the department every Wednes-

2 Troy Kennedy Martin 'Nats Go Home' *Encore* No 48, March-April, 1964

day, arguing our heads off about the theory of television and what it should be like. And of course some of the people like John McGrath knew about Brecht and all that sort of stuff, he tended to put a slightly theatricalised view...

'All this talk and thought had a very limited circulation and was not thought valuable by all practitioners. Some of us were always trying to move people in the way we wanted to go and were pointing to the bad grammar of early television directors. But you were always running up against people who just thought all the theory was bollocks. Or who were very English and said 'This is just a job, what's all this theory about? Go away and write a script, don't bother with all that'. And because there was real hostility about any kind of theory at the sharp end it happened that, as television drama opened out, it was the academics who rushed in, writing in impenetrable media studies gobbledegook'.

The other concern at the time was the influence of Mary Whitehouse and her puritanical constituency, disarming in manner but unscrupulous and damaging in her Fleet Street promoted 'clean up television' campaign. Looking desperately around for scenes of explicit sex to fulminate against, and finding sadly little of it on screen, the self-appointed Mrs Whitehouse felt obliged to broaden her brush. In *Diary Of A Young Man* she got excited about a scene in which the eponymous young man and his friend got drunk and vomited. She complained about the realism of the vomiting though in fact 'you never saw this, we used a machine that spurts out water over the pavement, so it was only the appearance of reality...

'We started a movement with Alan Simpson and Ray Galton from the comedy side to try and counter the Whitehouse thing. We had a couple of press conferences and the journalists got straight to the point with the question 'Would you advocate saying 'fuck' on television?'. If you said 'yes' you were done for and if you equivocated you were done for just the same. Then we had this guy Roy Shaw, later knighted, who came from the Arts Council and somehow took charge and then surrendered the whole thing. He turned up and chaired the final press conference and completely gave the whole thing away, so the movement collapsed. It was the first time I had seen an organisation taken over and destroyed like that. It was the beginning and end of my attempt to stop Mary Whitehouse.

'We were writers of drama and comedy trying to defend the craft of writing. We weren't trying to defend swear words or anything. Most television drama was really mediocre and what we were trying to do was push out the boundaries. If a few people got upset in the process that was a secondary consideration. There were so many people up there able to say 'No' to things, 'No' to a line or 'No' to a scene, it was difficult enough to get anything produced properly without this extra Whitehouse burden on our necks. But she was never able to take that argument, she was never able to see anything except in the most primitive way. At about the mid-Seventies time of *The Sweeney* we shared the platform at a Birmingham meeting. She was denouncing writers who showed policemen as corrupt. I managed to annoy her with the truth that there were more corrupt policemen in jail than there were writers of the genre'.

211

After these early struggles Troy Kennedy Martin's television credits became more irregular. Between 1975 and 1978 he wrote six episodes of the Thames police show createded by his younger brother Ian, *The Sweeney*. This was followed by the twelve-part *Reilly – Ace Of Spies* (1983) for Thames and a five-part dramatisation of Angus Wilson's novel *The Old Men At The Zoo* (1983) for the BBC. To be followed two years later by his television masterpiece, *Edge of Darkness* (1985).

'Your writing career has swung between television and cinema. Do you draw any distinction between the two?' – 'Well, cinema is really like a short story and the television I have liked to write has been the longer form, the mini-series really. Good movies have a striking idea and shorter plots. What really trips me up in movies is that I make them too long and complicated. Television is all dialogue, or a lot of it is, and cinema is all images. Television is much more influenced by cinema now than it used to be and there is a possibility of using real cinematic images on television. Theatre used to be influential but the mini-series has a narrative flow which owes more to the 19th century novel than theatre. That is novels before they became all about testosterone and personal visions as it were, where it is the story line that matters. That is why I think of *Edge of Darkness* as an extension of the 19th century novel'.

'Your liking for the 'novel' form of television drama may possibly explain your virtual absence from the era of the BBC's Wednesday Play and then Play for Today, say from the late Sixties to the early Eighties?' – 'Well, I didn't go back to the BBC for ten years, that's right. It wasn't so much the political thing, I didn't think they were doing anything substantial. In series Elwyn Jones and the people who followed him were really only interested in pap. They didn't feel they should make anything that rocked the boat. And I was never a Wednesday Play type person. I just couldn't get what I wanted to say in 90 minutes. I became more interested in doing movies partly because I thought the Wednesday Play people were a bit elitist. A lot of it wasn't very good, there was a lot of declamatory stuff, people making speeches. I thought they were just turning the audience off with the sort of production values they had then. Tony Garnett came round to this view and eventually said, in effect, that 'You are absolutely right, apart from Ken Loach's stuff and one or two other people I should really be making mini-series''.

'So Dennis Potter's *Pennies From Heaven* and Gordon Newman's *Law and Order* and others come along, for good or ill the single play begins to crumble away and you seize your moment with *Edge of Darkness*?' – 'I started writing it really out of sheer anger. I then felt it was going to be too way out and I was not confident that even Michael Wearing would be able to get it on air. But I was so angry. I think Jimmy McGovern said the other day, in some television interview, that 'You have to write out of anger' and by God I had a lot of anger in me. I was angry about the whole political situation, the whole Thatcherite thing, and how this connected up with the cowardice, the careerism and the lack of any kind of drive at the BBC. Politically I felt everything was being covered up'.

'So you start to write this television 'film noir' series about a detective investigating the murder of his daughter and revealing, with the help of the daughter's ghost, a huge cover up over nuclear waste contamination. How on earth did you get it through?' – 'Well, I was lucky in that Jonathan Powell was

about to take over as head of series and was denting the pap factory. He said 'I want to start with something really good, have you got anything in your drawer?' I had written a couple of episodes of *Edge of Darkness* and he said 'Great'. He slotted it in and I ran into a really big block while I was still trying to get the rest written. Then Reagan did his 'star wars' speech and the whole thing fell into place. It was the time of the whole move away from MAD (mutually assured destruction) to the idea that a nuclear war was winnable, all that stuff. I was able to get the baddie and had four episodes roughly in shape by the time they got to casting'.

'Once you had finished writing did you withdraw from the scene?' – 'No, far from it. Episode six turned out apocalyptic and that got people desperate. There was a battle royal over a lot of the material. We spent 13 or 15 weeks, practically the whole production time, arguing about the episode. I was around for that, they needed me for that. Also things kept coming up during the shooting. So I spent all of six months with the show and I think that made an awful lot of difference'.

'Do you like to be involved in the choice of director and casting?' – 'Michael (Wearing) chose the director (Martin Campbell) and then they got hold of Bob Peck (to play the protagonist, Detective Inspector Ronald Craven) and a lot of other people from the Royal Shakespeare... I'm hopeless over casting, I don't feel I want to do that. I might say 'I don't think that's the bloke', I might have a negative thing, but I don't really know the actors. I choose a producer I can trust and hope that the director will deliver. In this case Martin Campbell refused to read a book on nuclear power, so he didn't have the faintest idea what the story was about.... What directors really say is 'I don't understand this page, I don't understand this sequence, go away and rewrite it'. So it is through the rewriting process they learn what it is about... It was a real battle all the way through. I was lucky to have Dusty Hughes as script editor. He was writing for the National at the time and didn't give a fuck about keeping his job, so he took on Martin and Mike and encouraged my more crazy ideas. Eventually Martin had Dusty fired but he had taken the brunt of that first six weeks of rewriting...'

'But in the end Martin Campbell did deliver and then you unaccountably, it seemed, disappeared from television?' – 'Martin worries scripts to pieces, he is able to disassemble stuff but is not so good at getting it back together again. On the other hand he's a great action director, the series looked very good and the cameraman was absolutely wonderful. I didn't expect it to have the success it did have. The music was great. There were things in it which I would like to have changed scriptwise and I thought it was over-designed. I think design was the weakest element. The underground stuff looked too much like James Bond, I wanted it to look like a kind of illicit Irish still...

'Having spent six months in the field with *Edge of Darkness*, getting only a daily allowance, I was absolutely broke. I took me six months to write and then six months of production. The money for writing series in England was not good enough for such involvement so it seemed best to go for broke, to go to the USA and start writing there. I left for America with the VAT people on my heals, breaking down the door and demanding tax, all that sort of stuff...

'I was away in California and Australia for about eight years. I didn't feel any confidence in the new BBC and Channel 4 had limited funds, the only umbilical chord I kept was the personal one with Mike Wearing. I have done the single film now called *Hostile Waters* (transmitted by BBC1 on July 26, 1997), a true story from the cold war, because I needed the money. Tony Garnett produced and the BBC put a bit of money in and gave the impression of having more to do with it than they did have. But really it was Home Box Office in the US and it was hard to stop the whole thing falling apart. It seems to be part of the management culture at HBO to take scripts home and dream up daft suggestions. There were ten drafts before Tony gave an ultimatum to the Americans and they went back to the second draft. It was directed by David Drury, who did *Rhodes*, and the work was separated out. I felt really remote from the film, I had nothing to do with the production'.

'Looking back over nearly 40 years, and I suppose we have to look back rather than forward as far as television is concerned, you have stayed more or less in the genre of soldiers, spies and cops. Is there more?' – 'Well, I can still see myself writing another BBC series while Michael Wearing is still there, I am half-way through two ideas now. But yes I do like a bit of action. And there is more. Running through so much of my writing is a sense of loss and that goes back to the whole business of my mother, who died when I was 14. That was very apparent in *Edge of Darkness*. The thing was really about the loss of a daughter and the loss of a wife which lay behind the loss of the daughter. The hero has a breakdown which you don't often see in a genre piece. Also *Reilly – Ace Of Spies* was really about separation and loss, the spy is haunted and doesn't belong. Even in the early *Z Cars*, there were deaths and things as well as distinctive humour'.

Ian Kennedy Martin

The start of *Z Cars* was marked by a series of blazing rows between its creator Troy Kennedy Martin and its launch producer Elwyn Jones. After Troy's early departure the series formula was maintained, challenging content apart, much as he had conceived it. Other writers found the show a more or less prescribed but congenial production line. History repeated itself almost exactly after Ian Kennedy Martin, four years younger than brother Troy, conceived his most lastingly famous drama formula *The Sweeney*. Pre-production resounded with furious hostilities between freshman producer Ted Childs and exasperated creator Kennedy Martin. Ian, feeling his authority and experience was being brushed aside, resigned before episode one was shown. After which the show continued much as he had designed it. As with the initial *Z Cars* explosions it seemed necessary to have a thunderous creator v. producer struggle to clear the air before other high calibre writers could enjoy working for the show. Brother Troy himself contributed six episodes between 1975 and 1978.

By 1975 the original *Z Cars* had been transmuted and mellowed through *Softly, Softly* (1966–70) to the still more cosy BBC formula *Softly, Softly: Task Force* (1970–76). The Thames and Euston Films hit *The Sweeney* (1975), and more particularly its Ian Kennedy Martin written *Regan* (1974) pilot, arose from his impatience with the long dying BBC show. 'Here was a typical situation where a series has run out of ideas and all the executives can think of doing, as they sit around in their offices, is 'give the guy promotion'. Hence Detective Chief

Inspector Barlow (Stratford Johns). I have got a letter somewhere, with my contract for *The Sweeney*, which says that Detective Inspector Regan (John Thaw) must never be given promotion without my permission', Ian Kennedy Martin remembered when we met at his London home in late 1996.

'I was looking at *Softly, Softly*, which by then was a very poor extension of Troy's original, and around the same time I was meeting this guy from the Met's Flying Squad and finding out some of the police realities of the day. While the Home Secretary was protesting that 'We'll never arm the police' there were at that moment 200 armed policemen in London. They were called the Embassy Protection Squad. What an extraordinary coincidence that there was a bank robbery in South Kensington and the Embassy Protection Squad happened to turn up outside, fully armed and ready to shoot the people as they came out of the bank. So I knew what was happening and talked about it to my very good friend George Markstein, who was head of script development at Thames-Euston.

'He invited me to write an episode for their *Special Branch* (1969–74) police series. I said I'd seen it and it was terrible. He agreed and suggested I should try and think of a replacement. So I went to Euston on that basis and talked to Lloyd Shirley, the Thames drama boss, about the changes in policing signalled by the arrival of Commander Robert Mark as the new chief at Scotland Yard. I said there was a series to be made about the new style Flying Squad. The *Regan* pilot was commissioned for the Armchair Cinema slot and Euston committed to a series even before the single went into production.

'I wrote the pilot and worked with George Markstein, Lloyd Shirley and his partner George Taylor until we all considered it a finished script. It was always understood that the character of Regan was written for John Thaw who had been a great friend since he played the driver in my *Redcap* (1965–66) series for ABC. At this point Ted Childs arrived on the scene. He had come from *Special Branch* but I did not consider him a sufficiently experienced producer to be making the kind of demands for rewrites he, and director Doug Camfield, now made. My greatest fear was that *The Sweeney* would start with a class pilot and end up looking like *Special Branch*. Ted and Doug were writing pages of changes and I was rejecting every one. I am glad to say that the pilot, except for a short scene in a car in Soho, is exactly what I wrote. As a result of a huge row between Ted, Camfield and myself, in Lloyd's office, Doug left the production and John Clegg was hired to direct.

'Before the pilot was produced I had been commissioned to write the first three scripts for *The Sweeney* series. As I wrote Ted and I continued at loggerheads and, as is bound to happen when a writer and producer are in conflict, I was beginning to feel marginalised. At the time I was a young writer in demand, making relationships with top producers who subsequently put on some of my later creations, like *Juliet Bravo* and *The Chinese Detective*, and frankly I didn't need the hassle of a scrap with Ted over every *Sweeney* script I wrote. So, while remaining on good terms with George and Lloyd, I quit. Happily, while the pilot was in the production, there had to be new negotiations over my contract. My agent managed to secure for me a broad range of rights in any Sweeney films, novels and merchandising as well as the series itself. So, although no script of mine was ever used after the *Regan* pilot, I was going to make serious money out of the show. I still do'.

For his part Ted Childs has admitted[3] 'We had lots of fights about how it should be done, there is no denying that. I felt very strongly that we ought to pioneer a film technique rather than a tape studio technique. So what we really had to do was evolve a format where we exploited our advantages and obviated our disadvantages. I mean, given that we had to make these films in ten working days normally, and shoot five minutes a day, there were things we were very good at – action and two-handed dialogue on the run – in comparison with a tape production in the television studio. What we weren't good at were courtroom scenes and massive dinner parties because we had no rehearsal time.

'I more or less got my own way and I wasn't alone in seeking it. I certainly had the support of people like Chris Burt and Ian Toynton (film editors on the first series of *The Sweeney*), Tom Clegg (who directed *Regan*) and Terry Green. When I sensed that *The Sweeney* was something over which I was going to have control I began to look for writers who would do what we felt as a group we wanted to do. I think Troy Kennedy Martin was the definitive Sweeney writer because it was a logical development from the things he and John McGrath were doing on *Z Cars* before. He and Trevor Preston established how it would go in terms of script. But there were other people who made a valid contribution to the look. Roger Marshall and, latterly, Tony Hoare were also important writers'.

Troy Kennedy Martin's memory is that he came to *The Sweeney* initially to help out his brother. Ian agrees. 'It was John Thaw and I, not Ted, who talked my brother Troy into a committment to write for *The Sweeney*', he remembers. Whatever the truth of this Ian admits that, despite 'a few naff scripts', with Lloyd Shirley in overall command and Ted as producer it was a success'. He adds: 'Many folks have claimed to be the inspiration behind *The Sweeney*. In my view there is one person who was centre stage. That was Lloyd Shirley, head of drama, who commissioned it and chaperoned it to the screen'.

Although a Londoner by birth Ian Kennedy Martin spent much of his youth in Ireland. He followed brother Troy to Trinity College, Dublin, but was 'kicked out' before he graduated. He was still in Dublin and wondering what career to take up, thinking mainly in terms of art illustration, when he began to be attracted by the life style of the writers' pool at BBC Television Centre in London. Troy had got in thanks to an article he wrote for the *Daily Telegraph* about soldiers in Cyprus. This had interested the documentary maker Gilchrist Calder who encouraged Troy's debut play *Incident At Echo Six* (1958). Ian tried the same route. He wrote a pair of television plays. Neither was produced but John Hopkins tried to chaperone one of them through and eventually he and Elwyn Jones invited Ian to join the pool. He started work in 1961 as Troy was leaving.

Like his brother before him Ian read scripts, made adaptations and generally learned the terminology and techniques of television drama. Though 'it was definitely the relaxed life style that attracted me'. Gradually, looking forward, he could see that there were two ways to move on. One was to write single plays and the other was to opt for popular series.

3 Manuel Alvarado and John Stewart *Made for Television, Euston Films Ltd* BFI 1985, page 57

'There were the serious writers like David Mercer who would write two heavily reviewed plays each year, getting £900 a script if they were lucky. I sold my first BBC play for £80 so I knew that £900 would be very lucky. Then there were people like Brian Clemens working on ITV shows like ATV's *Danger Man* and ABC's *The Avengers* and driving a Ferrari, which must have cost him all of £2,000. So I chose to write for production line series. You could write say eight or nine episodes of the BBC's *Troubleshooters* (1966–72) and then go on to another series, in my case BBC1's *Colditz* (1973–74)'.

'After contributing like this to formulae created by others it appears that you made a conscious decision that your own creations would be placed, more or less, in the cops'n'robbers genre?' – 'Look, there are only three kinds of people who can walk into a situation and, more or less of right, ask questions. They are doctors, lawyers and cops. There were quite a few people who went down the doctor way and there were a few who opted for lawyers but I think that both Troy and I chose cops because we found it easiest to research them. They always want to talk about themselves and their last case and there's a kind of energy which gives you the ability to tell a fast moving narrative. You don't get that with doctors or with lawyers. It's a very logical thing. If you want a high tension story you go for a policeman rather than a doctor'.

'You mention Troy and yourself as just missing each other while working in roughly the same area but also, to an extent, helping each other. Does sibling rivalry ever come into the equation?' – 'No, I don't think it does. We did do one series together, using pseudonyms and all the rest of it, we were both broke at the time and also we did it for fun. It was hilarious. It was a ludicrous thing for Anglia and ITV called *Weavers Green* (1966), about the life of country vets in Norfolk. It was a twice-weekly soap which cunning old fox Lew Grade (the ATV boss) didn't want and managed to kill off with split networking. Peter and Betty Lambda took credit for all 49 episodes though I used my name as story editor. We also worked together on *Parkin's Patch* (1969–70), the Yorkshire rural police series. We sat in the south of France and just knocked out episodes of that. I took them back to England and got them right. It was just for the money really.

'But we learned fairly early on that Troy and I don't work in the same way. I am a sort of 9 am to 3 pm neurotic. I like to write a bit every day, a straight run through without lunch or other interruptions. And he does his work in bursts and flashes. It doesn't work together.... Then he decided to go a different way. He went first to Hollywood and he loved everything he saw. He loved the swimming pools and the Beverley Hills Hotel. When I went there it seemed every person I saw was an absolute fucking nightmare. I loathed everything to do with the place. Though I did later get married there and it has lasted 26 years so far. I think Troy is much better at vicarious living. He loves meeting film producers who are actually involved with the Mafia, he likes pretty girls, he likes watching. I think he went there after having been paid a lot of money for *The Italian Job*, he was a bit of a number there, the first of the English writers to make serious money.

'But the truth I learned about Hollywood is that by the time they've finished buggering you around you make less money than you do sitting over here and working for Thames Television, getting a good series off and going. I was back and forth for three years and did three Hollywood studio projects,

writing scripts that never got made. At one point I was storming down Sunset Boulevard and I met John Hopkins. I complained to him that I had written three fucking screenplays and I could't get any of them on. He said 'Well I've written 16 that haven't been made'. Now I think he is dying somewhere over there, poor old John. What was it George Melly wrote about his *Talking To A Stranger* (1966) quartet? 'The first authentic television masterpiece'. Even then 50 per cent of the people in the business thought it was a joke. It was all one lane stuff even if very well acted and produced. I remember that at the same time I was reading R D Laing and I thought to myself 'John's just shifted all this stuff over to the screen', case histories and one thing and another'.

'All of which suggests that you, like Troy, were never specially keen on the single play concept as it emerged from the BBC at that time?' – 'I always tried to do a professional job but I think these personal things needed a slightly different attitude. I have never been in the area where television is used as a platform for the socially committed, left wing thing. I was suspicious of that whole Wednesday Play thing because I know it's quite easy to write that sort of stuff. You take a mallet to crack an egg, you say the working class are in a terrible position, all that sort of thing. I have always found it Stalinist and suspect. You bang away at the same thing, you bring in archetypal people in a stress situation and you say how terrible society is. I belong to the left but I suspect how easy it is to do some of that stuff'.

'Though I suppose that you could be accused of writing social documents in the shape of your *Juliet Bravo* (1980–85), the pressure for a woman holding down a commanding job in a male domain; and *The Chinese Detective* (1981–82) about this Chinese cop surviving in an Anglo Saxon environment?' – 'Yes, I plead guilty to that. Yes *The Chinese Detective* was a sort of social document in the way I used the Chinese guy to look at our society and comment on it, that's where it came from. That idea came before *Juliet Bravo* and I sent two pages of script and eight paragraphs to Graeme MacDonald at the BBC. He said he liked it but had no money to make it. He also said that the BBC1 controller, Billy Cotton, had come up with this idea for a series about a woman Detective Inspector.

He said 'It's much easier to go along with the heads of the BBC, it saves an amount of aggravation, so why don't you go up to Lancashire where we still have *Z Cars* contacts, there's a woman Inspector up there who could serve as a model'. So while we were waiting for money to make *The Chinese Detective* I went up to Lancashire and produced the format and 17 scripts for *Juliet Bravo*.

'In those days that is what I used to do. I would be commissioned to write a script and I would do that before the contract came through. Then I offered two courses. I told them I was very happy to write a pilot and walk away and if they wanted my involvement after that there were certain producers I worked with and others I did not. I said 'If you are going to put me with someone I don't like or admire let's just leave it at the pilot'. I had my list, Ian Toynton, Terence Williams... They would say 'Terry Williams, what a good idea'. I would then ring Terry and say 'Look, I've got a job for you, somebody's going to ring you, and if you think I'm not going to have anything to do with the fucking casting you are wrong, we are going to choose the director and do the casting together''.

'Hence the memorable performance of David Yip as *The Chinese Detective*?' – 'Well, I wrote that with somebody else in mind, an actor I had met and thought was very good. But when we interviewed that actor and David Yip it was obvious that David was absolutely right for the part. David is half Chinese and half Irish, so he could act as well as be Chinese. He became a close friend of mine from the moment when we cast him'.

'Those were the days when the BBC drama department could still make decisions and ITV companies still gave producers creative space. These days you are obliged to wrestle with the BBC's *Madson* and London Weekend's *The Knock*. Not so much fun I guess?' – 'Yes, well when we were making *Madson* we were screamed at for spending a penny over the top and on the other side of the building this madness, this extravagance was going on as they made the last Potters. Ian MacShane, the acting star of *Madson*, got a credit with me as joint format writer. I don't want to cause a lot of trouble but I am dead against the decisional apparatus which allows popular actors to run riot. John Thaw is not one of these back seat drivers, he's never formed a production company and stormed and ranted round the place. But people like Ian Mac-Shane, Jimmy Nail and David Jason... it is not healthy. It is quite clear that that recent Jimmy Nail thing was produced and acted to make his music career, as cynically as you could possibly think. Alan Yentob is obviously a bit a star fucker and him being head of drama has been a nightmare.

'I turned out ten episodes of *The Knock* to buy time for a film screenplay I wanted to write. But I am not all that unscrupulous. I turned down £50,000 this morning, I was invited to write two episodes for the BBC's *Silent Witness*. It is a quality series, beautiful music, well directed, well written and I could have done it but I knew it wasn't quite right for me and I saw that this had the potential for disaster. Not that working for the shows Paul Knight supplies to London Weekend, *The Knock* and *London's Burning*, is so comfortable with the Granada accountants looking over your shoulder.

'Granada now is looking for precinct drama at about £340,000 an hour. When they took over London Weekend these guys arrived from the north like a bunch of thugs, looked at Paul's shows costing £550,000 to £580,000 and said 'Don't even argue about it, we want money taken out of these things'. I'd already finished my first six episodes for *The Knock* when the crunch came. Paul had one of the best organisations in television and two hit shows, he had performed brilliantly for years and years and was trusted to deliver. Then Granada come along, saying they don't like his way and trying to take control. And writers inventions are more prescribed than ever before'.

Epilogue

He (John Birt) has introduced rampant commercialism and made the lives of programme makers like me a misery... The talent now knows I cannot make the programmes they want... I have no choice, it is creatively impossible for me to remain.

As attentive readers will have noted it became one of this book's refrains. Writers reminded themselves that while Michael Wearing still had a desk at the BBC, as head of drama serials or whatever, there was still some hope. It was circa 1980 when, as an English Regions producer at BBC Birmingham, he fought the action that made his name as a doughty supporter of the best writing. He shielded Alan Bleasdale's *Boys from the Blackstuff* from an inadequate budget and the doubts of the mandarins above and, with ingenious compromise as between film and tape recording, saw the series through to broadcast. Whether this event is seen as the tail end of 'the golden age', or an isolated triumph, it was clearly a time when television drama departments were still empowered to make decisions. They were able to keep the door open for freshness and surprise. They could still encourage, to borrow from my introduction, the drama that "helps us recover the sensation of life and makes us feel things".

In late 1997 Wearing was still in place. Introducing his 'sub-LA style' of management Director-General John Birt had centralised all effective decision making with Director of Television Alan Yentob and his two channel controllers. It was a trio uncontaminated by the experience of having worked in drama. Wearing, like the rest of his department, was rendered impotent. He hung on as the last authoritative relic of his era in the hope that his experience, and his links to writing, directing and acting talents, could still influence. Until, as this book was going to press in February, 1998, he announced that he had had enough. A project on which he had staked his reputation, adapted from a Janet Neil novel by Jeff Case, was thrown back by BBC1 Controller Peter Salmon. The rejection was 'the straw that broke the camel's back' and Wearing advised: 'If I were Jeff Case I would never work with the BBC again'.[1]

1 Ben Dowell BBC Drama 'Man To Leave' *The Stage*, 5.2.98

'The talent now knows that I cannot make the programmes they want... I have no choice, it is creatively impossible for me to remain', he said.

In the wider picture the misery and departure of a single programme maker may appear as of little account. But his story is symptomatic of a rampant malaise. The vandalism that has reduced BBC Drama to a nearly empty shell and handed so much of its work to independent producers, who must strive to satisfy focus groups, market researchers and Birtist executives, has ensured an era of constructs that cannibalise from past ratings winners and eschew new approaches. After the Wearing resignation was made public Alan Yentob tried for damage limitation, in a letter to the Guardian, asserting that 'focus group research is never used in BBC Television as a deciding factor in any commissioning decision'. The deciding factor, we may be sure, is the whim of his controllers and himself. Who, with self protection necessarily in mind, know where it is safe to look for advice.

Moving towards the end of his first year as Secretary of State for Culture, Media and Sport smiling Chris Smith suggested, between the lines, he realised the purpose of the BBC was to make and broadcast programmes and that he should use any power he had to help restore concentration on that purpose. So far he had found no way of budging the prevailing doctrine which made theoretical 'efficiency' an end itself. Creative talent was deflated, programme makers were miserable, schedules were dulled but 'efficiency' had never been in such wonderful shape.

At the time of writing the latest Smith corrective was to advertise for new BBC governors, instead of making mysterious government appointments from the ranks of 'the great and the good'. He also announced an intention to make the Board more accountable to parliament and public. There should be more representation of women and the young, he suggested. Whatever was thought of this as a long term aim, and it was undeniable that the Board of Governors has always had more than its share of boring old male farts, Smith clearly failed to address the immediate need. Thoughts of sex and age, even accountability, amounted at this point to an unnwanted diversion. For the health of British broadcasting the urgent requirement was for governors, of any age or sex, with a passionate concern for programmes in general and television drama in particular. There could still be a better future, all was not lost, but there could be no turn around until the managerialist hi-jack had been first recognised and then corrected.

Further Reading

Manuel Alvarado and John Stewart *Made for Television - Euston Films Limited* BFI 1985.

Peter Ansorge *From Liverpool to Los Angeles, On Writing for Theatre, (Cinema) Film and Television* Faber and Faber 1997.

Colin Brake *EastEnders, a Celebration* Penguin/BBC Books 1994.

George W Brandt (ed) *British Television Drama* Cambridge University Press 1981.

George W Brandt (ed) *British Television Drama in the 1980s* Cambridge University Press 1993.

Fliss Coombs *The Making of Rhodes* BBC Books 1996.

Graham Fuller (ed) *Potter on Potter* Faber and Faber 1993.

W Stephen Gilbert *Fight and Kick and Bite - The Life and Works of Dennis Potter* Hodder and Stoughton 1995.

John Hill and Martin McLoone (eds) *Big Picture, Small Screen - The Relations Between (Cinema) Film and Television* University of Luton Press 1996.

Jeremy Isaacs *Storm Over 4, A Personal Account* Weidenfeld and Nicolson 1989.

Hilary Kingsley *EastEnders Handbook* BBC Books 1991.

Bob Millington and Robin Nelson *Boys From The Blackstuff - The Making of TV Drama* Comedia Publishing Group 1986.

Frank Pike (ed) *Ah! Mischief, The Writer and Television* Faber and Faber 1982.

Dennis Potter *The Changing Forest* Minerva 1996.
 Waiting for the Boat - On Television Faber and Faber 1984.
 Seeing The Blossom Faber and Faber 1994.

Irene Shubik *Play for Today, The Evolution of Television Drama* Davis-Poynter 1975.

Antony Thomas *Rhodes, The Race for Africa* BBC Books 1996.

Index

INDEX OF NAMES

225

INDEX OF TITLES